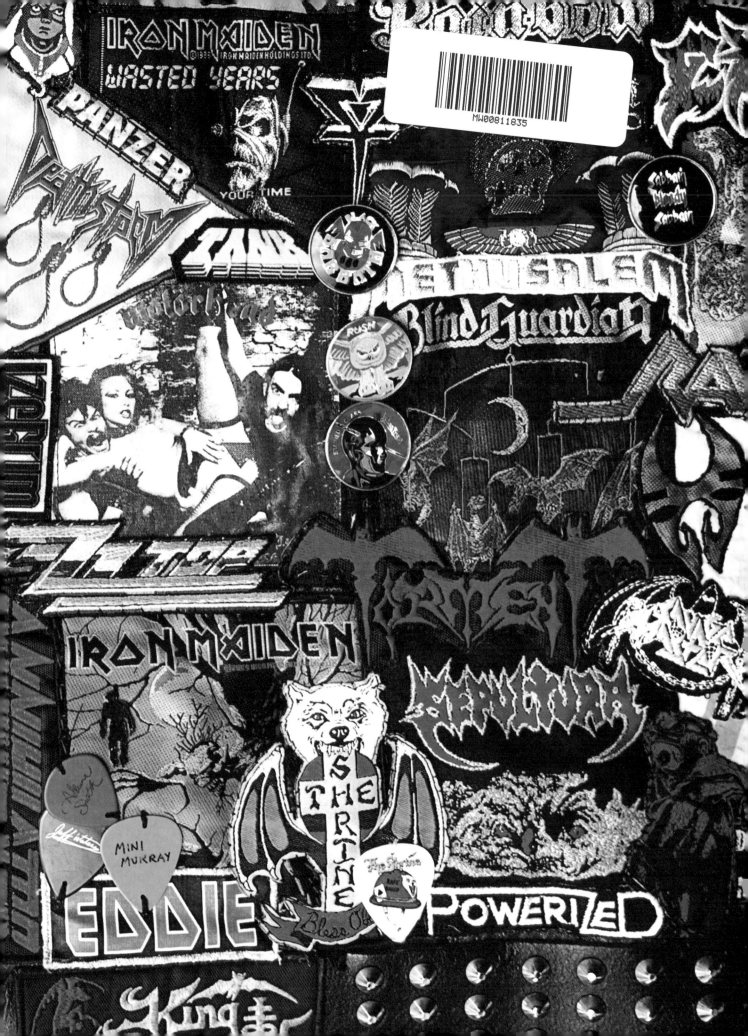

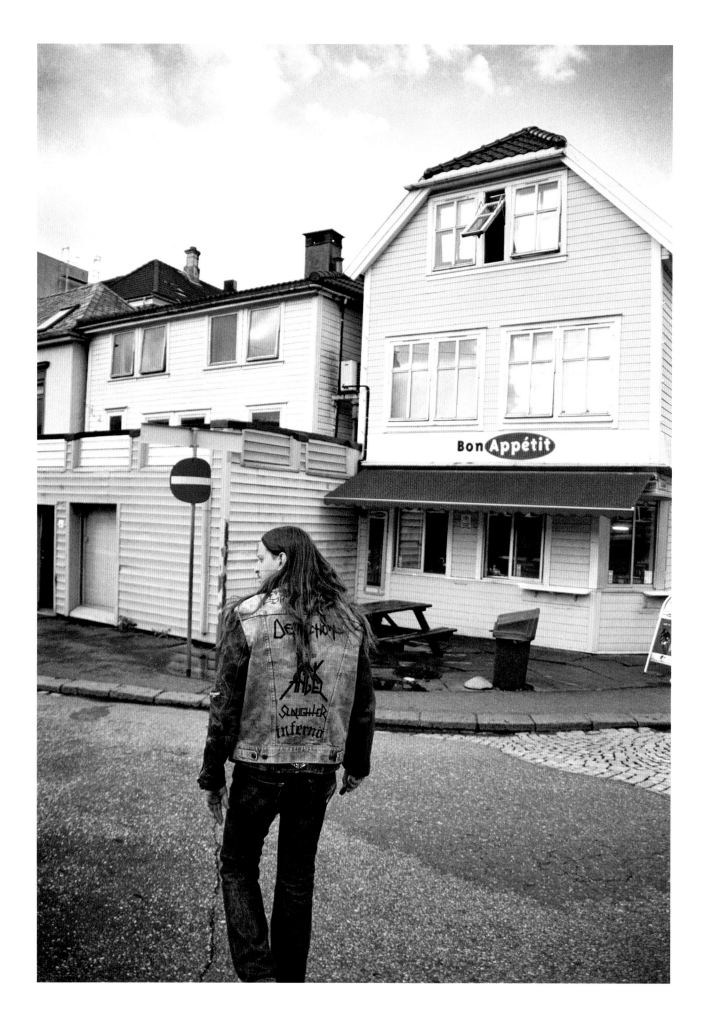

DEFENDERS OF THE FAITH

THE HEAVY METAL PHOTOGRAPHY OF PETER BESTE

Defenders of the Faith

ISBN: 978-0-9996099-4-1

Published by Sacred Bones Books
Design by Peter Beste and Sacred Bones Design

First Edition

1 2 3 4 5 6 7 8 9 10

All requests and correspondence can be addressed to:

Sacred Bones Books
144 N. 7th Street #413
Brooklyn, NY 11249

Printed in China

FOR MY FAMILY

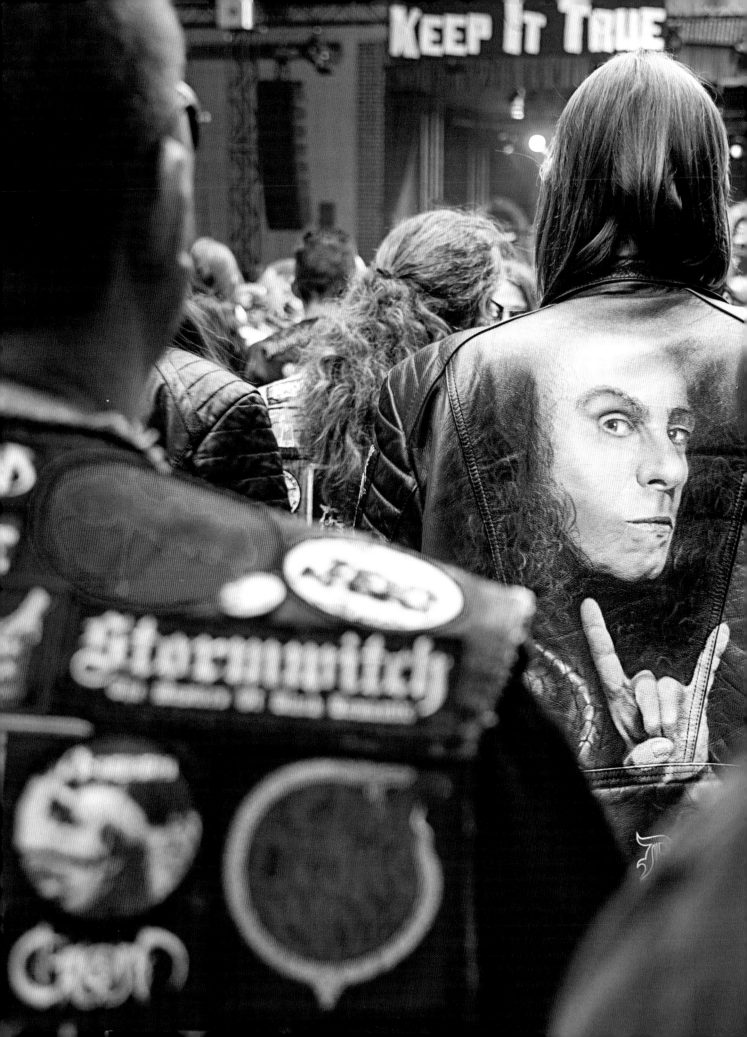

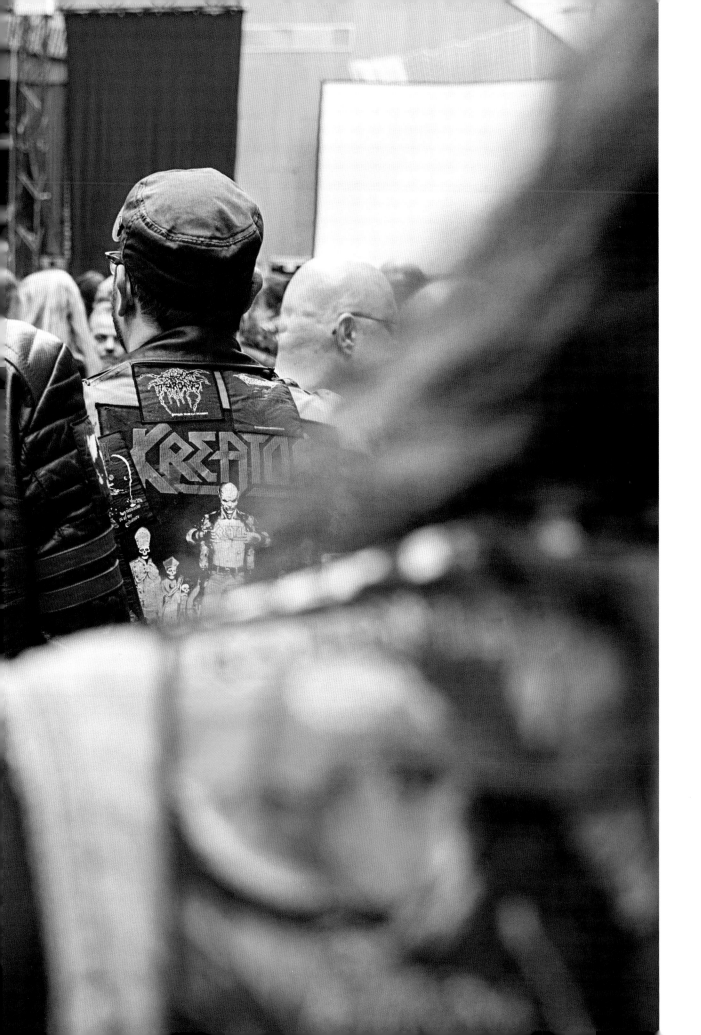

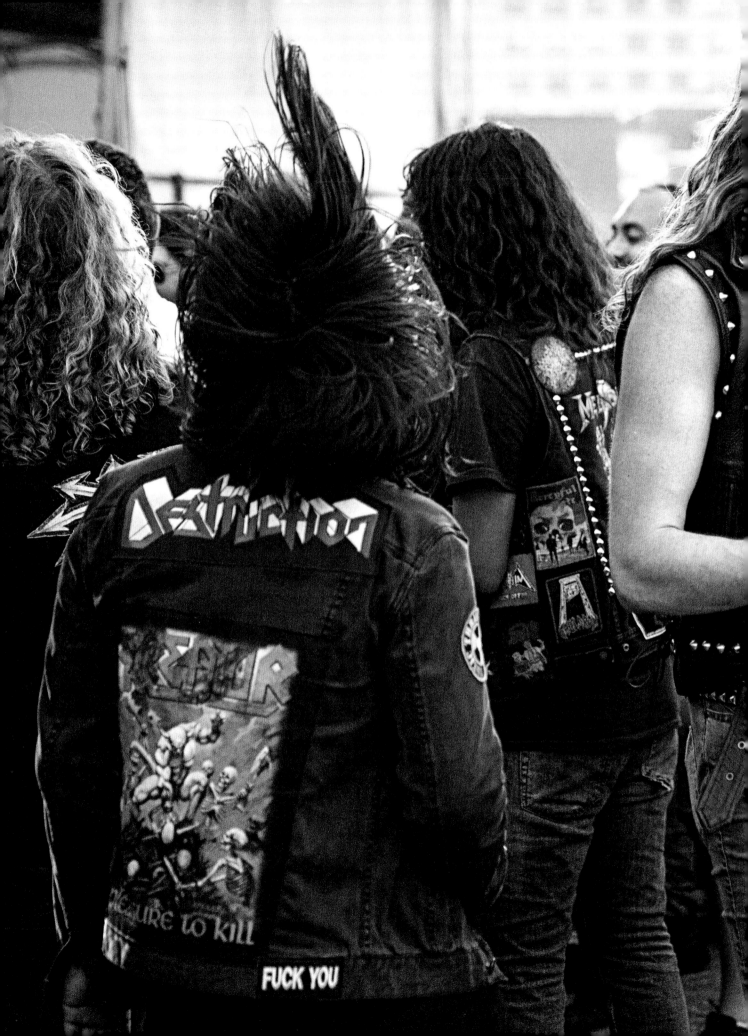

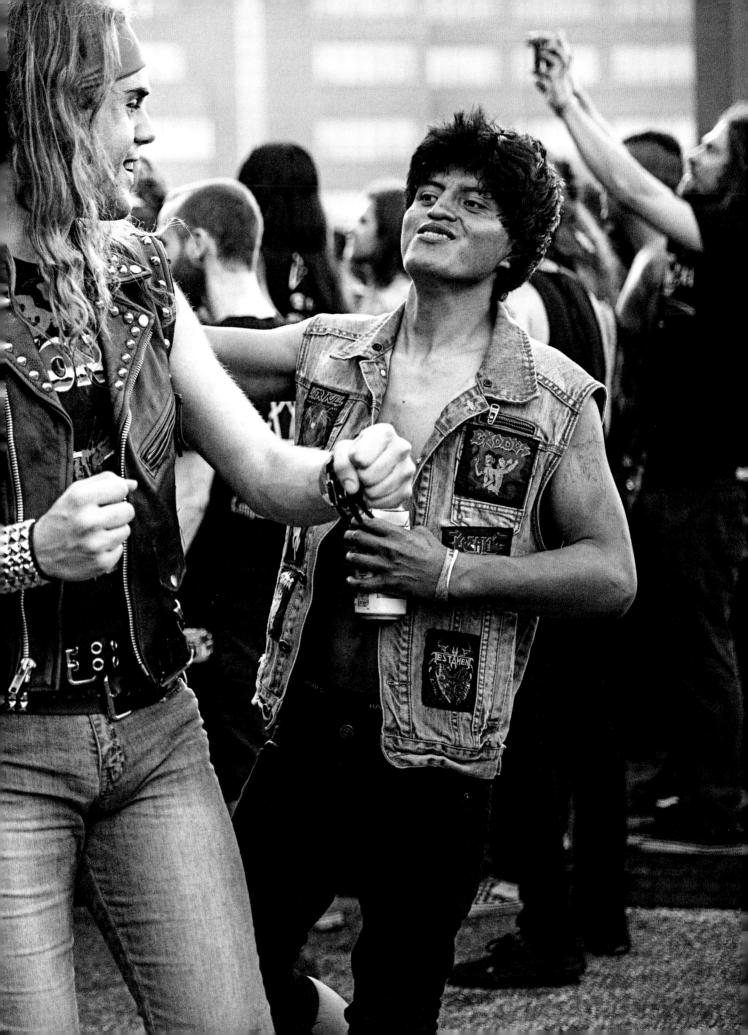

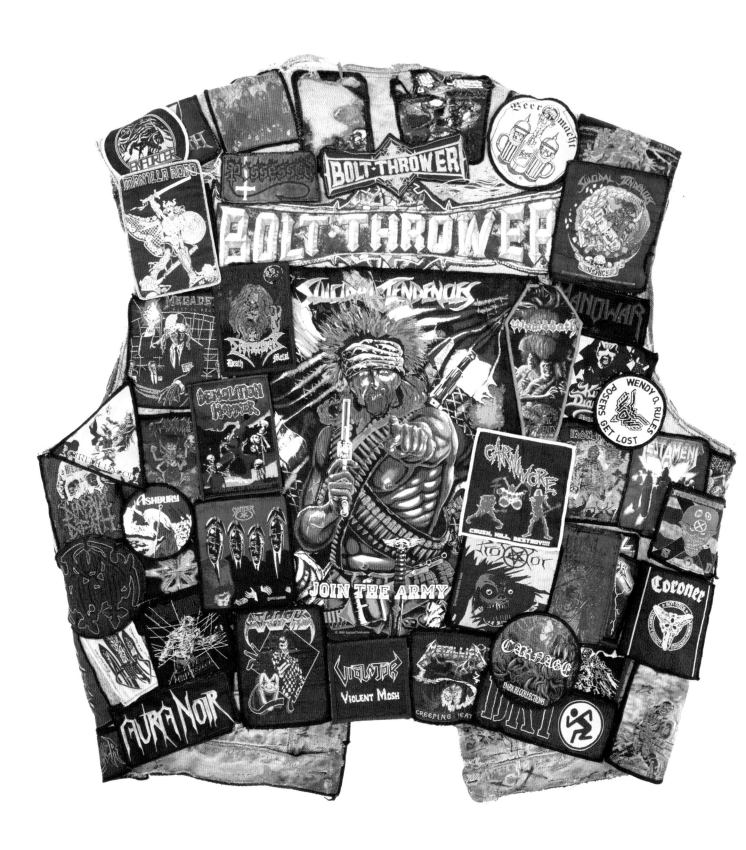

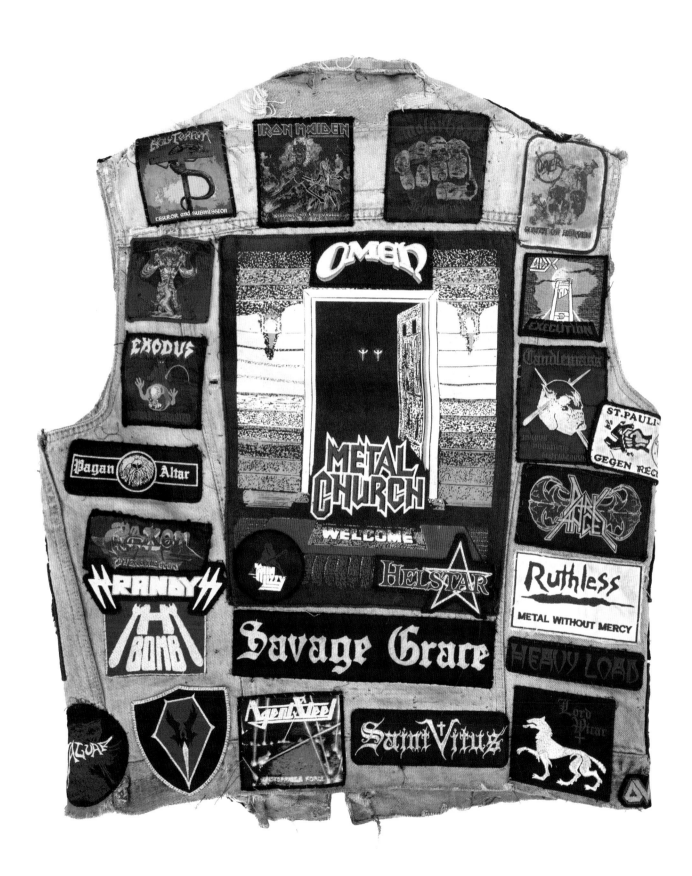

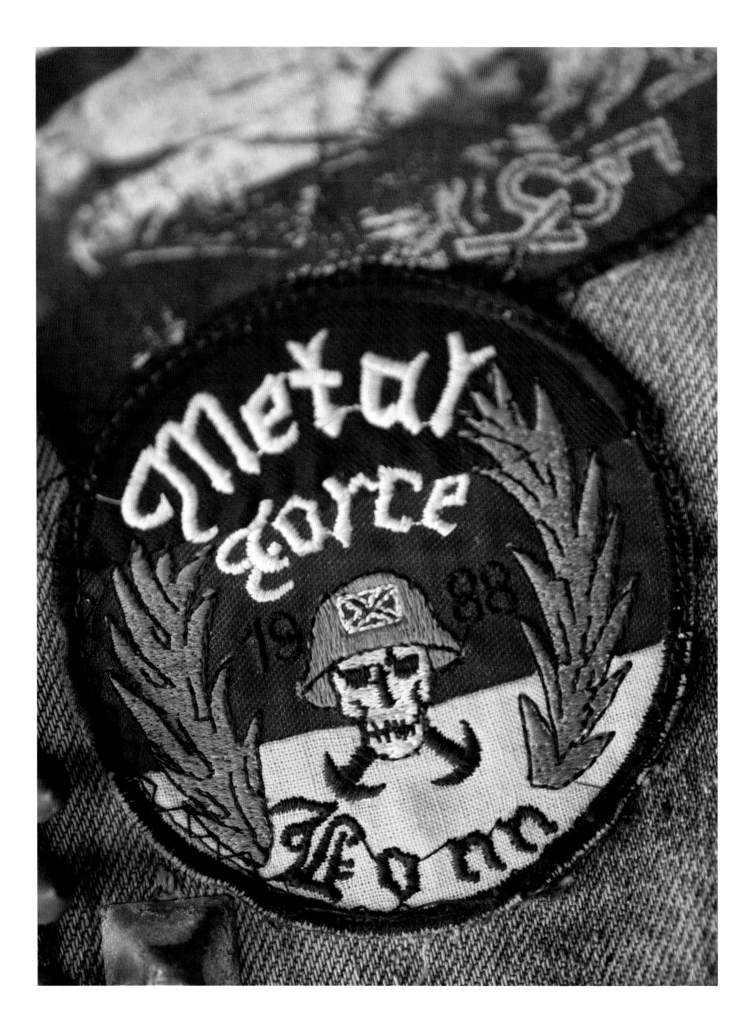

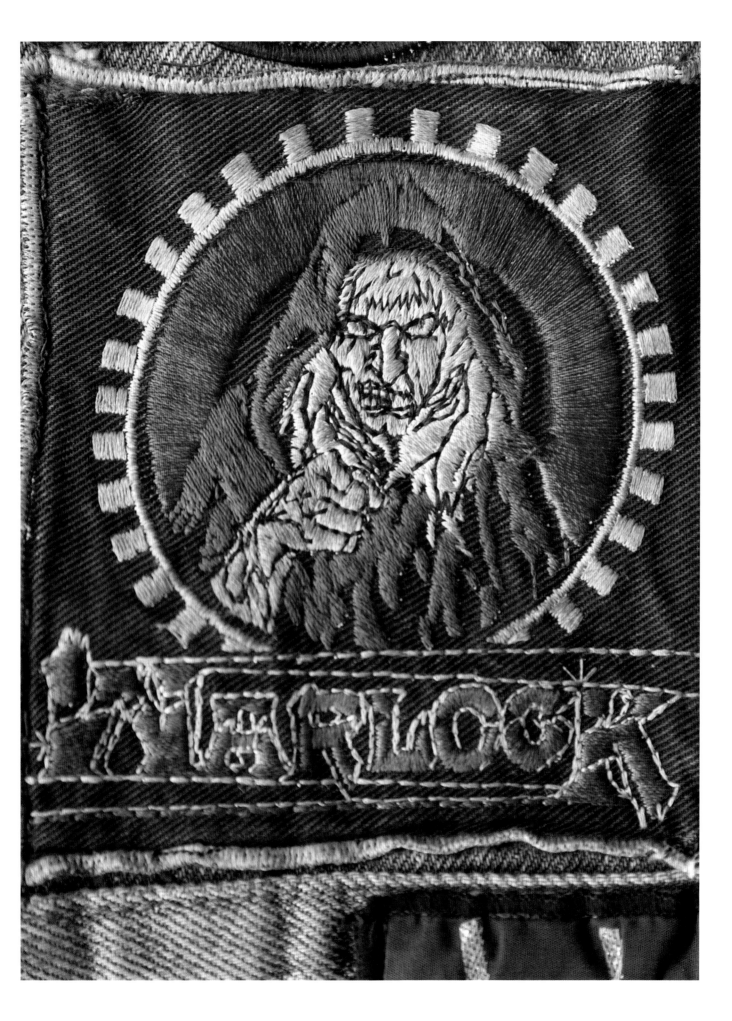

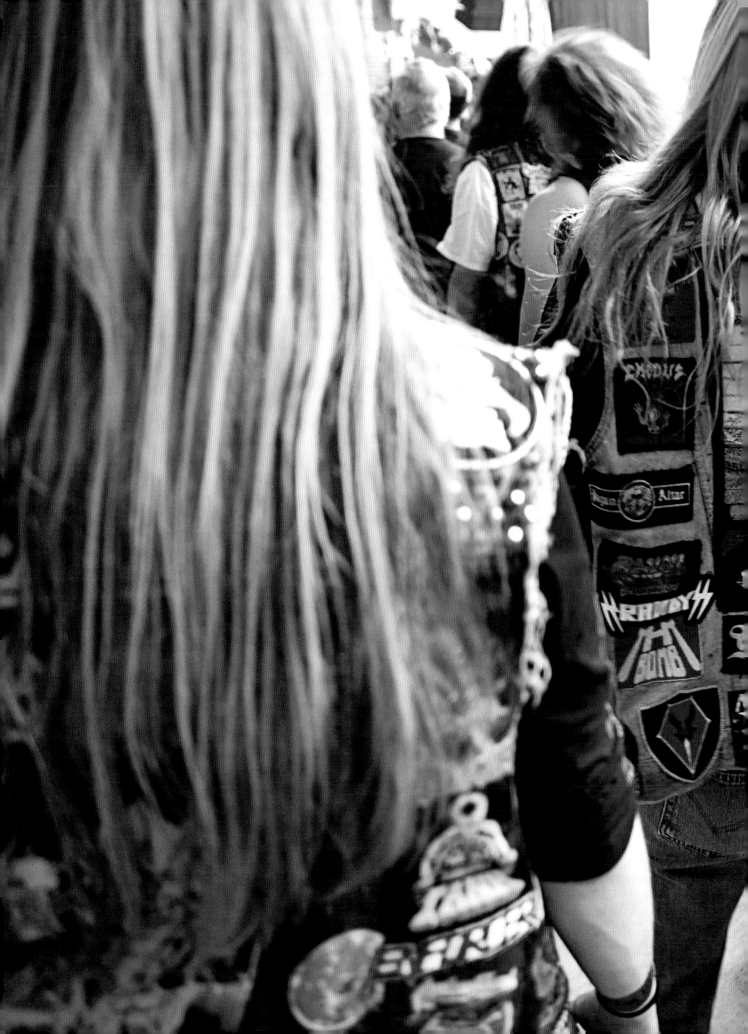

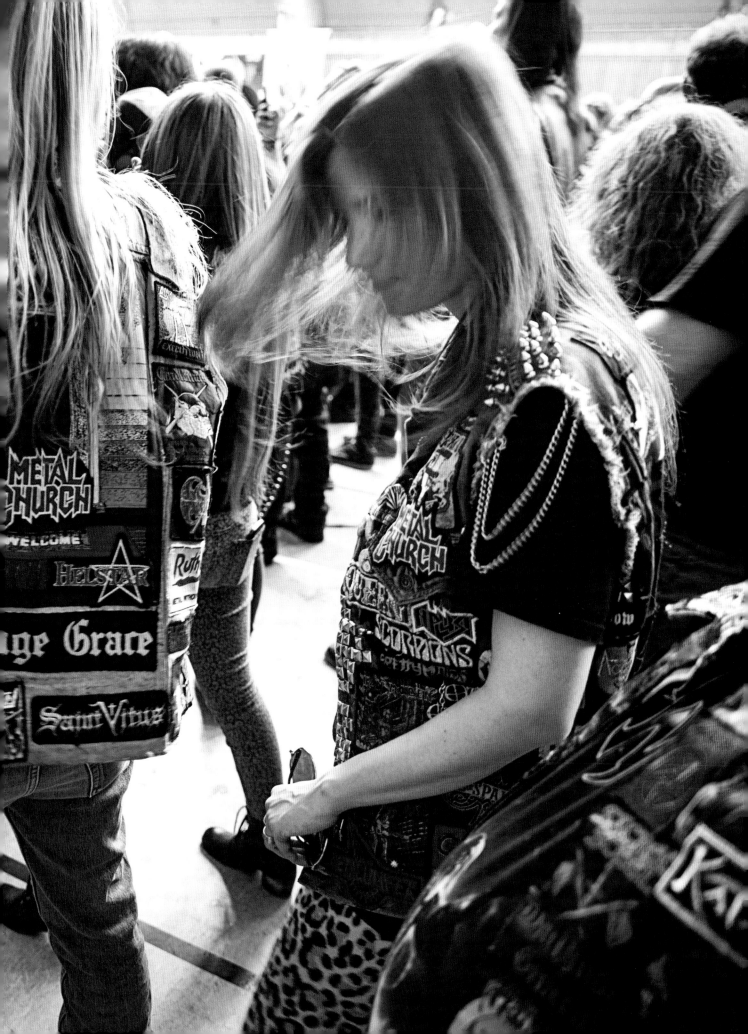

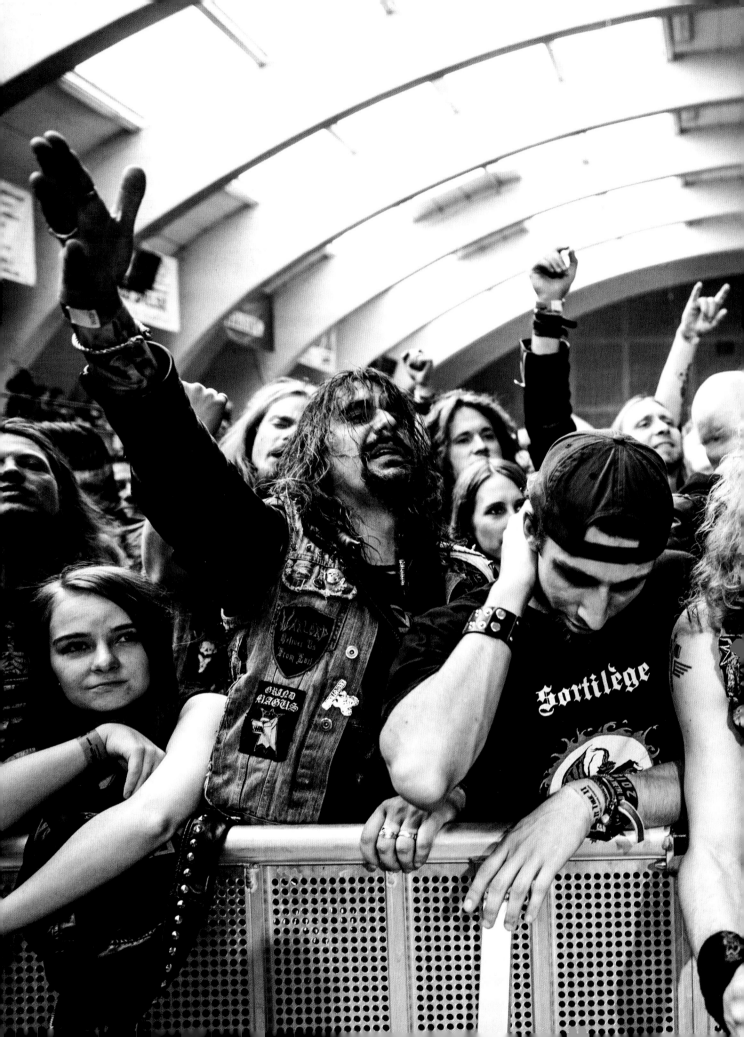

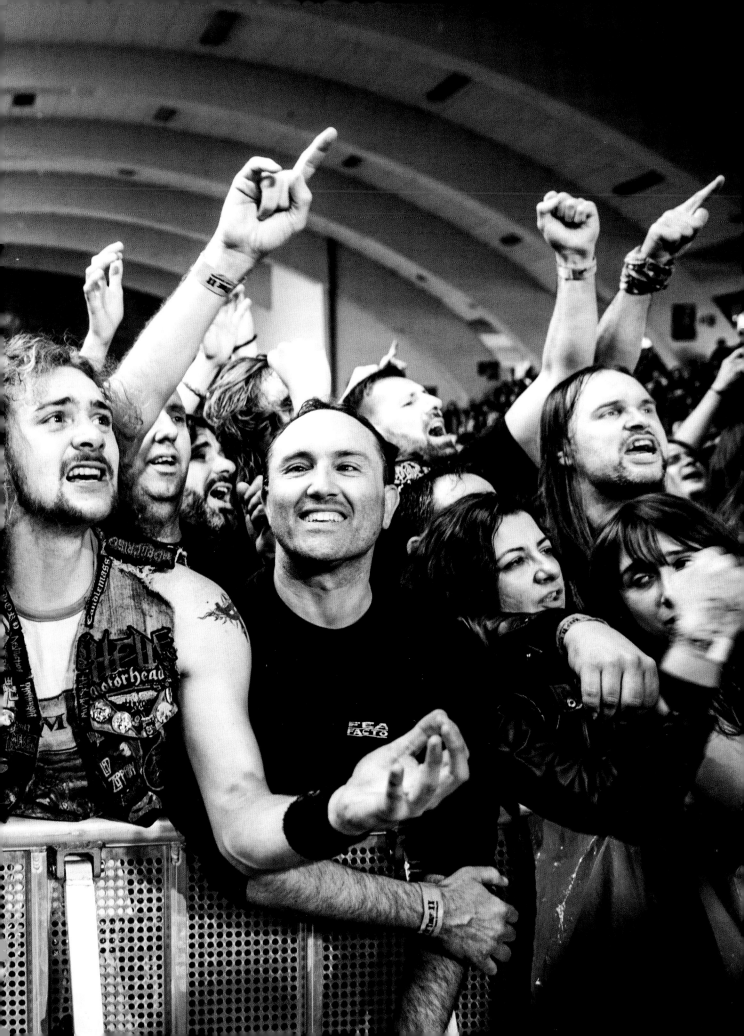

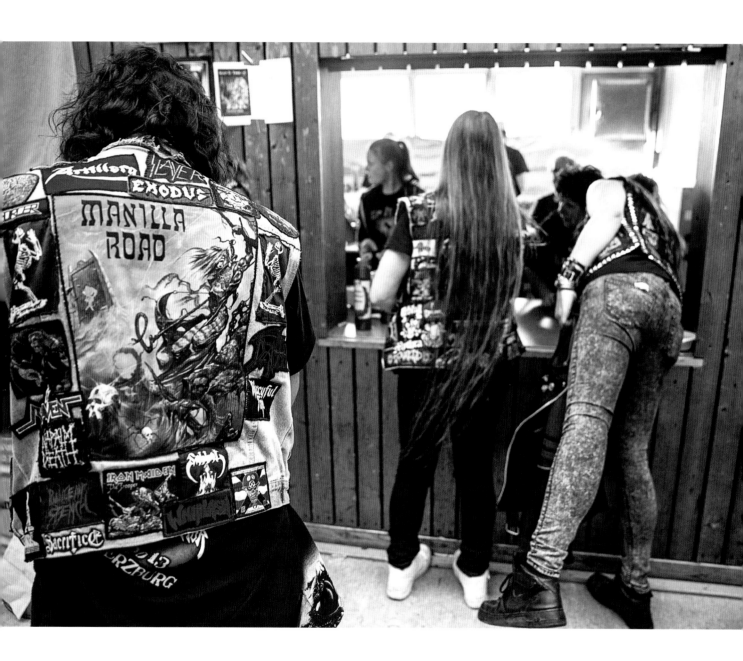

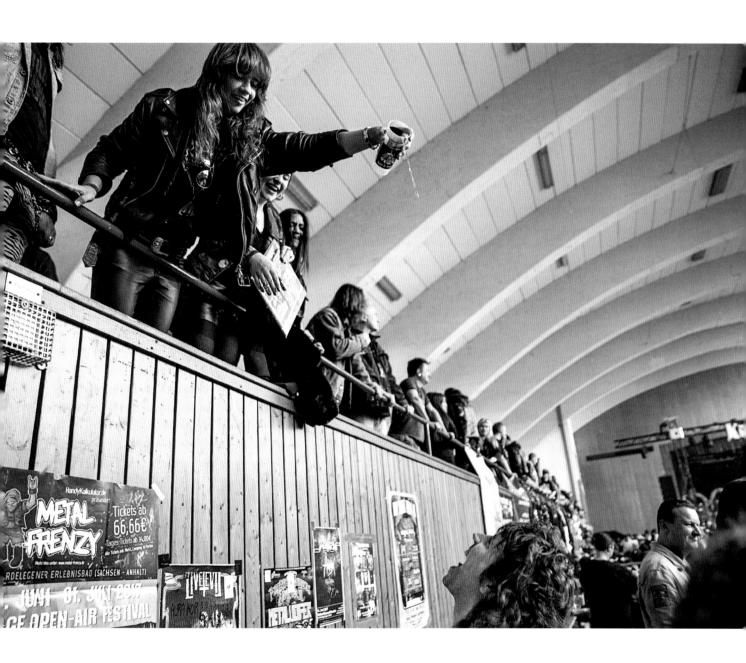

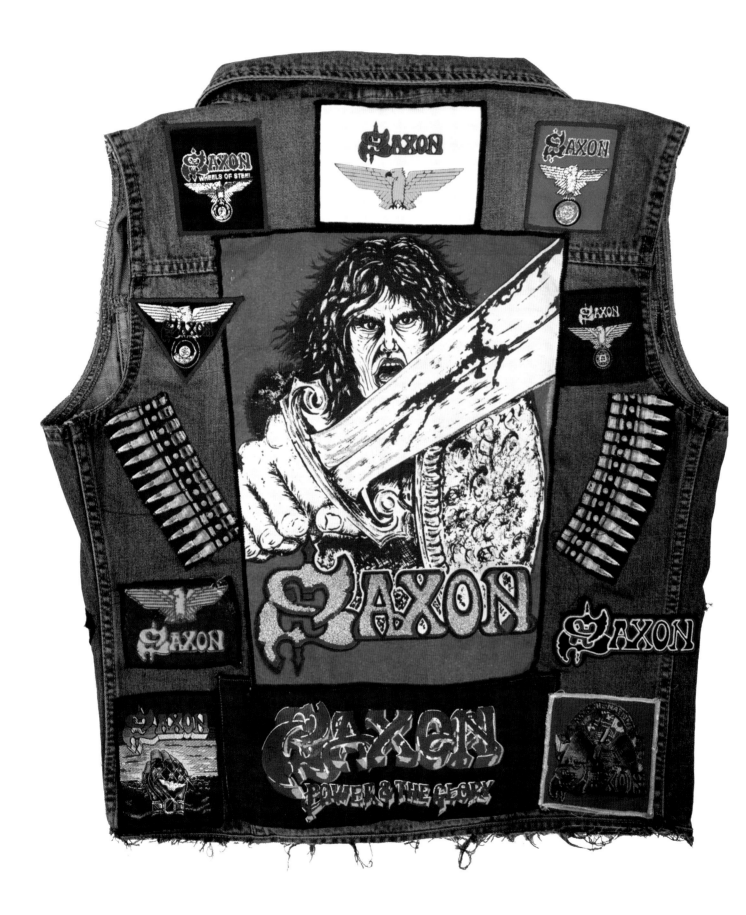

FOREWORD

The first time I saw one of these battle jackets at a show was back in the late '70s at a Motörhead concert. Bullet belts, leather coats, high boots, tight jeans. This image was imprinted into the rock n' roll DNA and is still with us.

A denim cut-off jacket, usually worn over a leather jacket, with the band emblazoned on the back was the way of telling the rest of the audience and world that you were part of a family, a gang, a team. This has been going on for over a thousand years: people wearing capes, shields, banners to let others know which clan, army, guild they belong to.

American motorcycle clubs brought this idea into modern times, wearing colours to let people know where they belonged. The designs were painted onto leather or denim jackets. This form of the battle jacket was made famous in American motorcycle movies.

These days, the battle jacket says you are part of an exclusive community. It seems to be strongest in the world of Heavy Metal, my world! Here, every fan is looked on as a friend.

Generally, bands like Saxon go out of their way to meet with as many fans as possible, at meet-and-greets or outside the tour bus or hotel. This camaraderie is, I feel, unique to this music genre. Let's face it: to be a fan of a band for over 40 or 50 years is extraordinary. And not just one band! A fan can have multiple favourites. It's also ageless, with younger fans liking older bands and older fans liking younger bands.

You can have any job. Brain surgeon, builder, student, unemployed, gangster. It doesn't matter. If you're at the show or you bought the album, you're in! The battle jacket is one way of showing this, with patches, embroidery, studs, chains, paint, anything that looks rock n' roll. It became part of the fashion mainstream for models and actors to wear rock regalia in films, on the catwalk, and in photo shoots, and when we went to America in 1981, the look had already arrived via British rock magazines like Sounds and Kerrang.

Which brings me back to the beginning. Wearing a battle jacket sets you apart from the crowd, and makes you a member of a worldwide club. As a man once said—I forget who it was now—denim and leather brought us all together!

And I know it did! I was there!

—Biff Byford

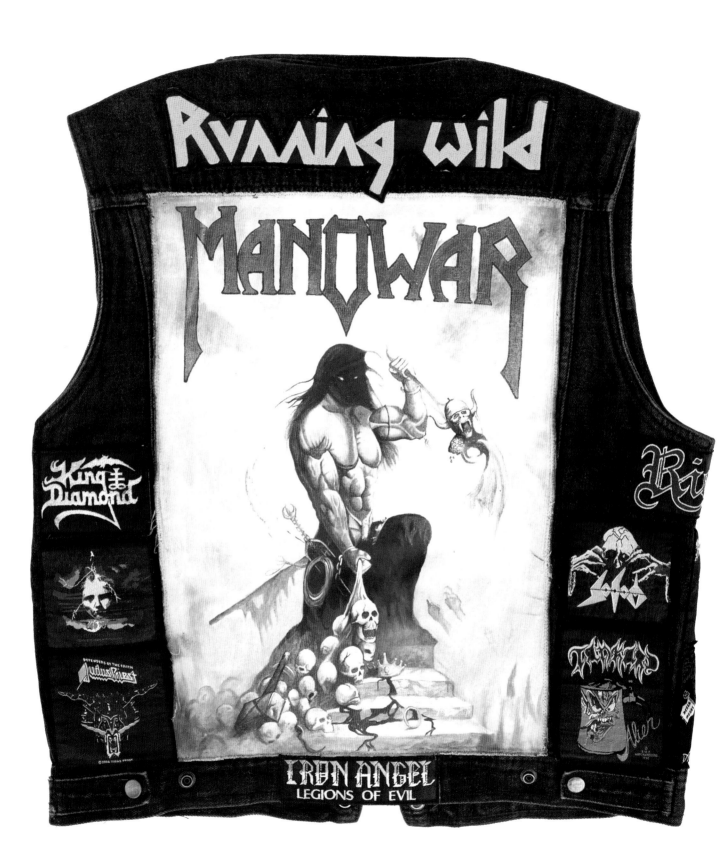

INTRODUCTION

This is our fourth book together. Starting in 2007, Johan Kugelberg edited Peter Beste's first long-term photo project, which resulted in the book, *True Norwegian Black Metal*, an overview of the most extreme and previously isolated metal scene. A few years later, Johan edited and published Peter's photographic immersion into the Houston rap underworld. Most recently, we collaborated on a book about the hardest-partying of subcultures, the Scandinavian *danseband* community, where summer festivals become bacchanalias of drink and dance.

At this point, it is probably clear that Peter Beste is a veteran of interacting with Dionysian subcultures, where the human condition is celebrated with music, with drink, with togetherness, and with grabbing life by the throat and headbanging it.

For the last four years, Peter has traveled to metal festivals, shows and gatherings around the world, photo-documenting the identity, the uniform, the fun, and the rituals of the global metal tribe. After four years of shooting, Peter brought hundreds of spreads and over a thousand photos to Johan. We argued about every spread and every sequence until we were both happy. *Defenders of the Faith* is the end-result of that process.

What we have attempted to provide is a celebratory documentation of a subculture that brings people of all ages and backgrounds together under the universal language of Heavy Metal.

Nobody cares what you do for work, how much money you have, or who your parents are when you are rocking out at a metal show. Metal fans are metal fans.

This book is about passionate Heavy Metal fans—the metal tribe. This identity is an escape hatch from the humdrum, and it's the foundation of the strong, vibrant community that's depicted in these pages.

We love the metal vests, the bullet belts, Eddie's face grinning at you from a thousand backs, the tribal logos, battle axes, dripping swords, and the hot Frazetta babes.

For those about to rock… you know all that already.

—Johan & Peter

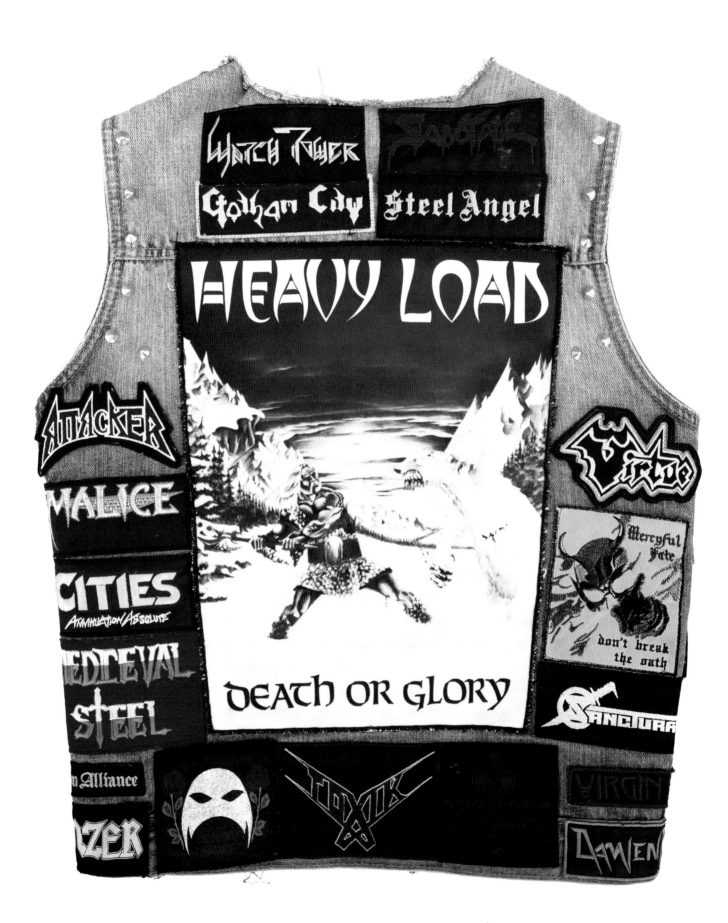

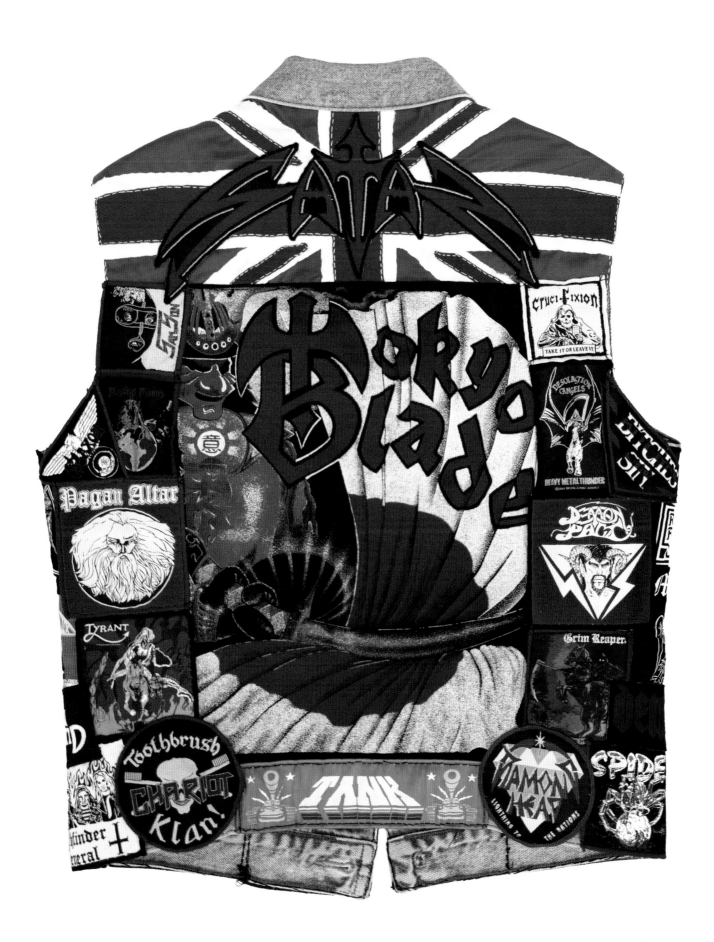

23

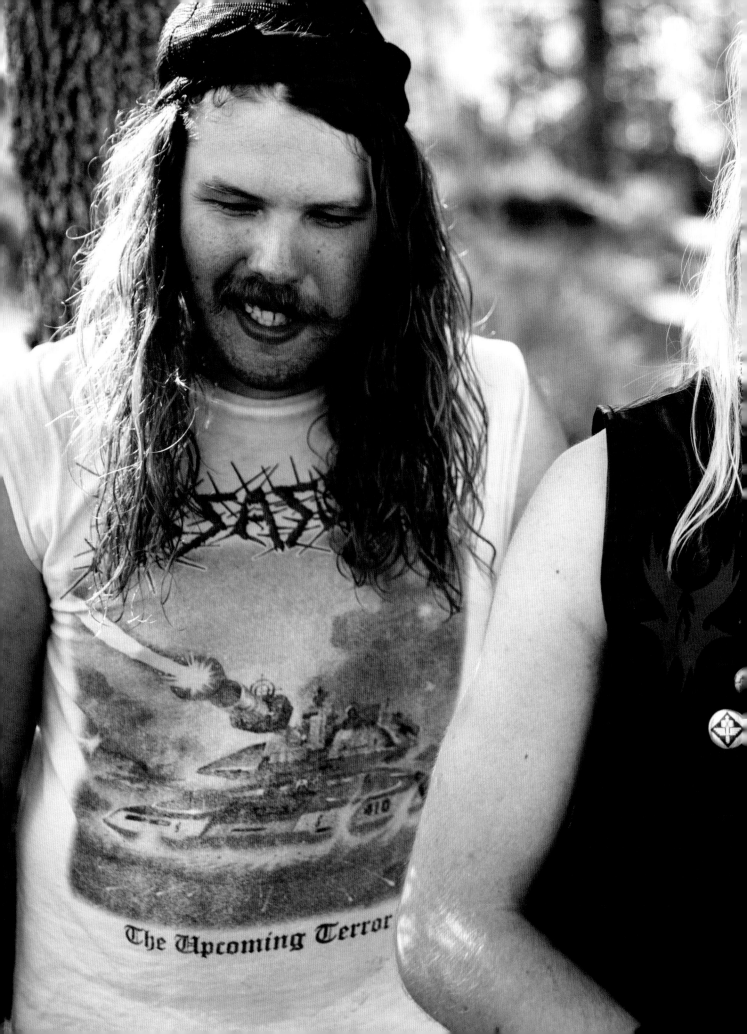

The Upcoming Terror

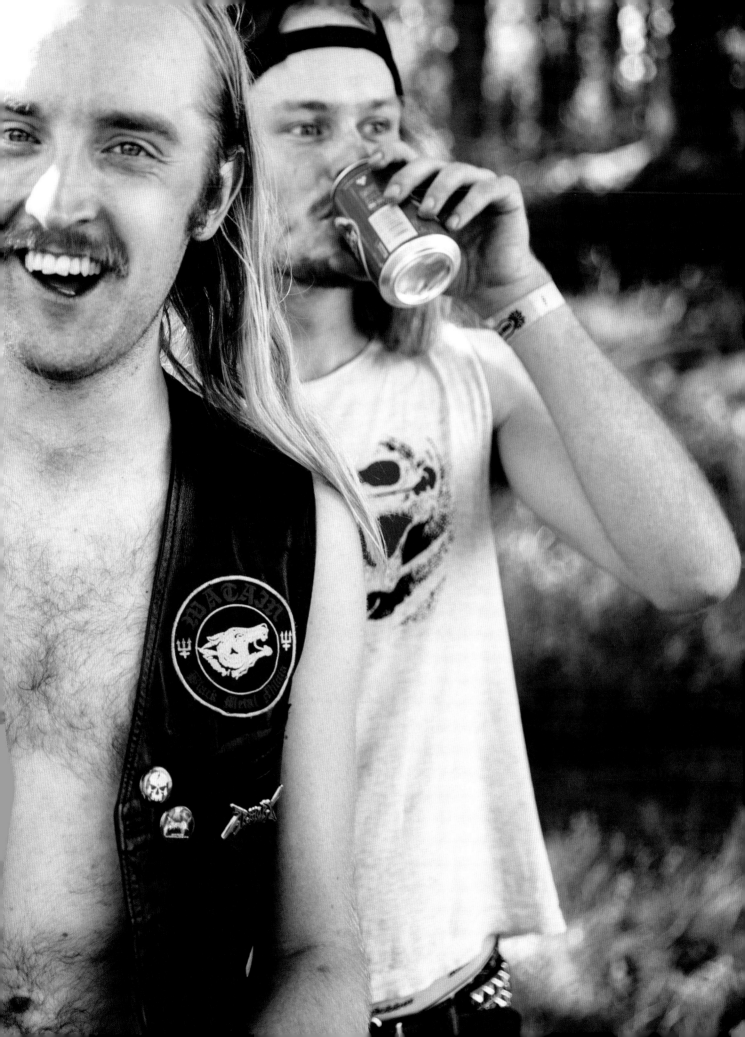

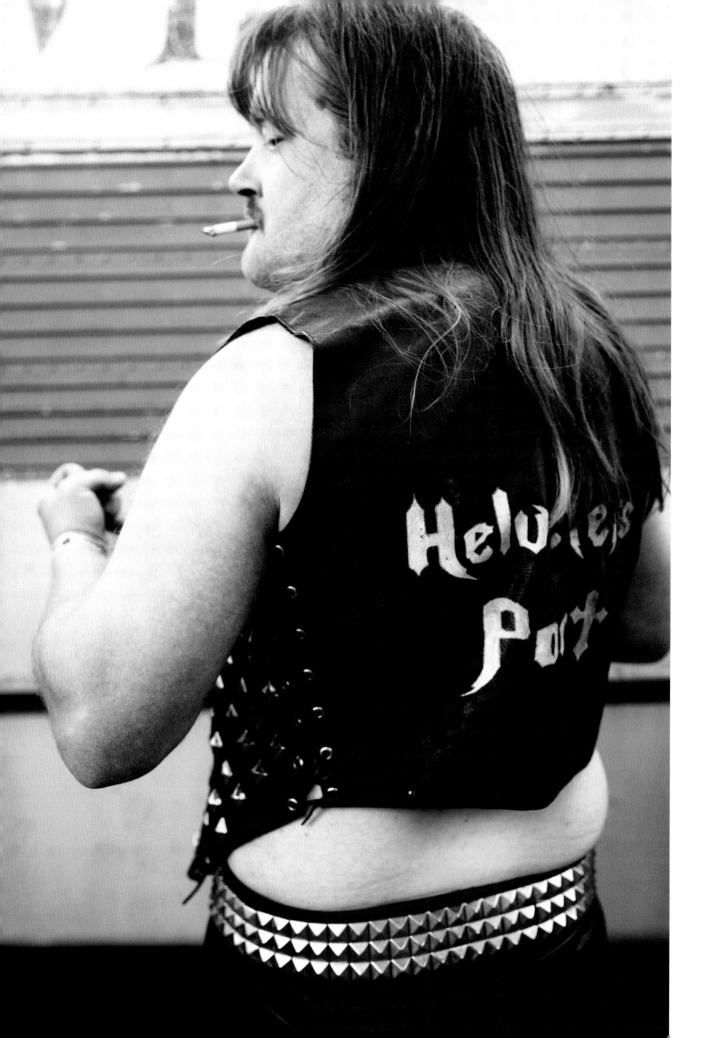

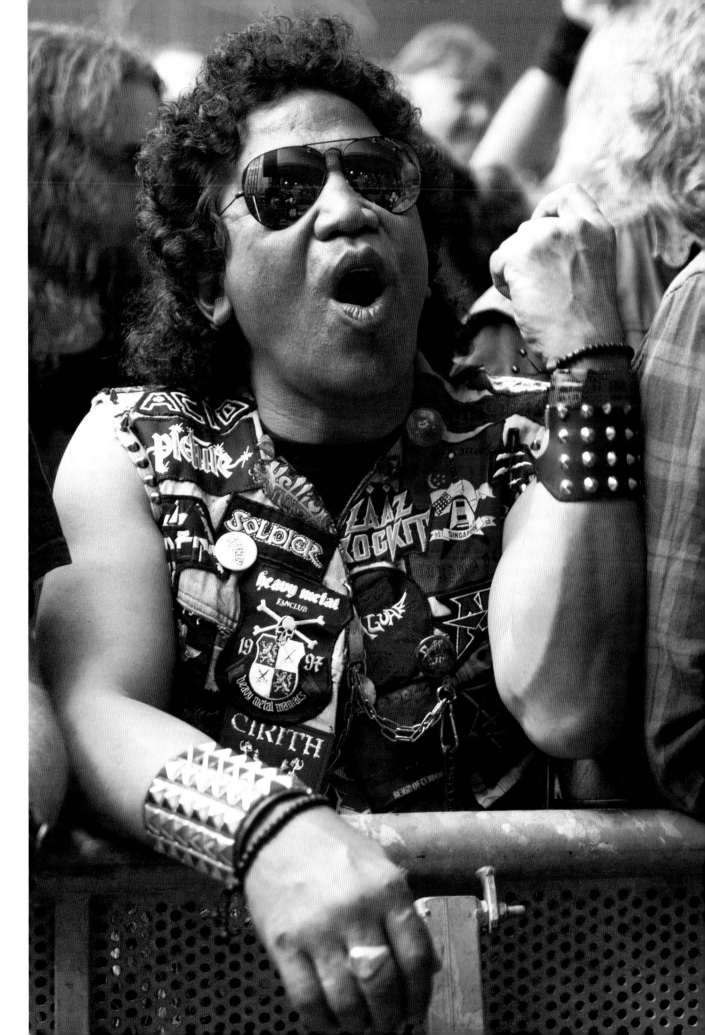

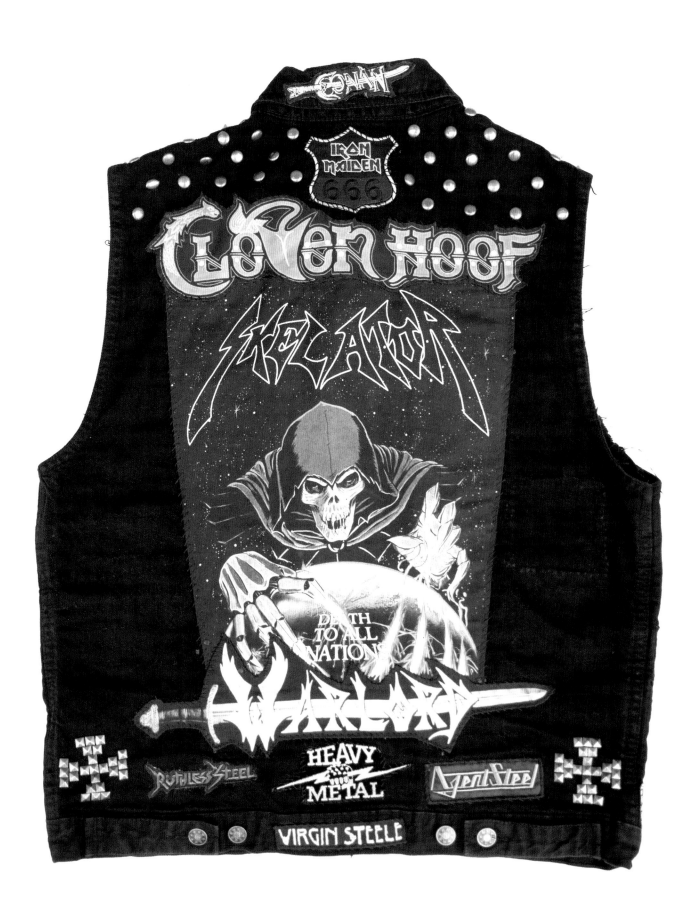

28

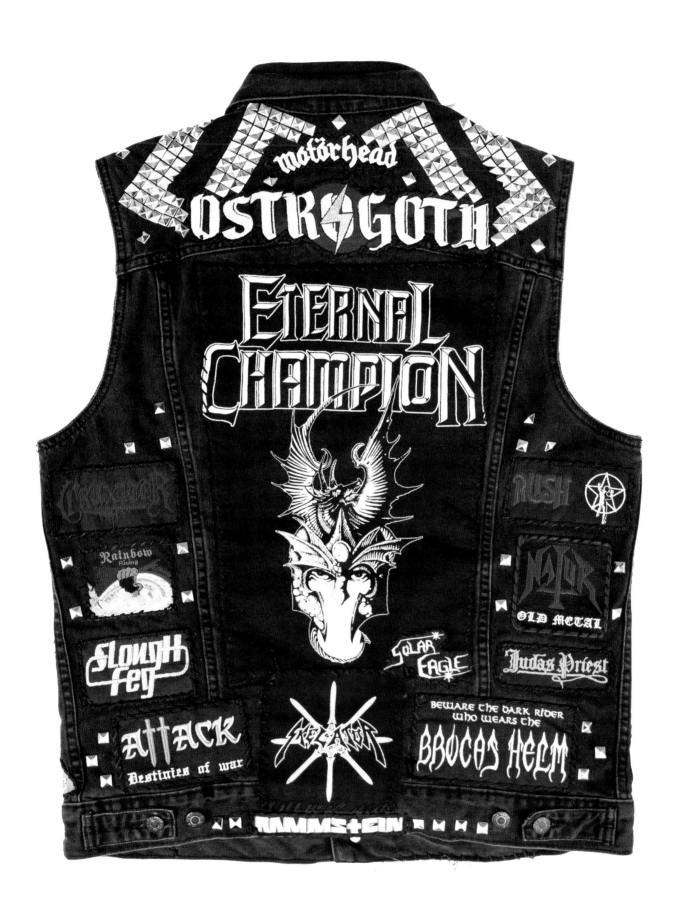

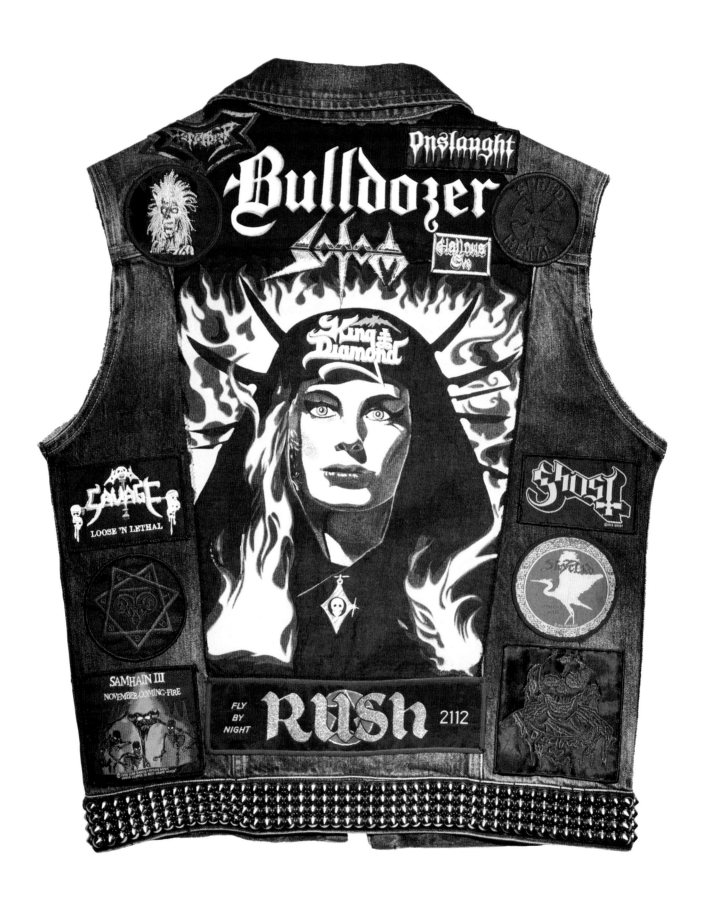

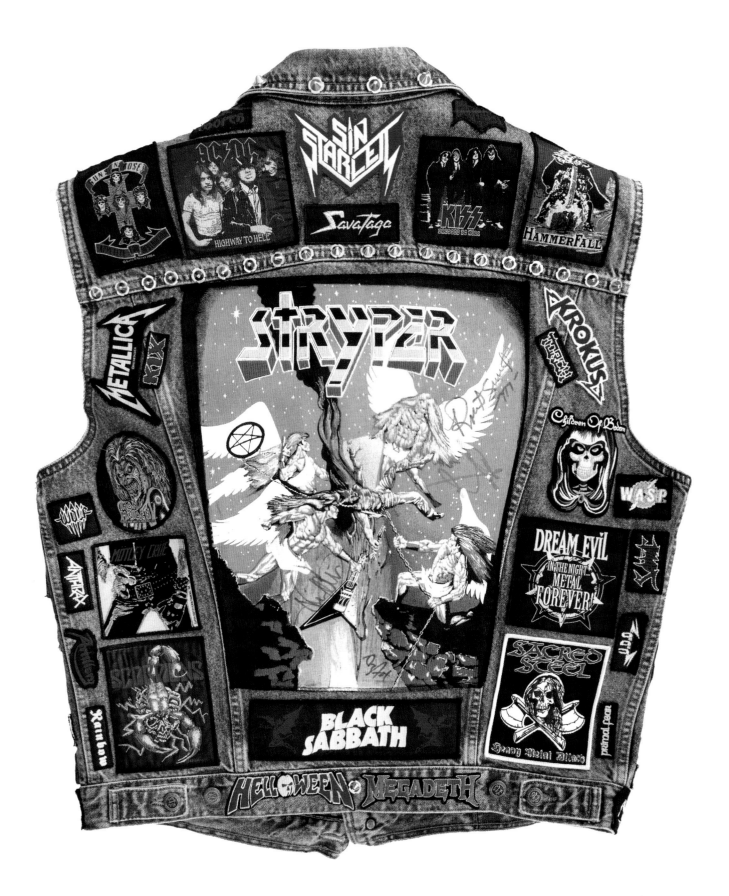

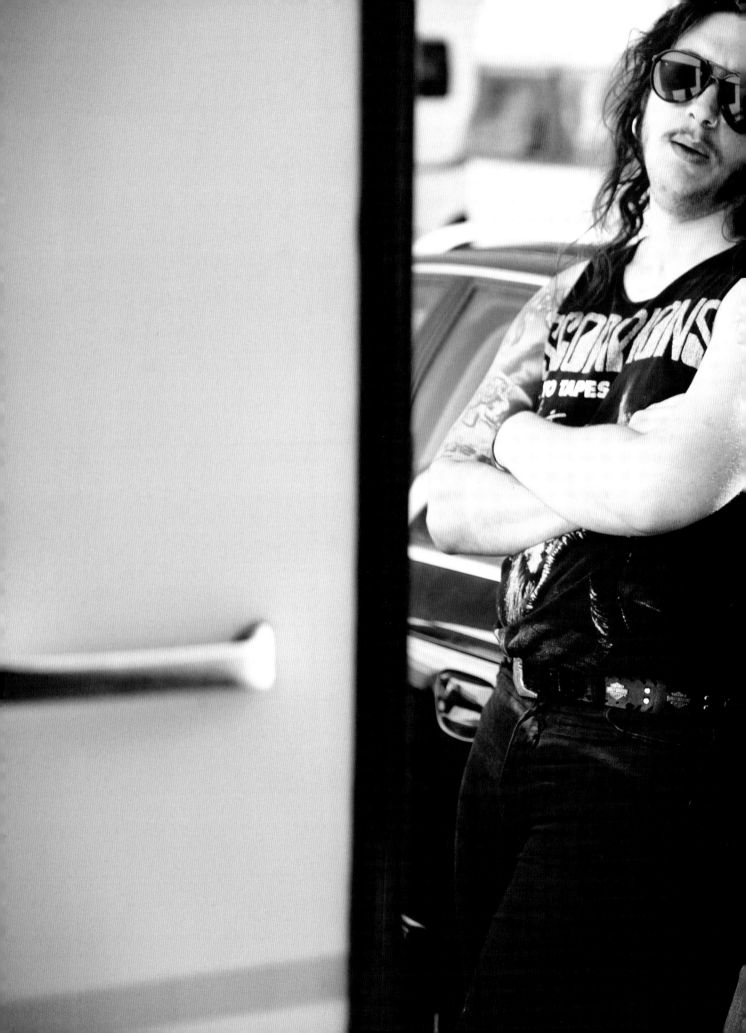

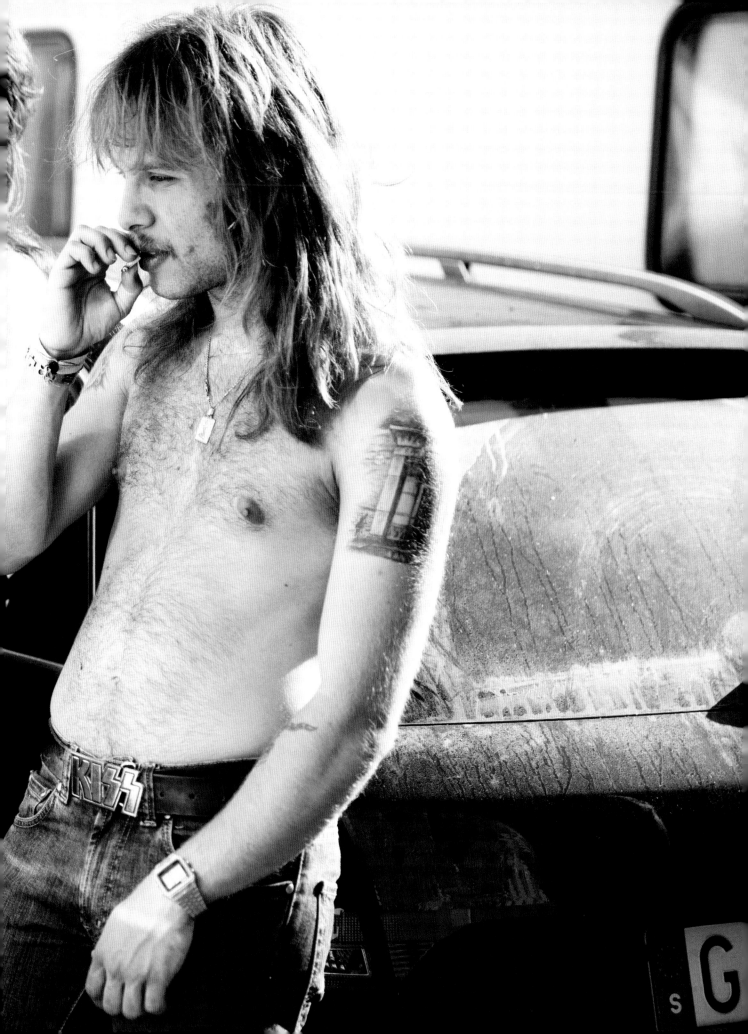

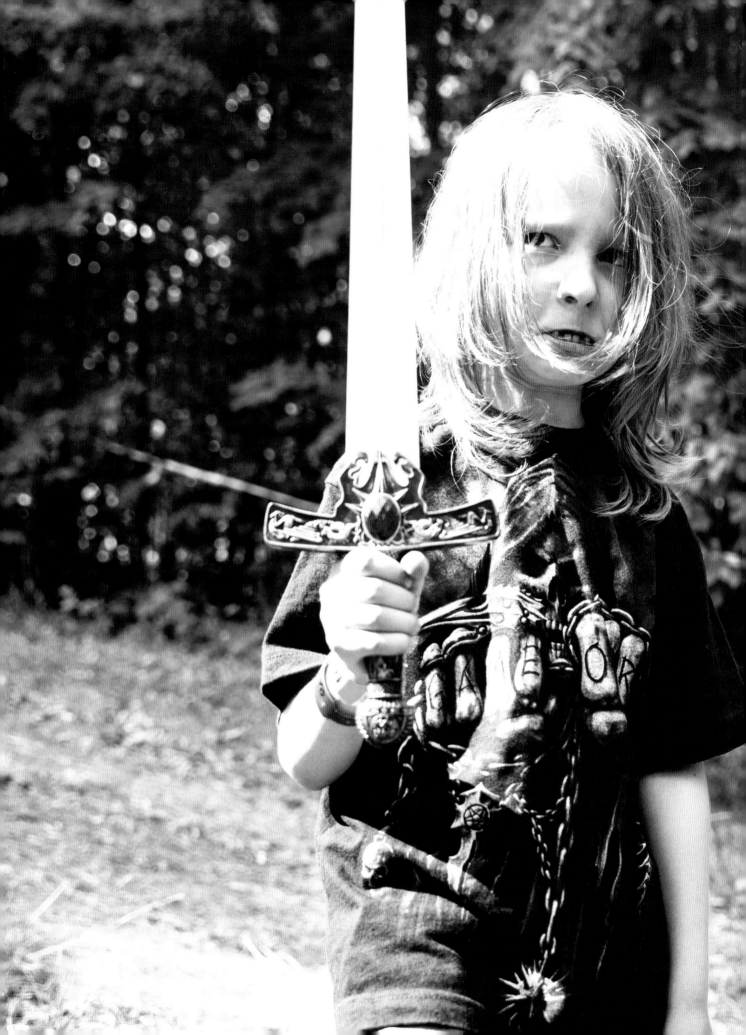

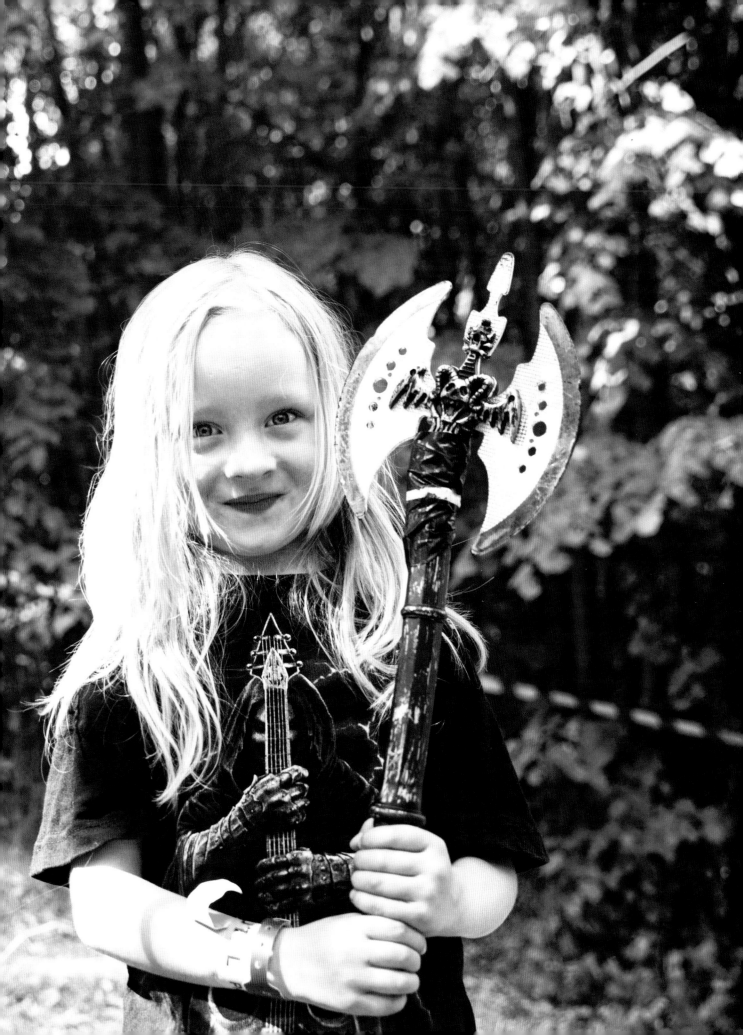

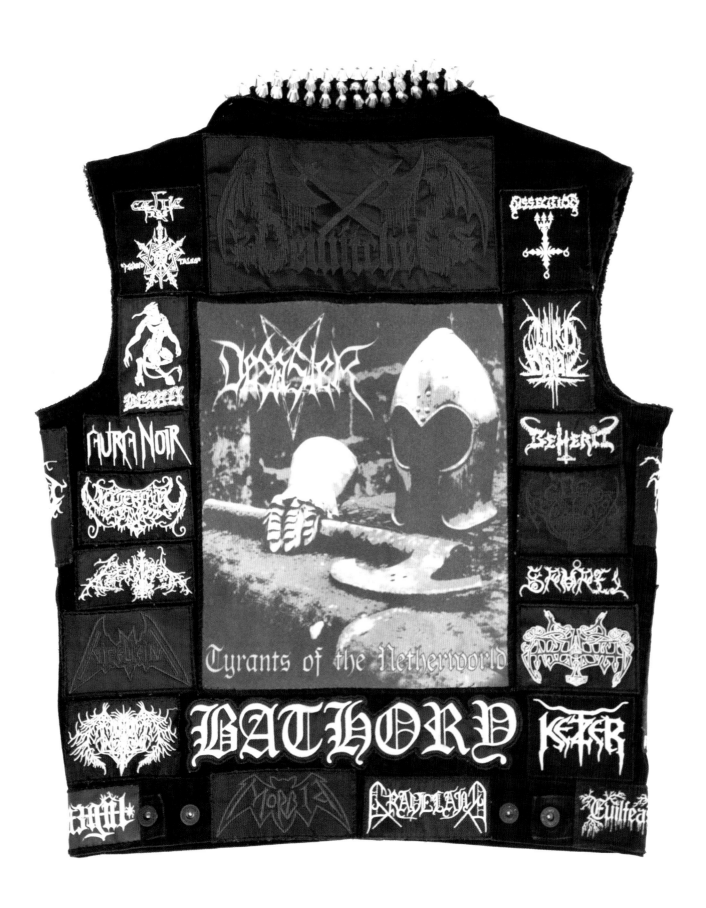

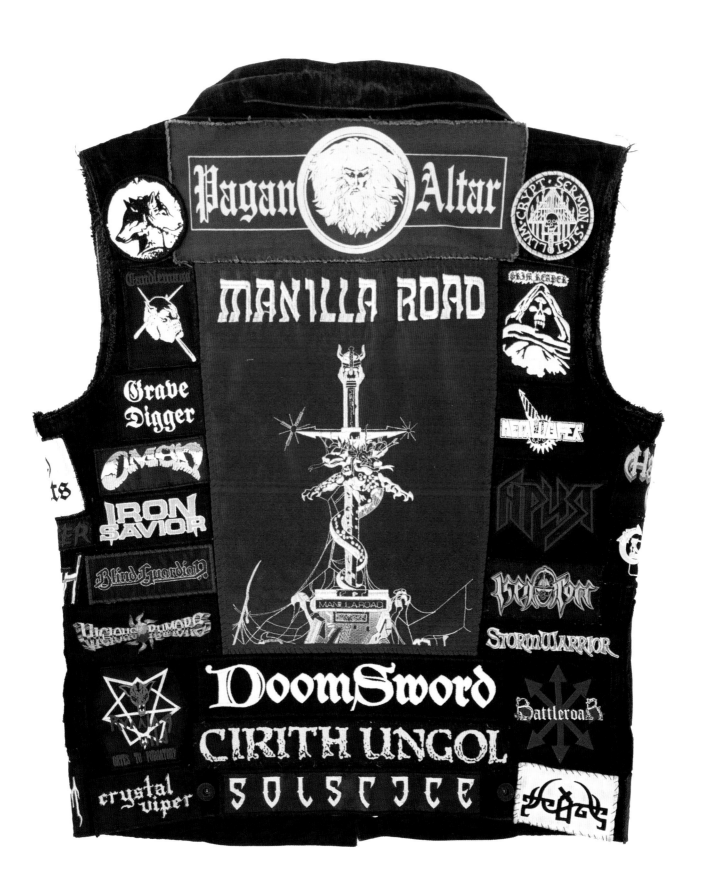

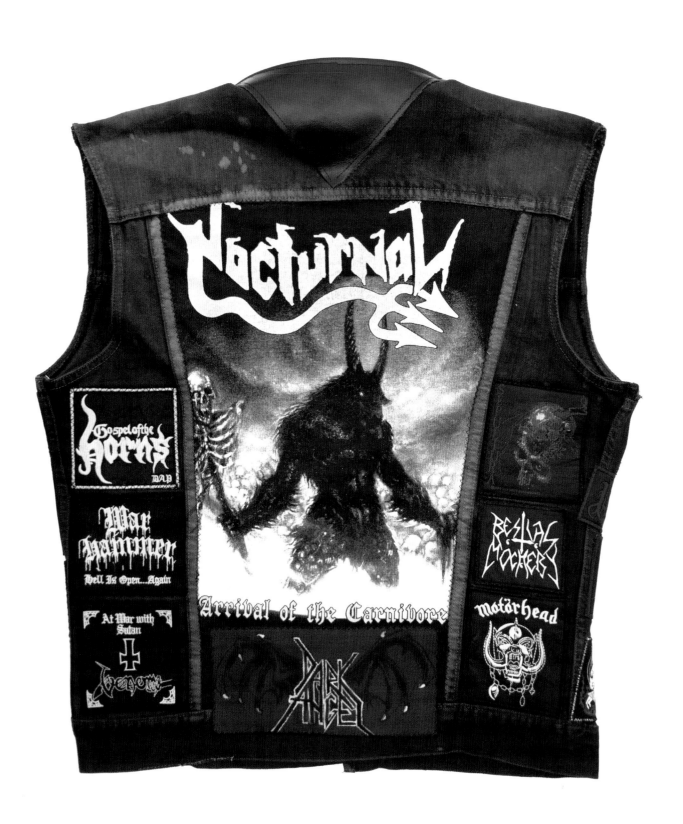

38

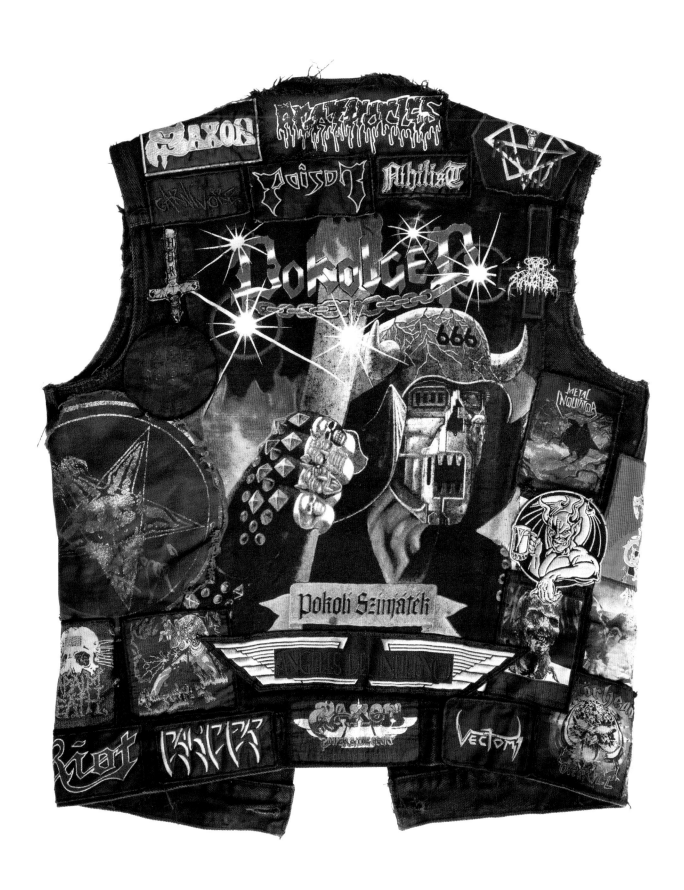

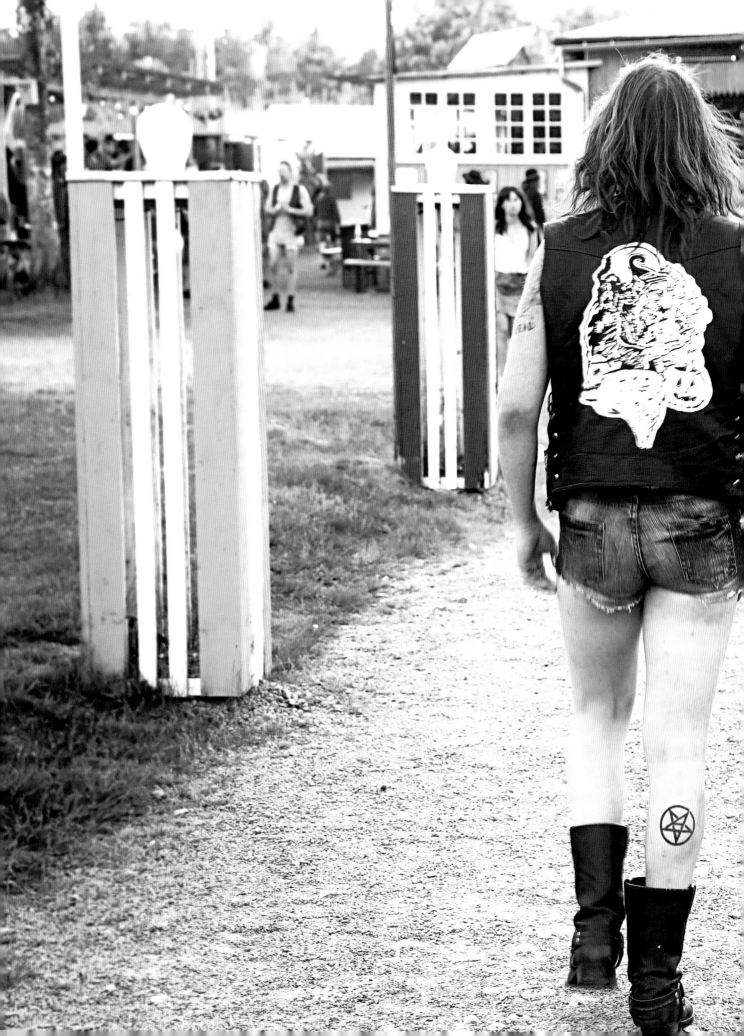

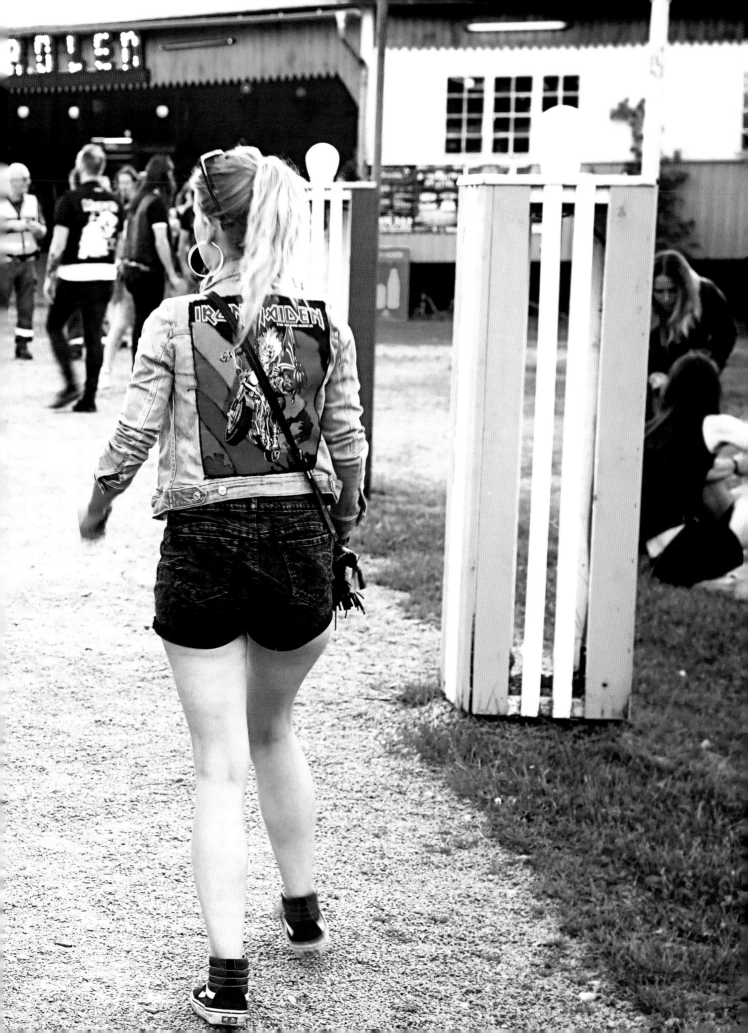

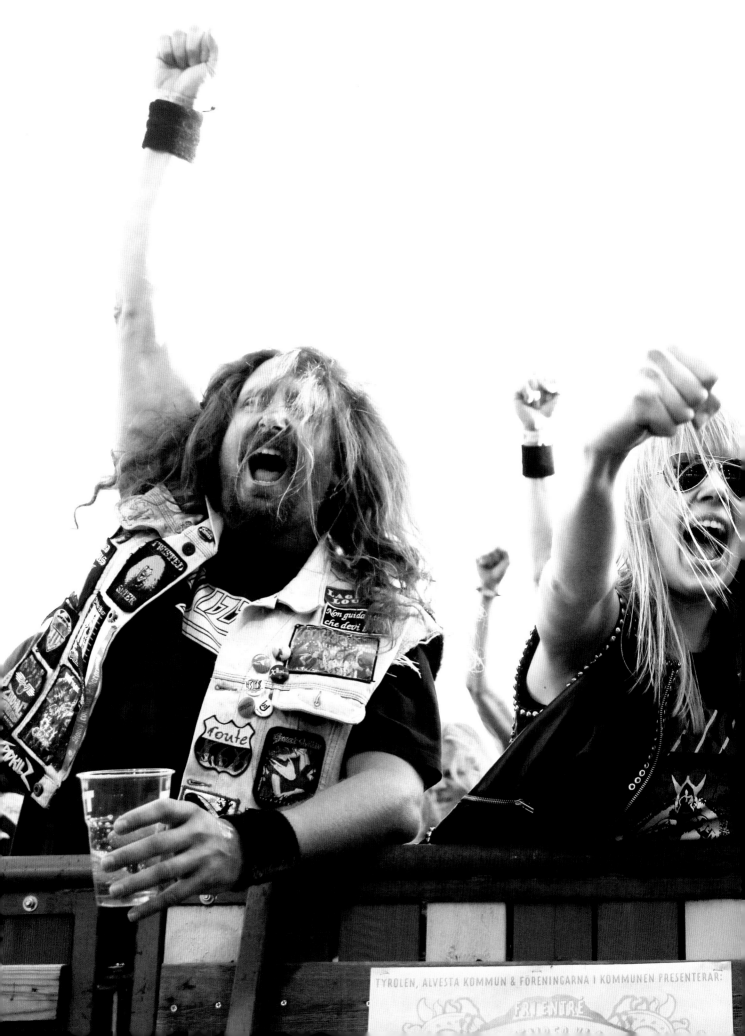

TYROLEN, ALVESTA KOMMUN & FÖRENINGARNA I KOMMUNEN PRESENTERAR:

FRIENTRÉ

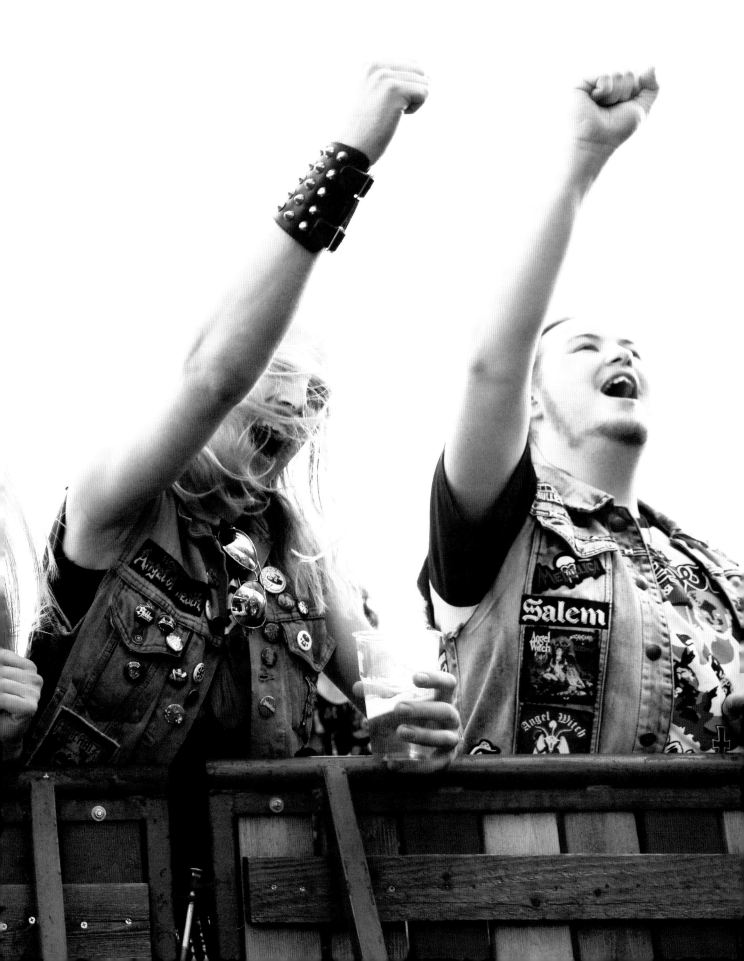

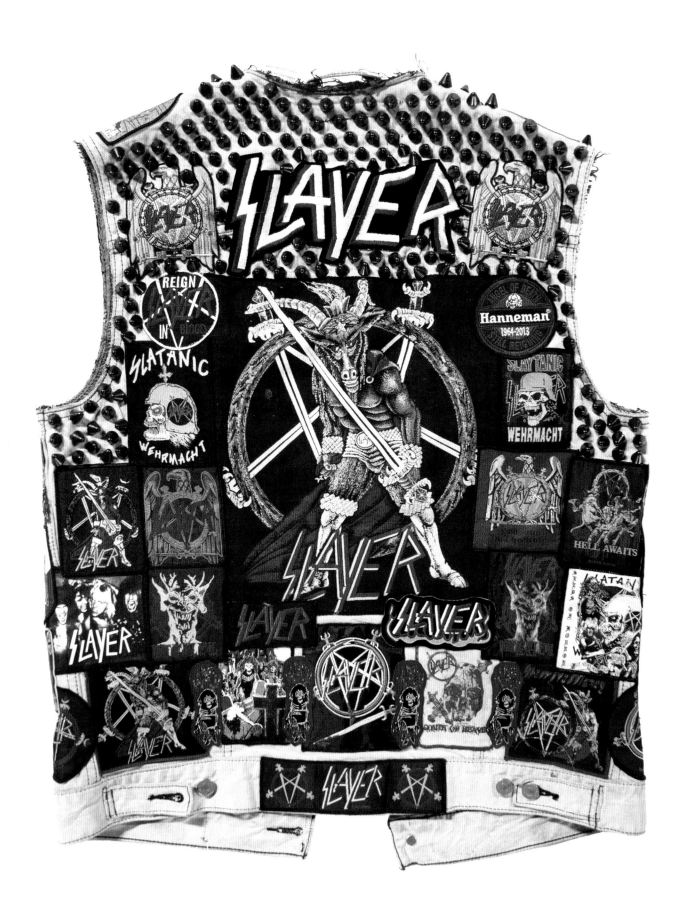

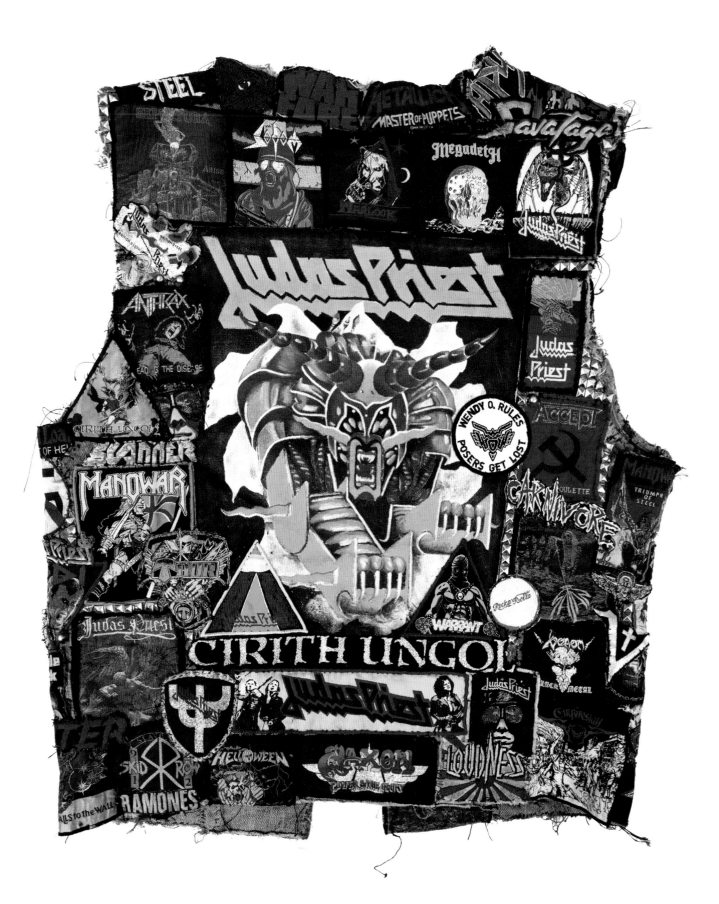

45

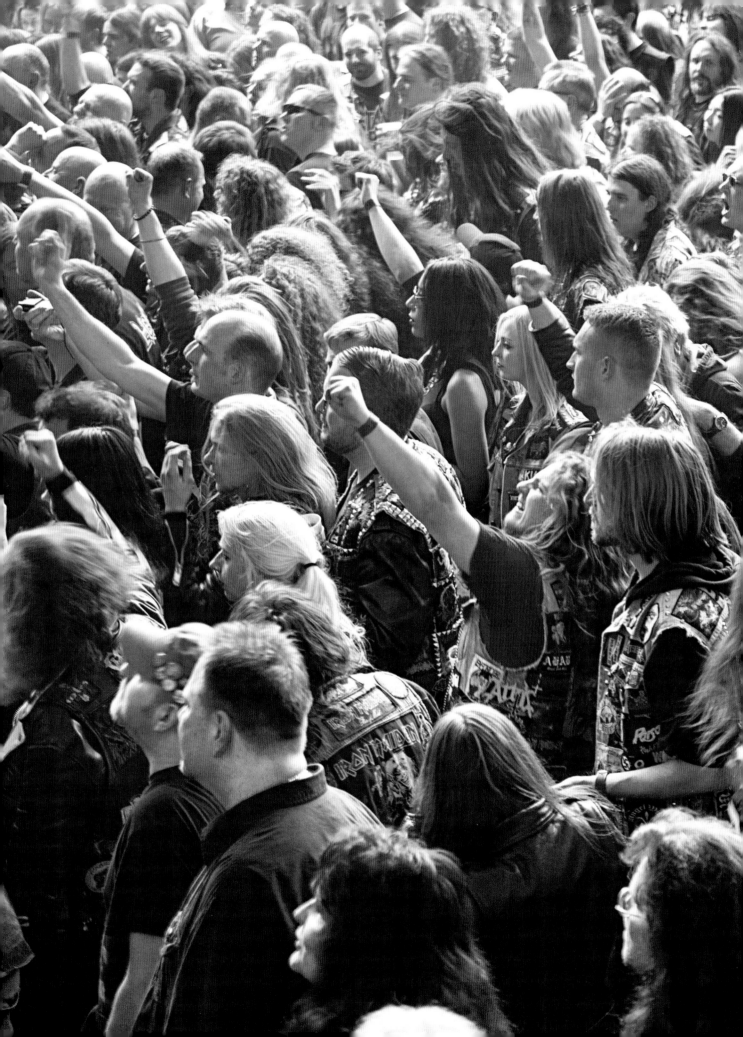

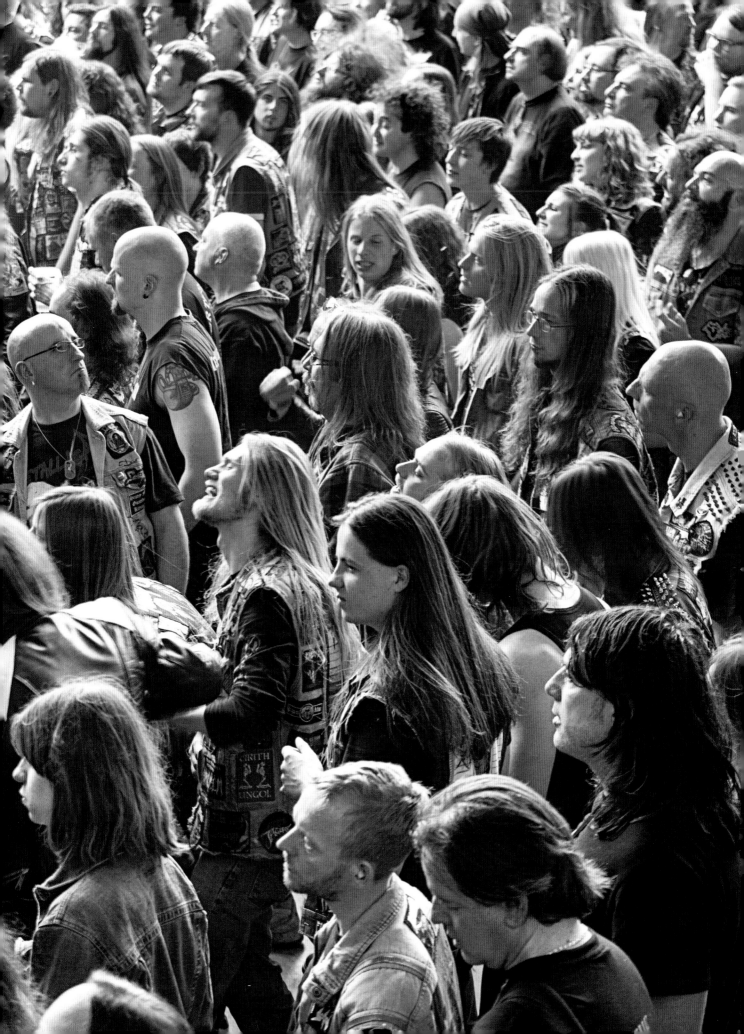

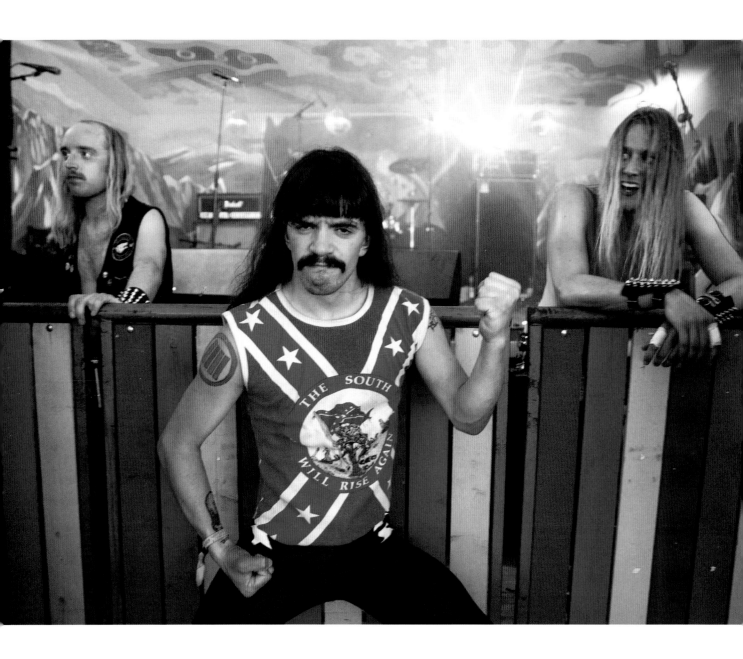

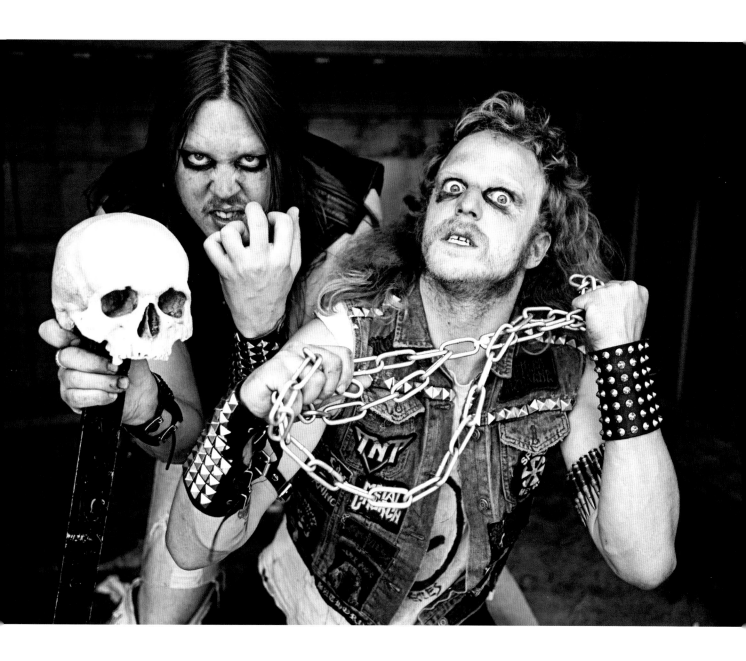

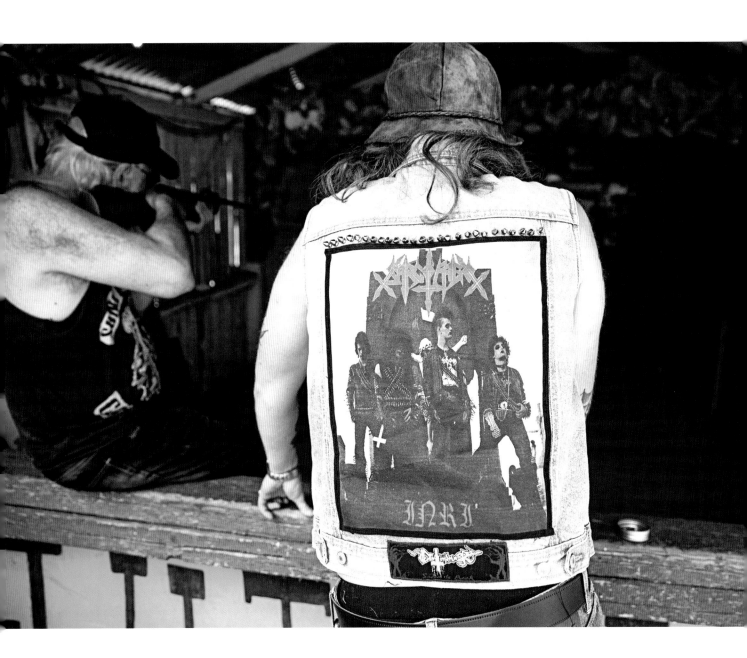

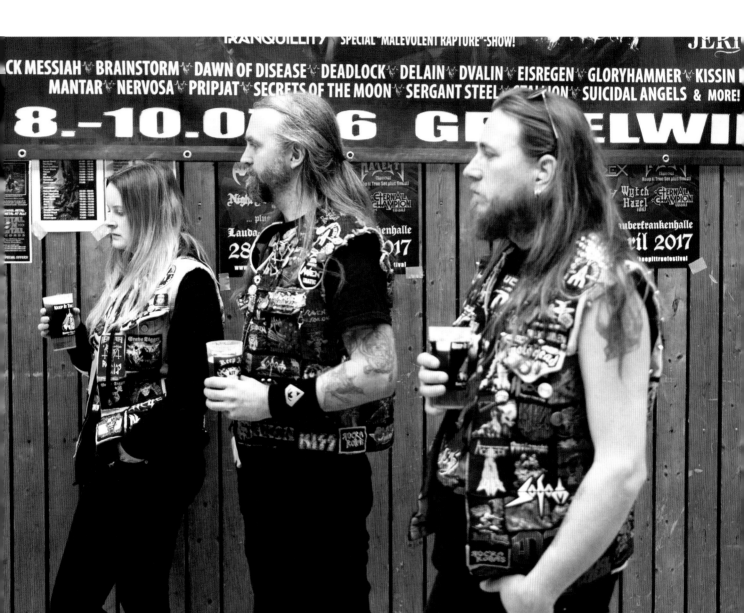

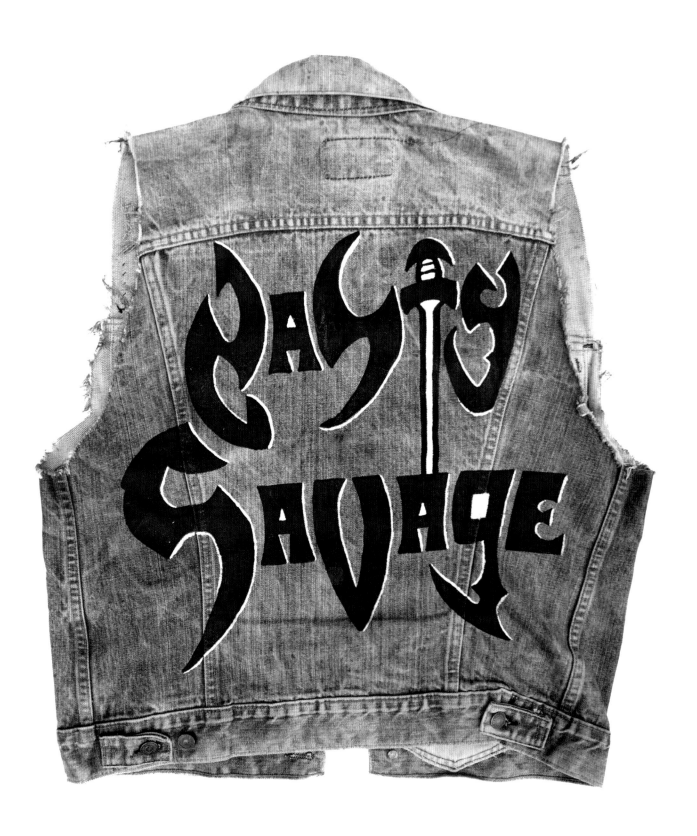

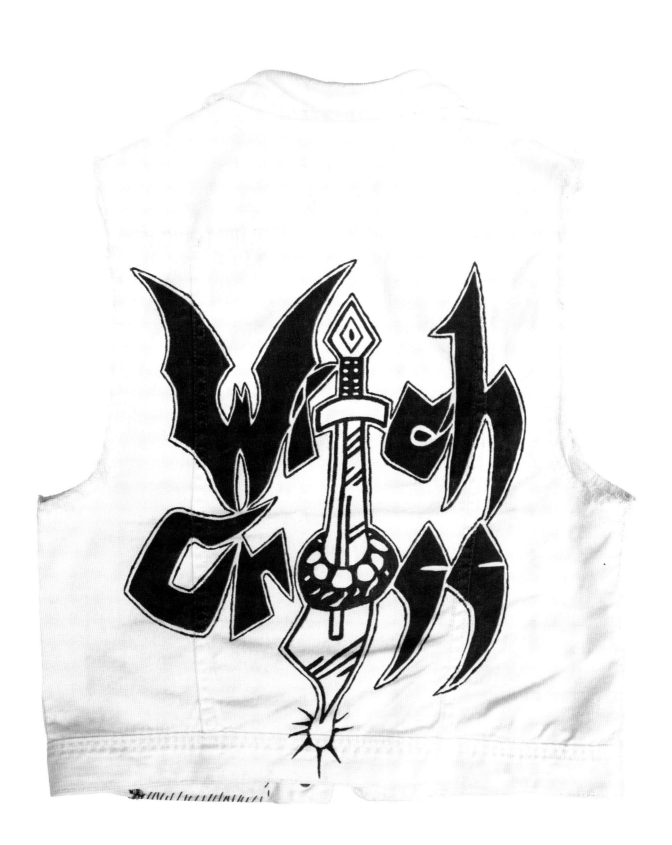

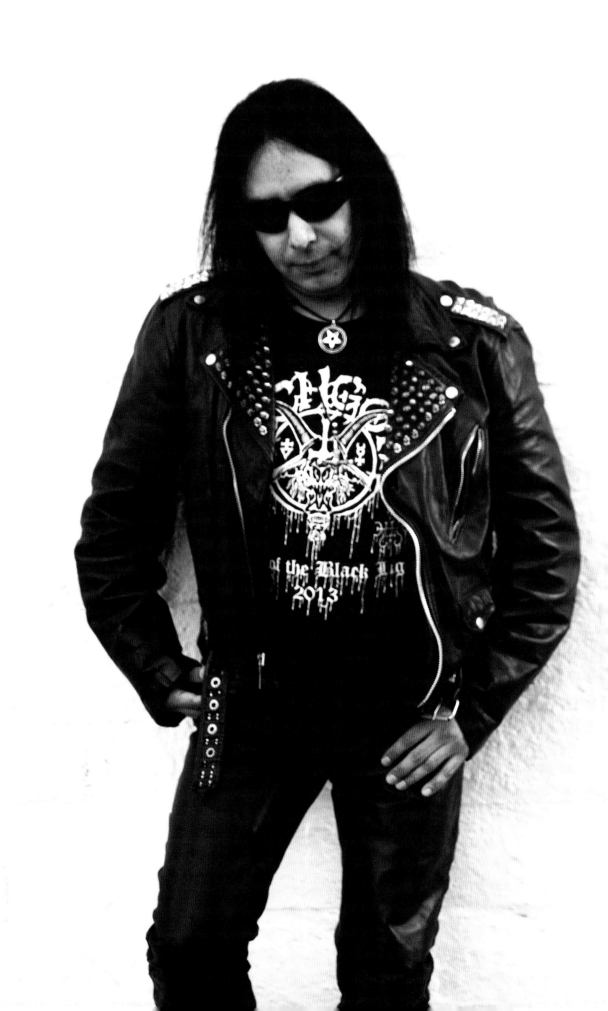

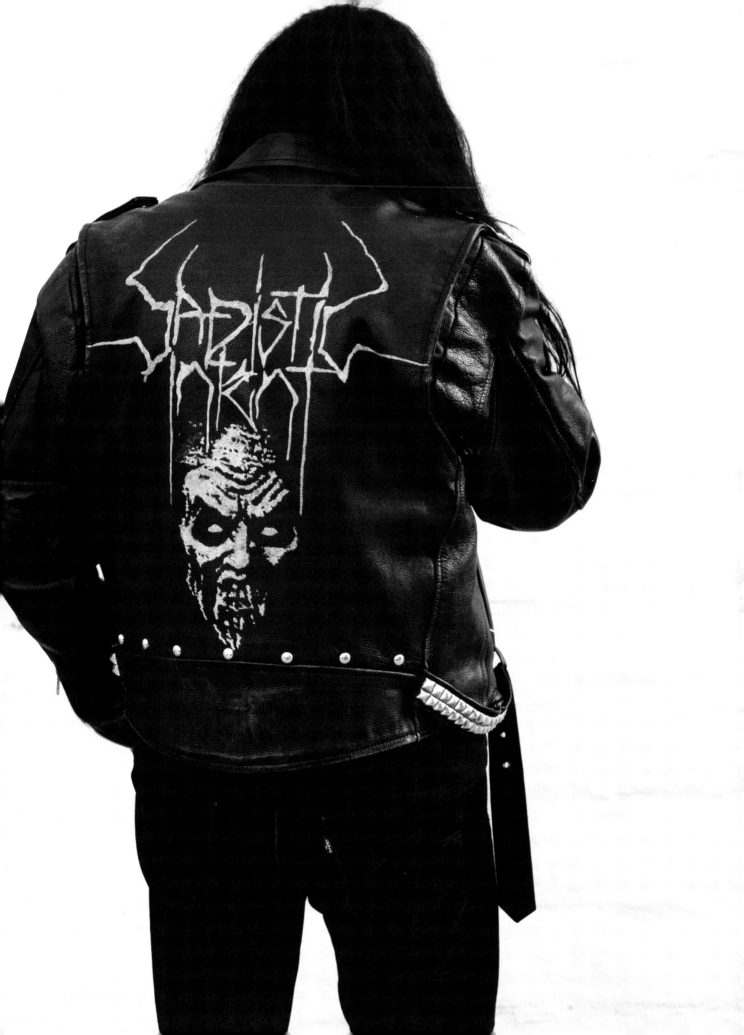

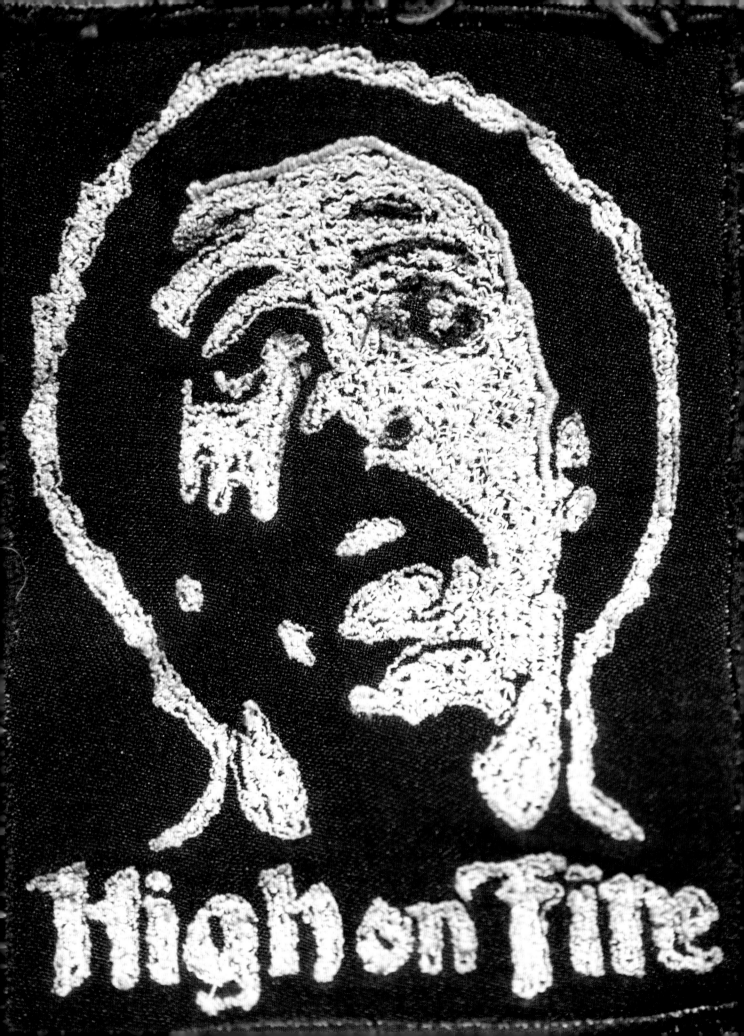

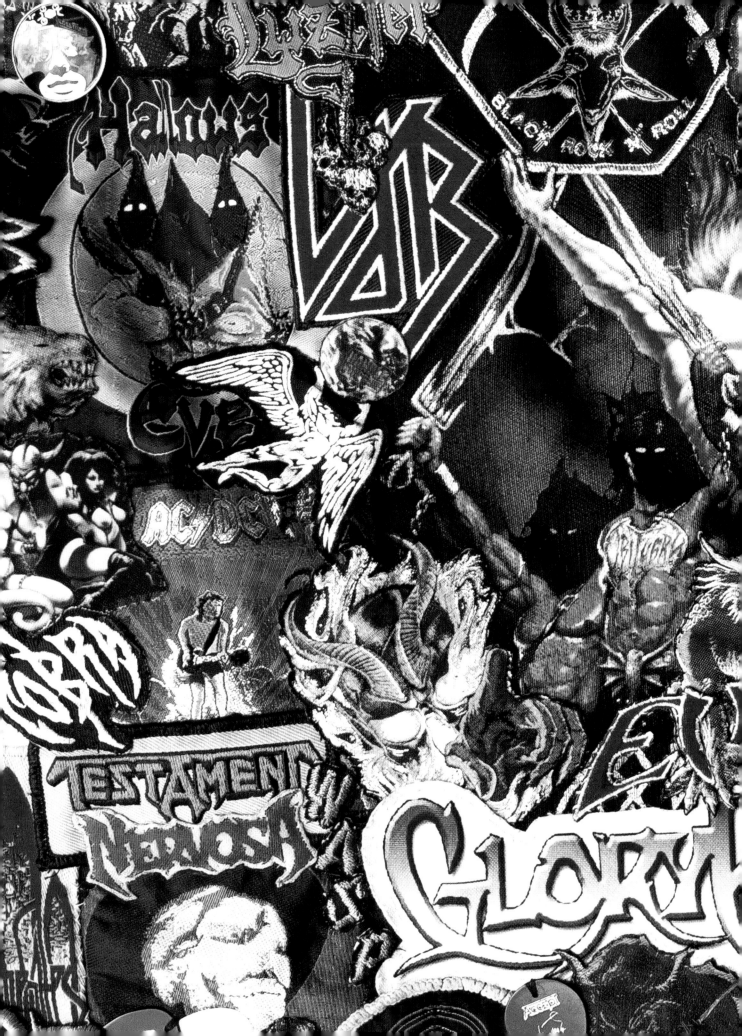

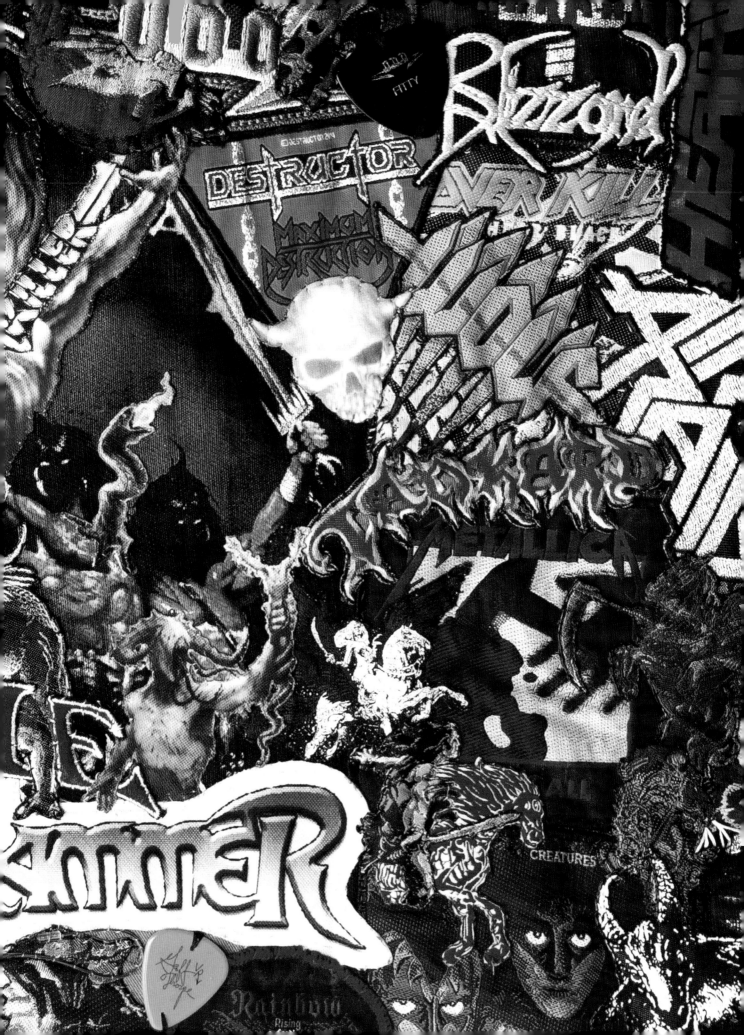

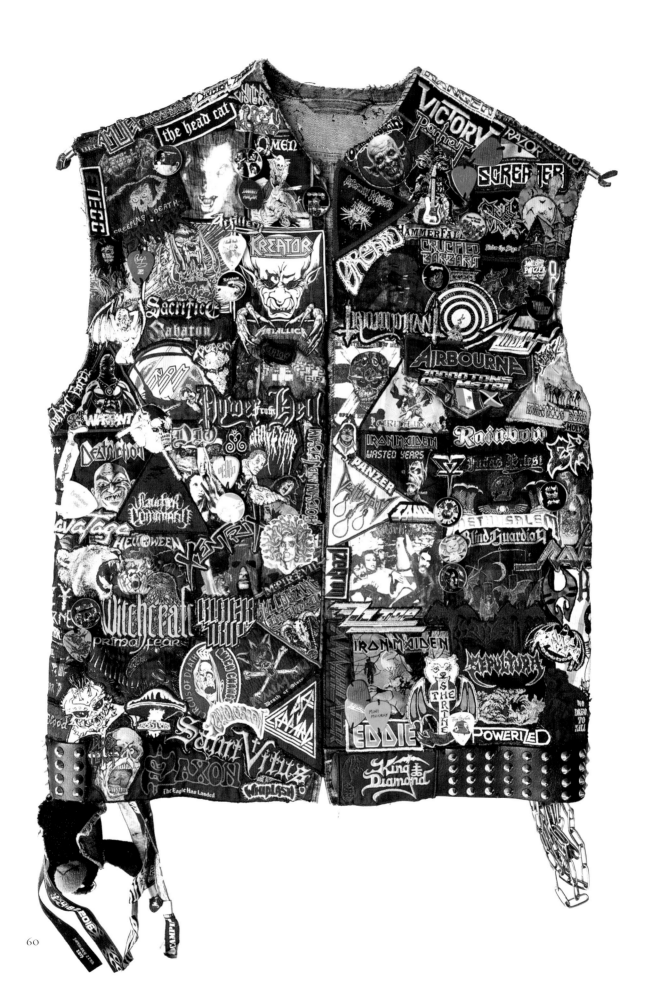

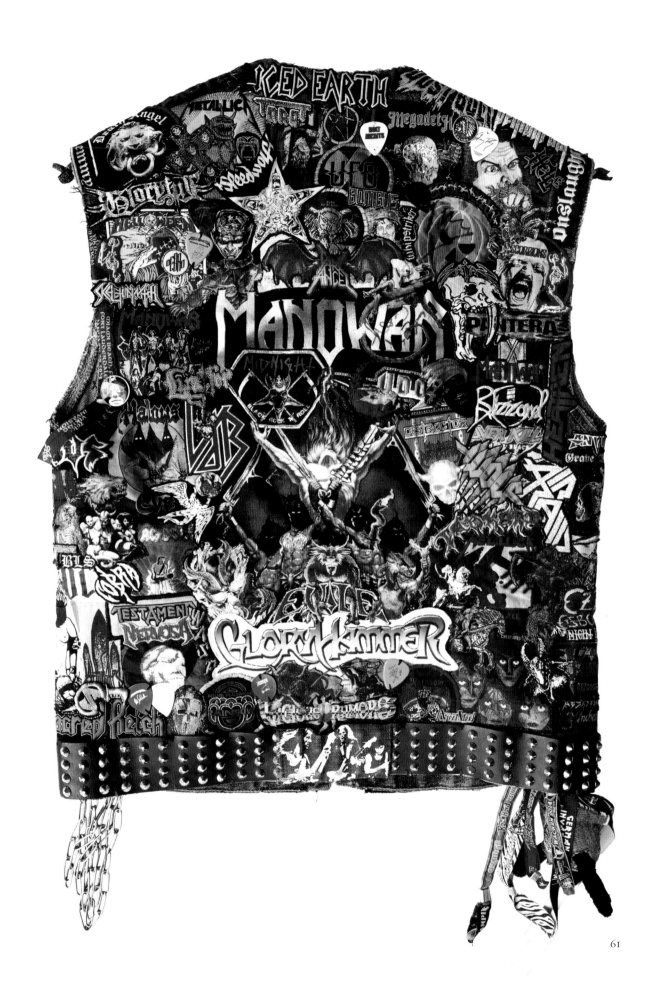

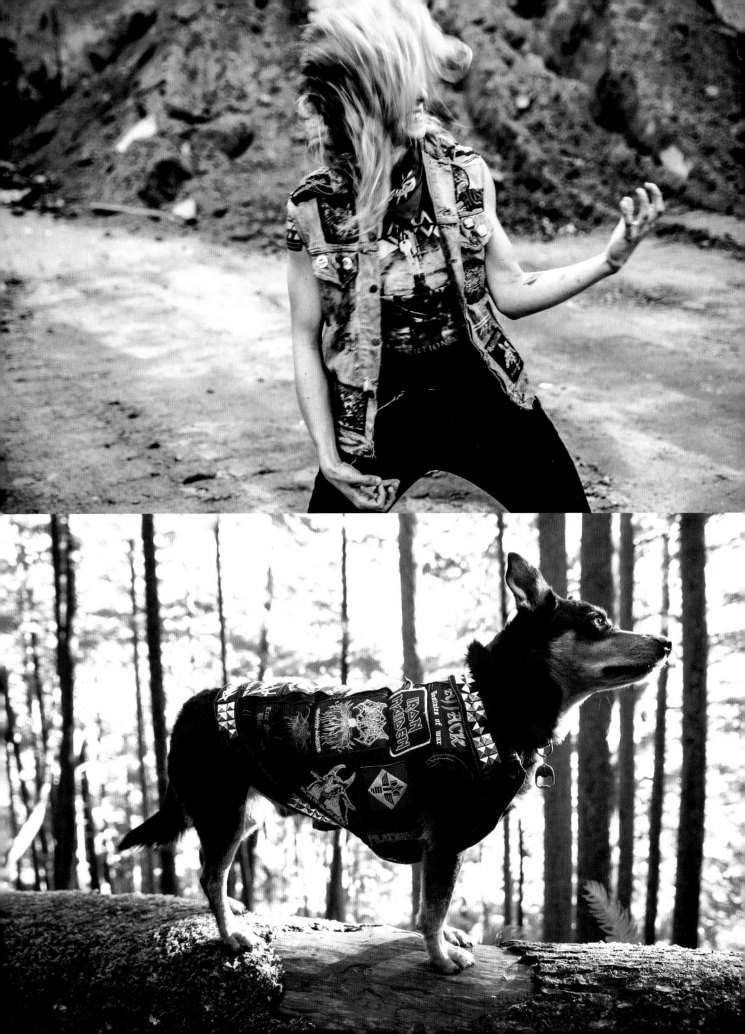

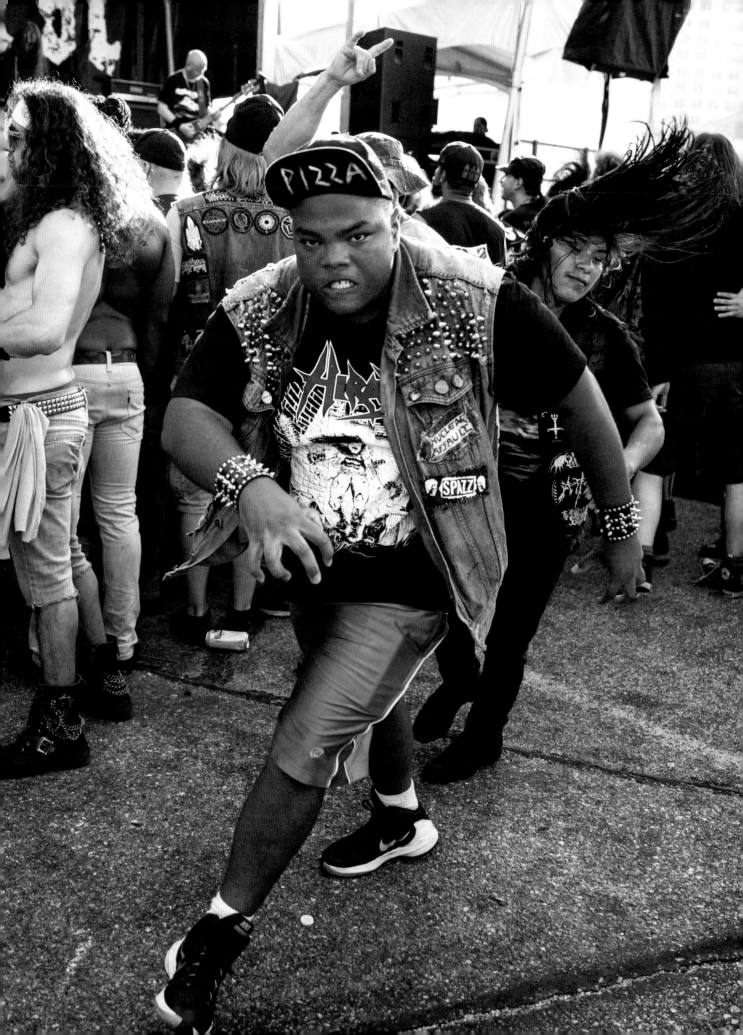

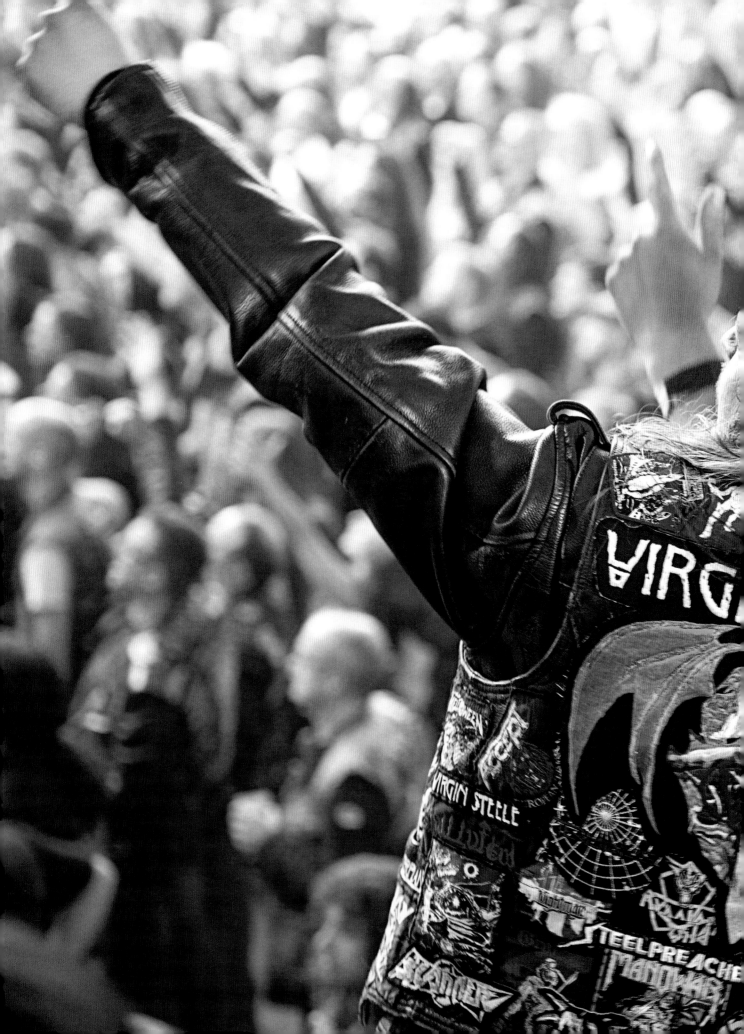

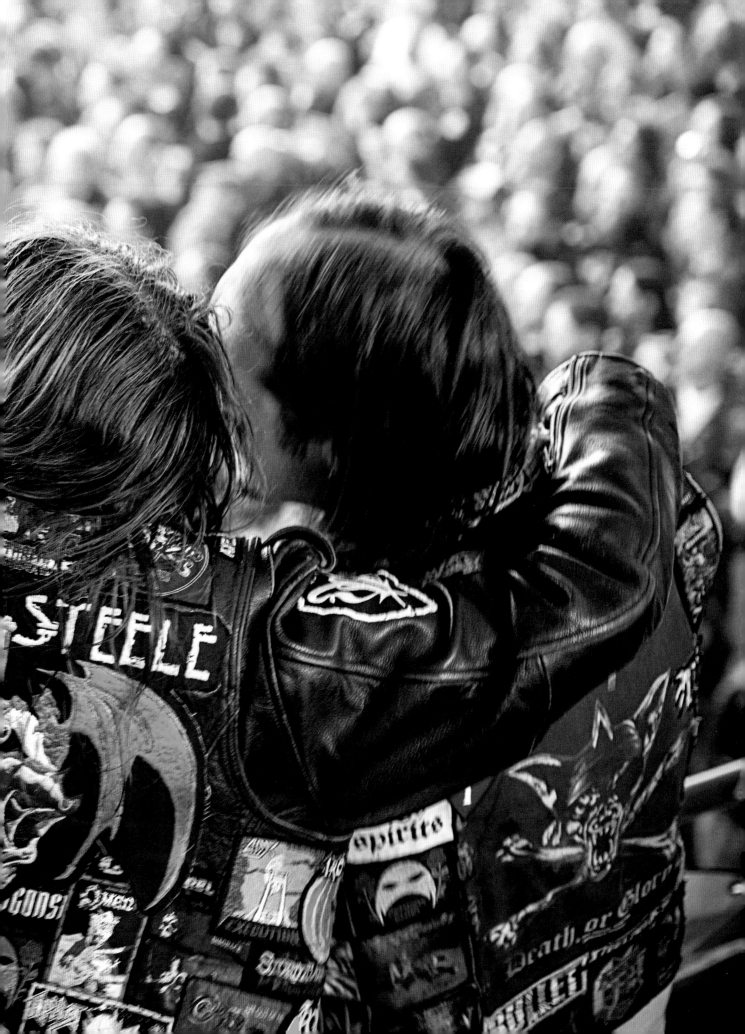

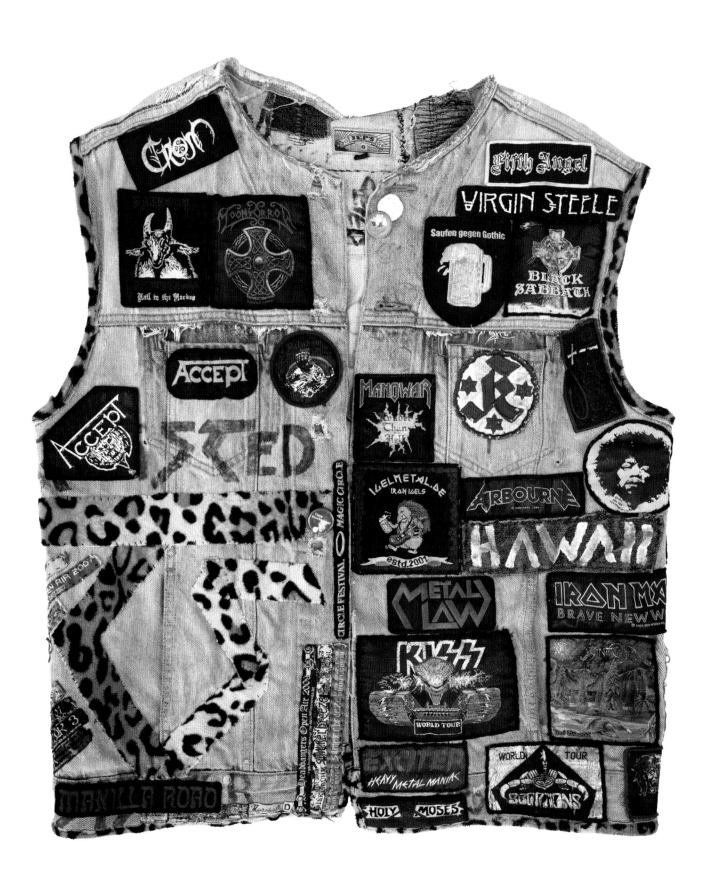

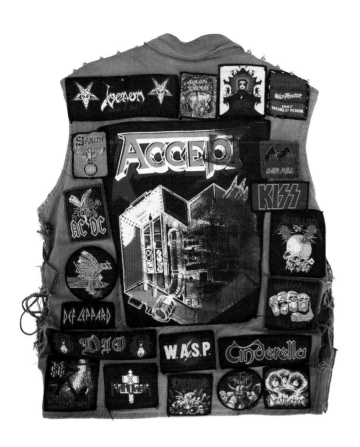

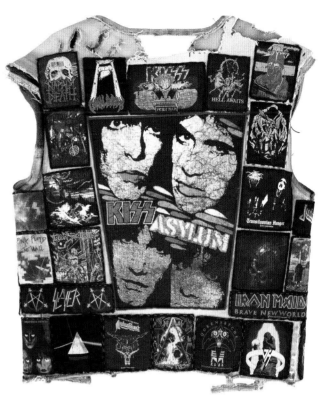

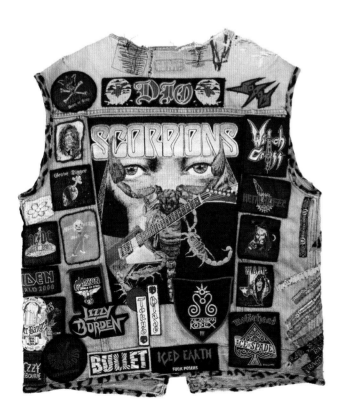

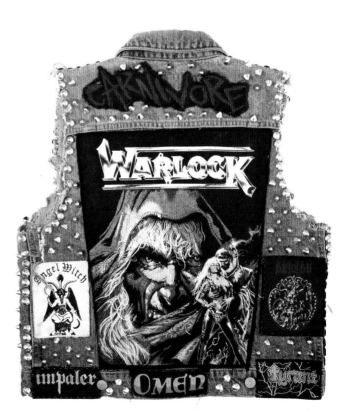

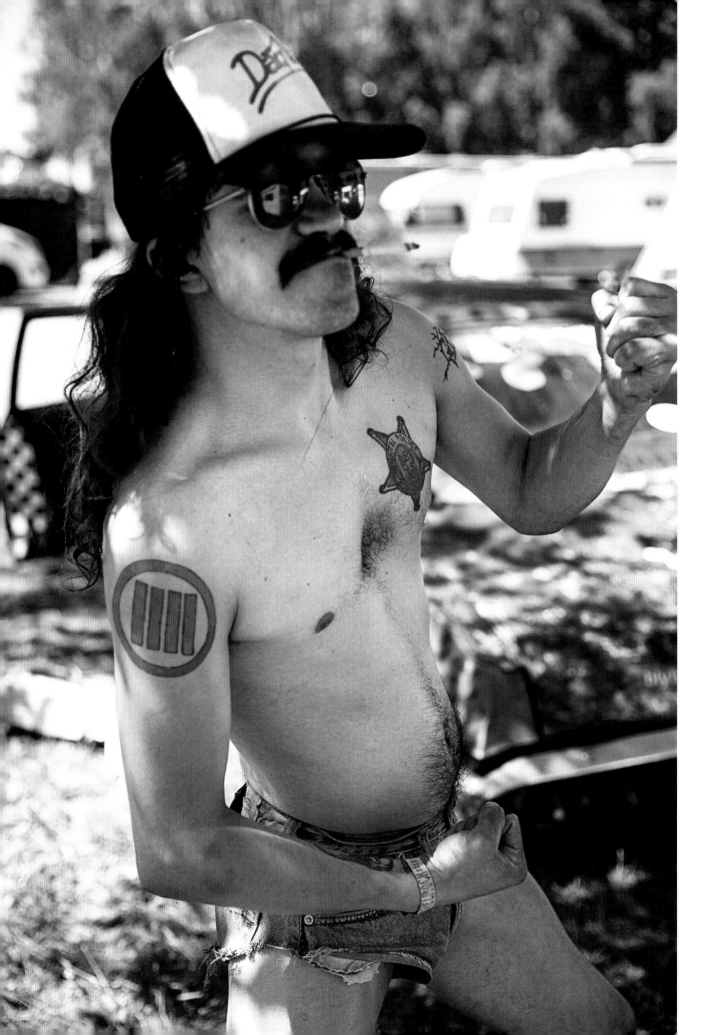

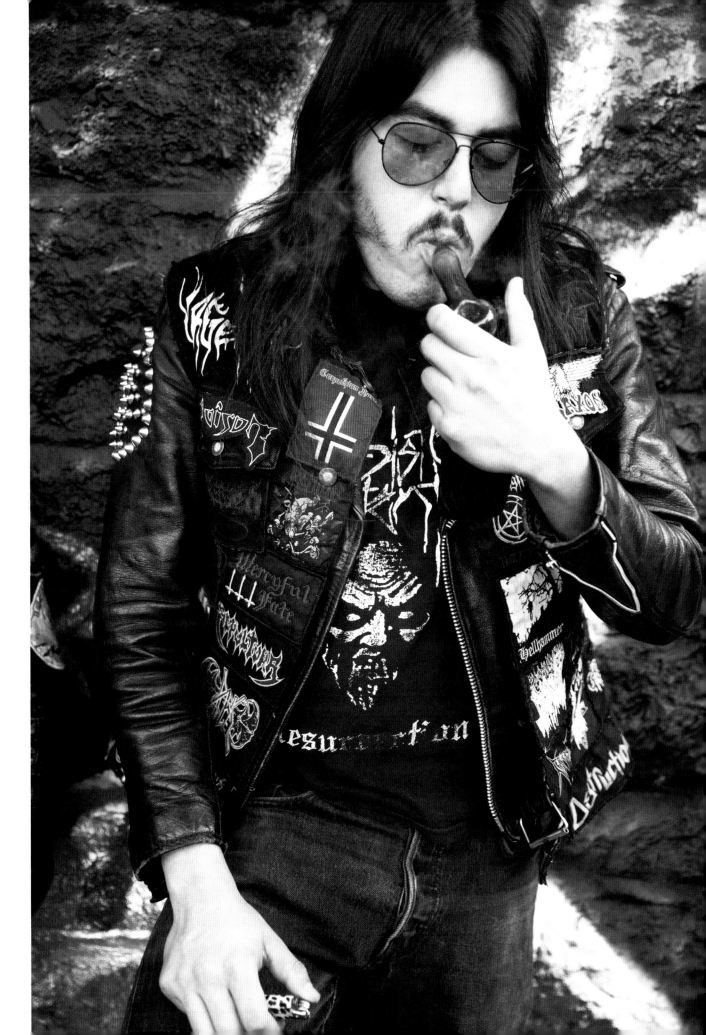

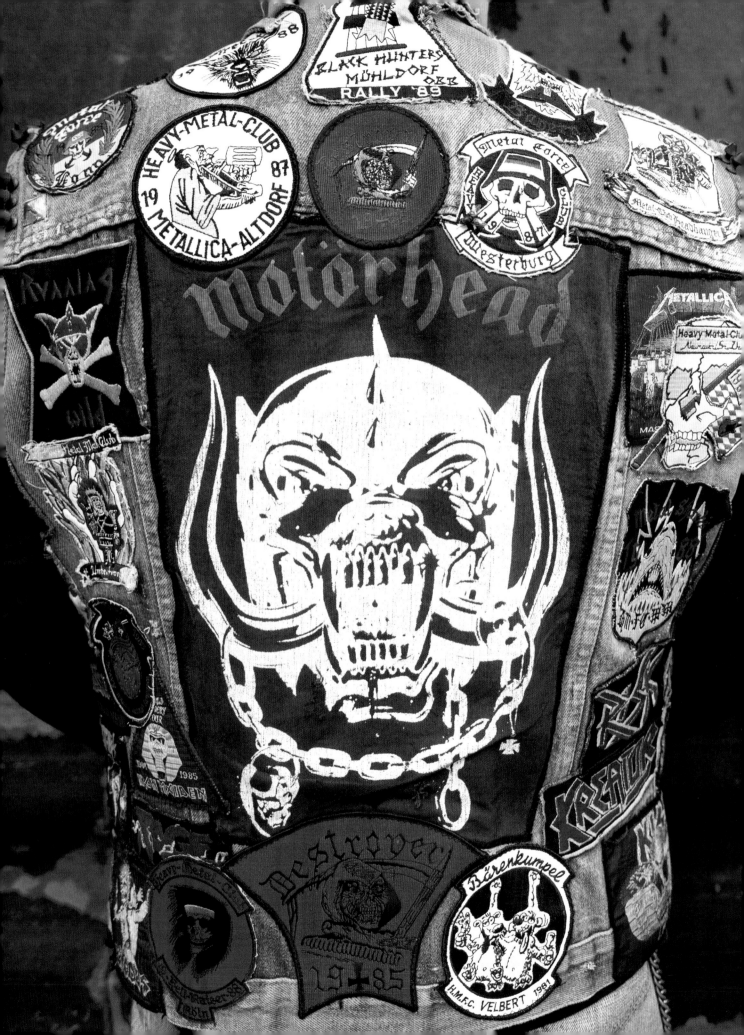

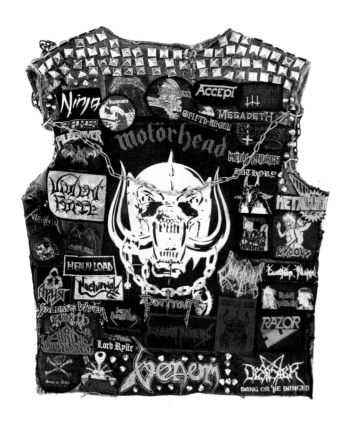

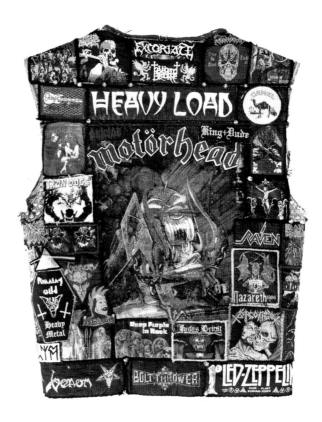

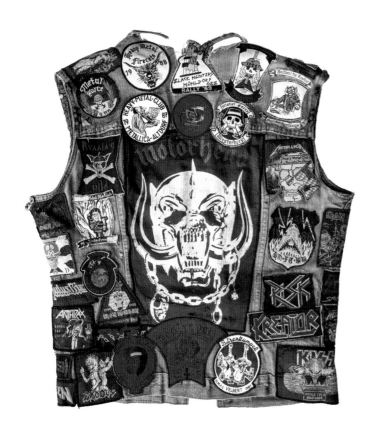

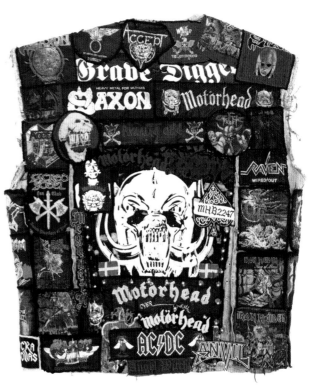

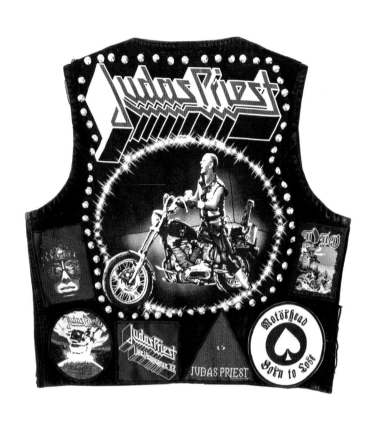
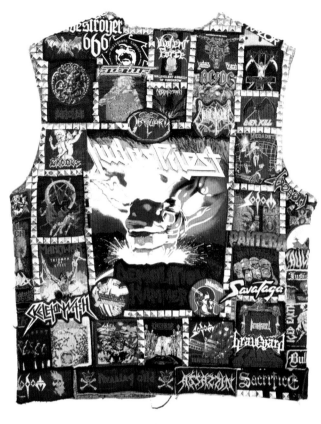
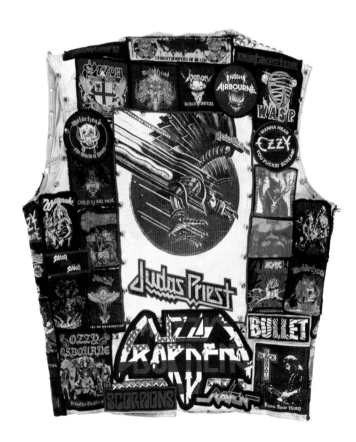
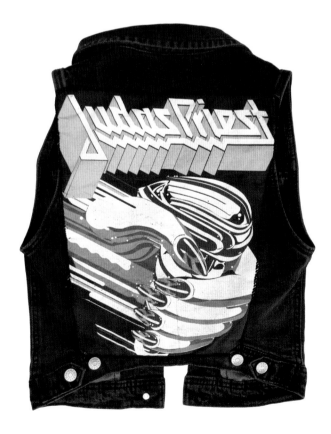

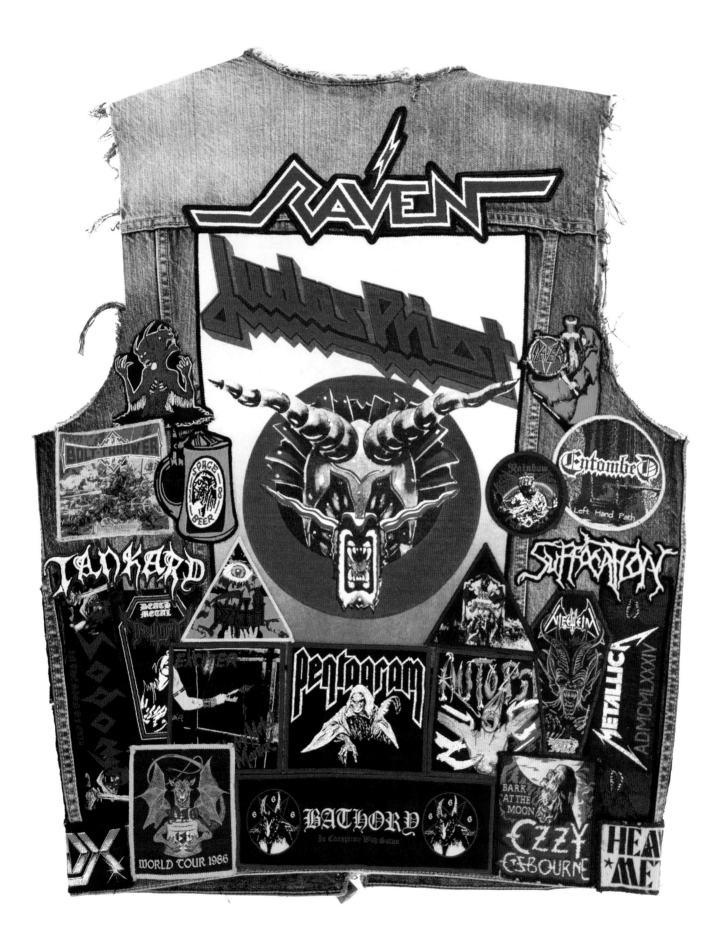

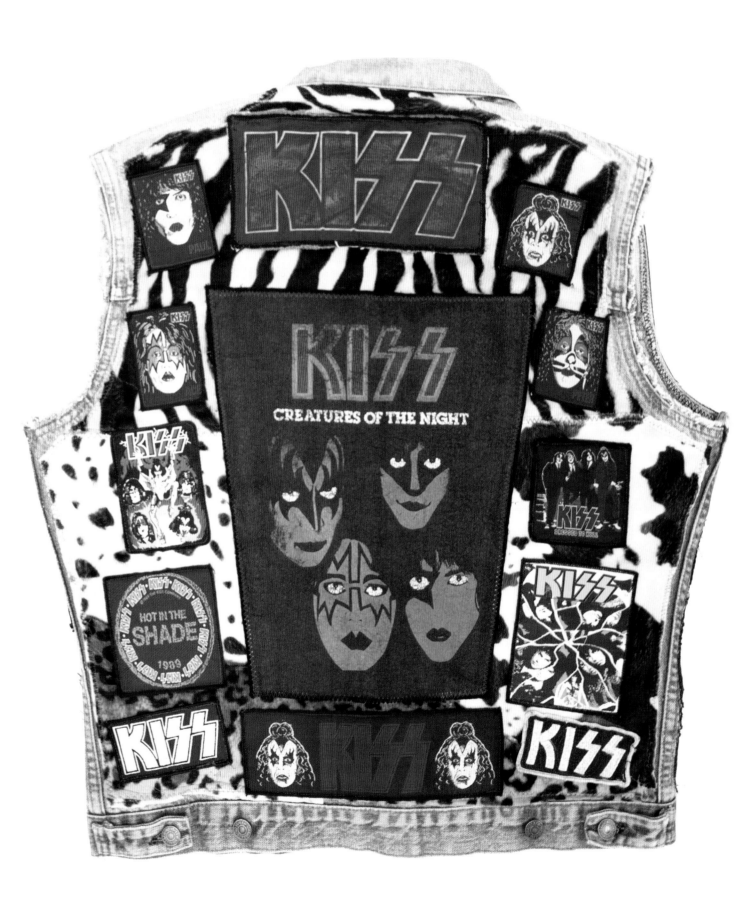

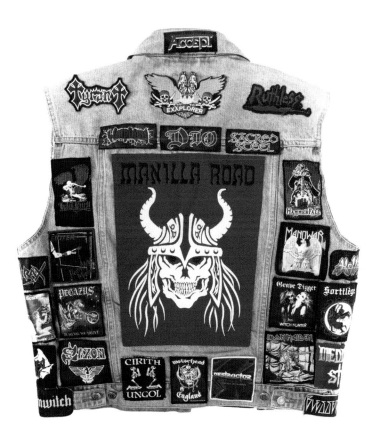

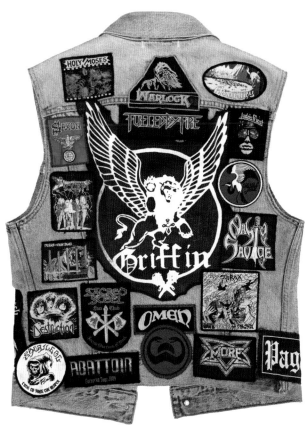

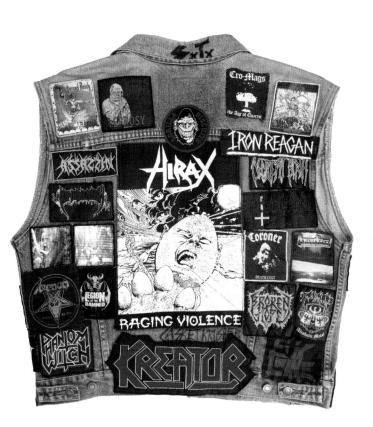

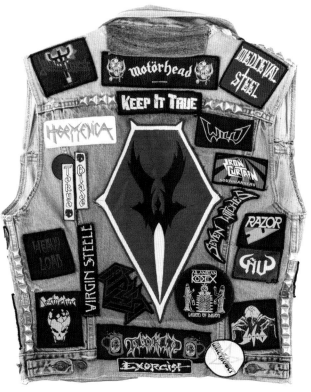

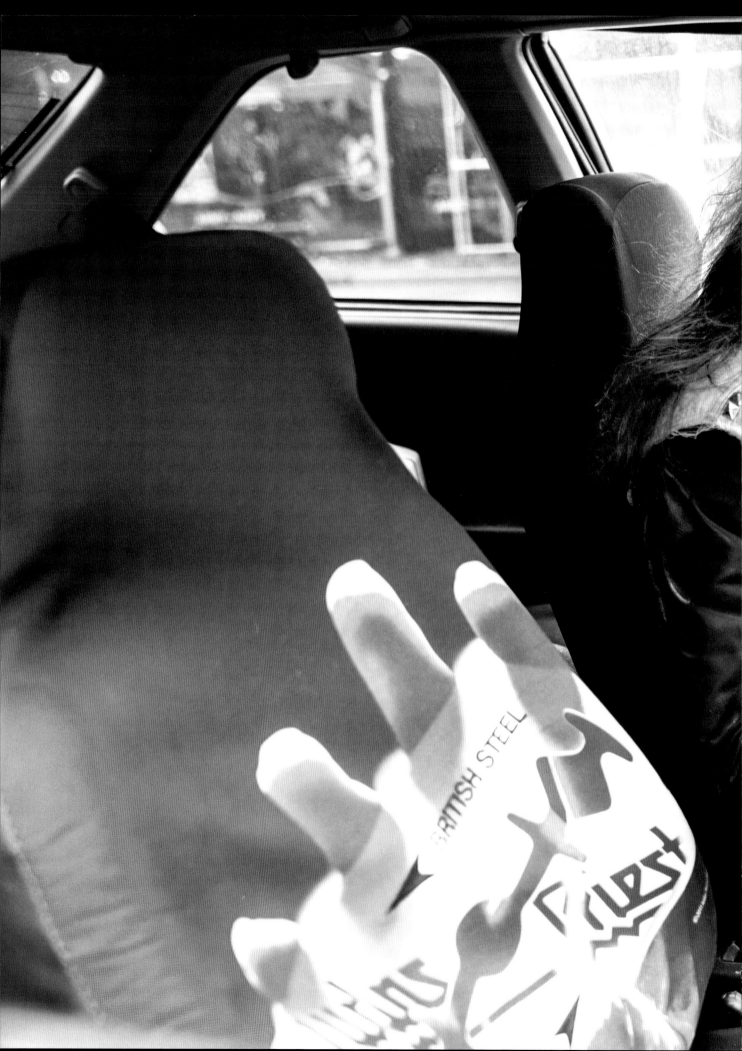

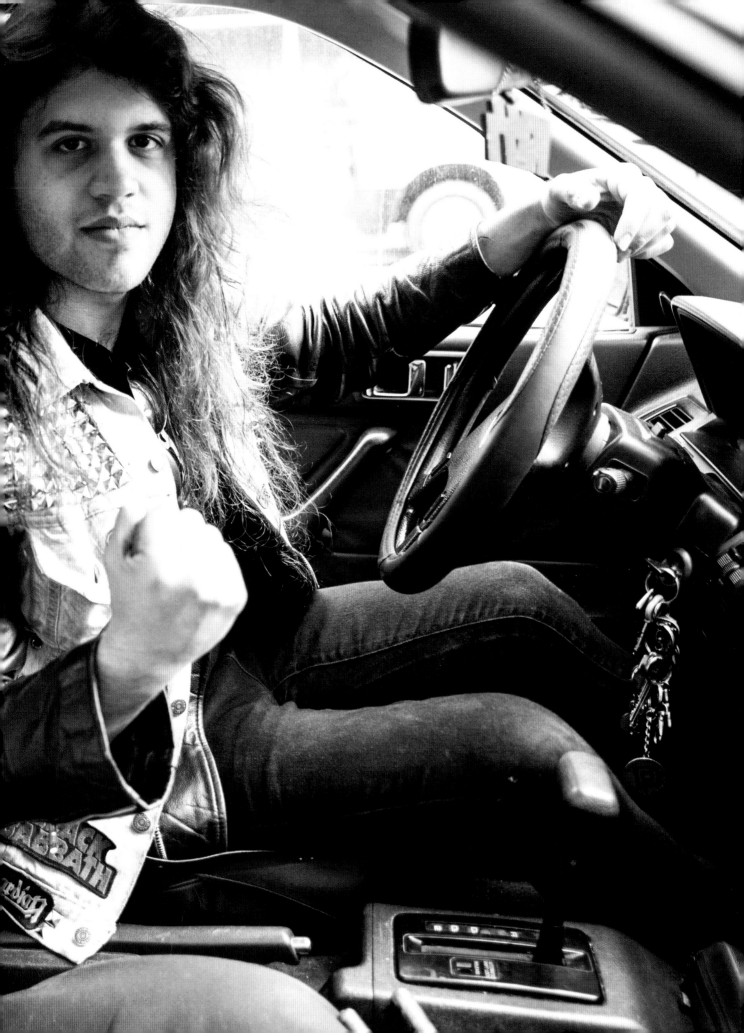

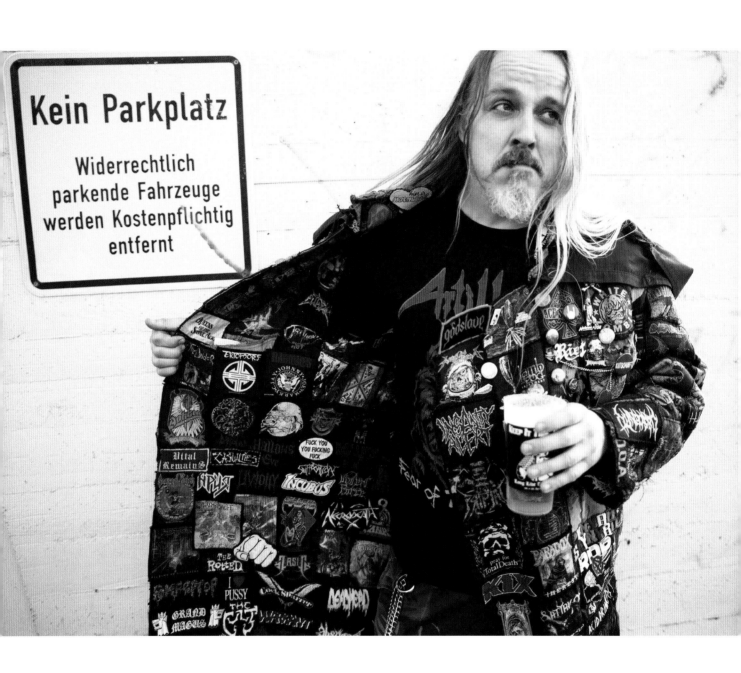

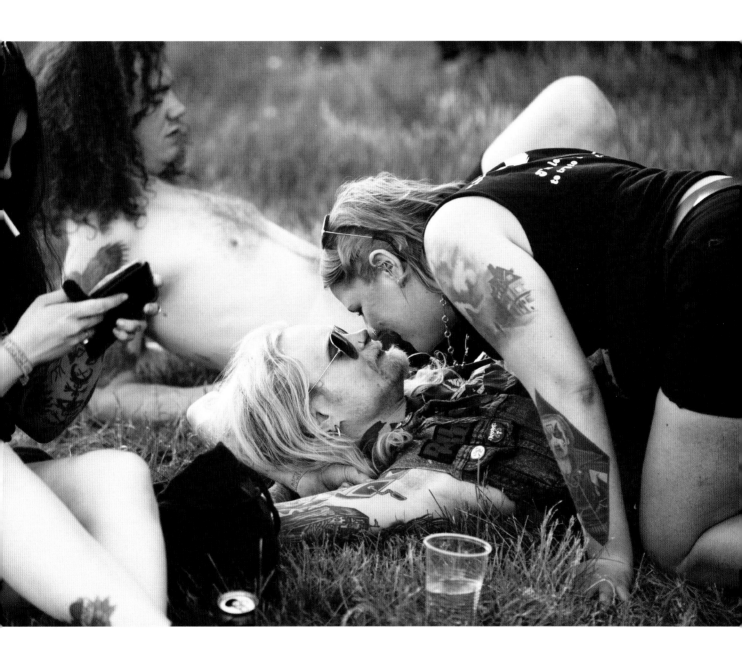

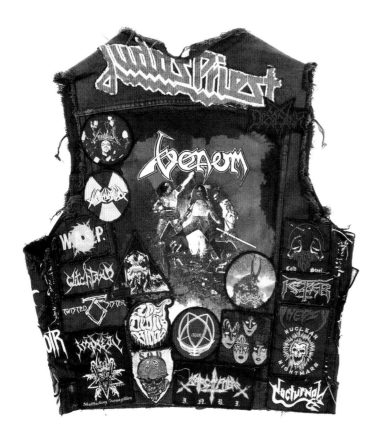

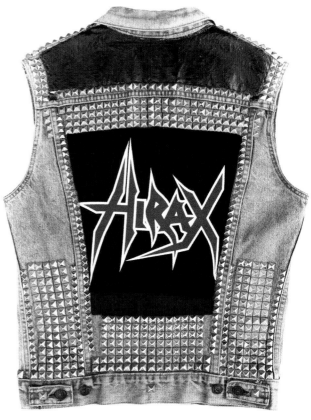

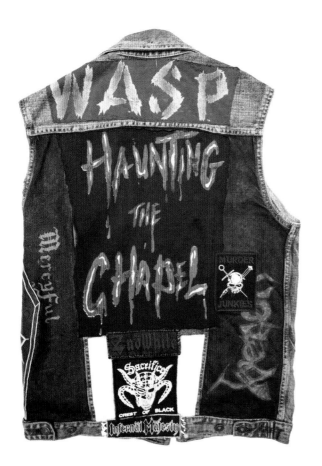

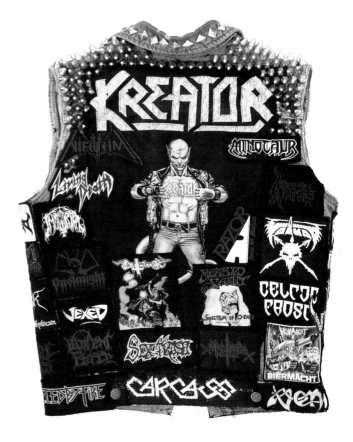

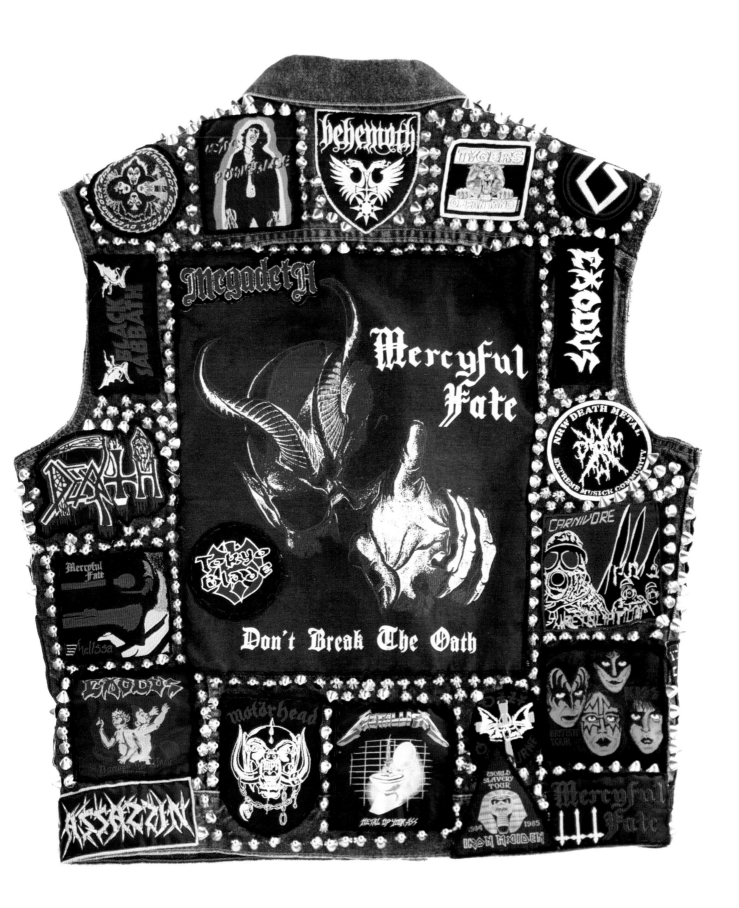

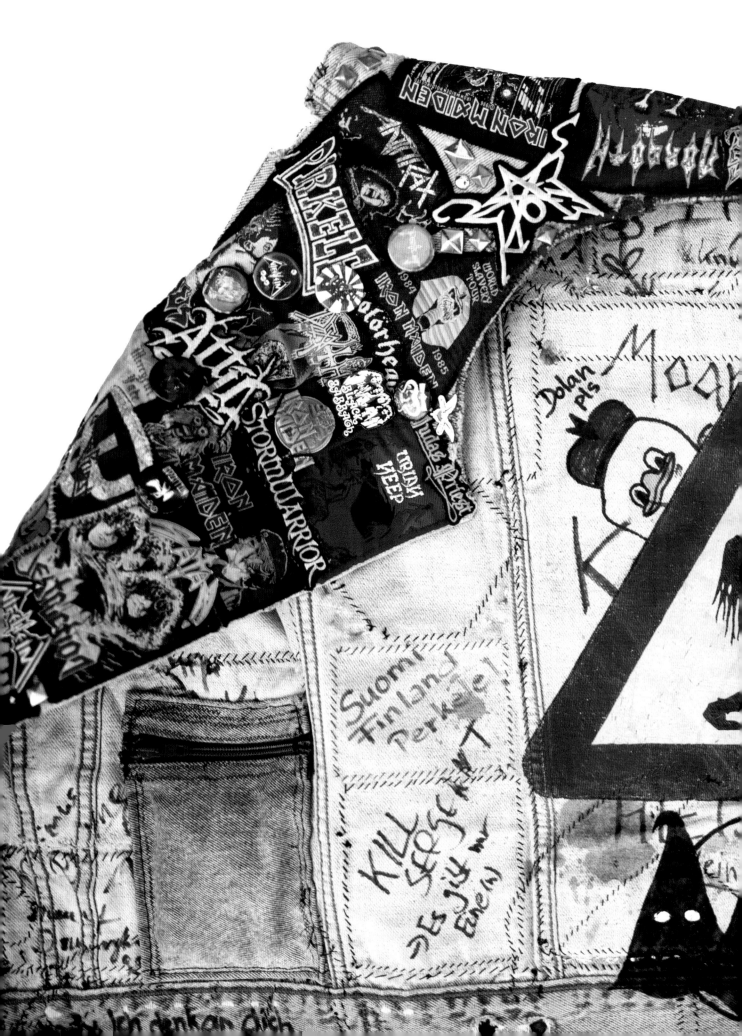

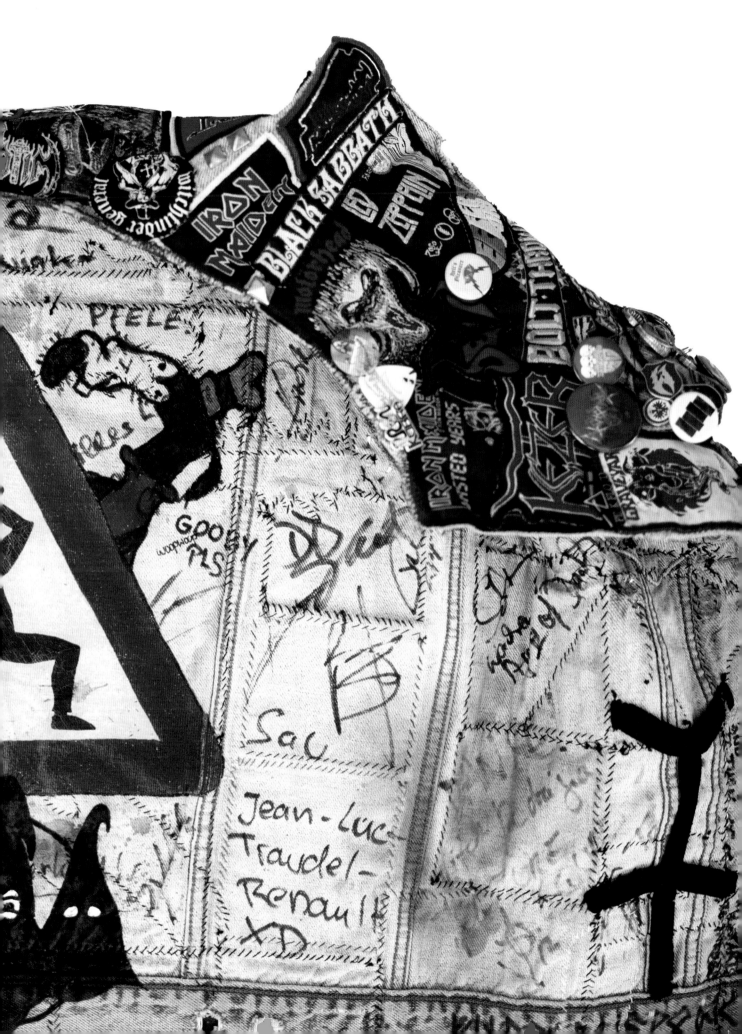

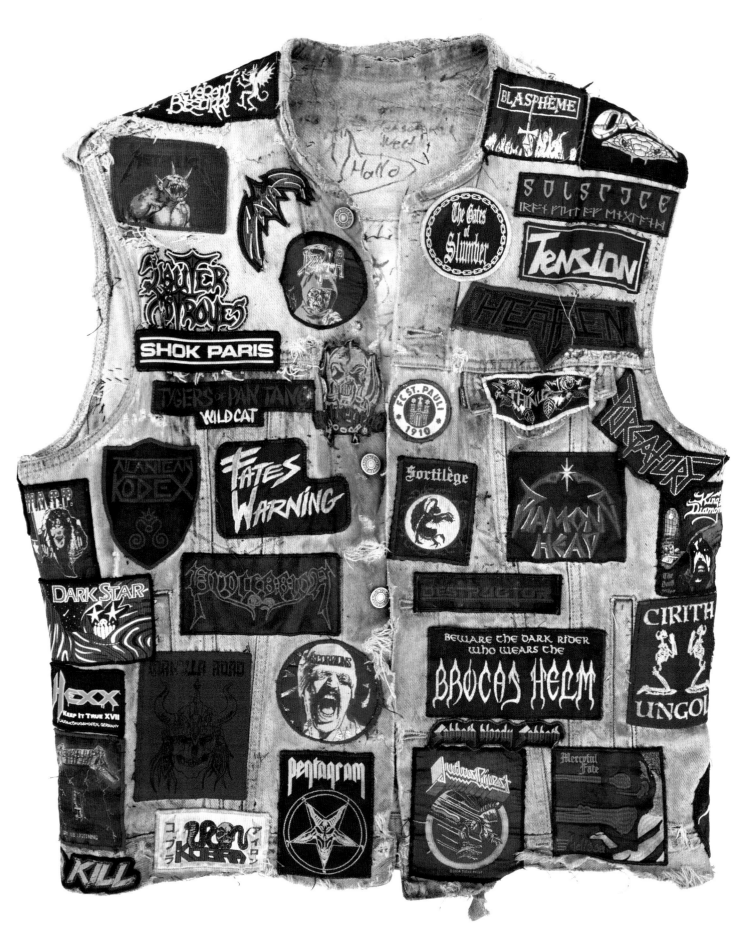

84

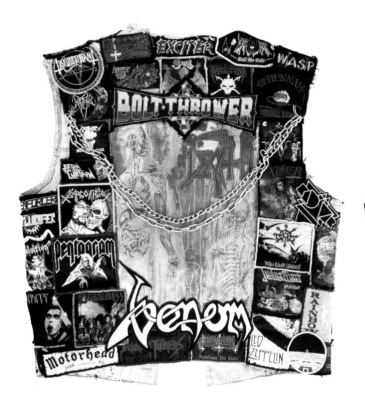

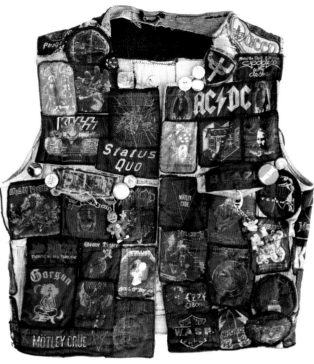

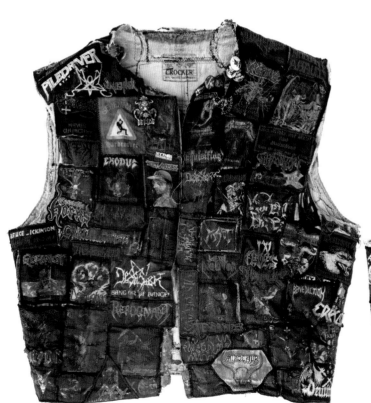

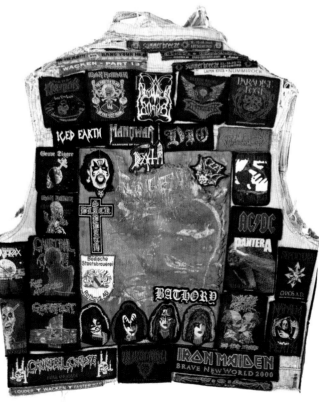

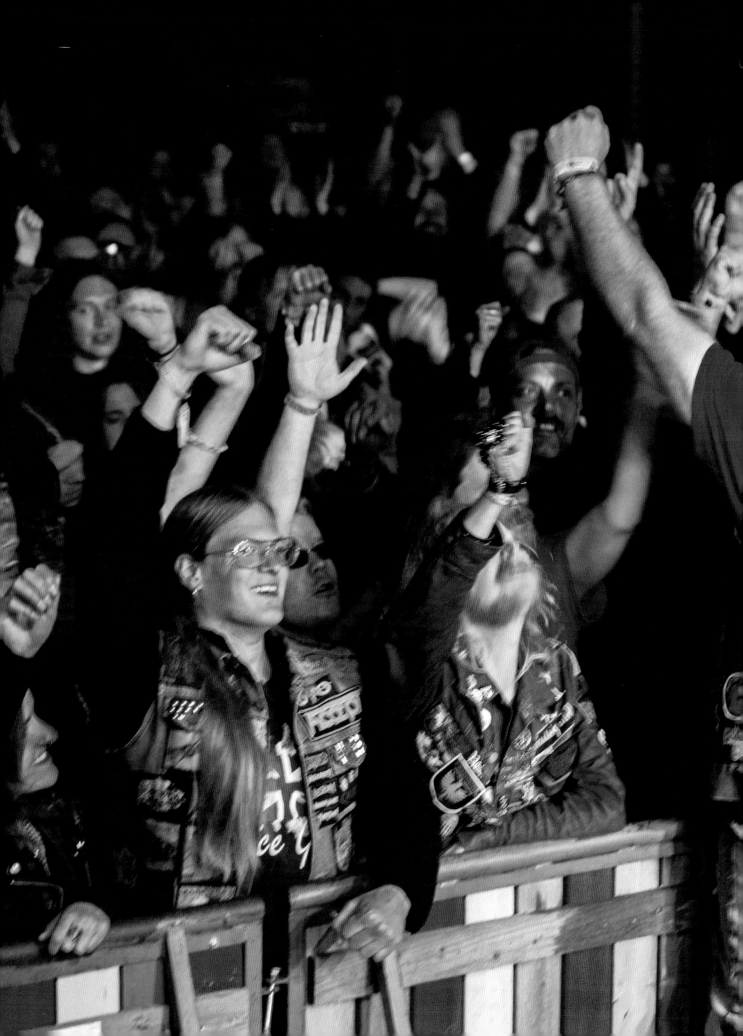

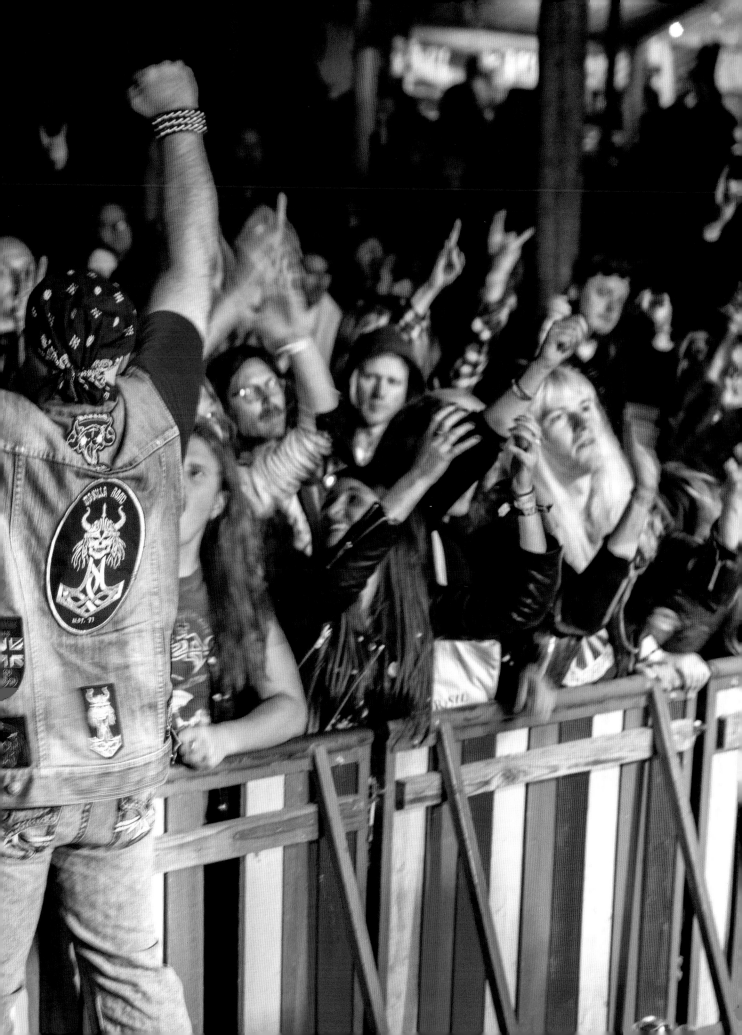

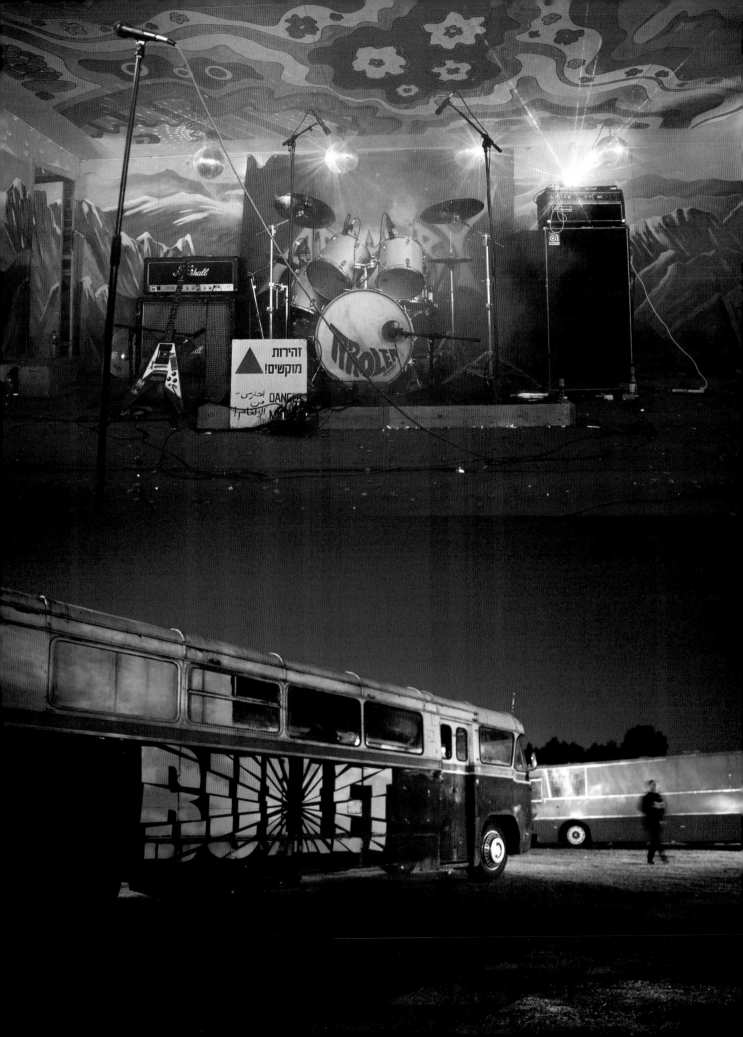

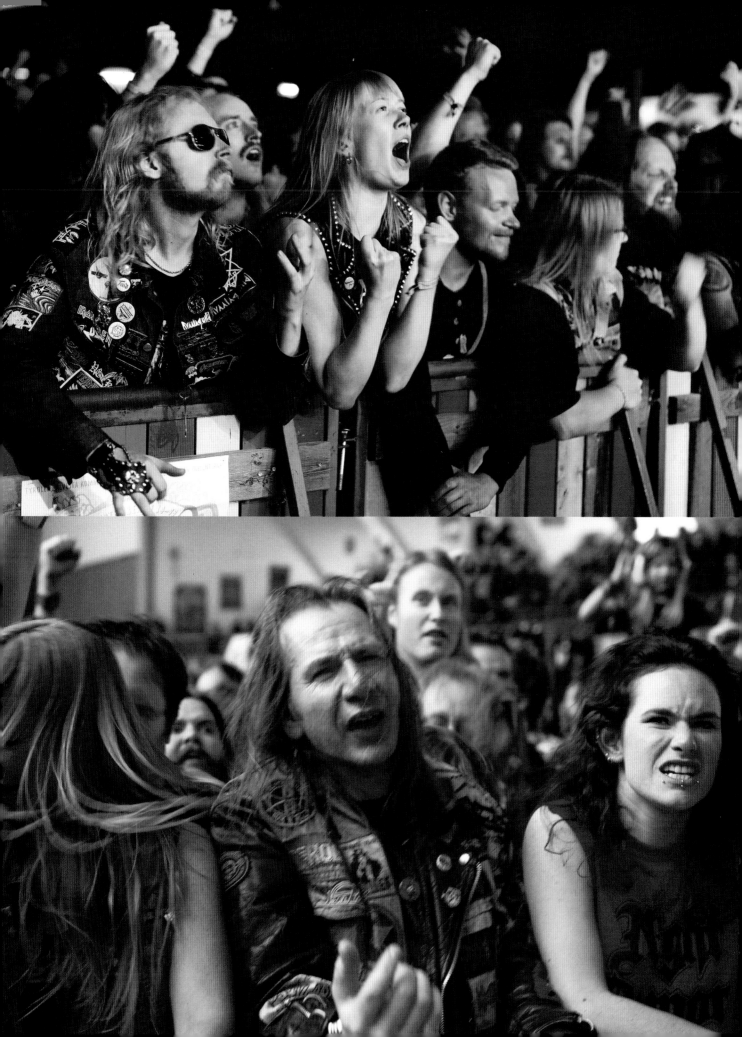

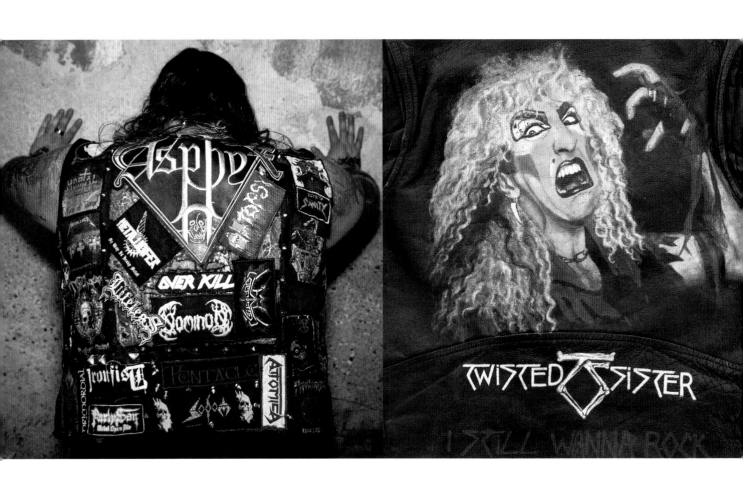

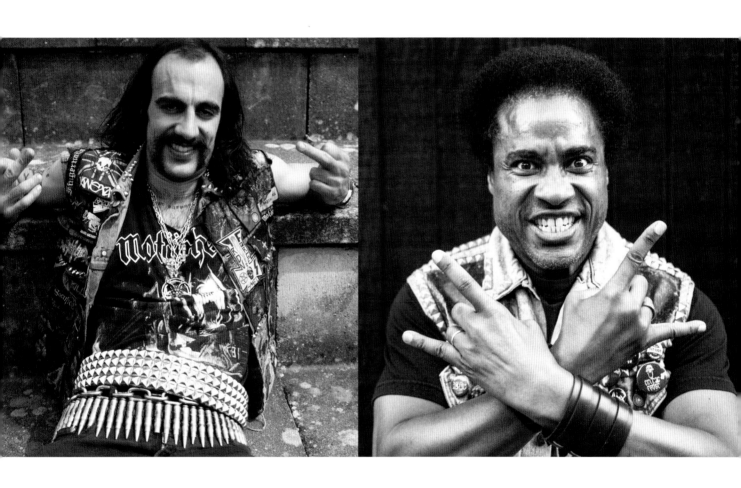

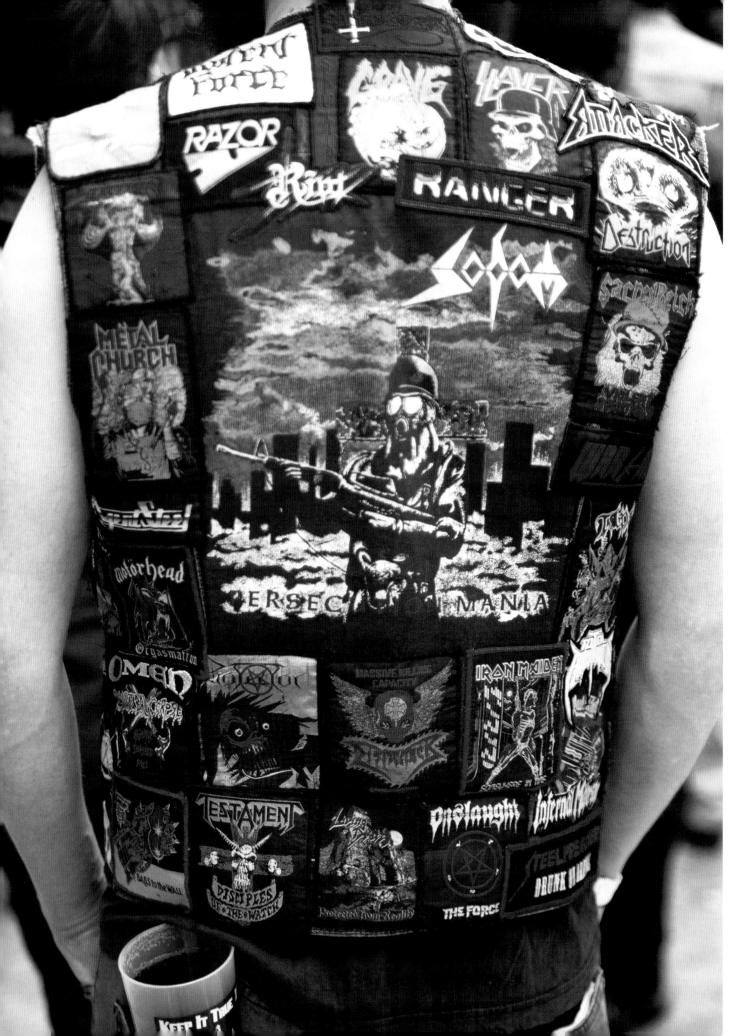

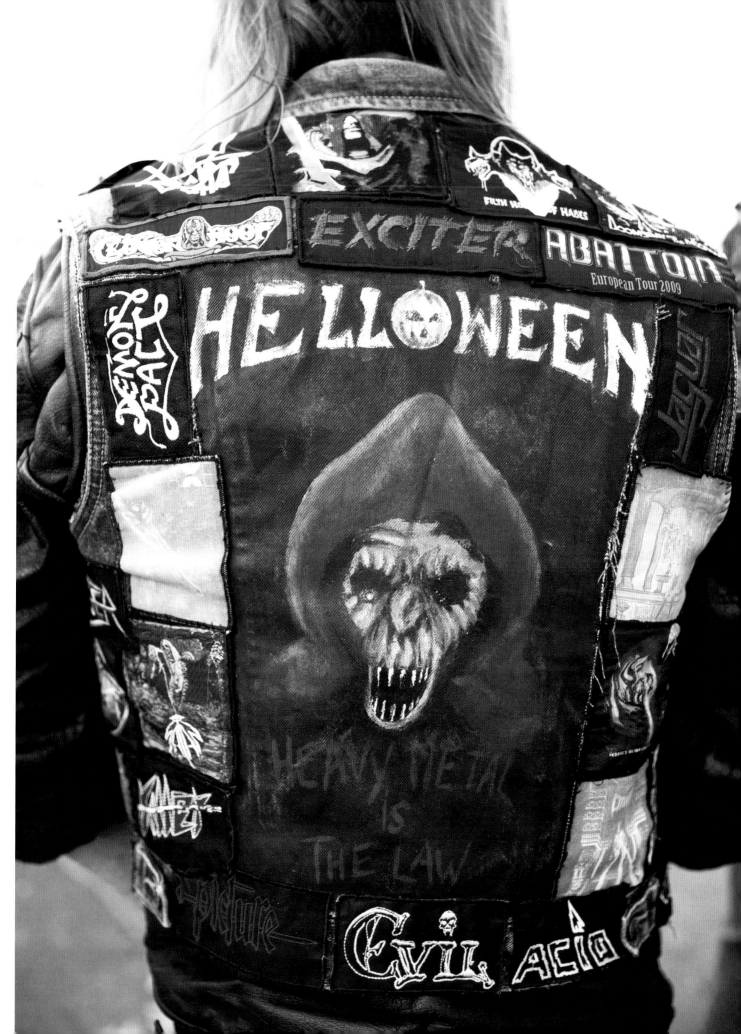

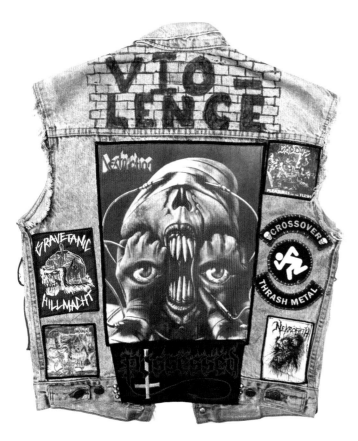

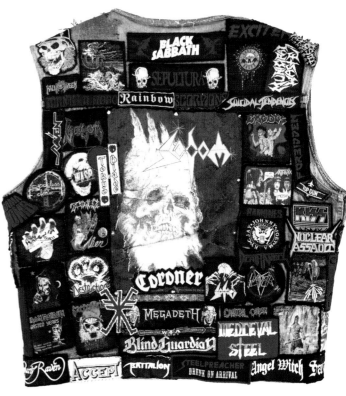

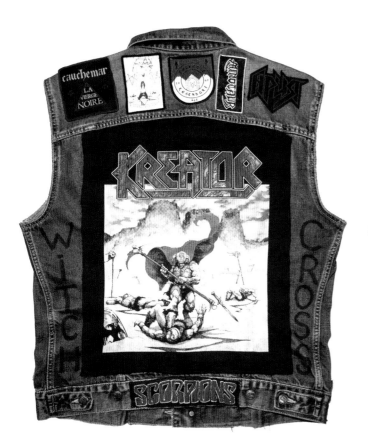

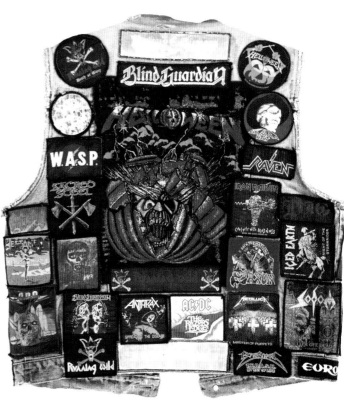

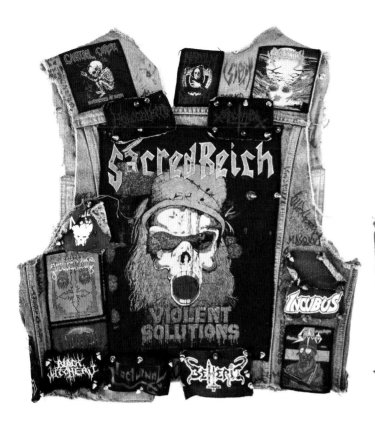

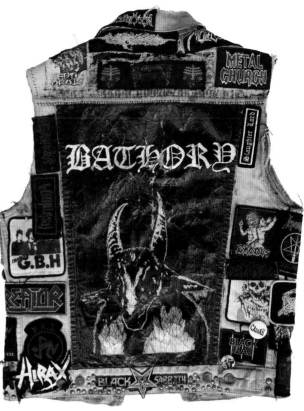

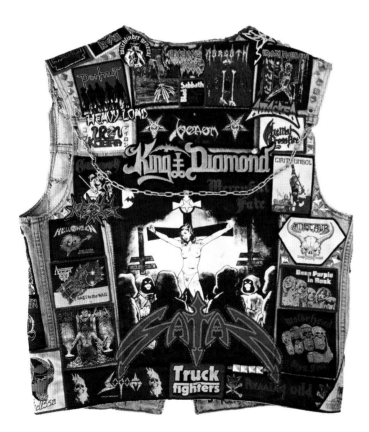

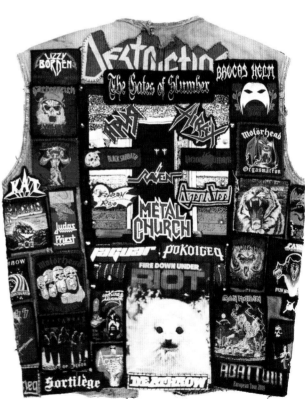

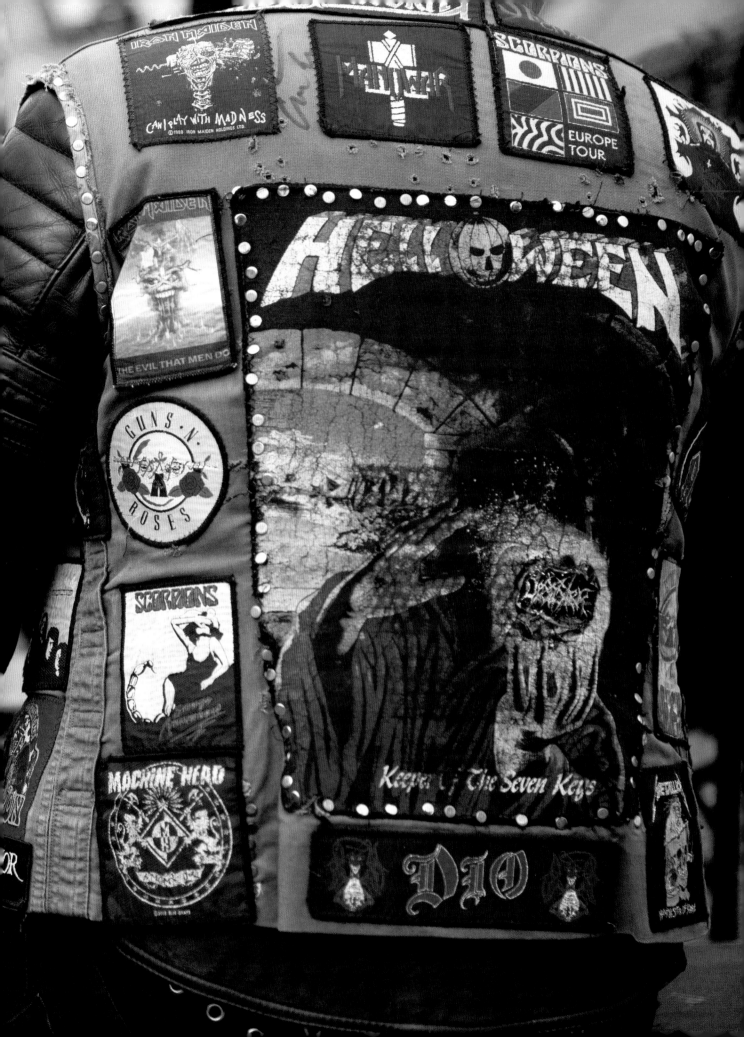

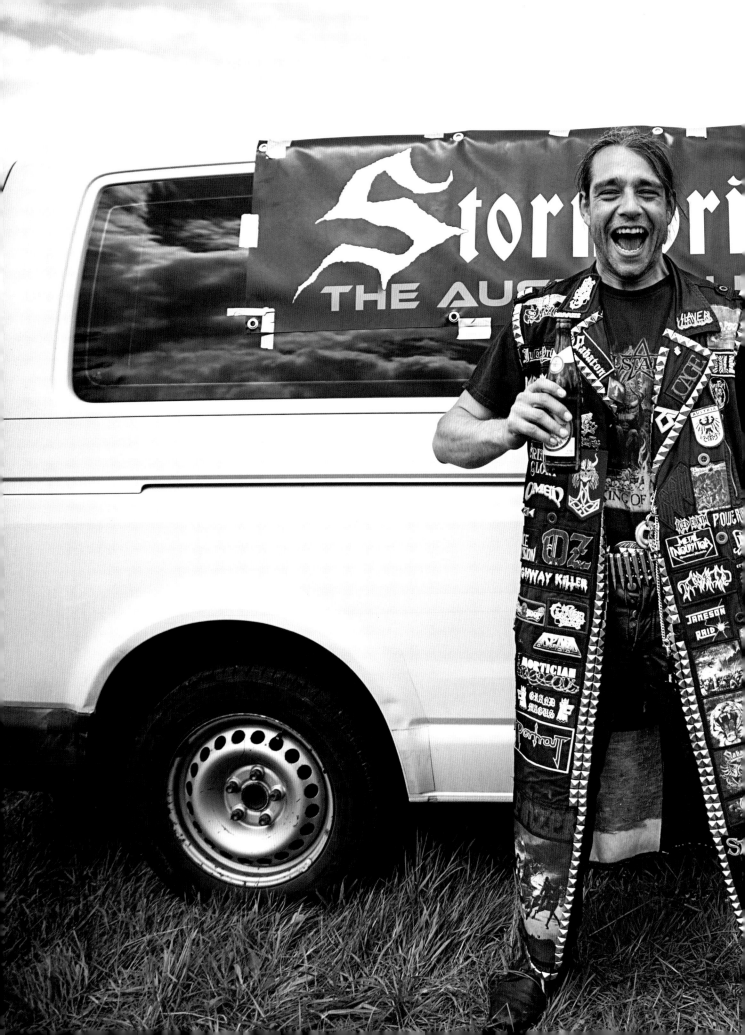

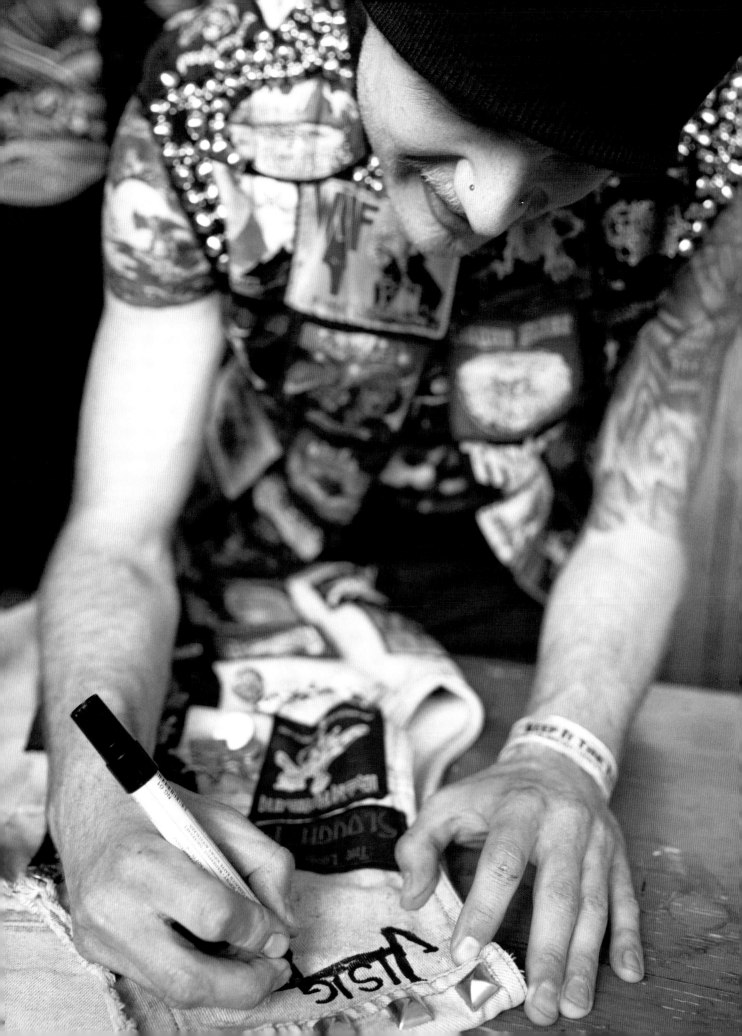

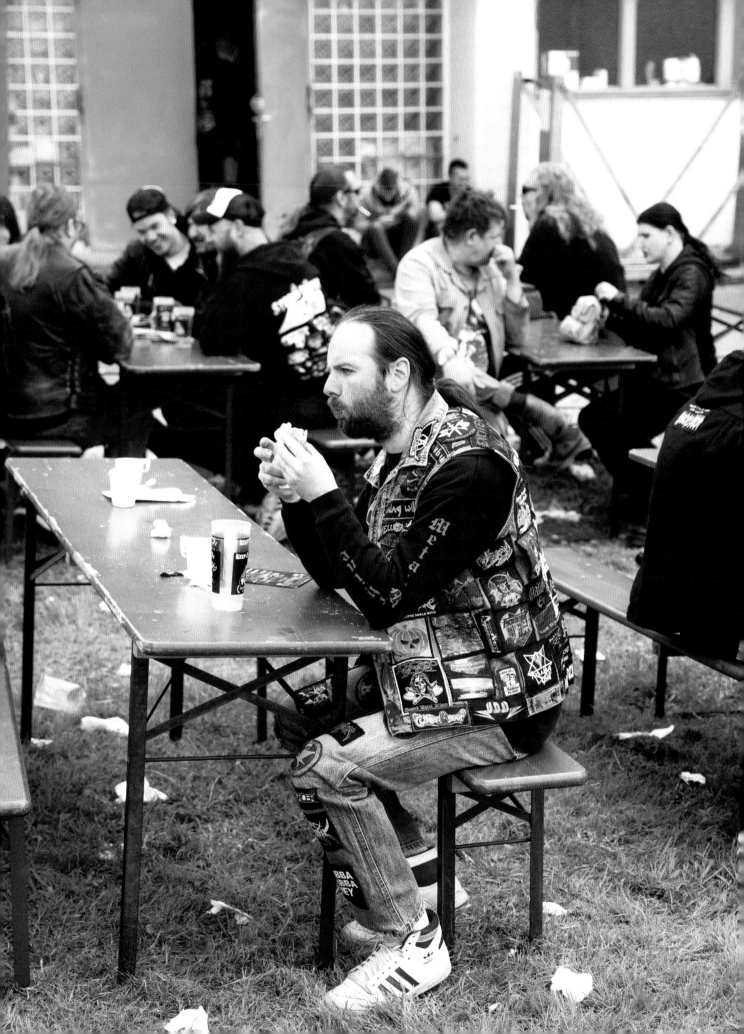

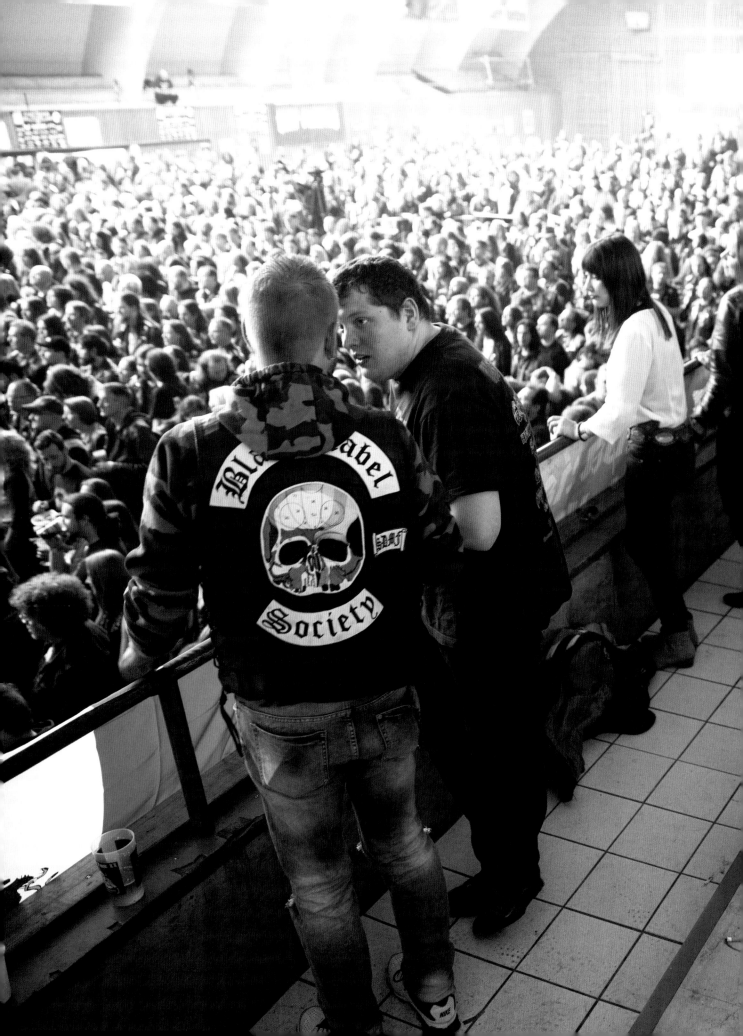

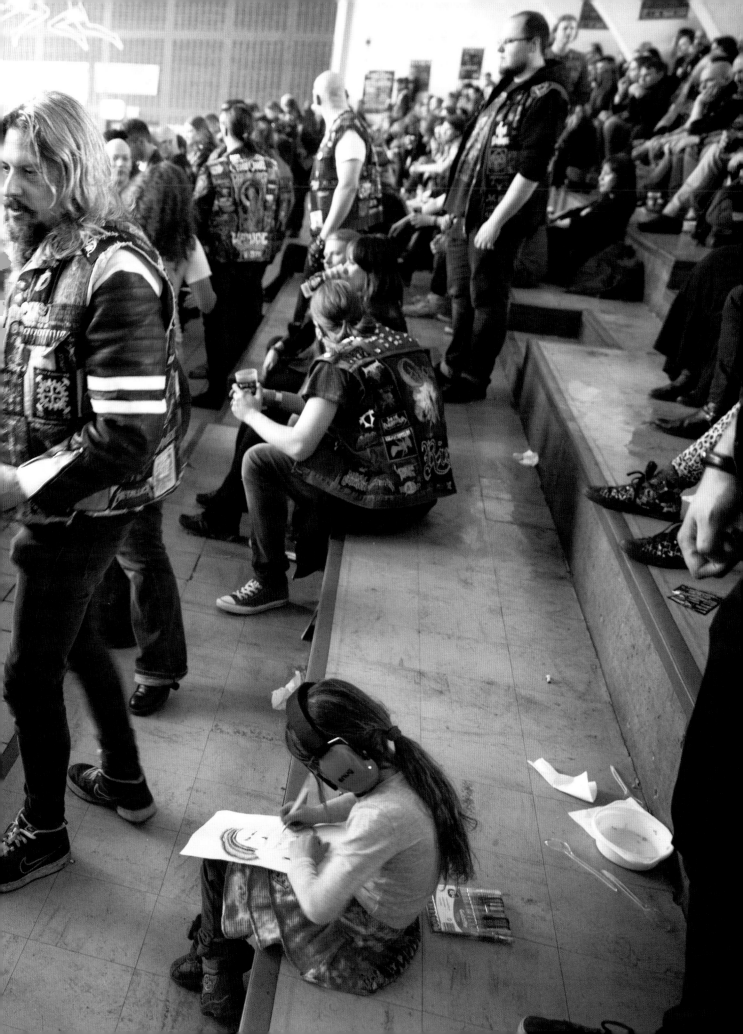

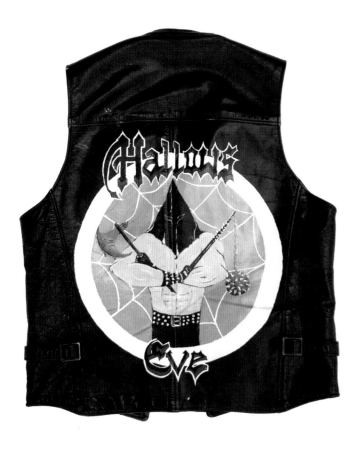

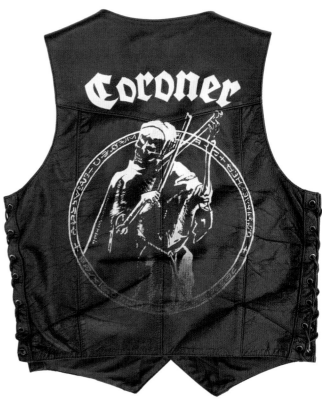

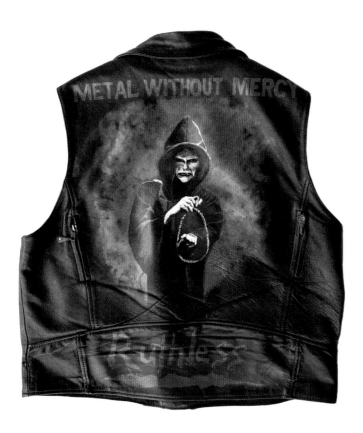

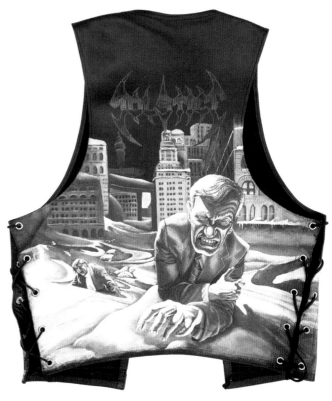

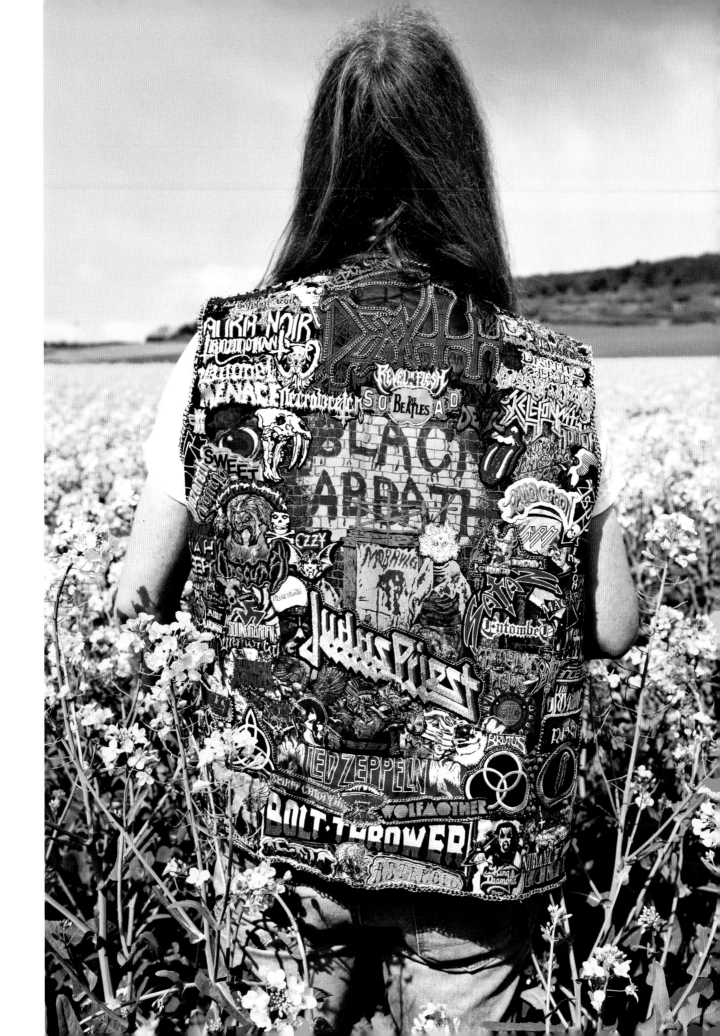

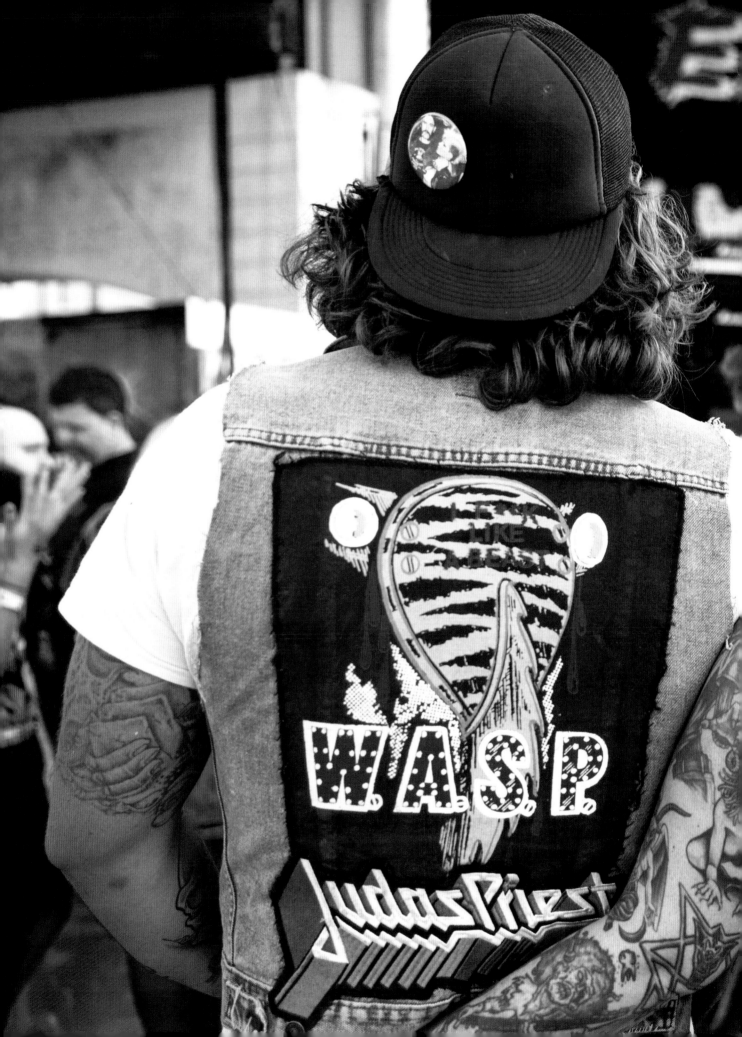

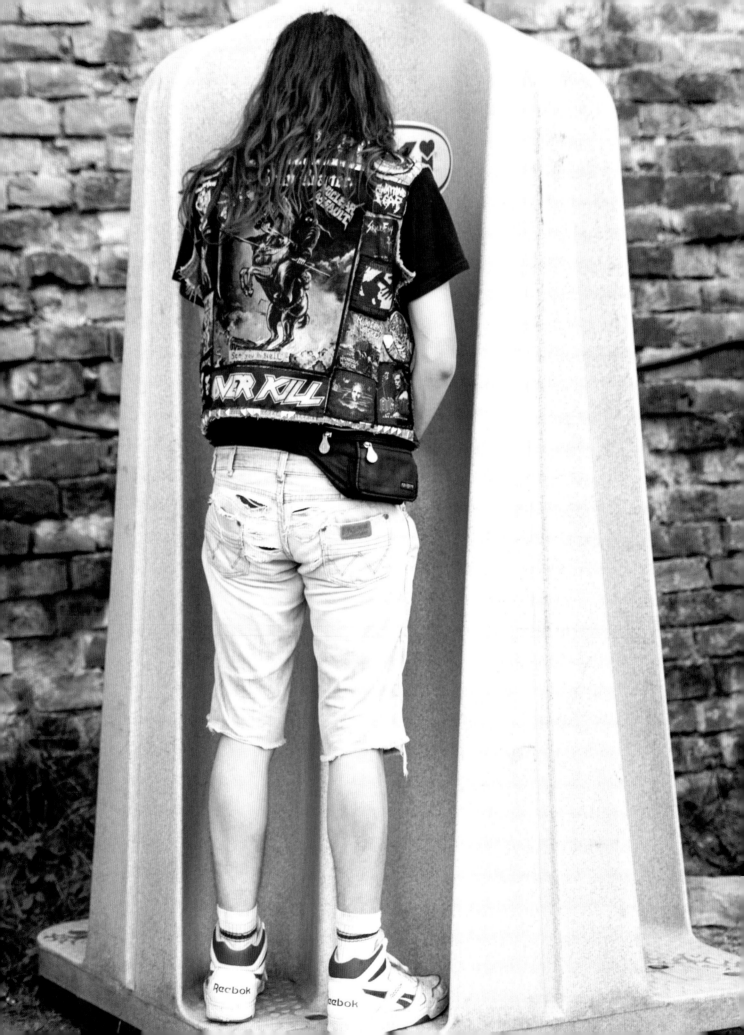

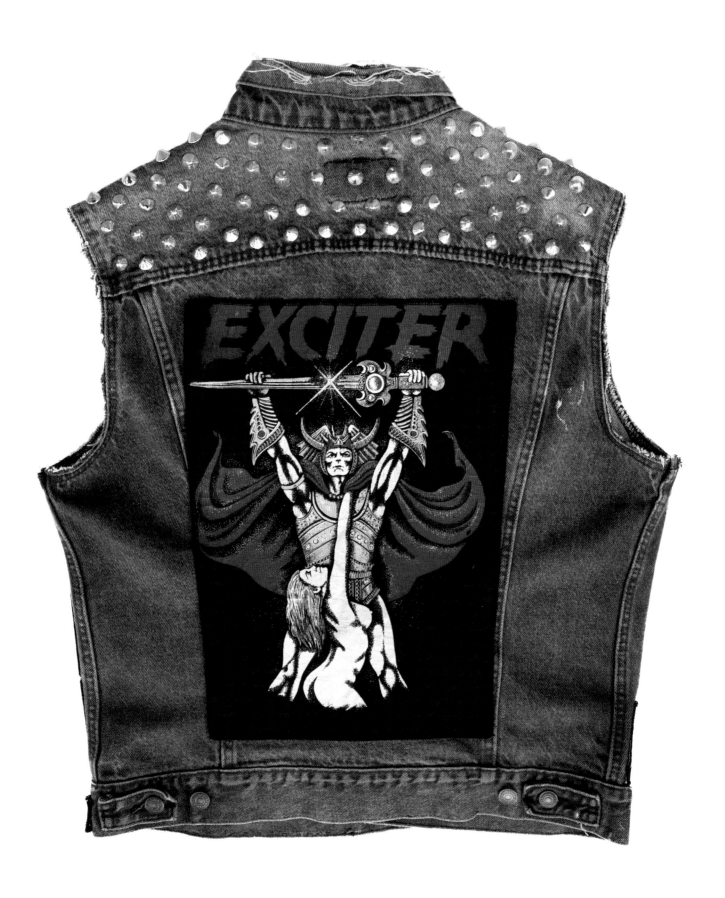

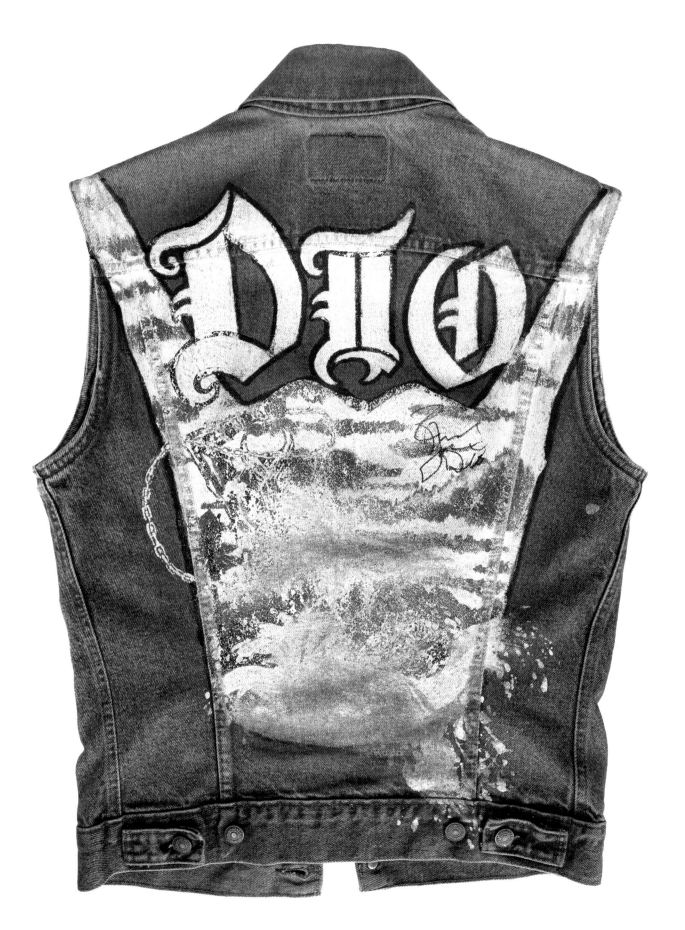

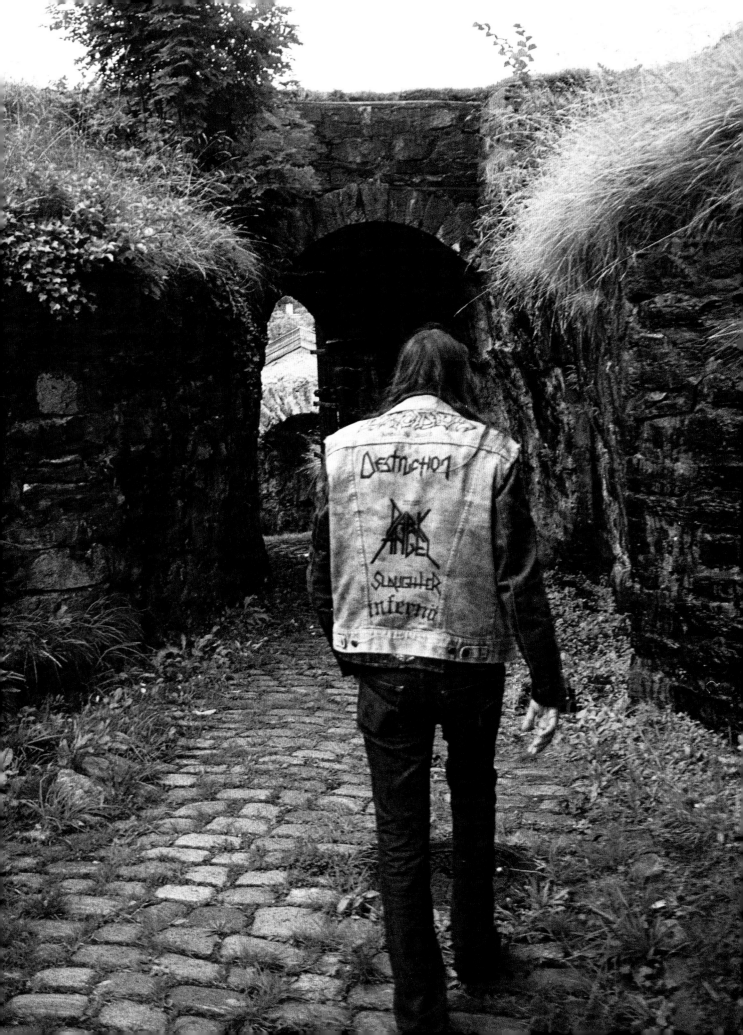

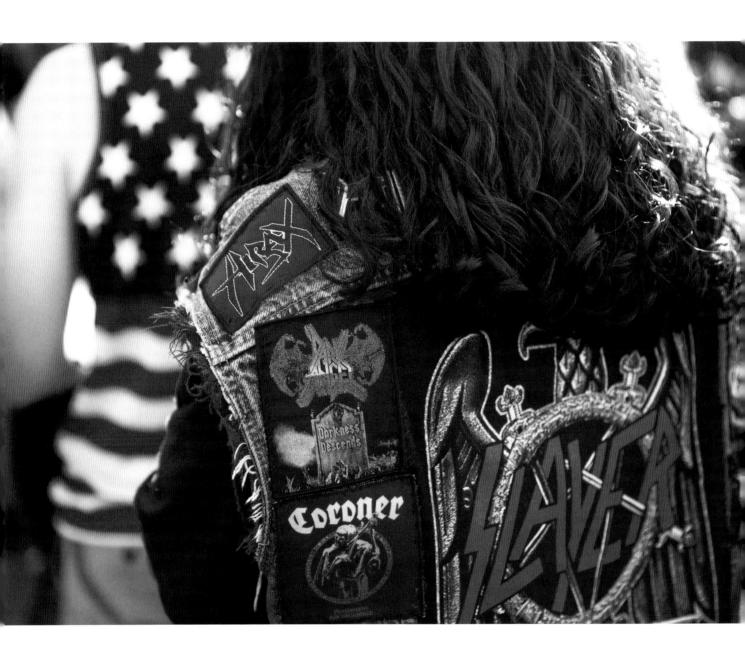

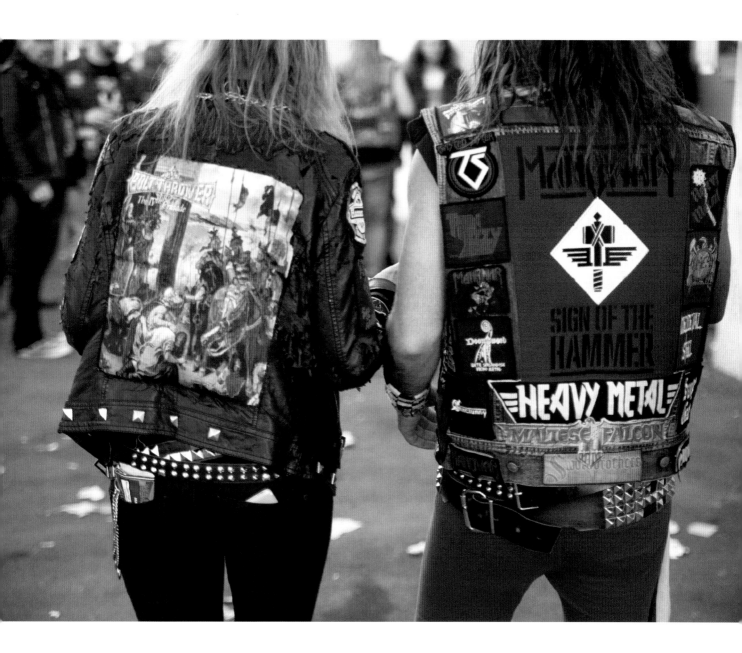

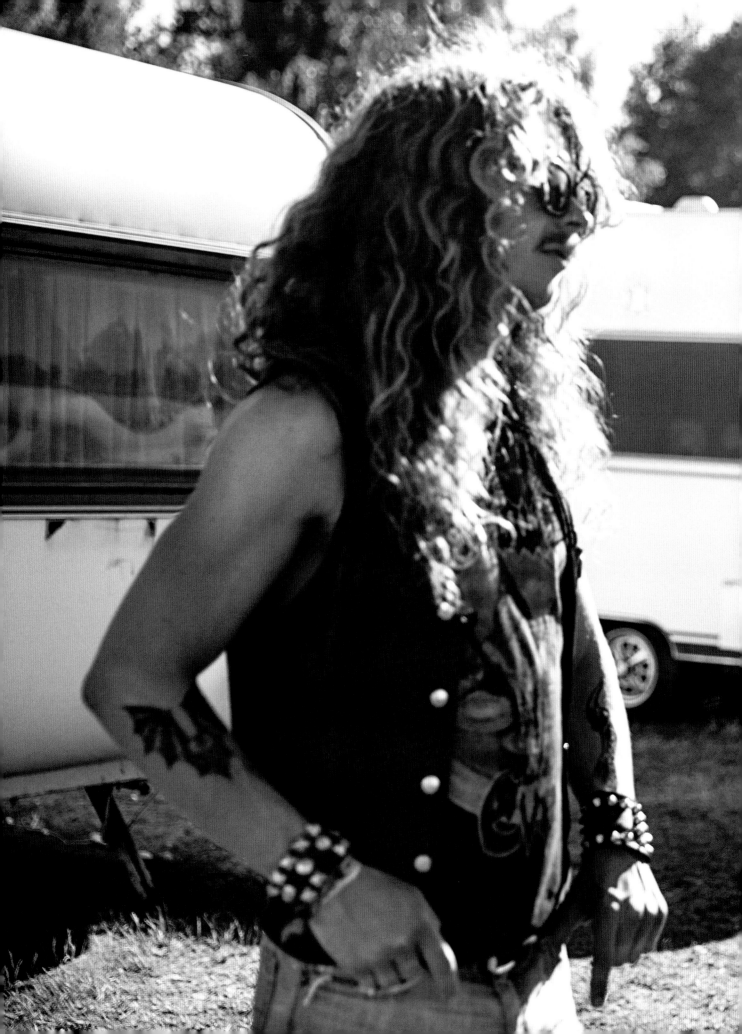

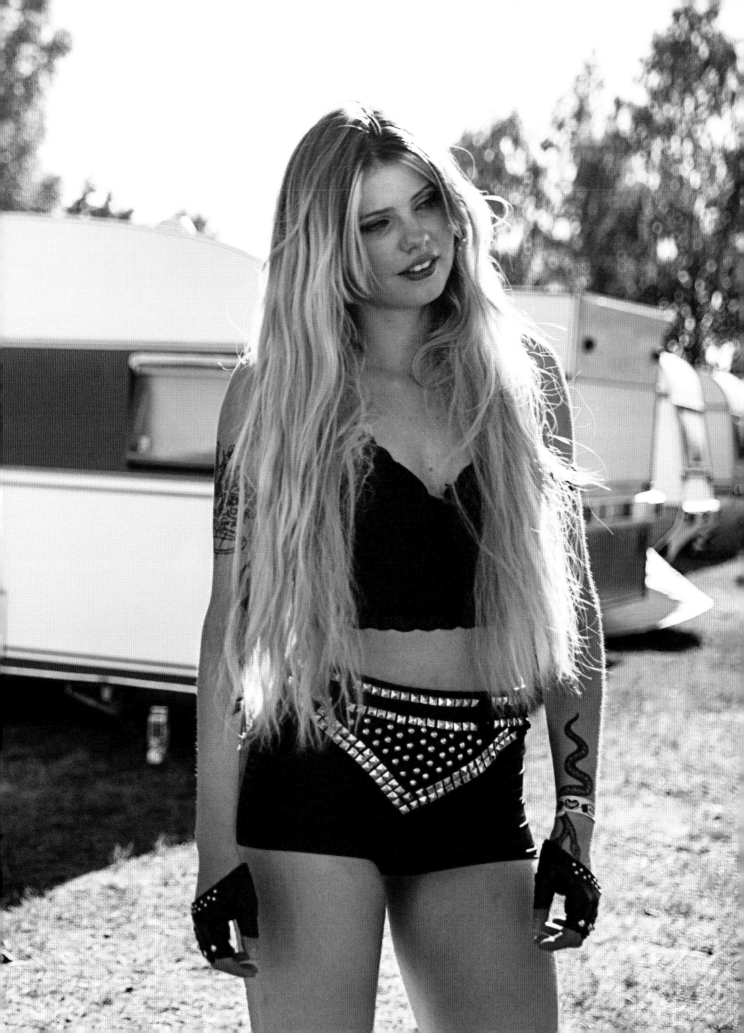

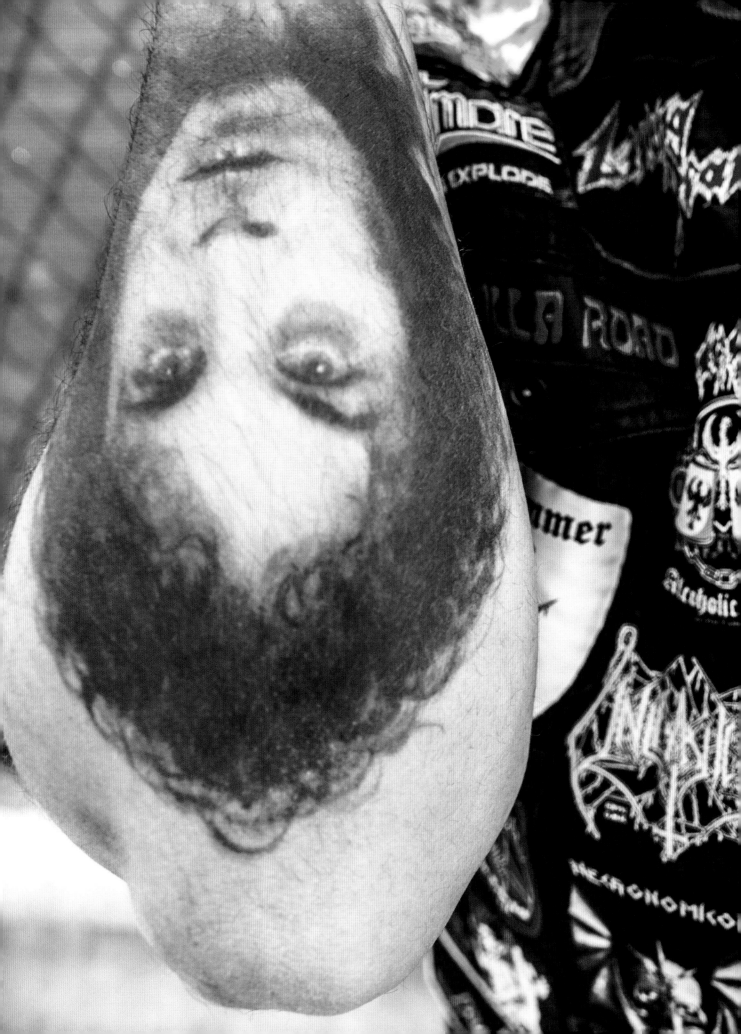

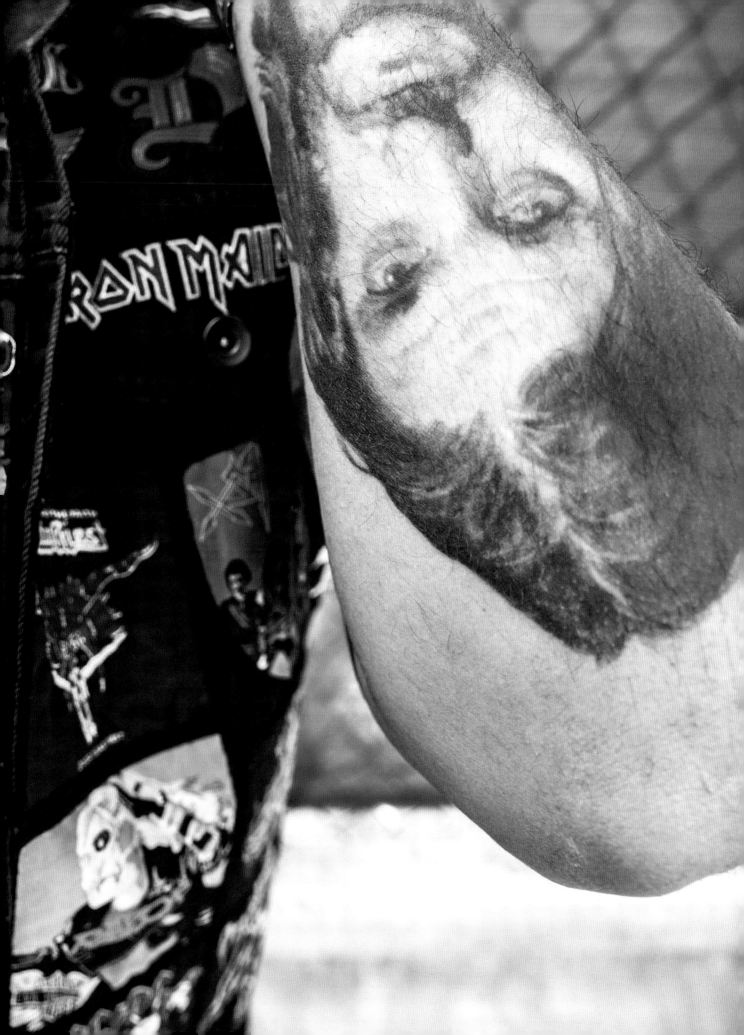

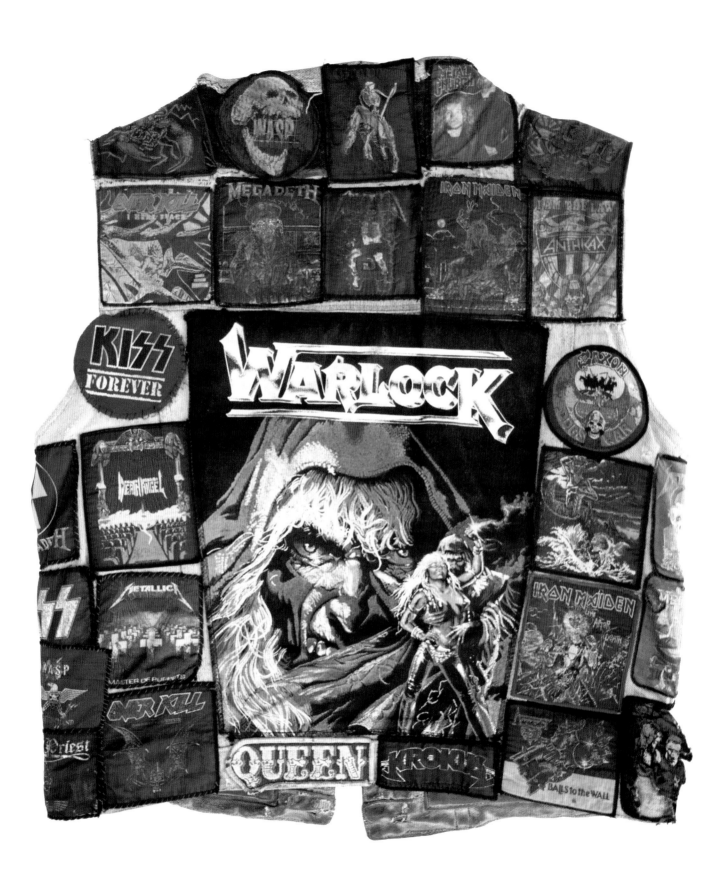

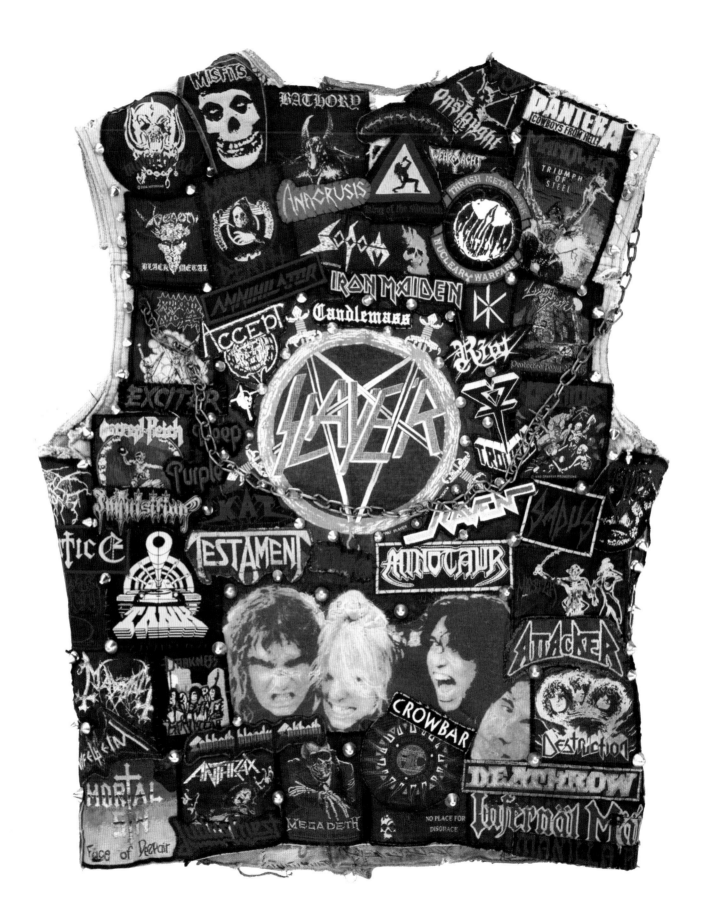

119

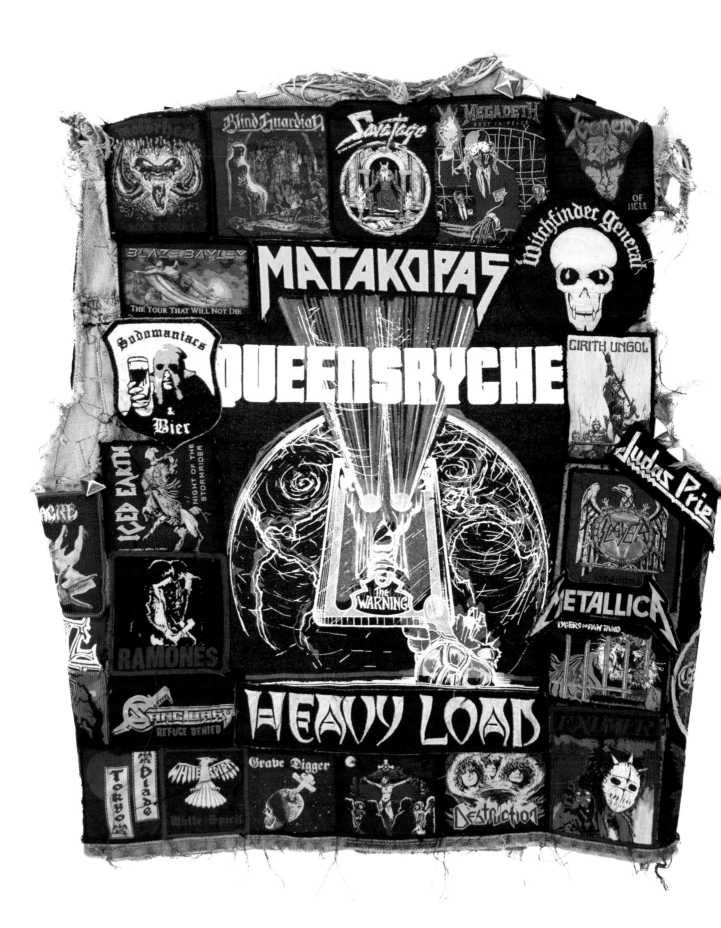

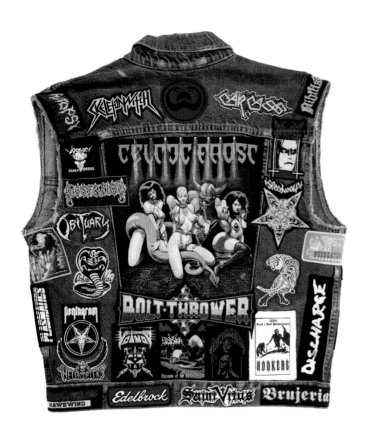

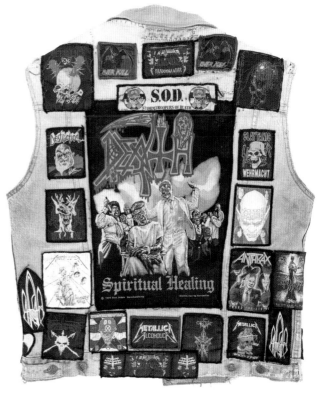

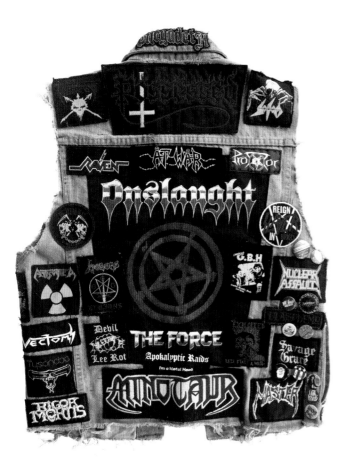

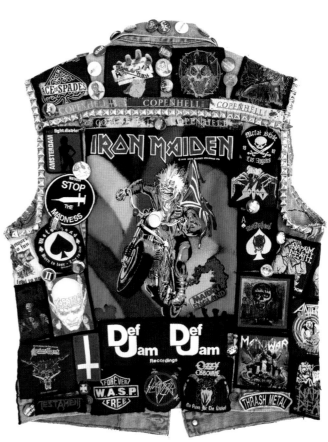

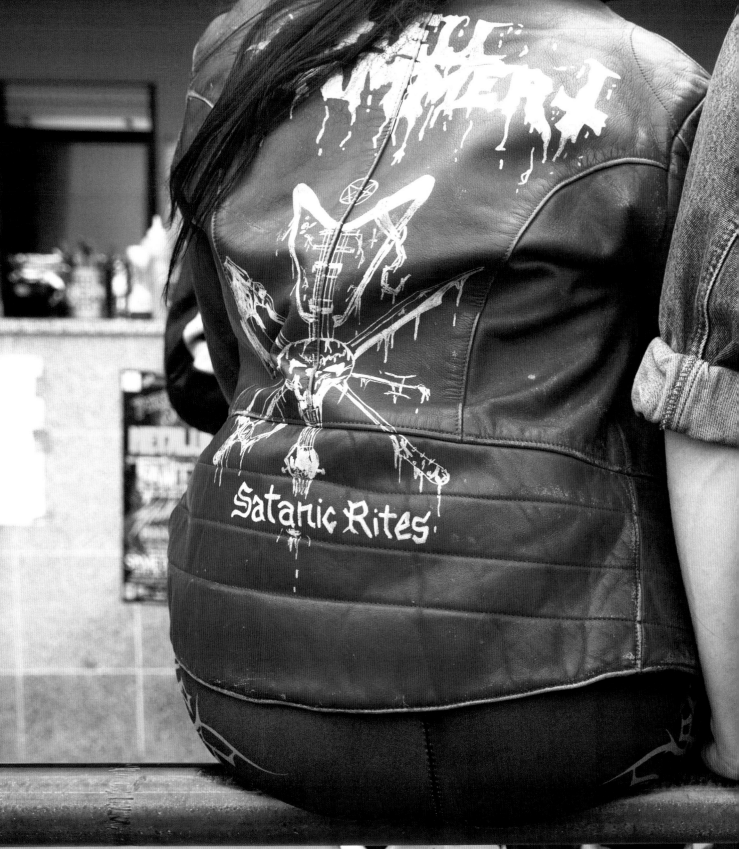

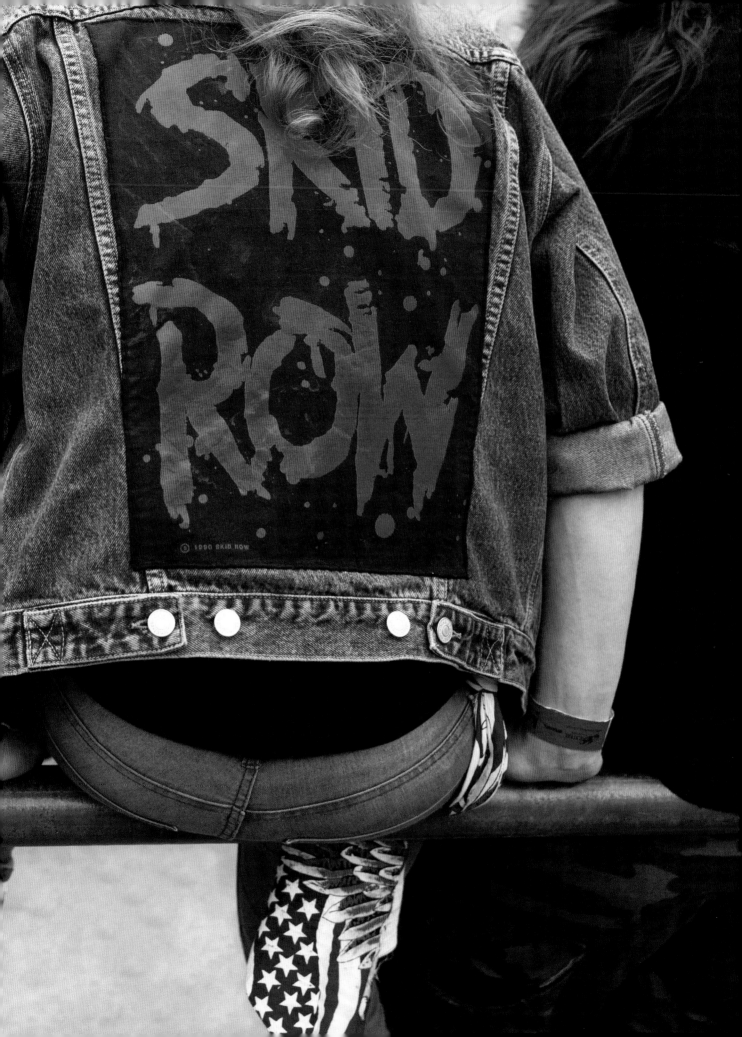

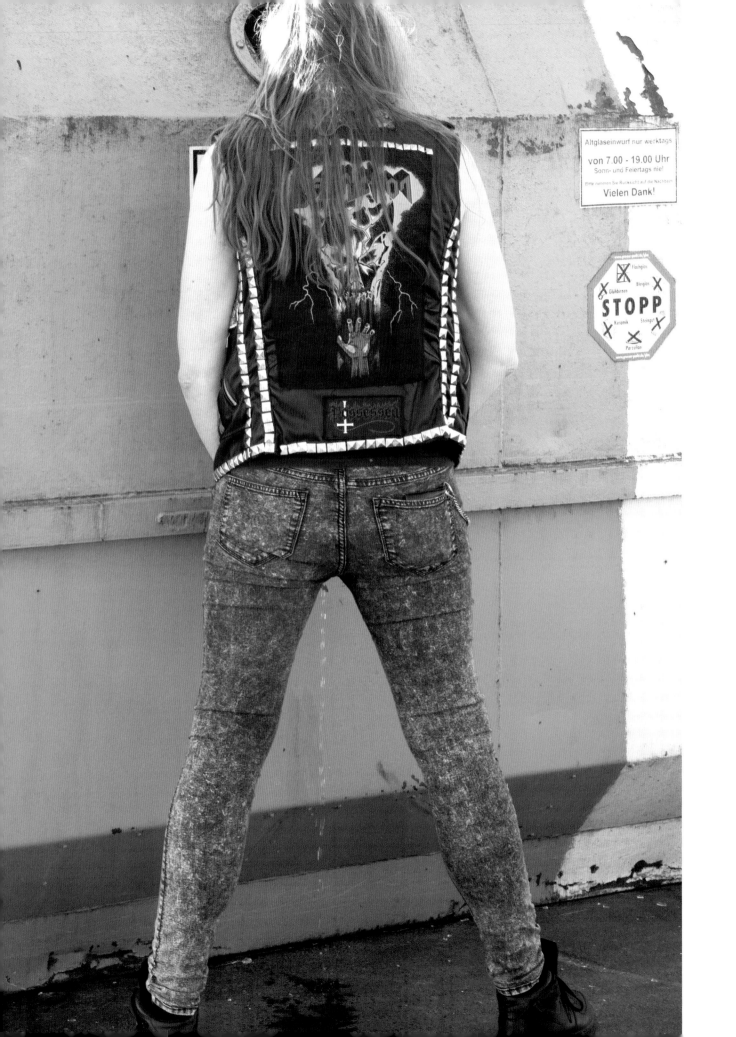

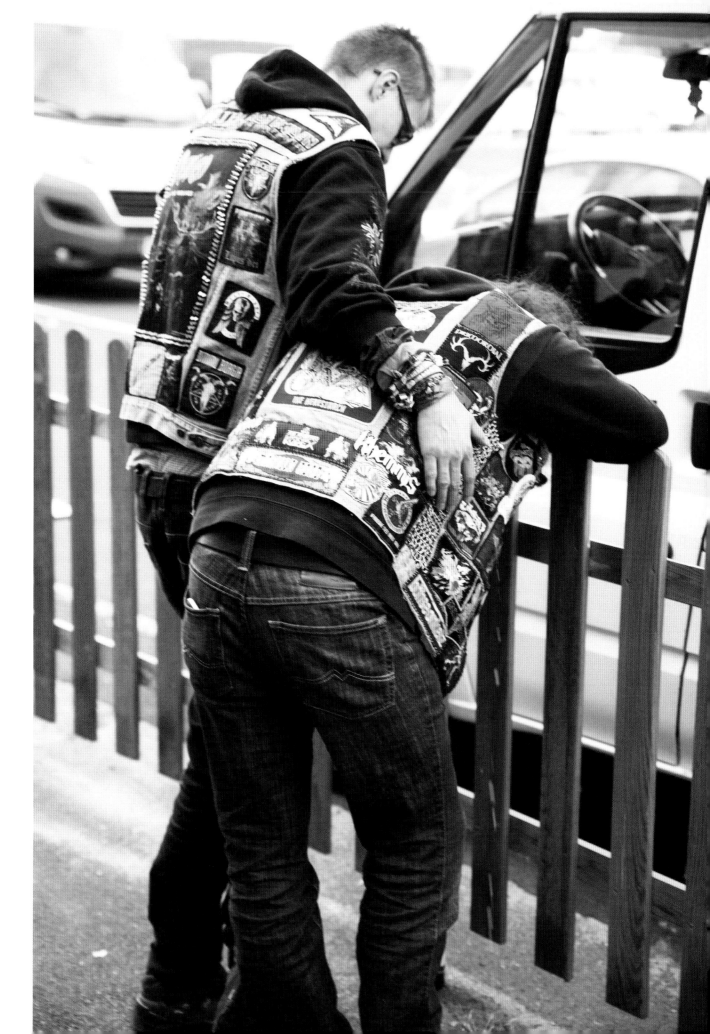

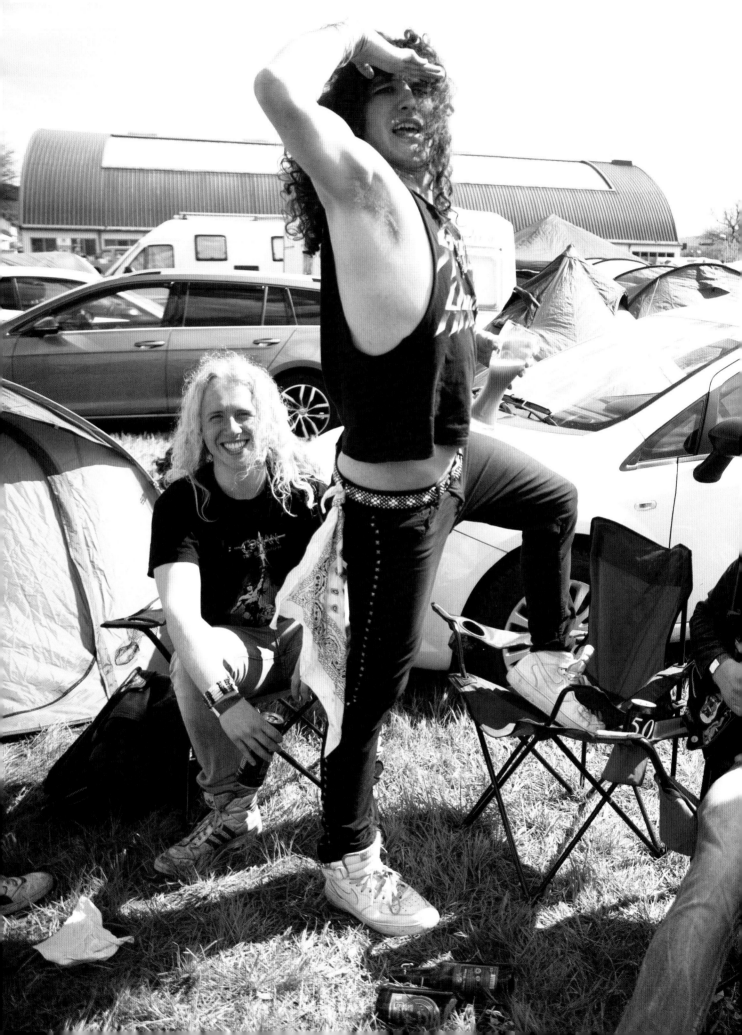

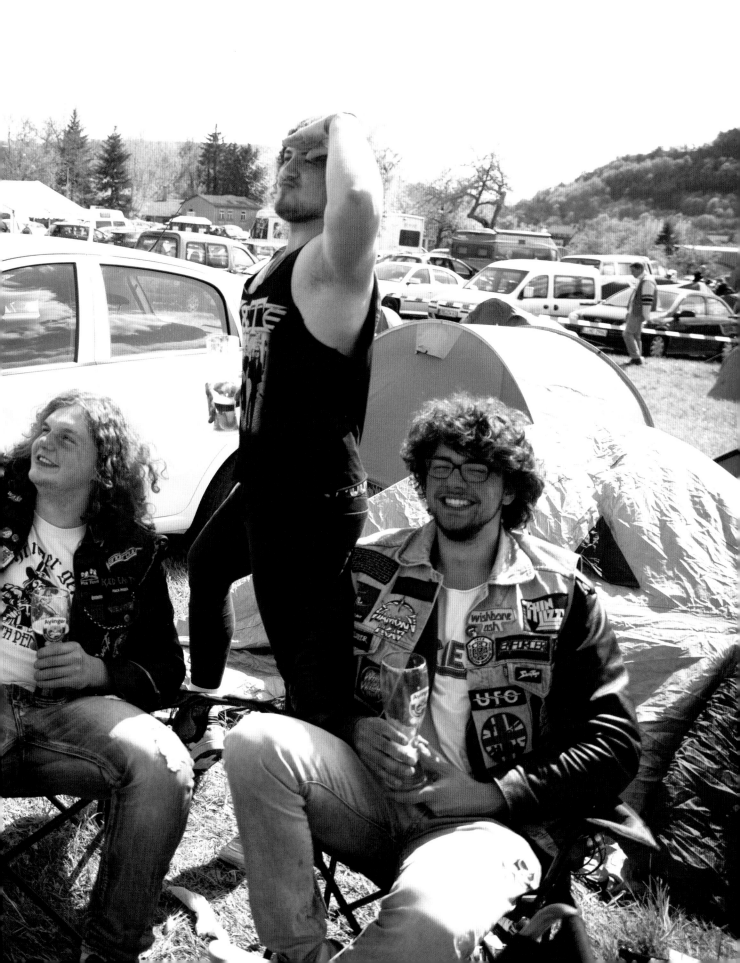

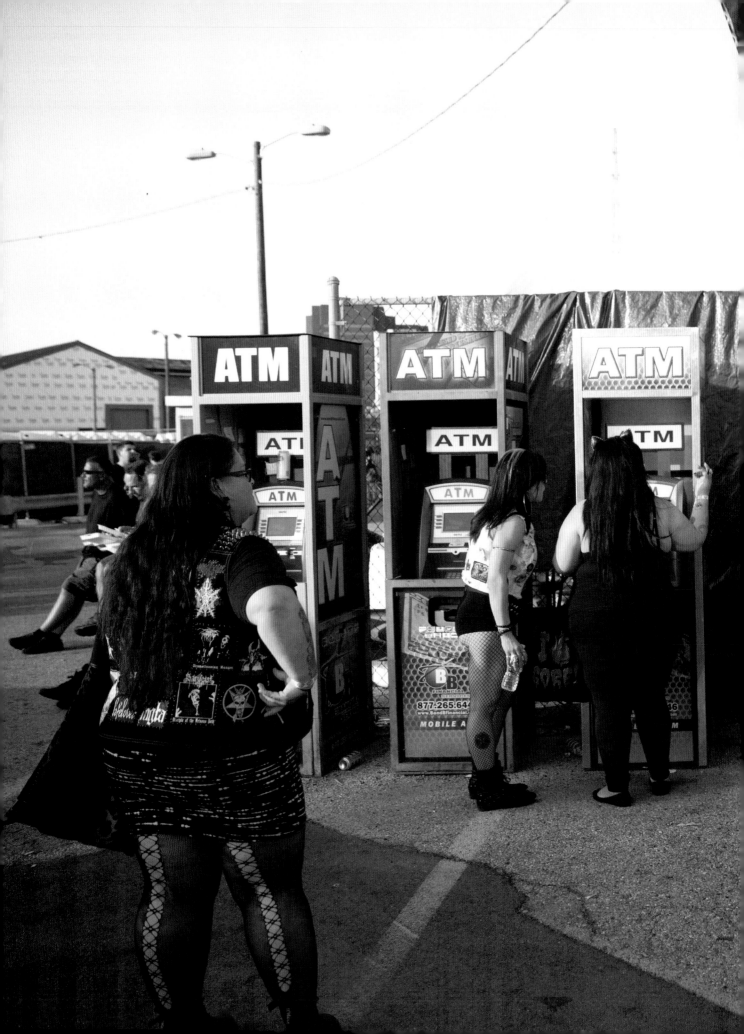

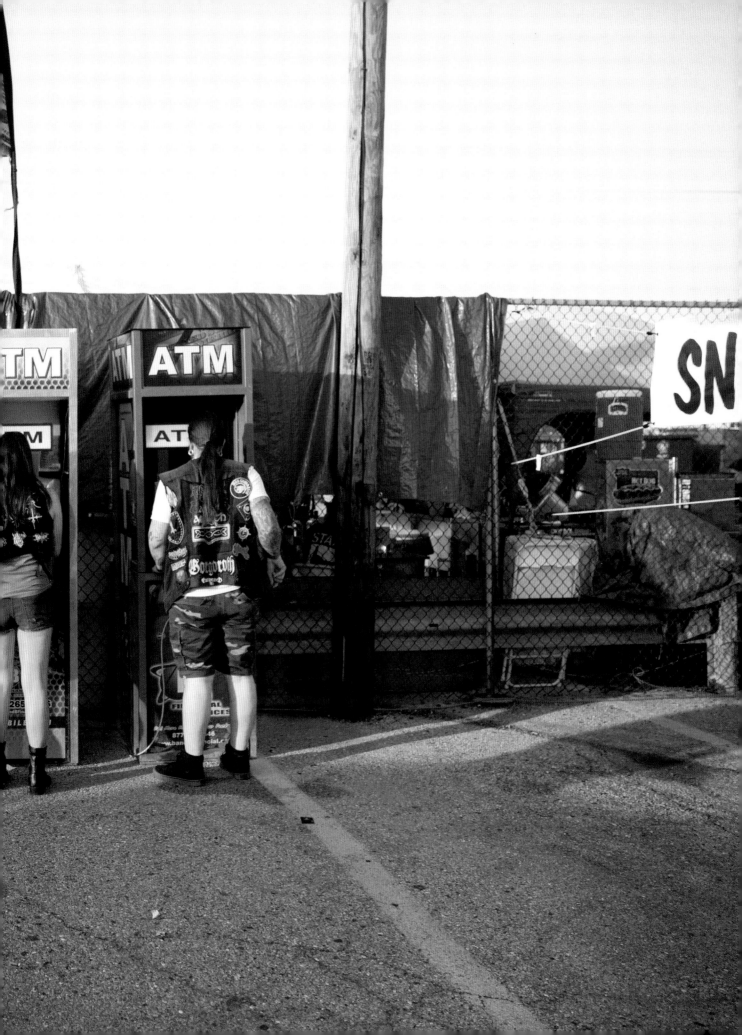

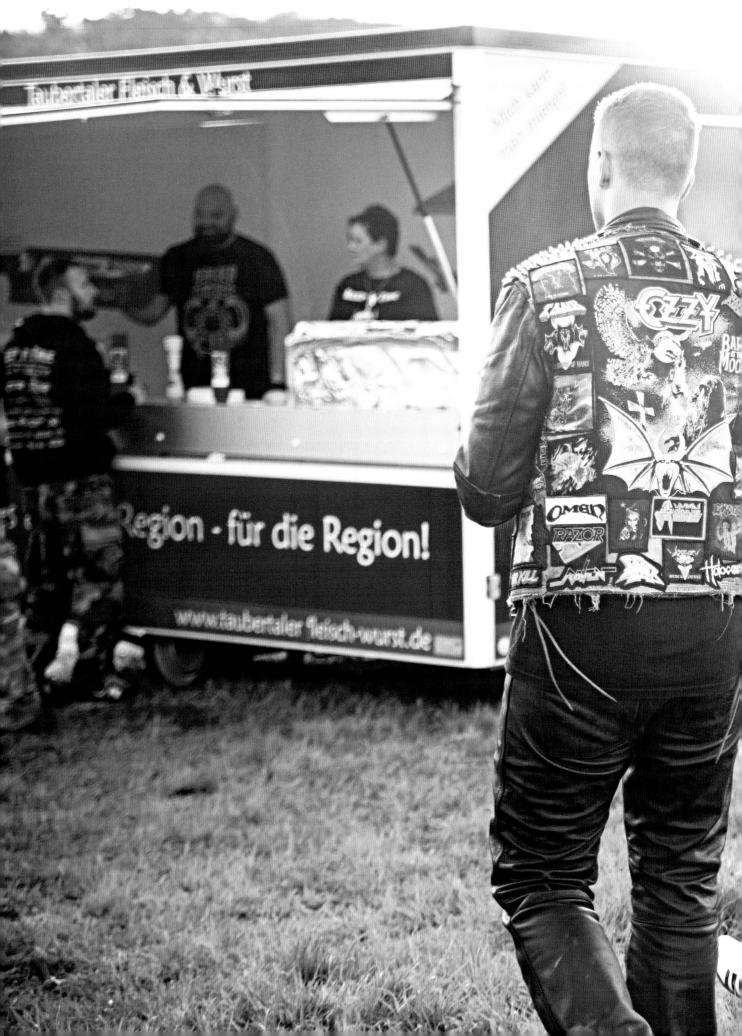

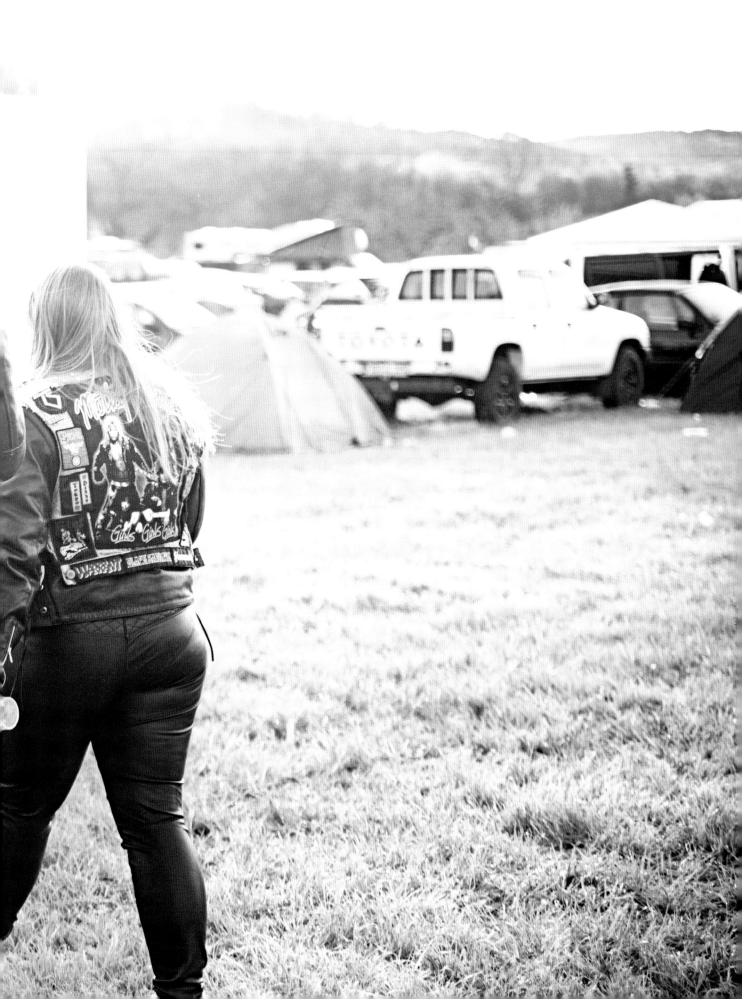

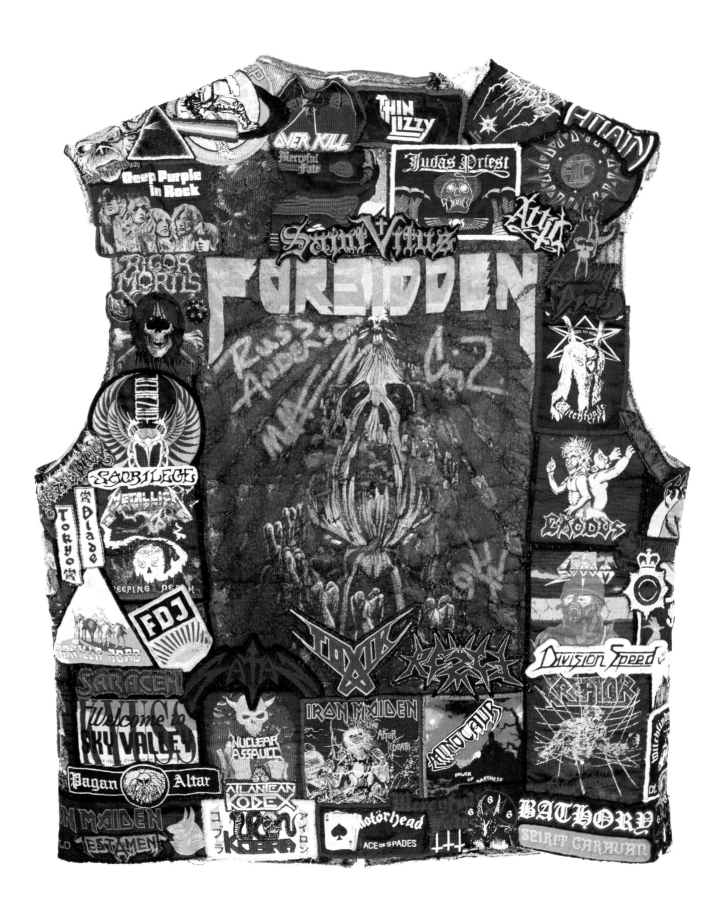

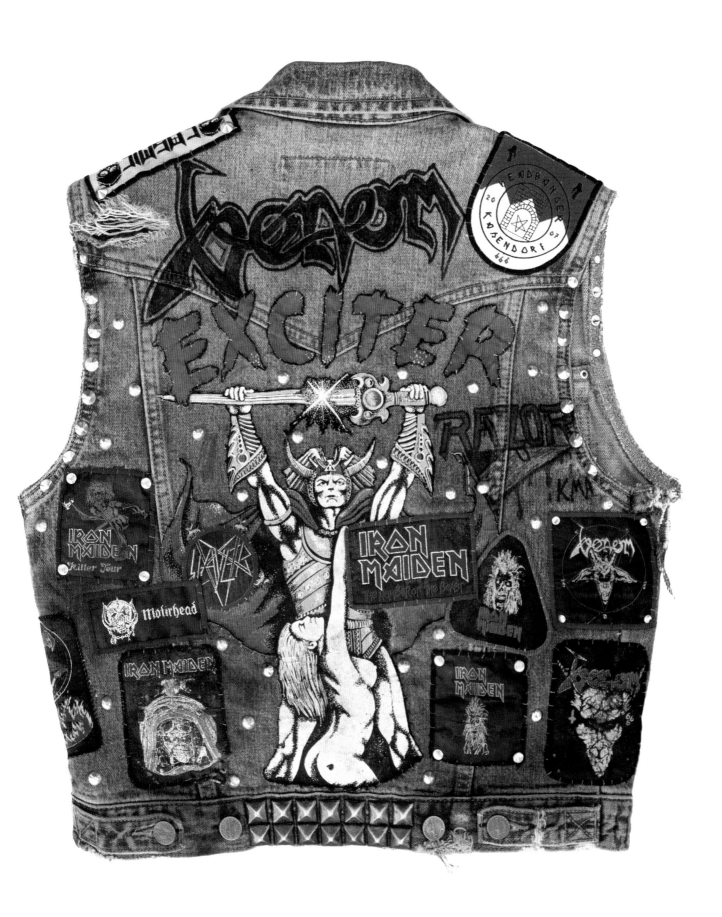

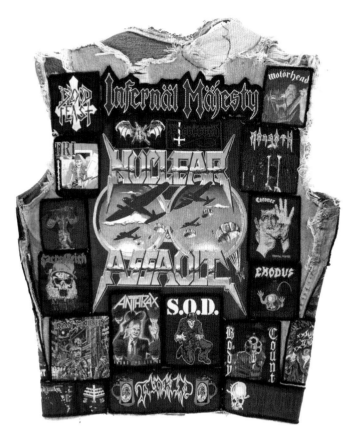

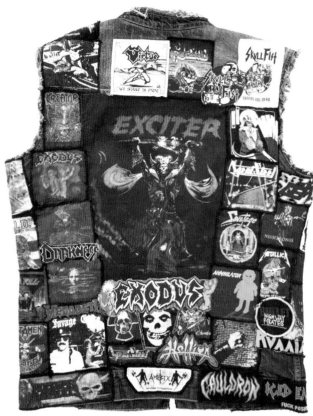

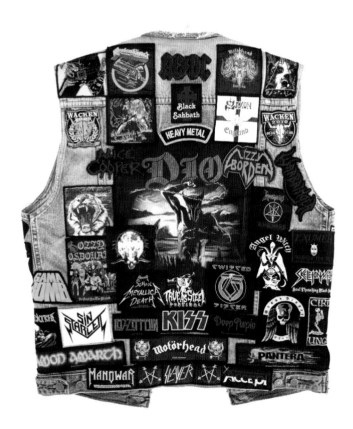

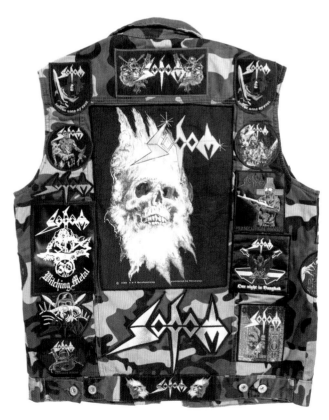

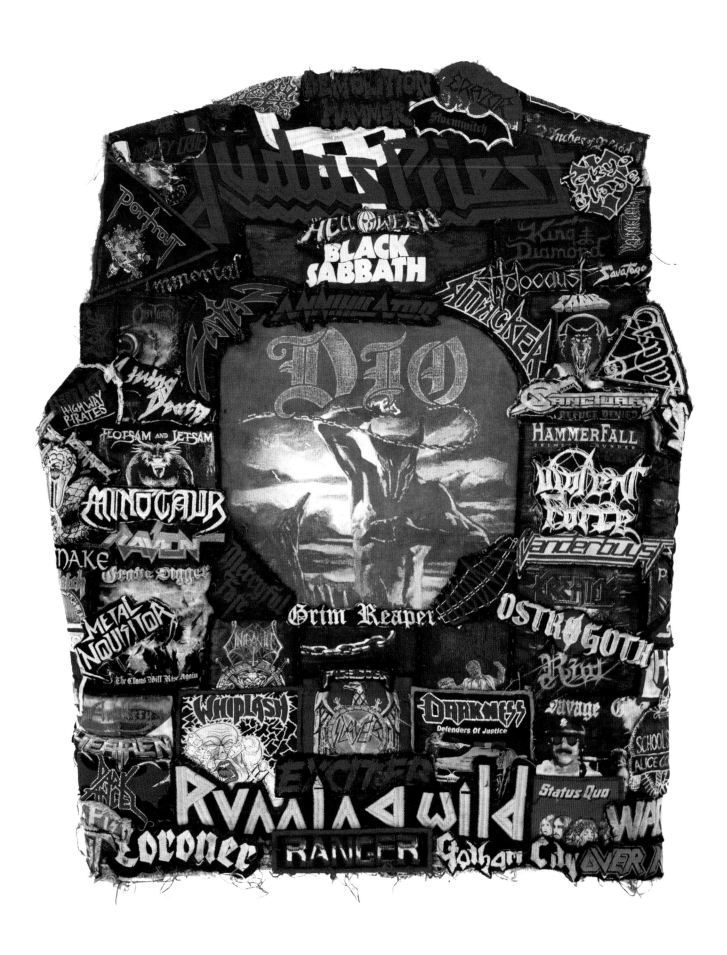

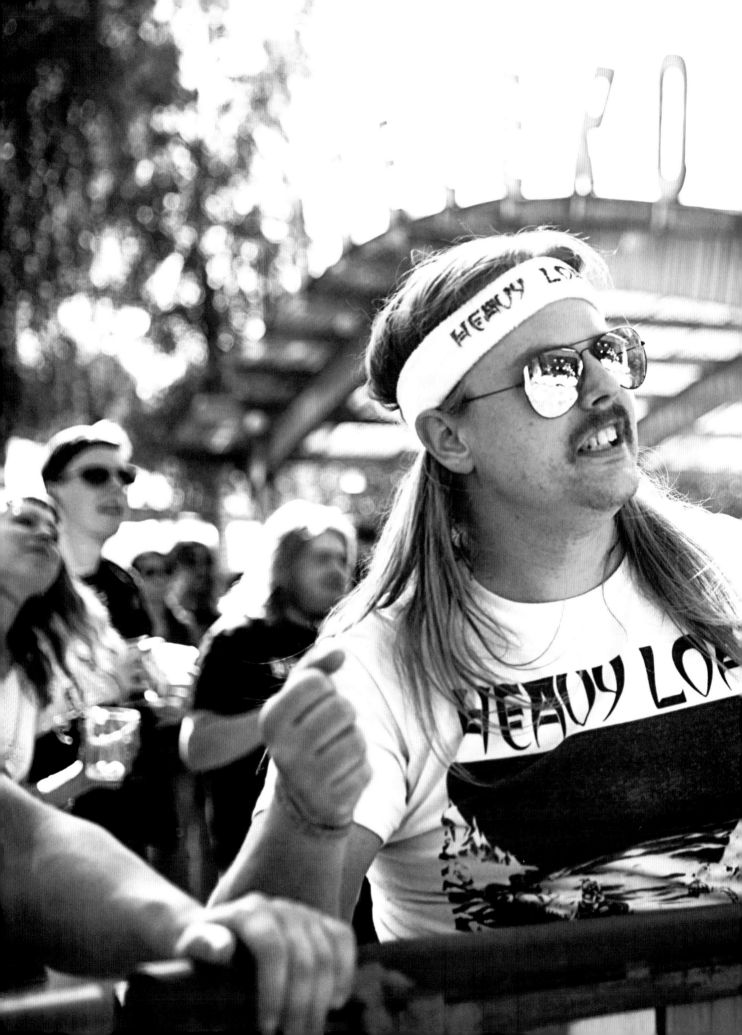

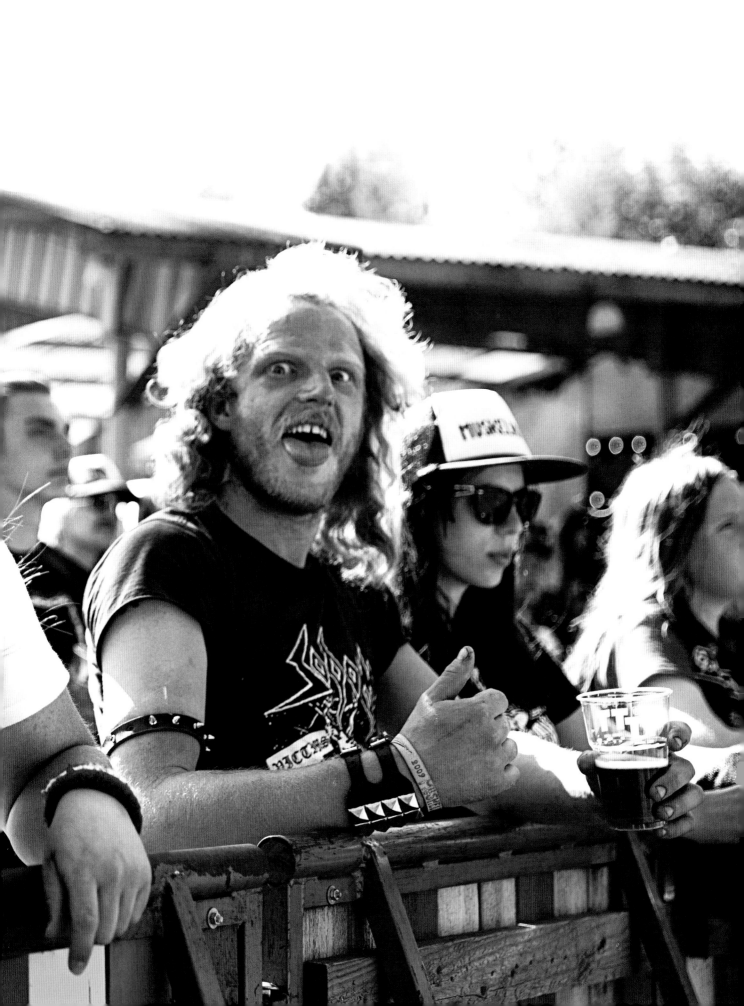

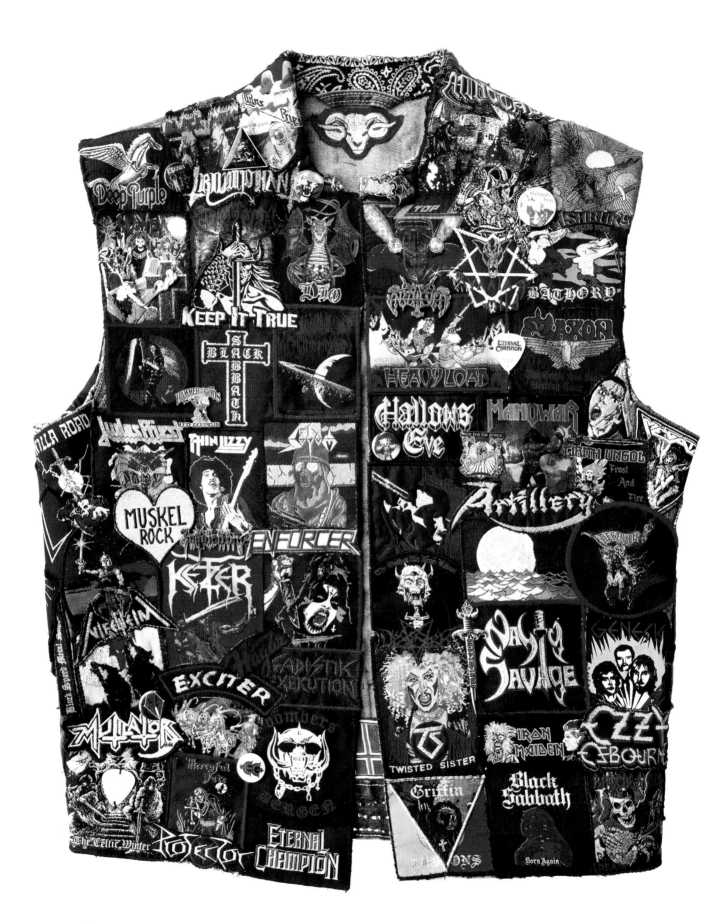

138

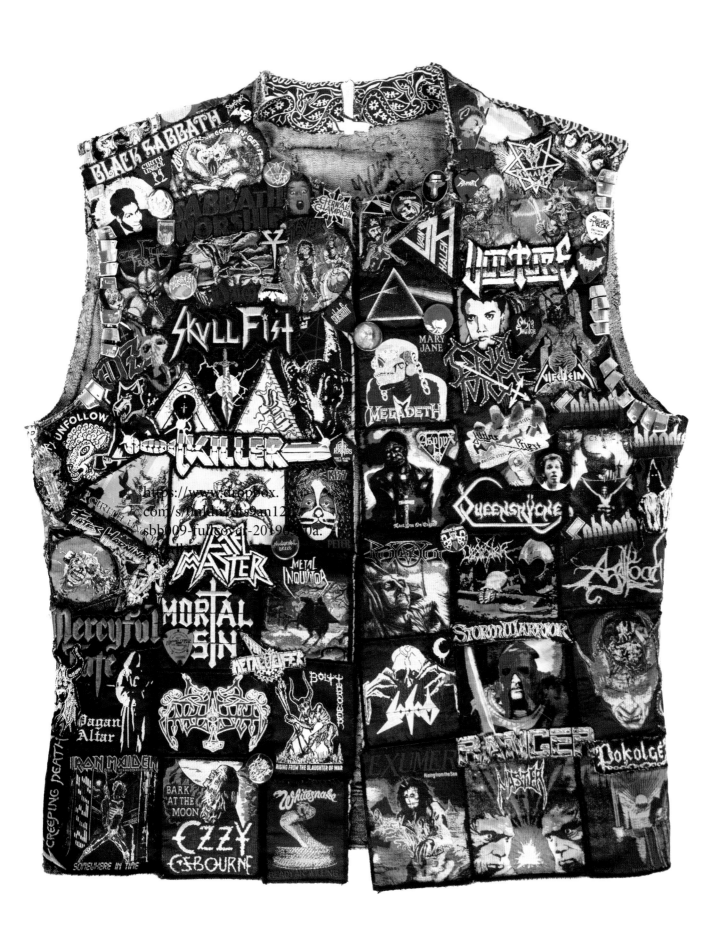

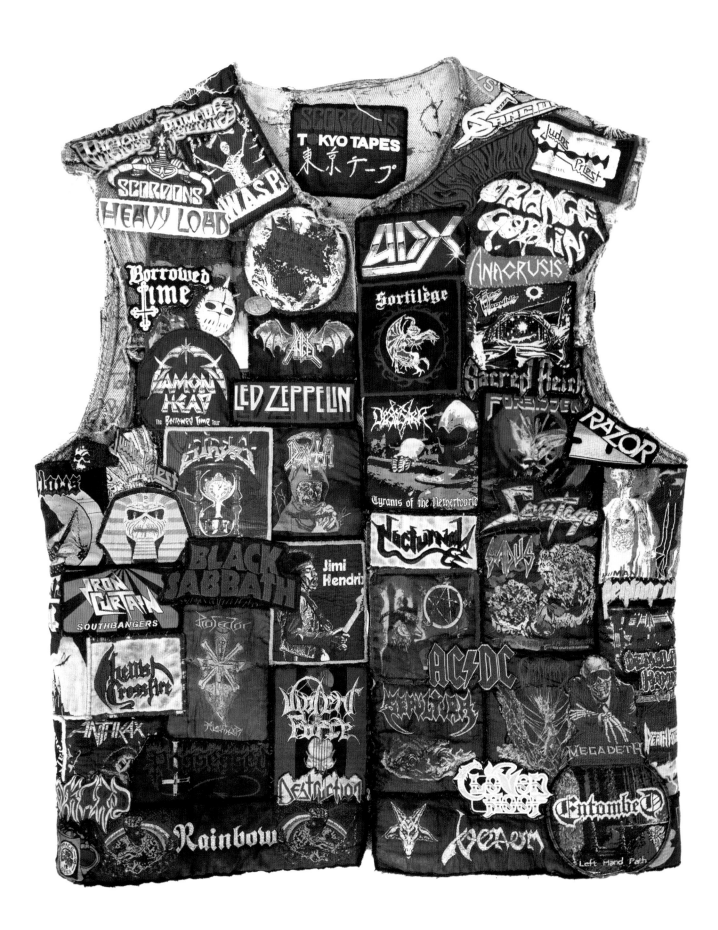

140

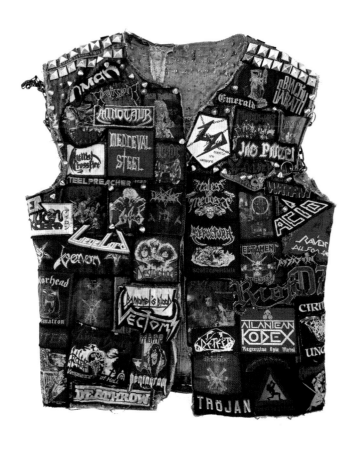

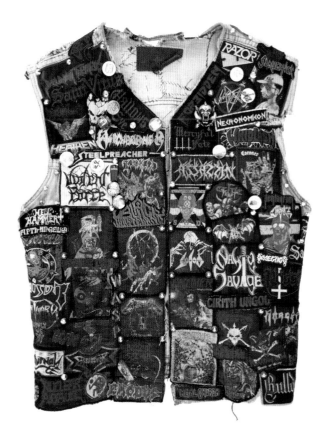

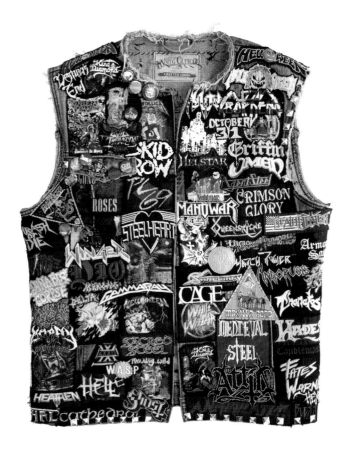

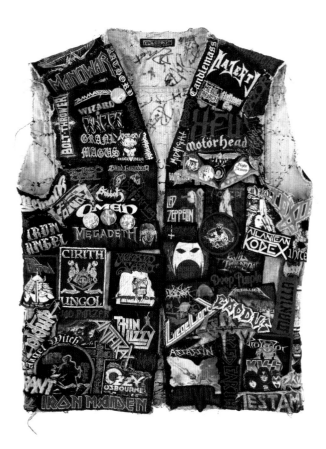

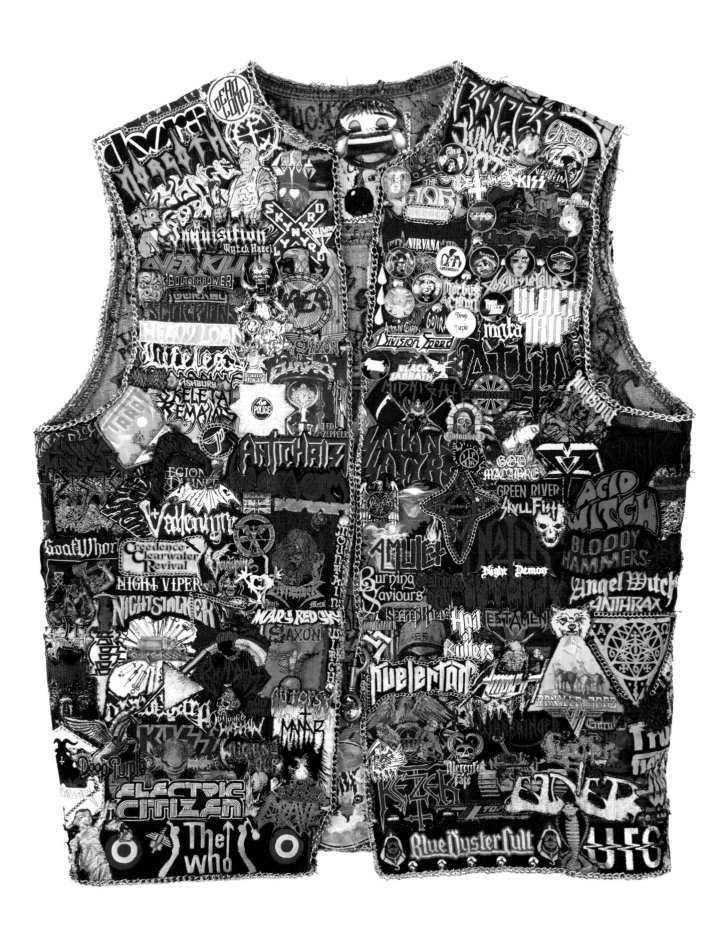

142

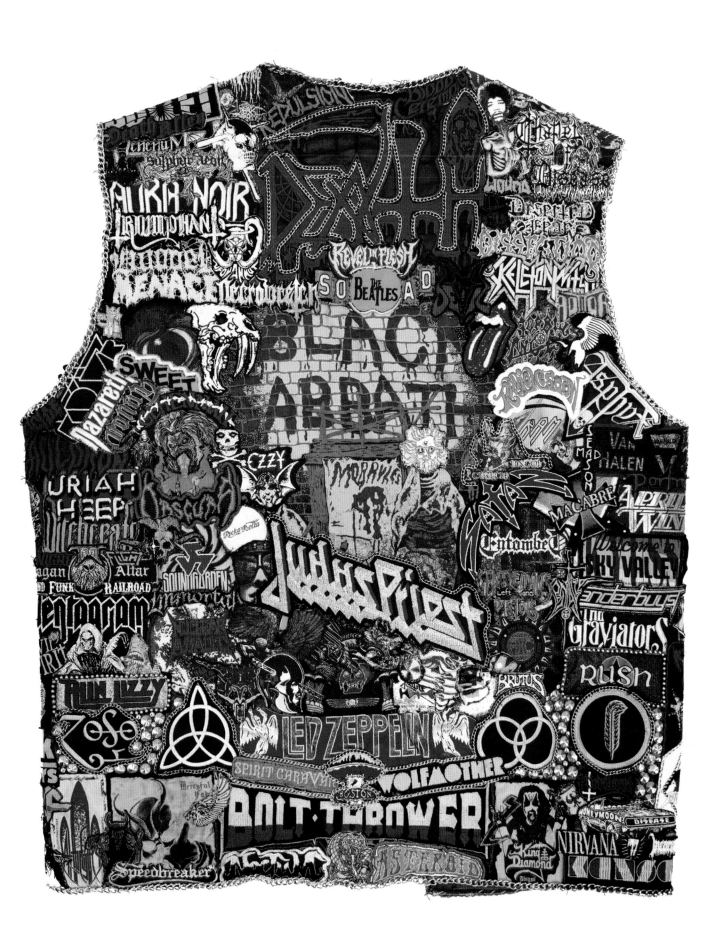

143

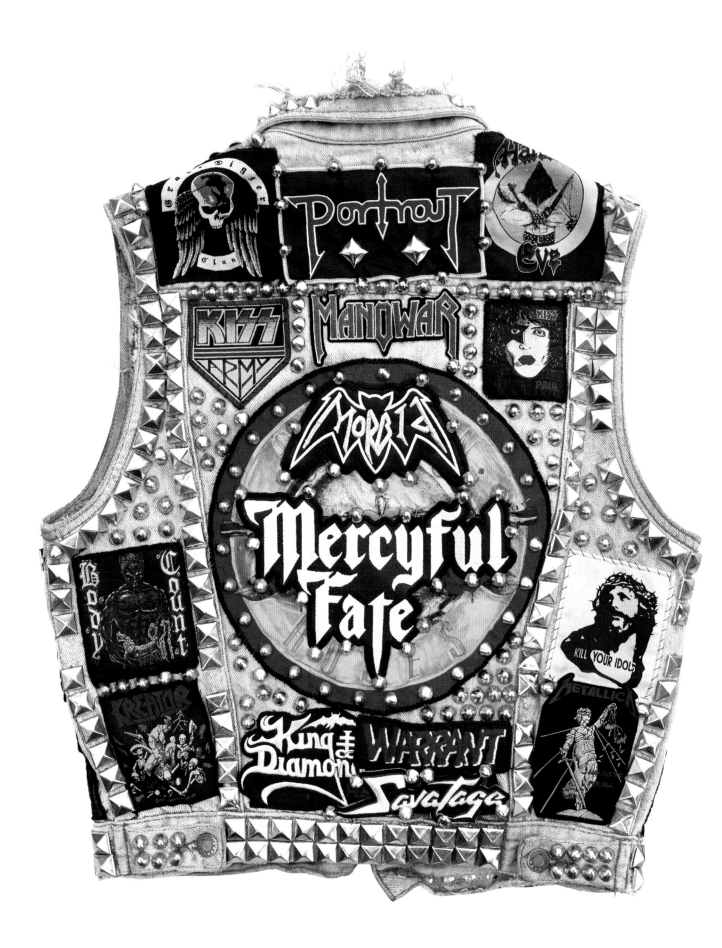

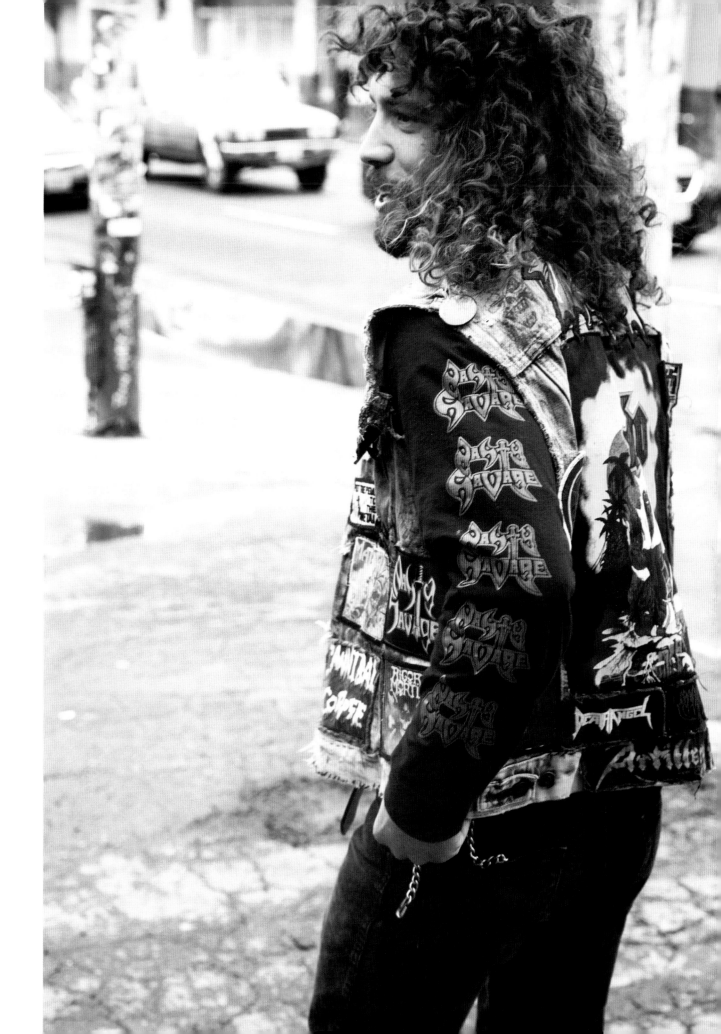

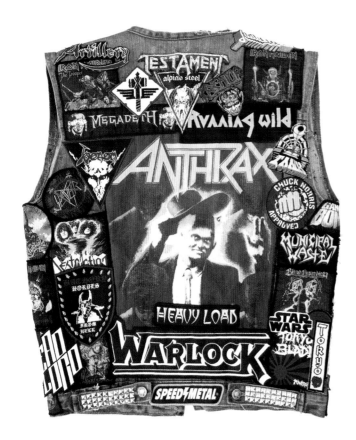

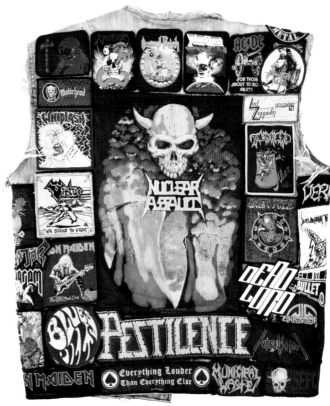

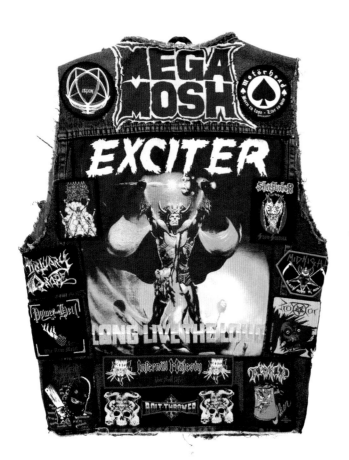

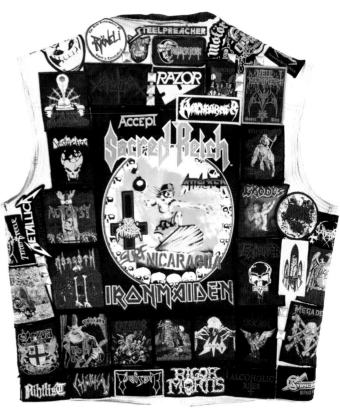

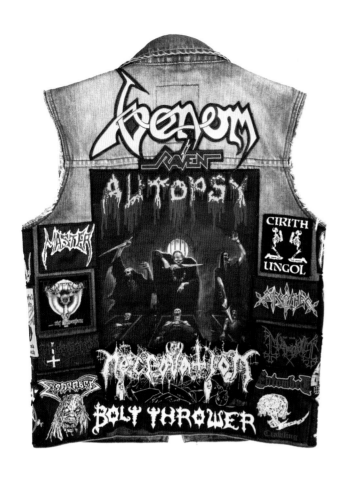

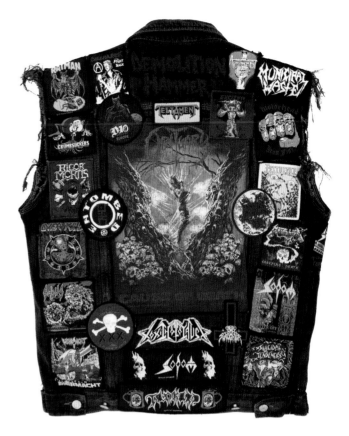

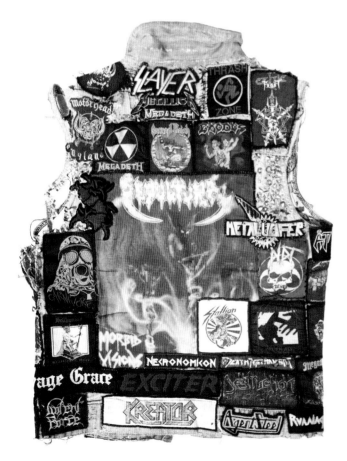

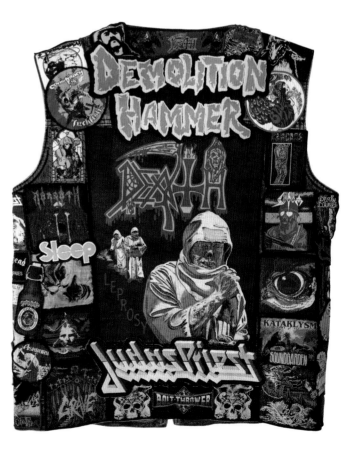

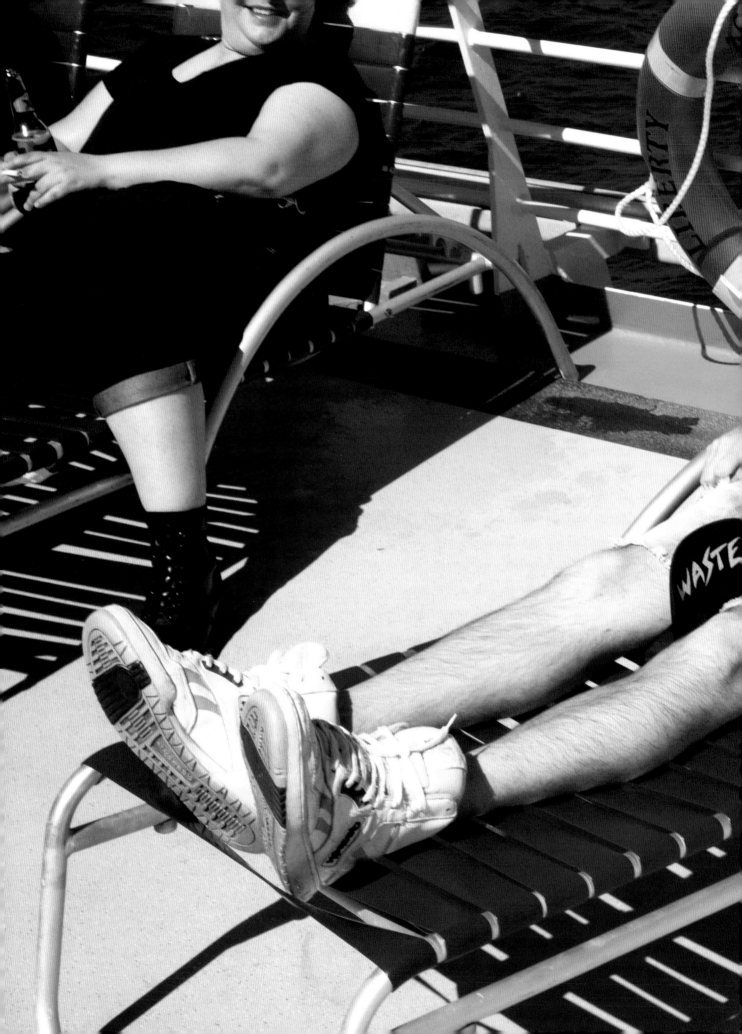

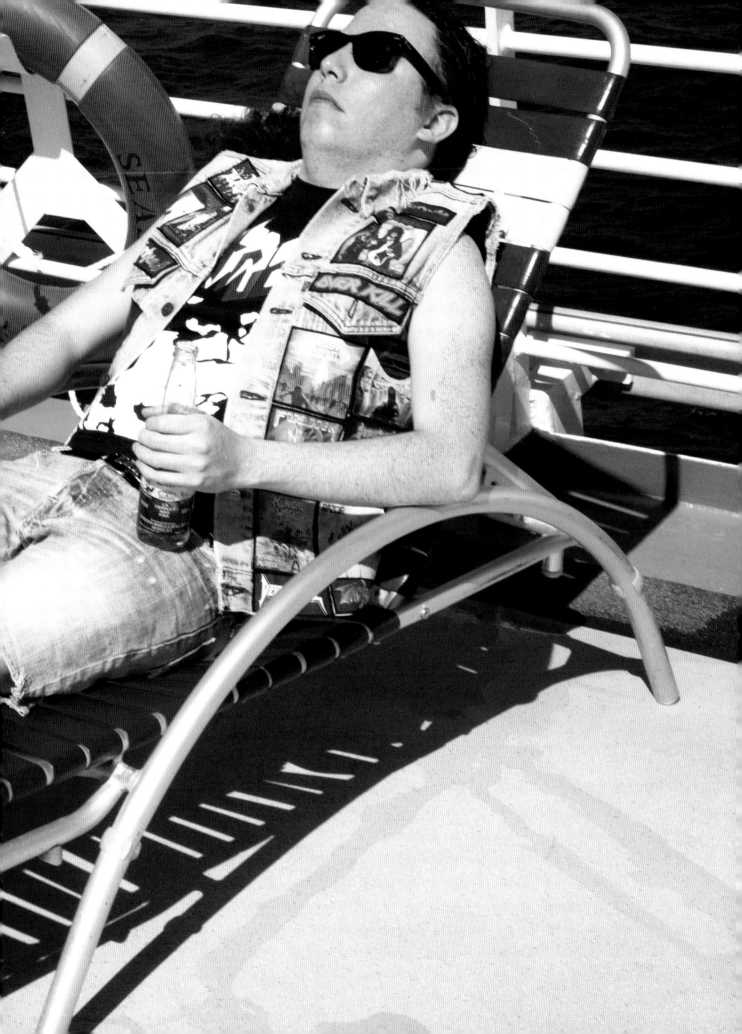

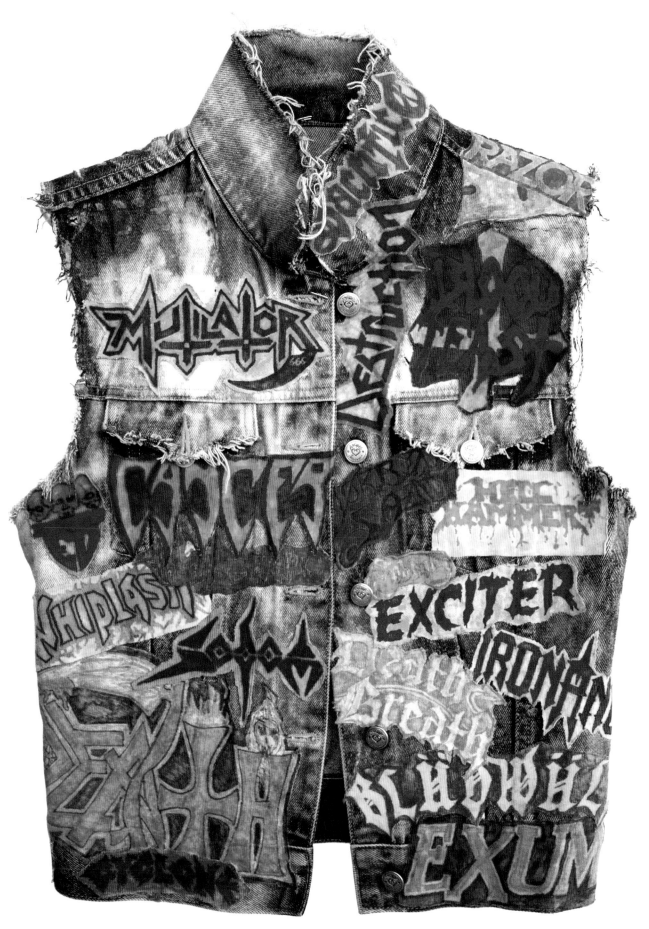

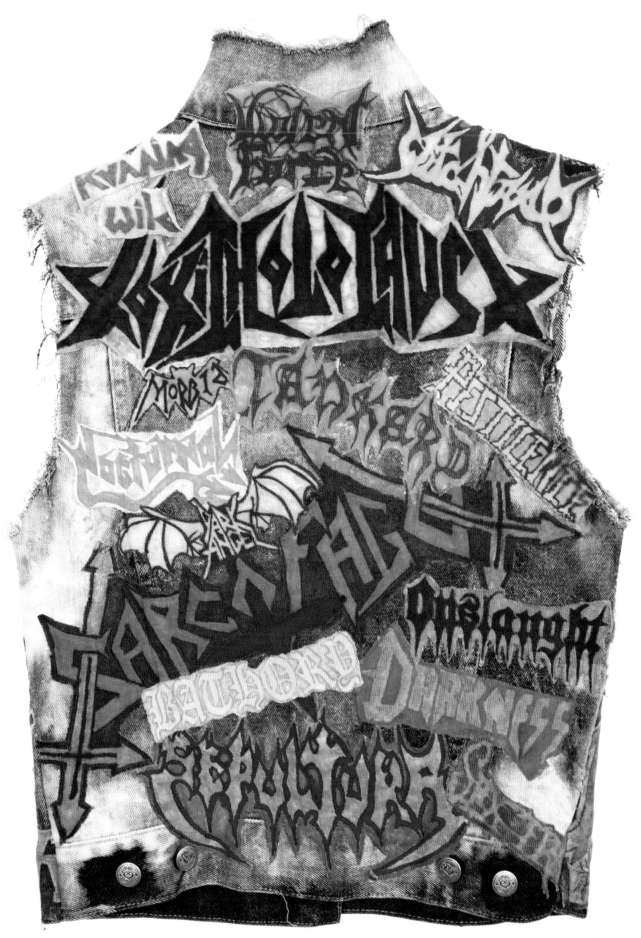

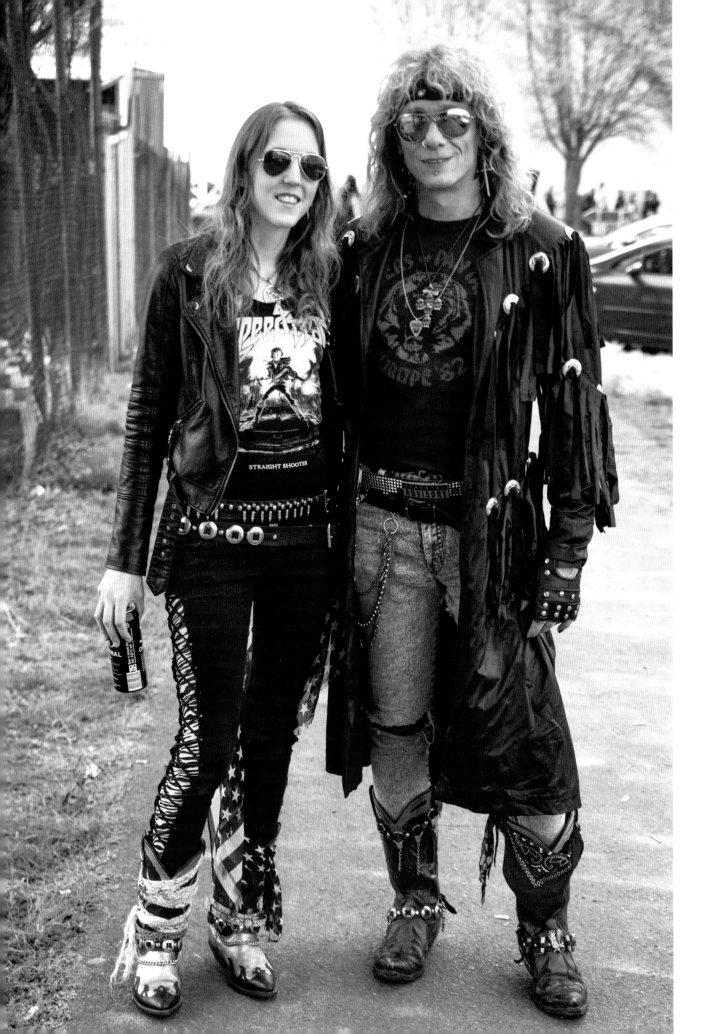

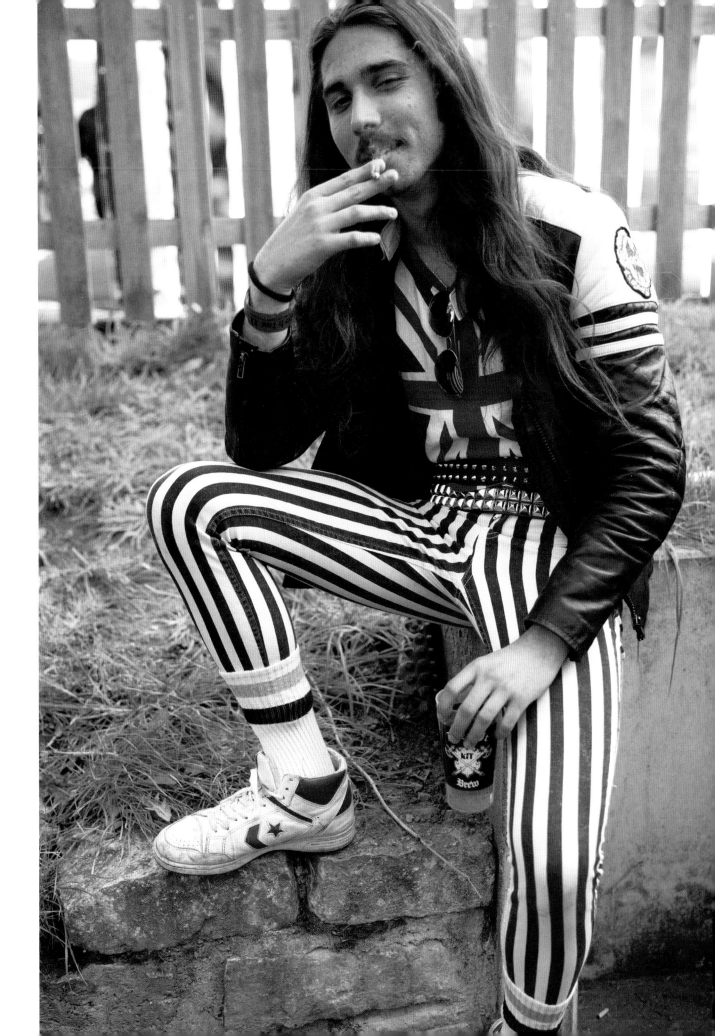

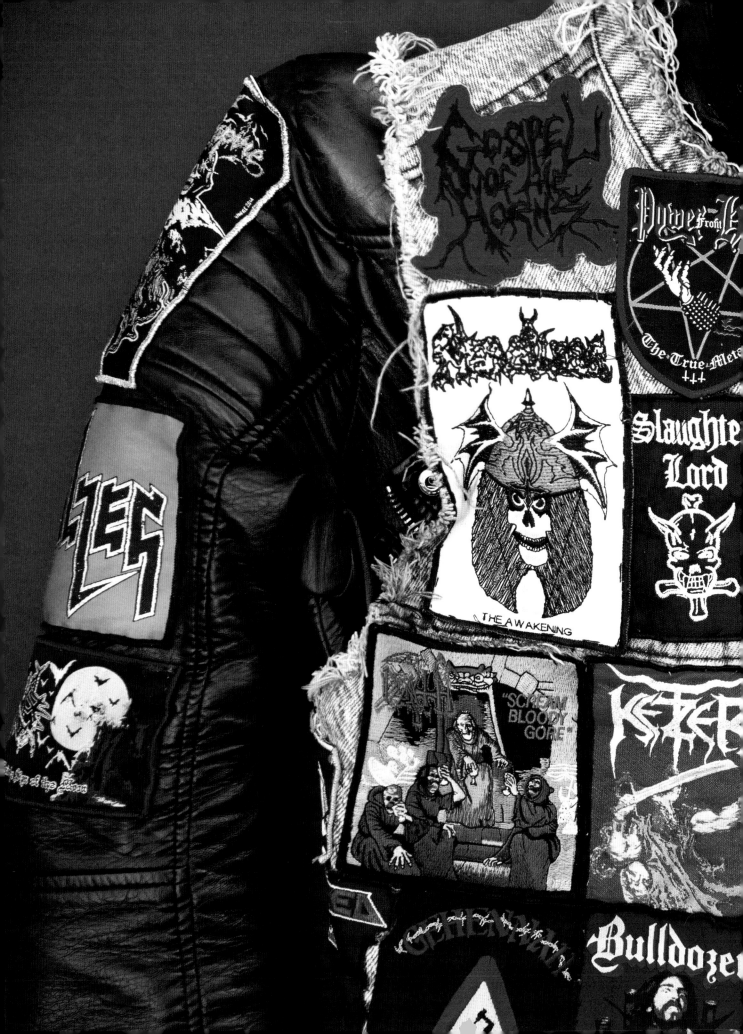

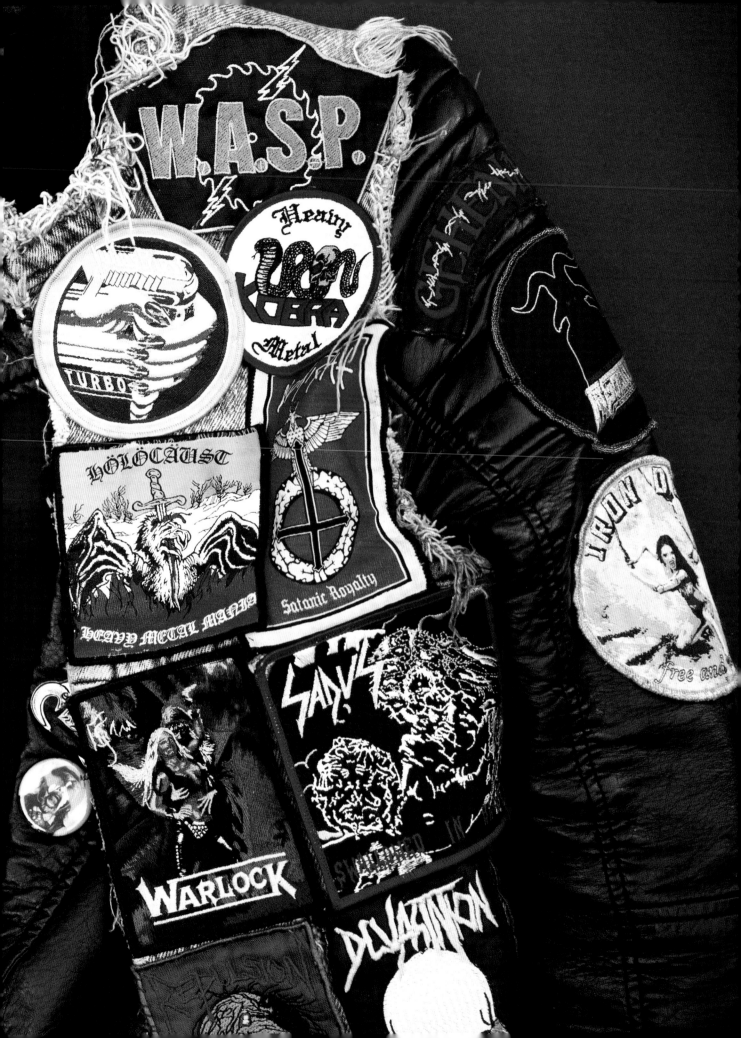

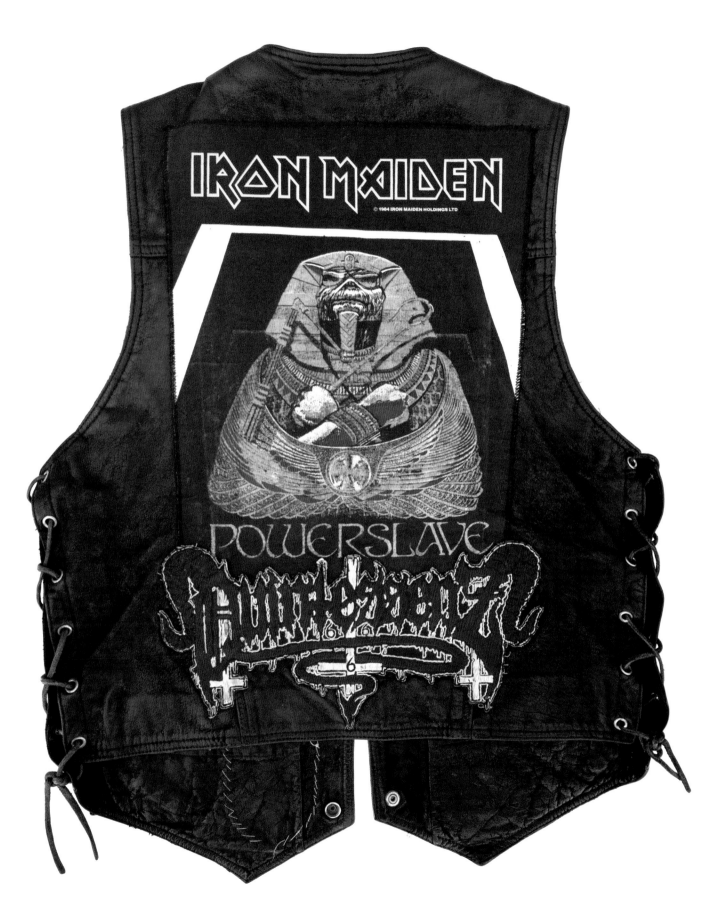

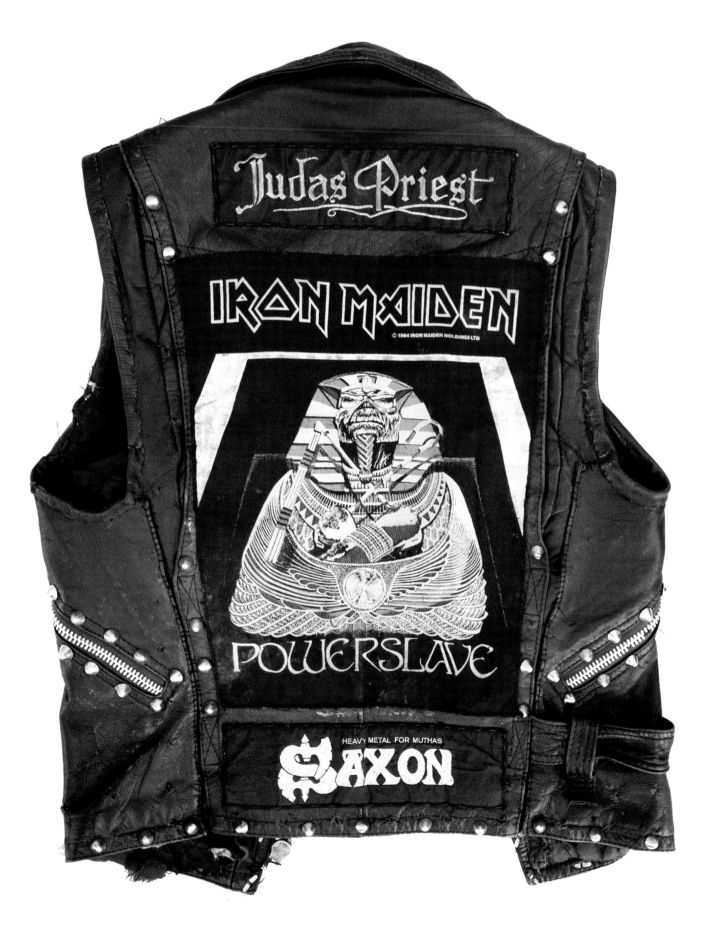

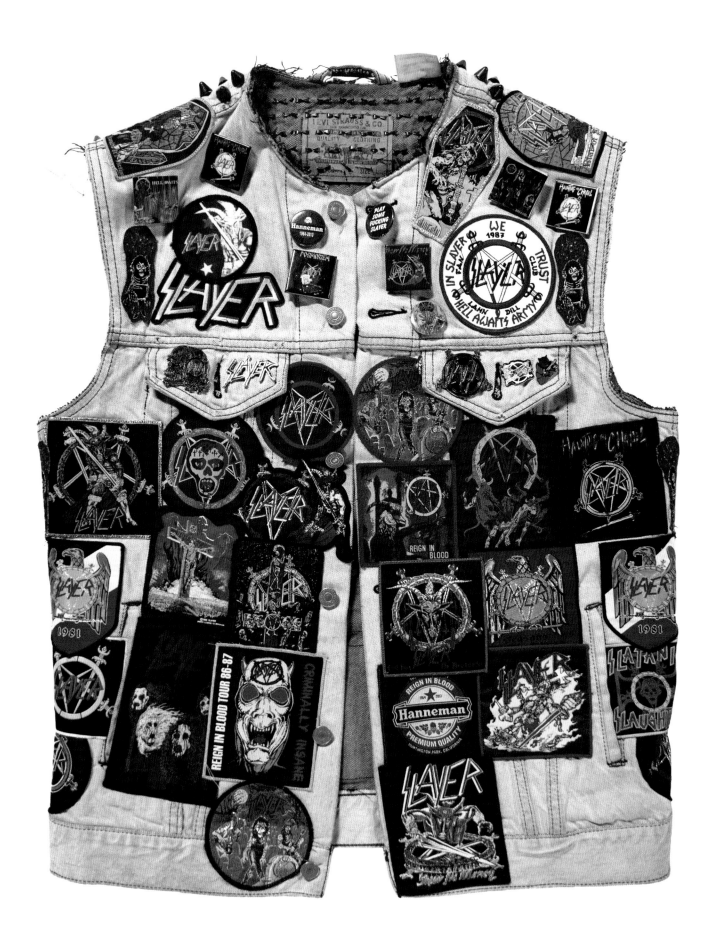

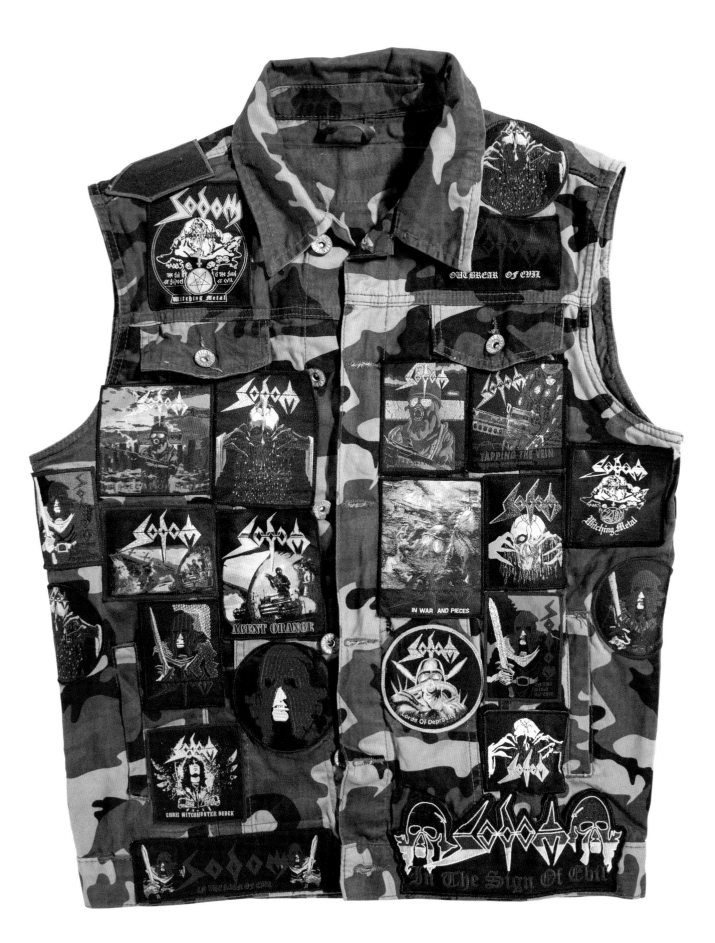

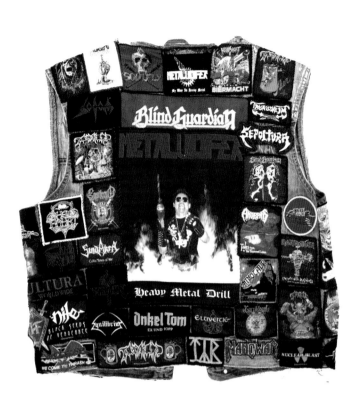

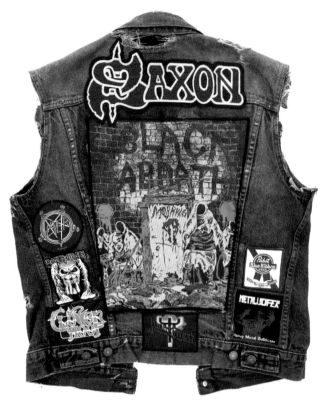

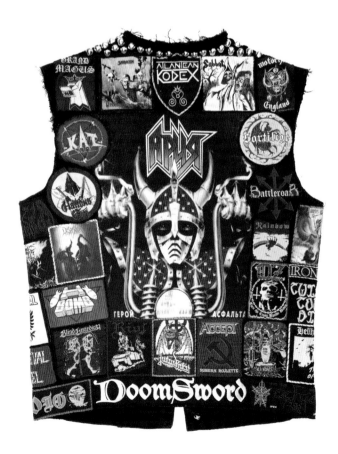

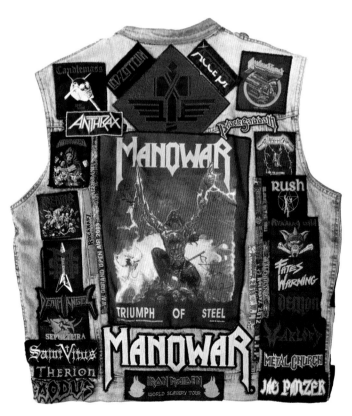

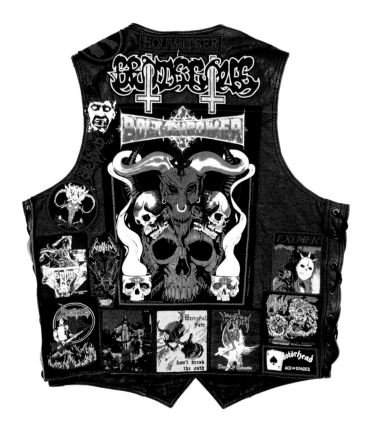

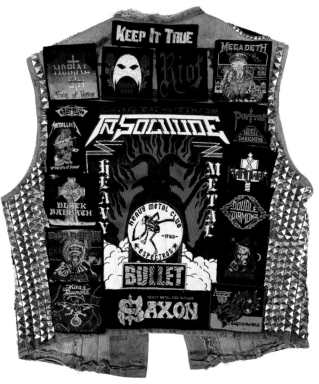

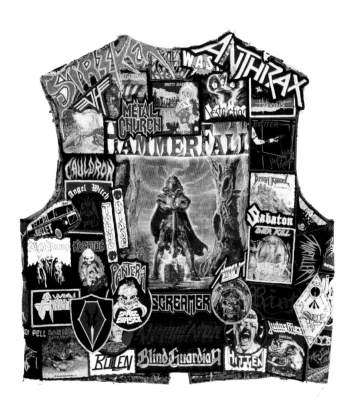

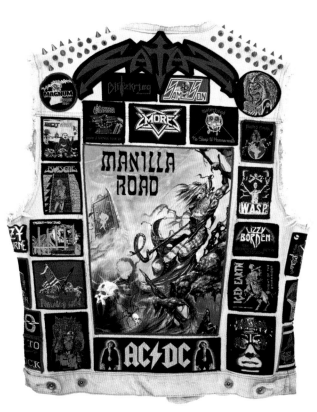

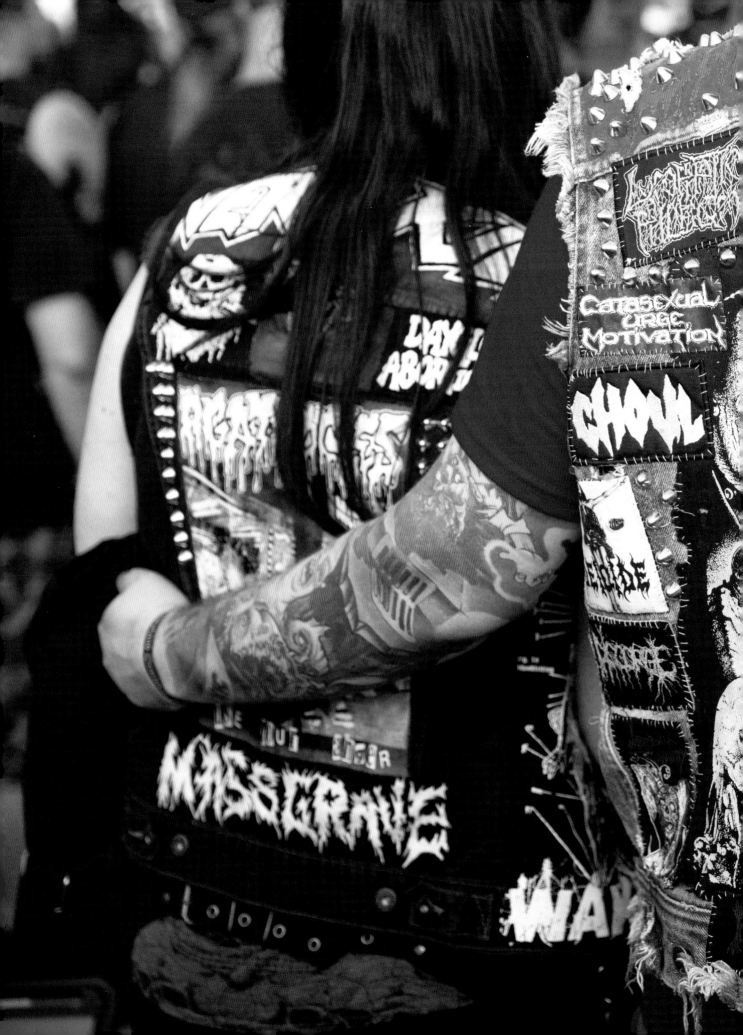

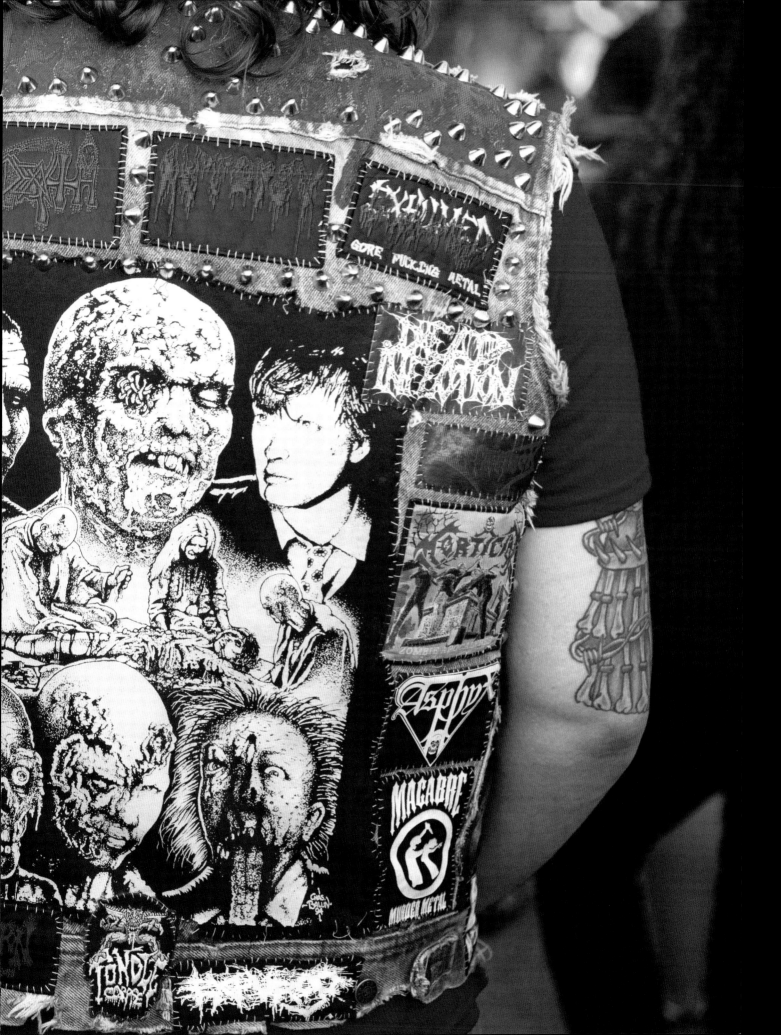

Mercyful Fate

Come To The Sabbath

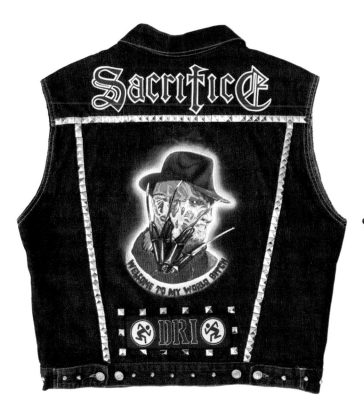

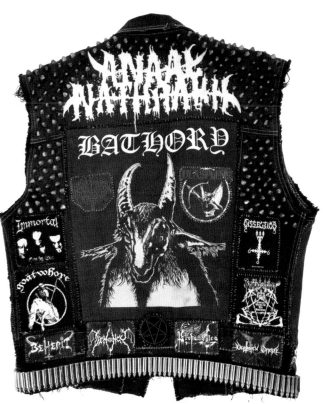

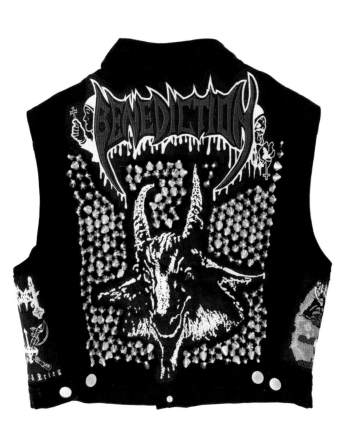

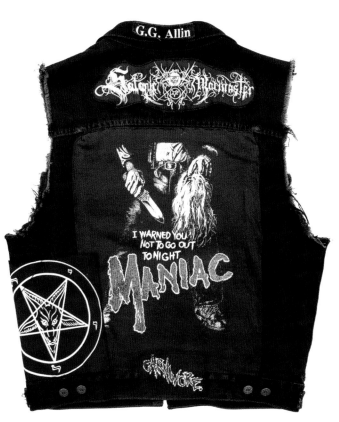

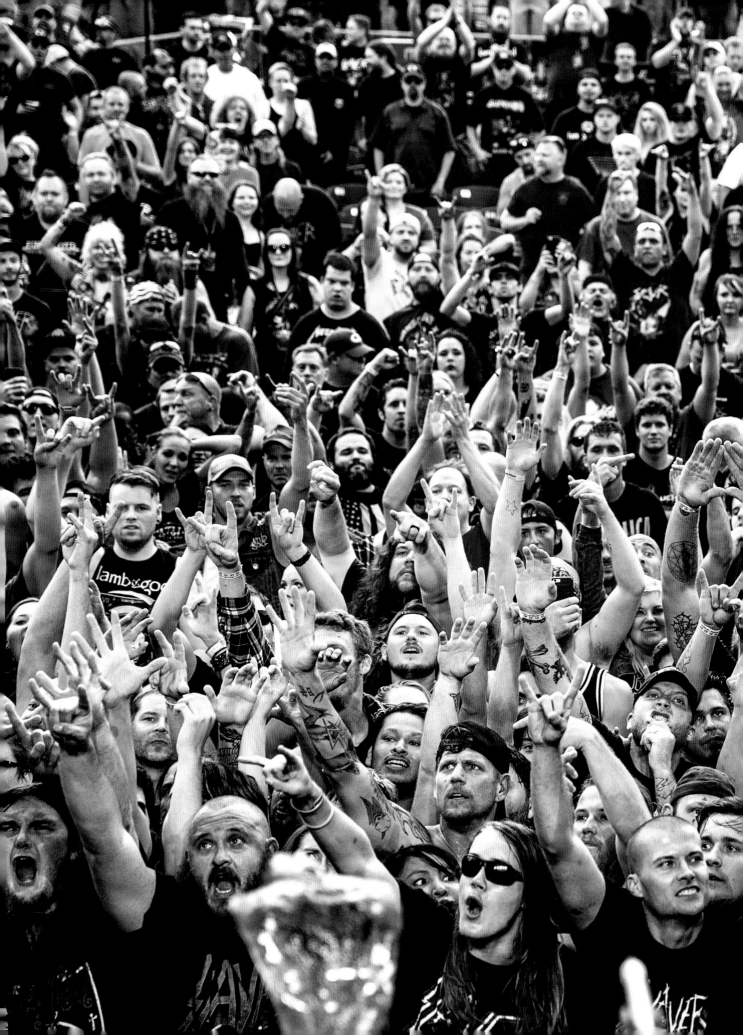

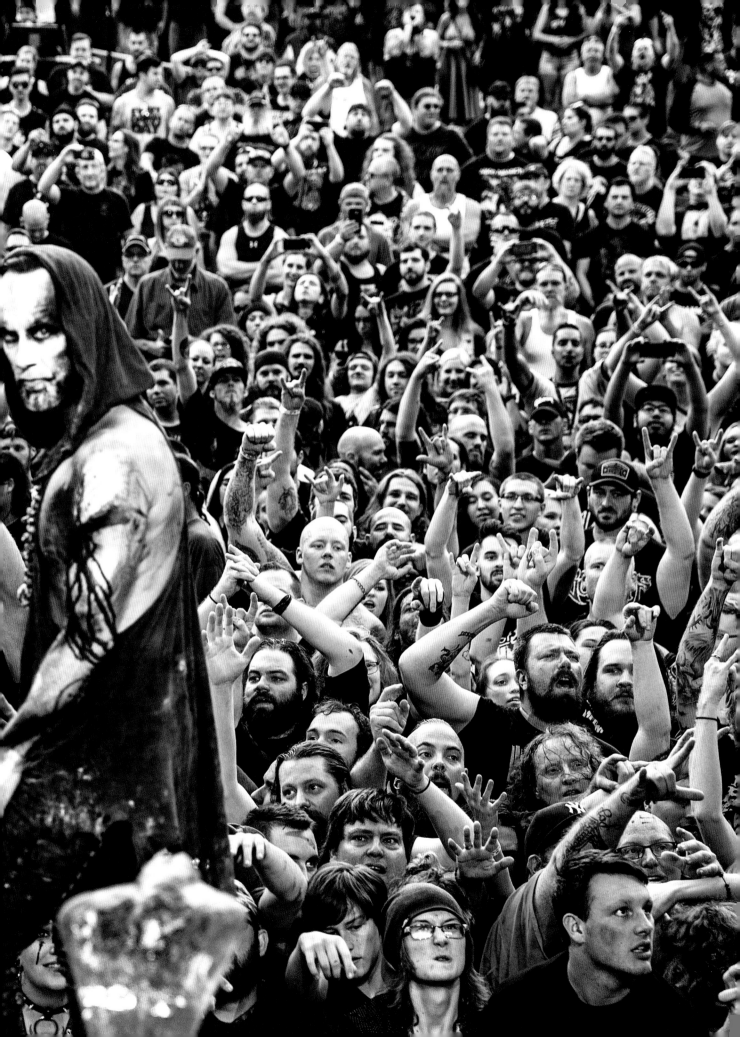

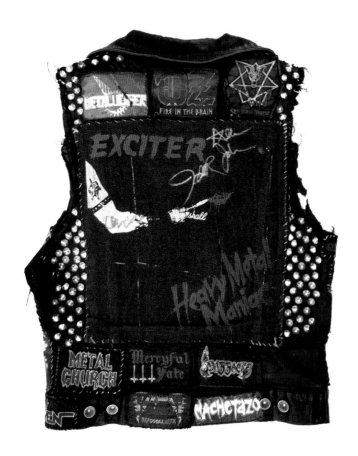

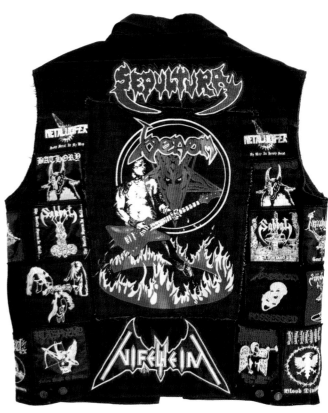

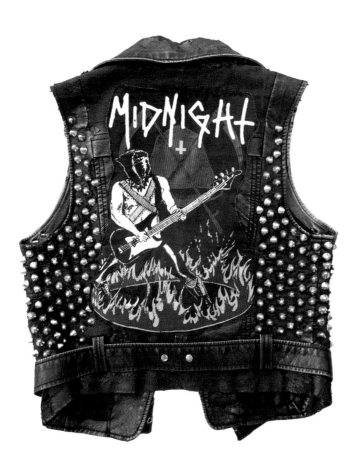

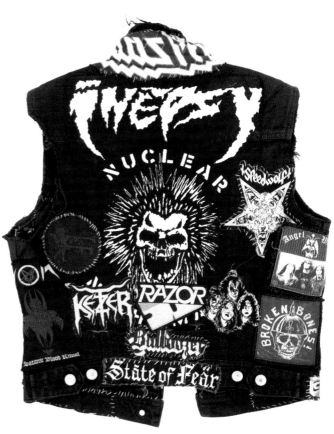

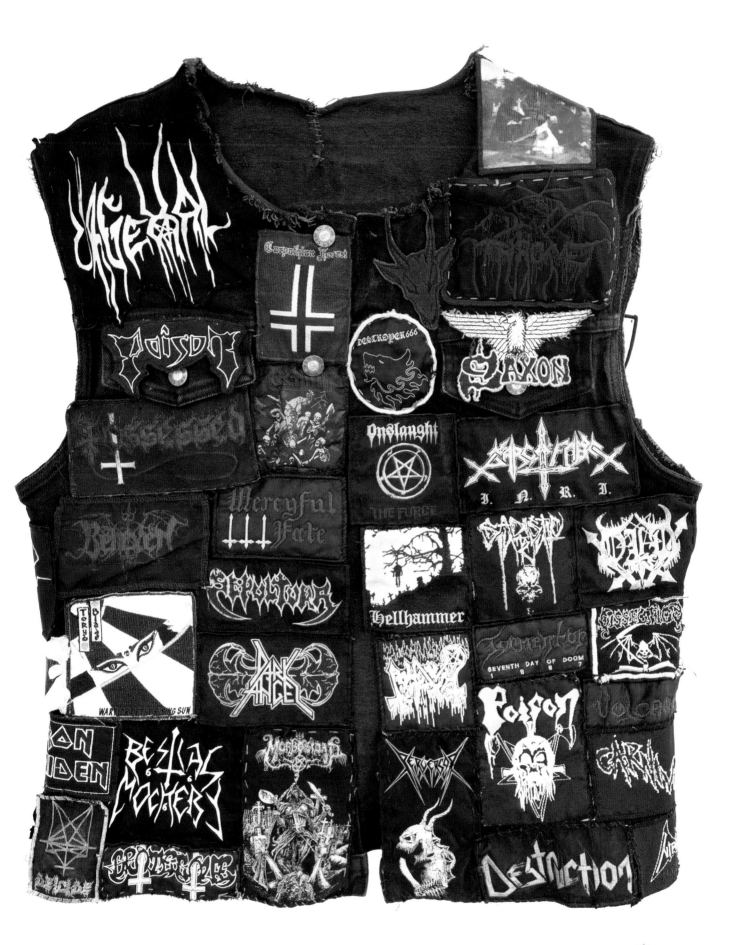

169

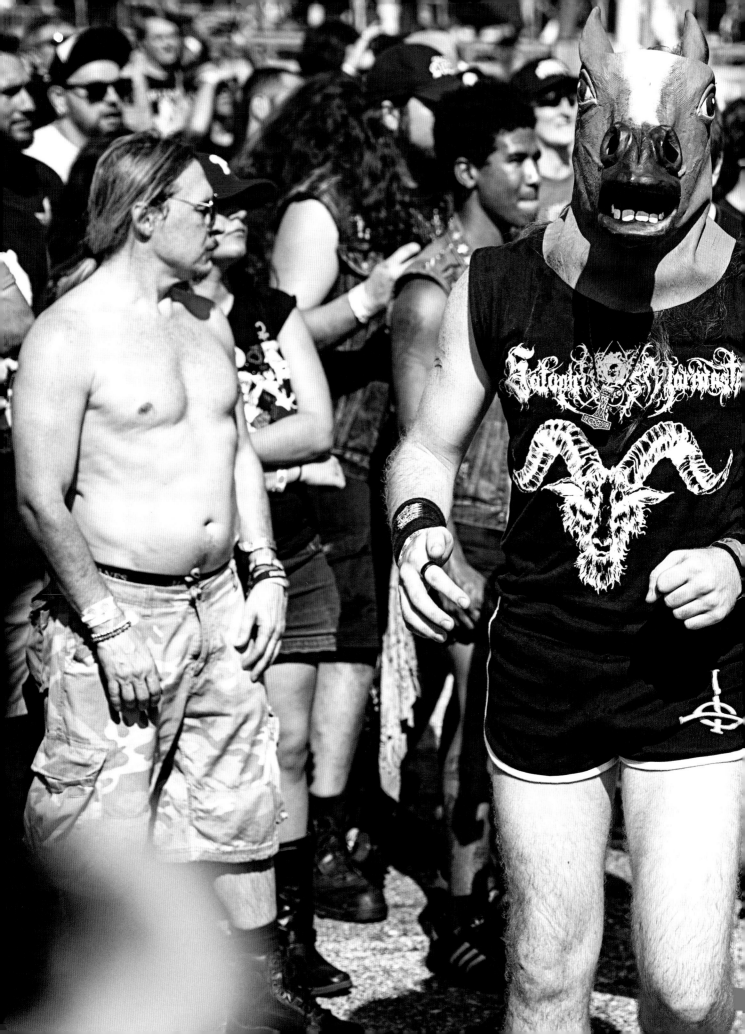

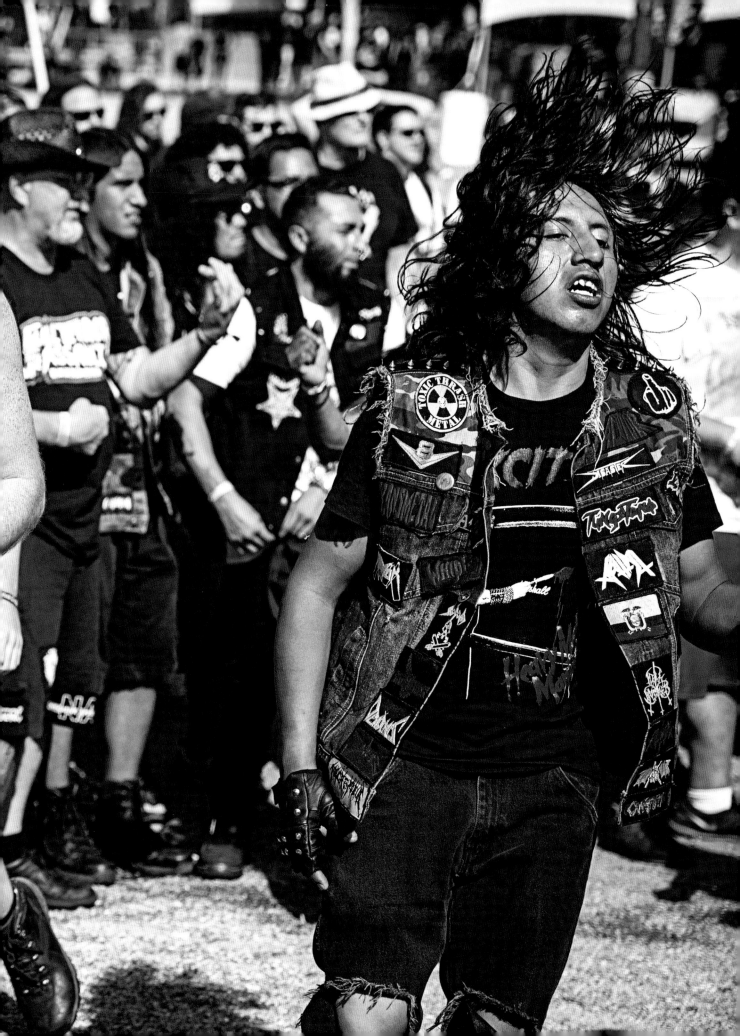

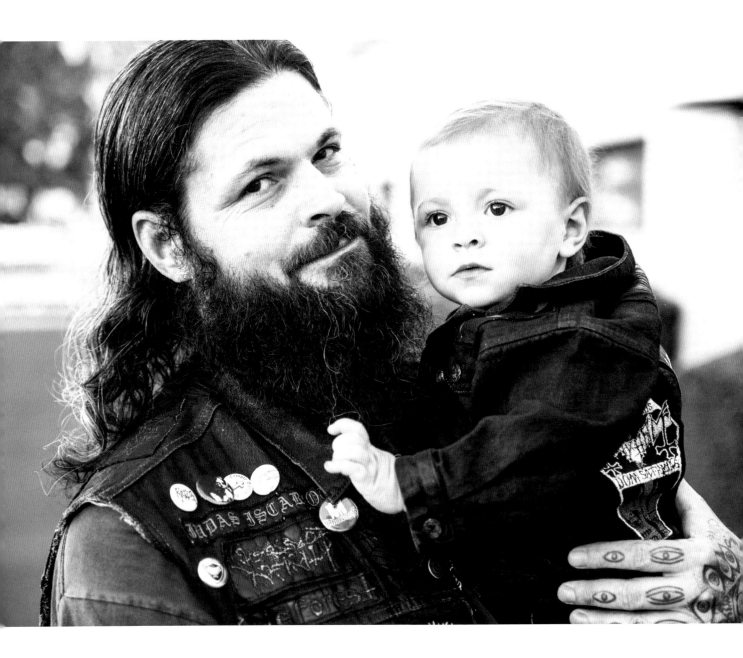

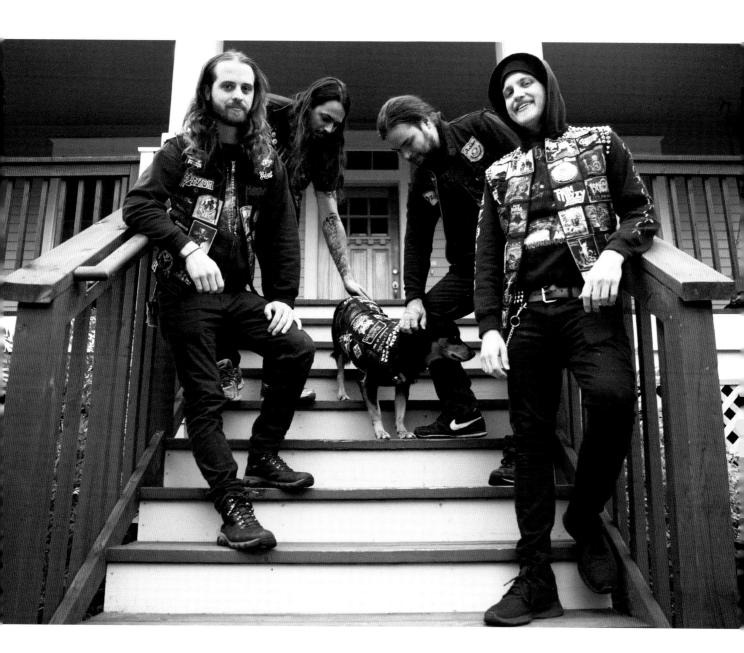

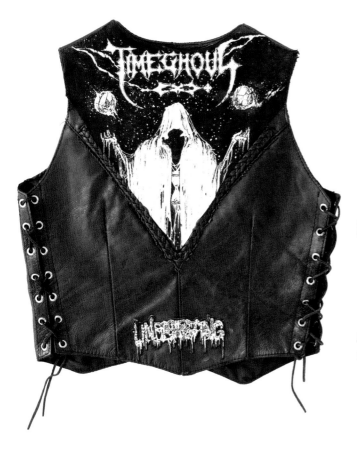

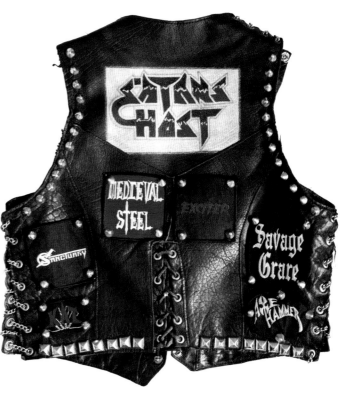

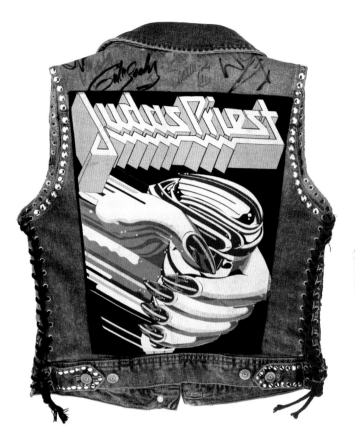

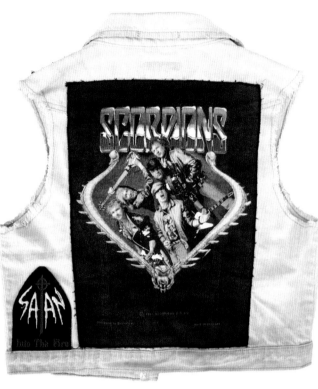

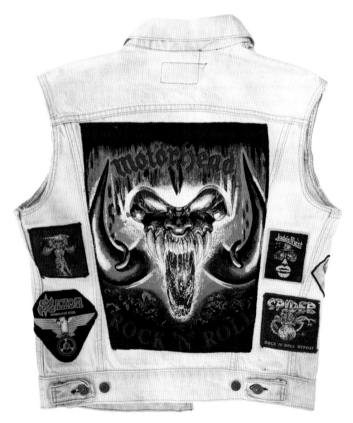

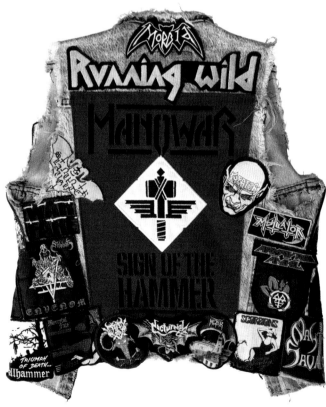

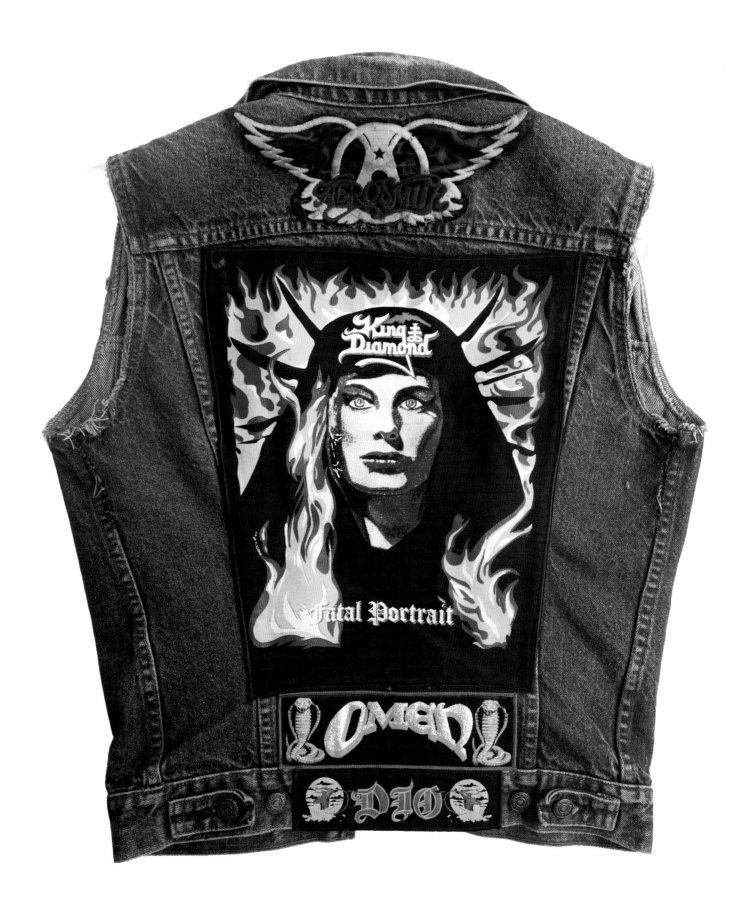

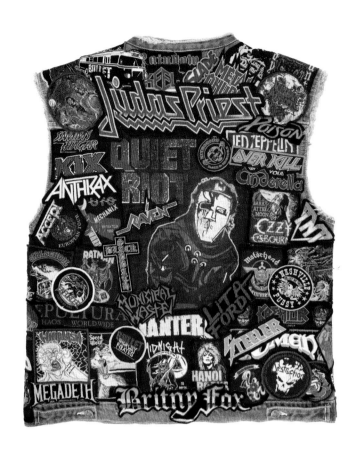

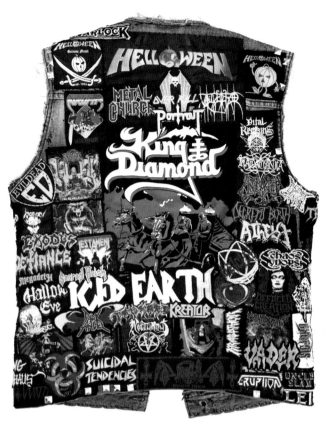

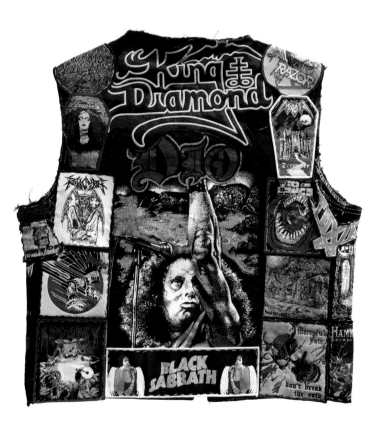

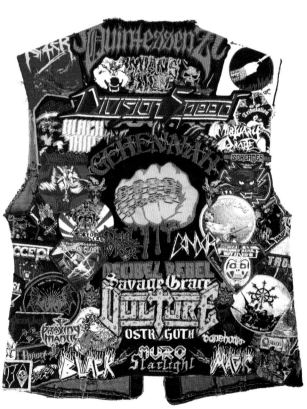

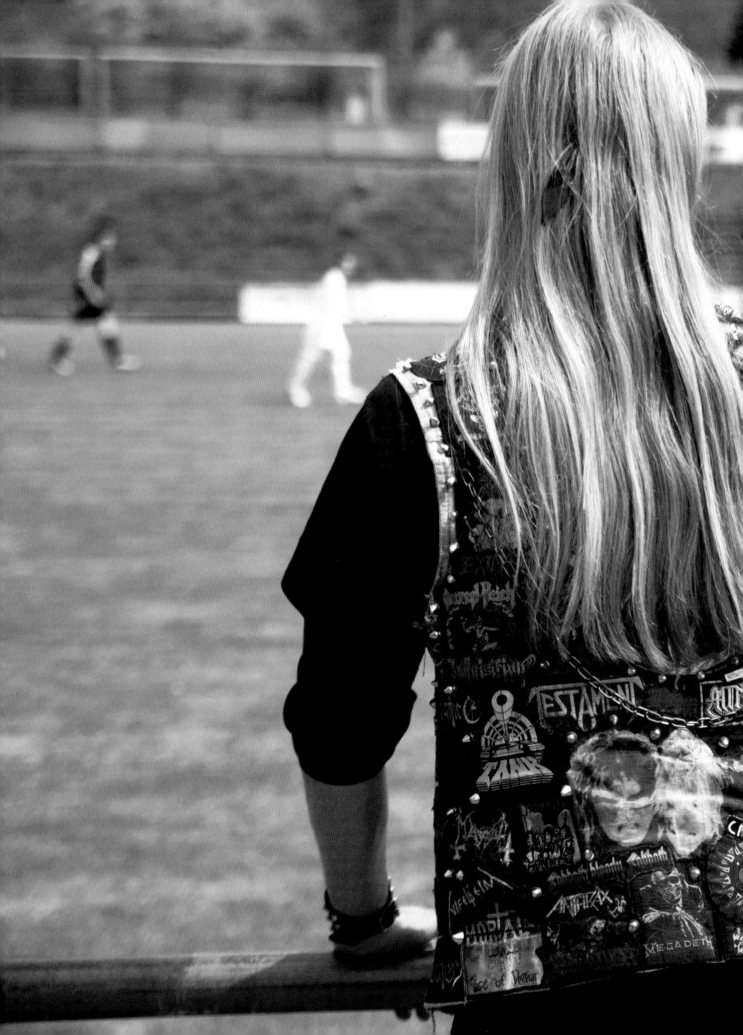

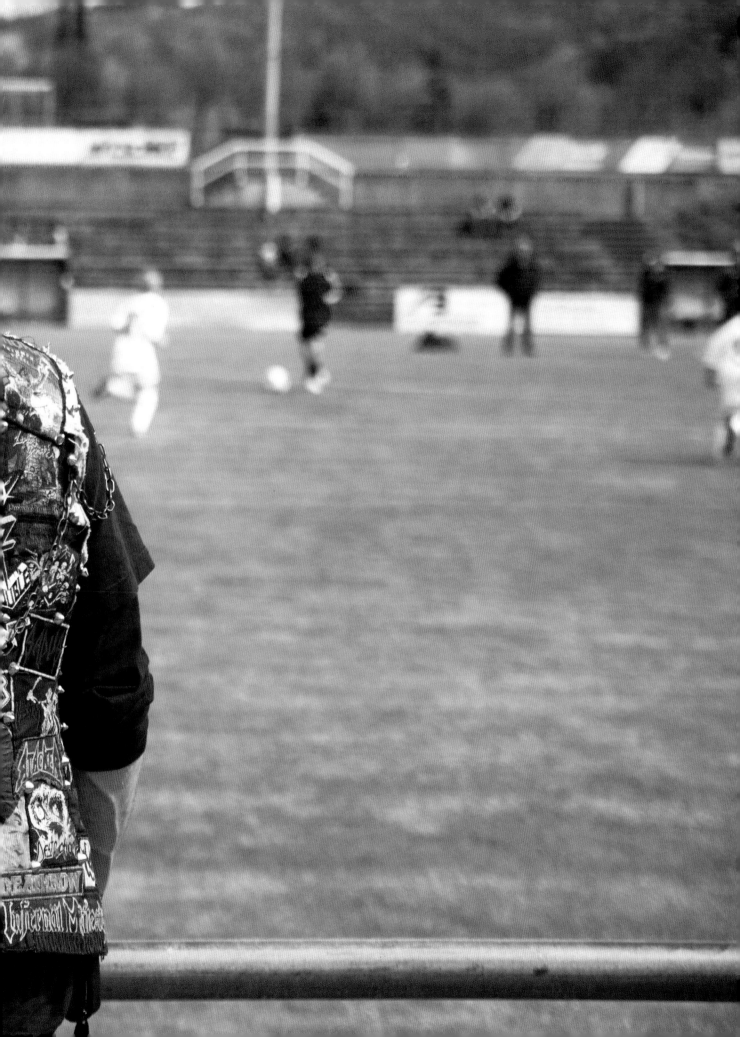

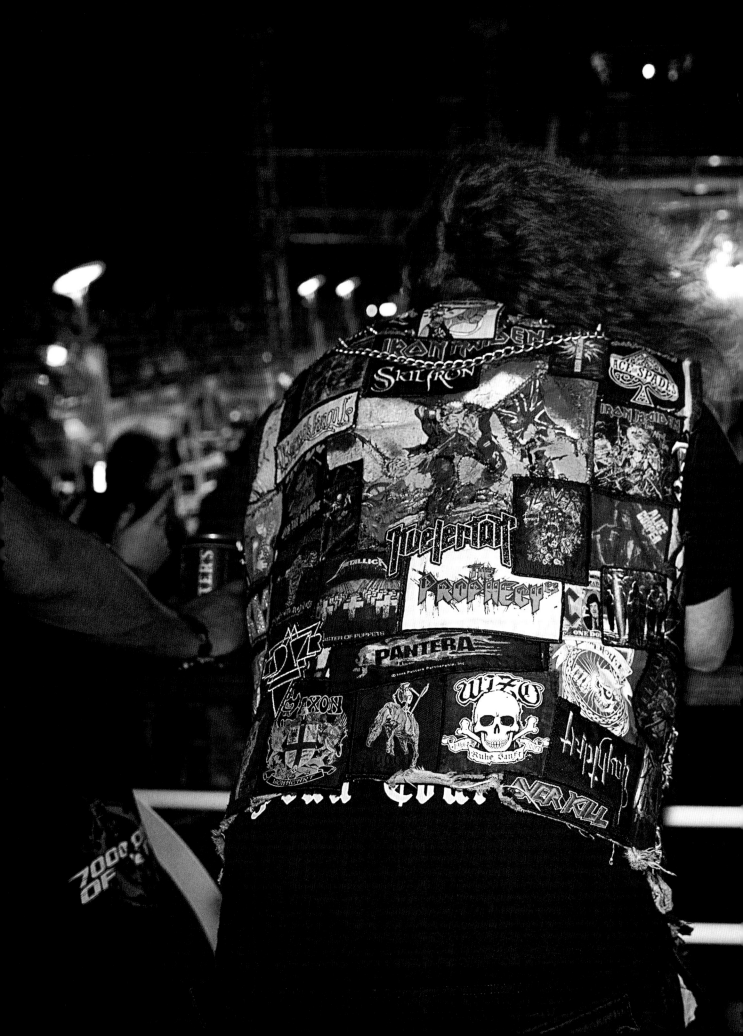

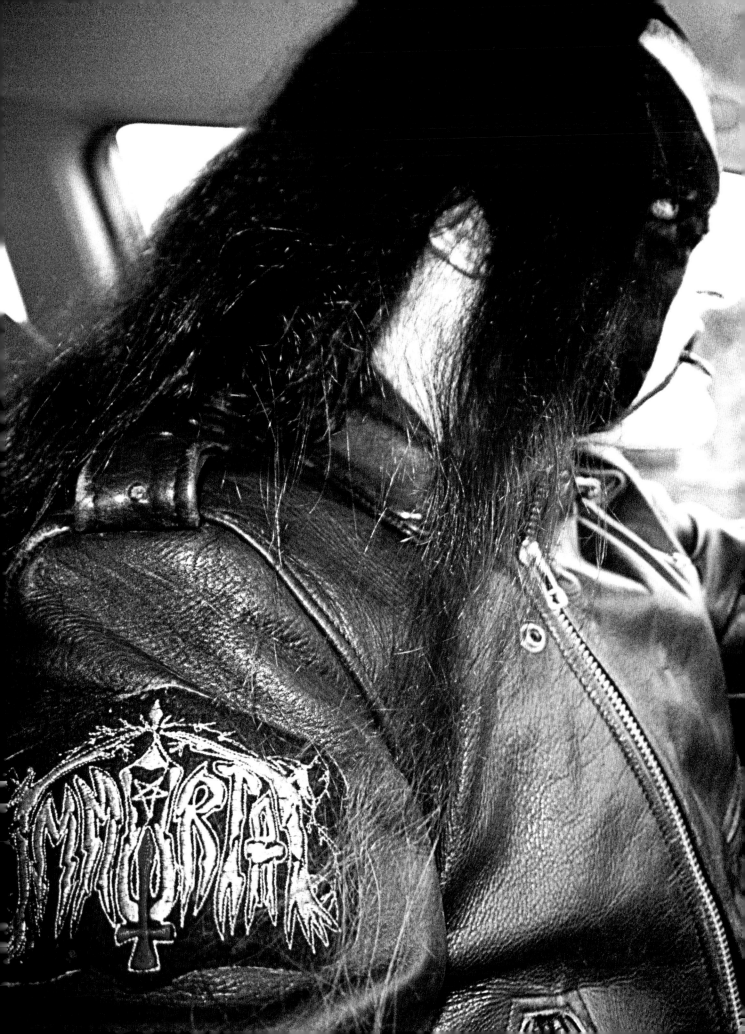

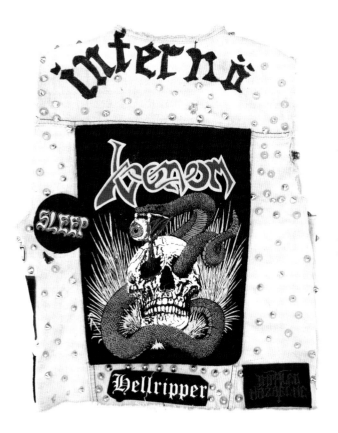

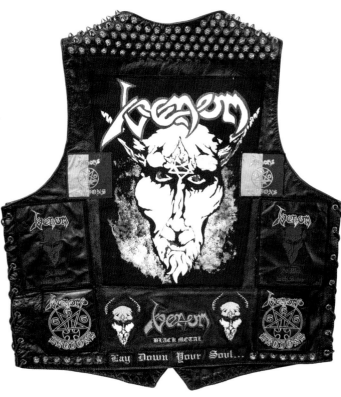

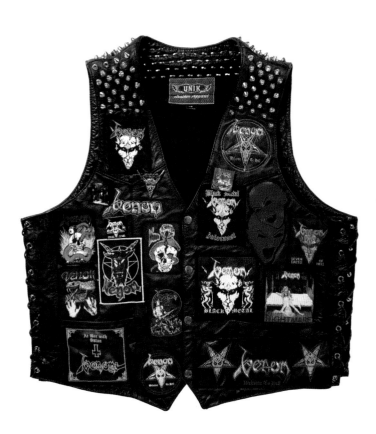

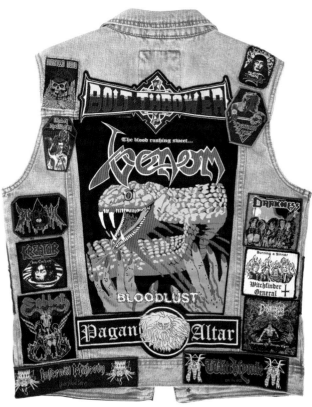

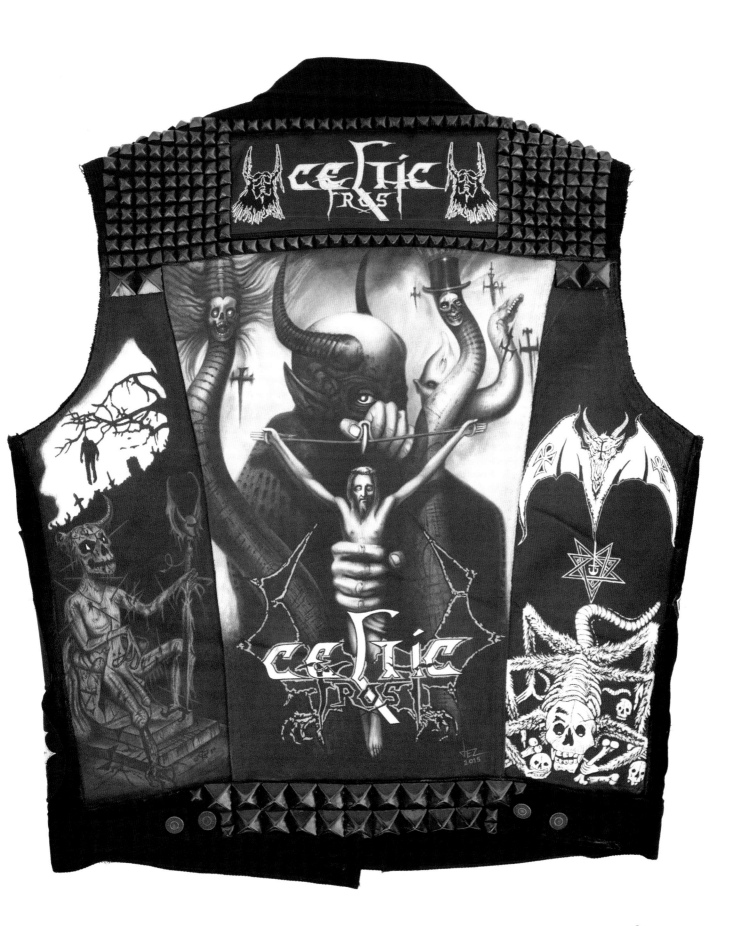

187

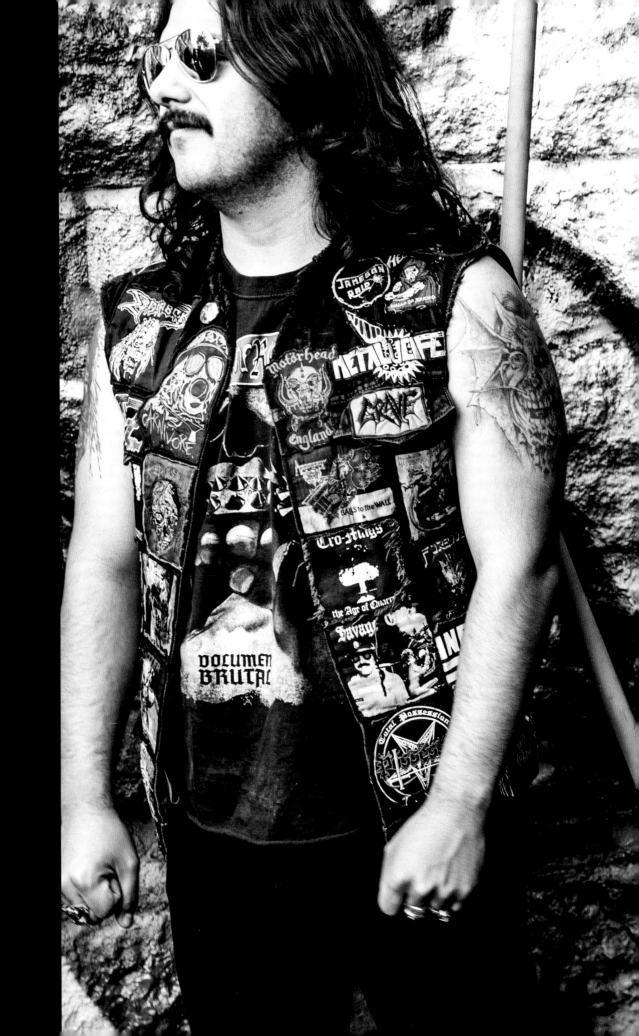

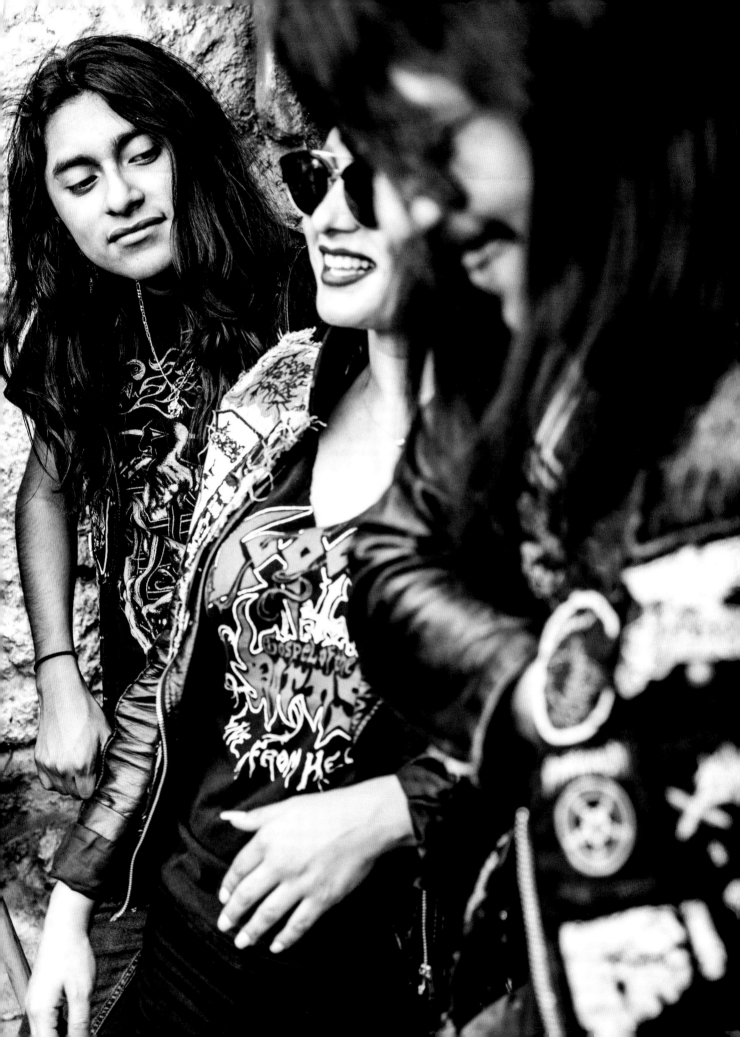

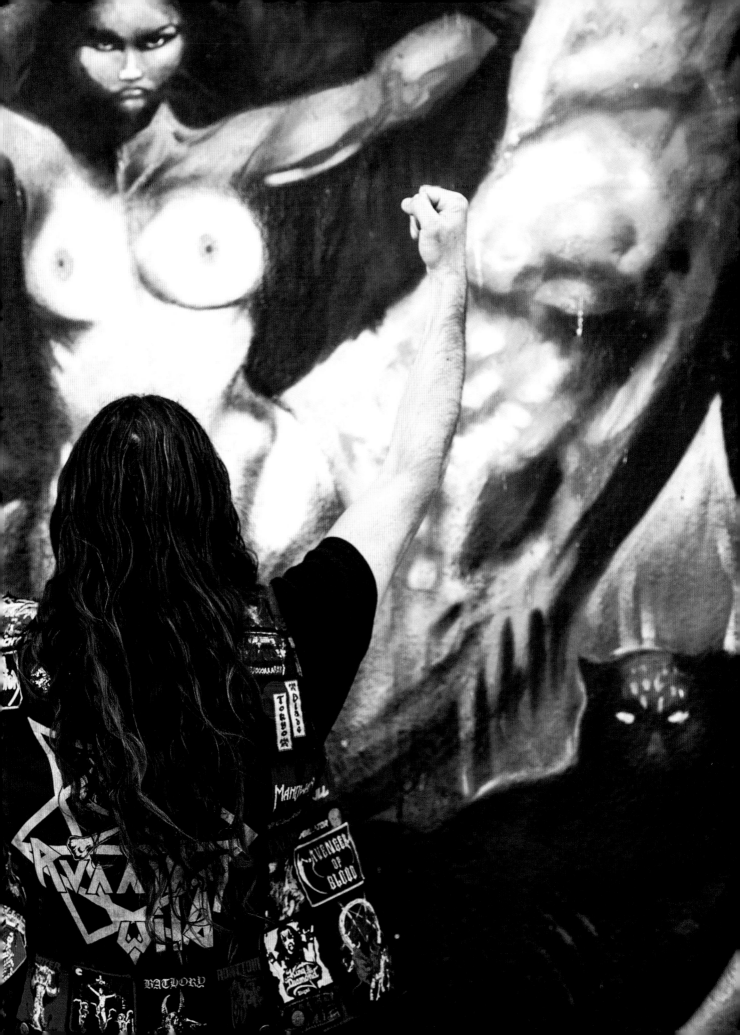

NASTY SAVAGE

Wage of Mayhem

GLADIATORS

MEGA

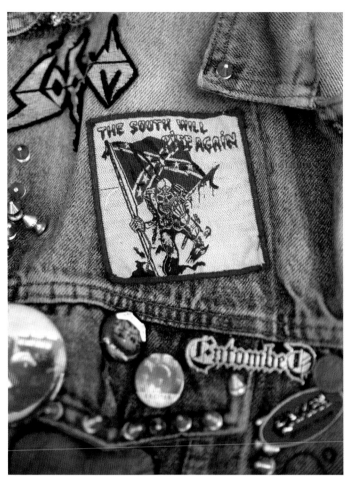

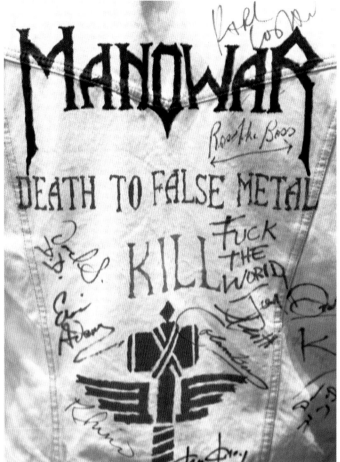

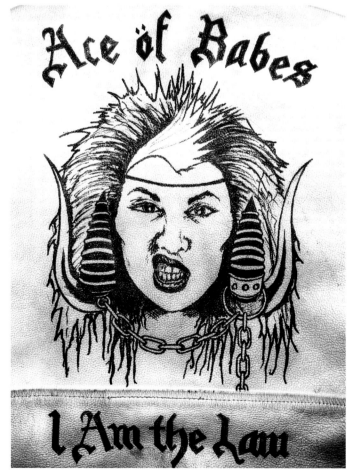

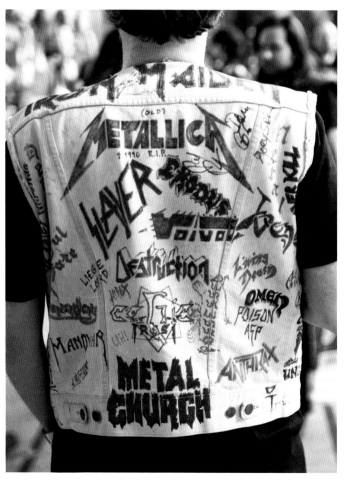

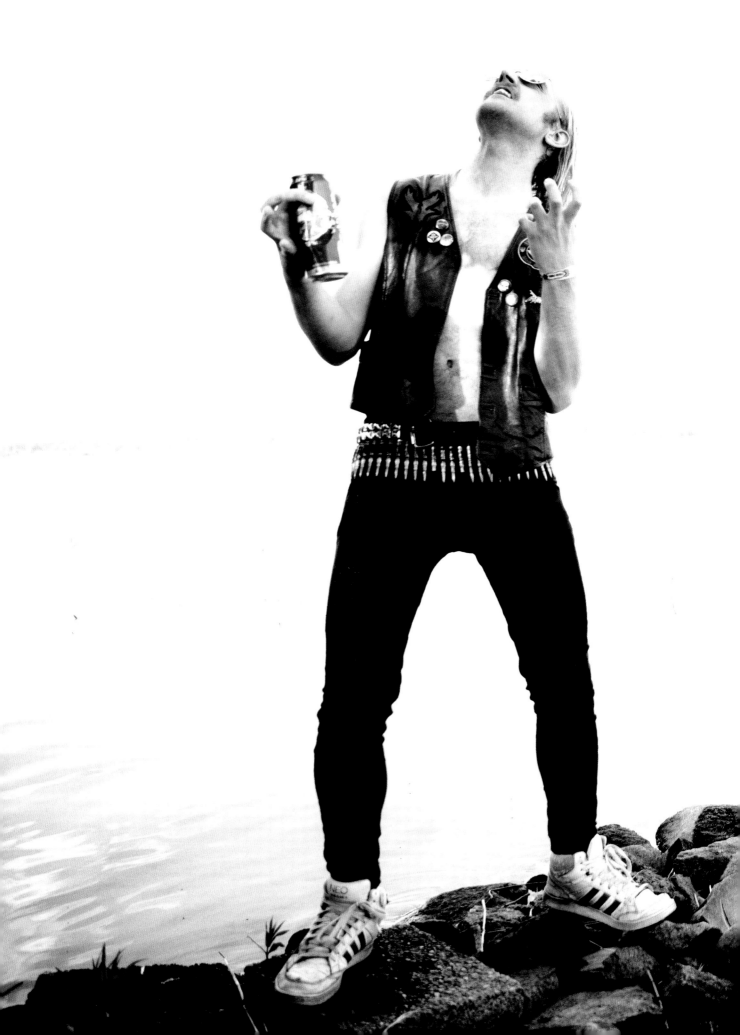

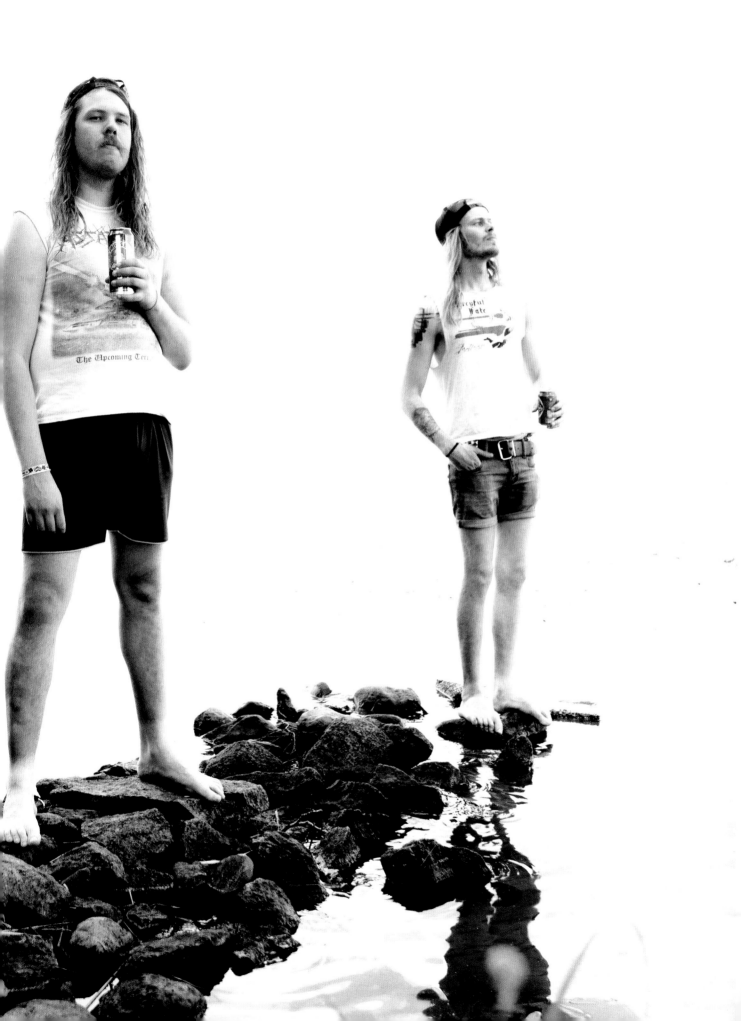

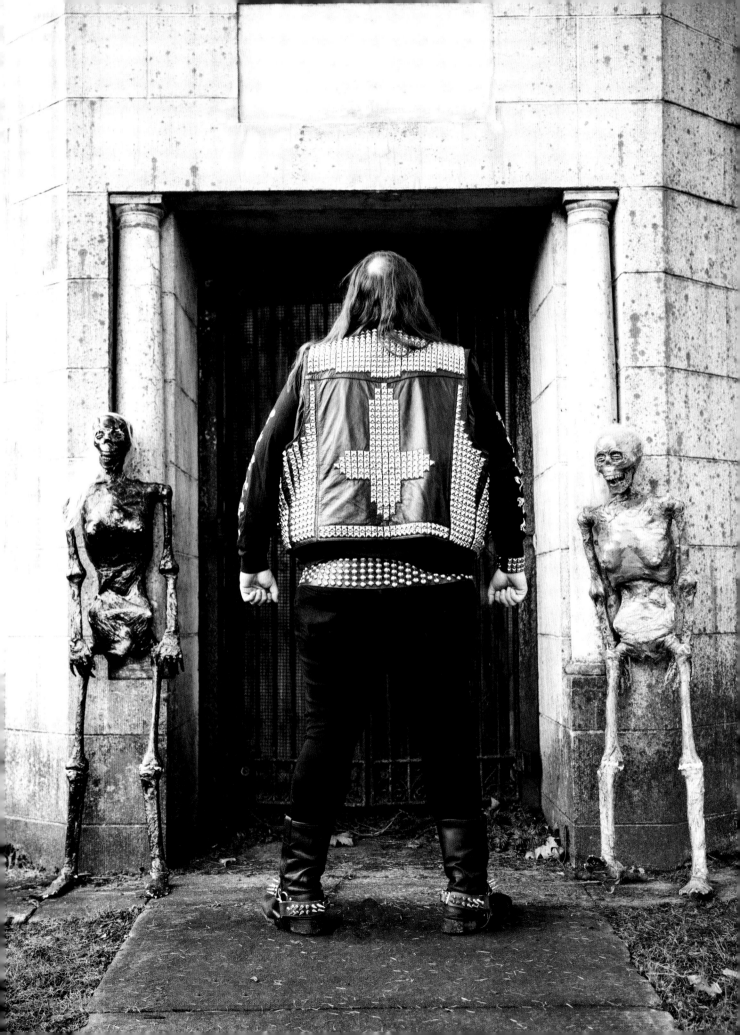

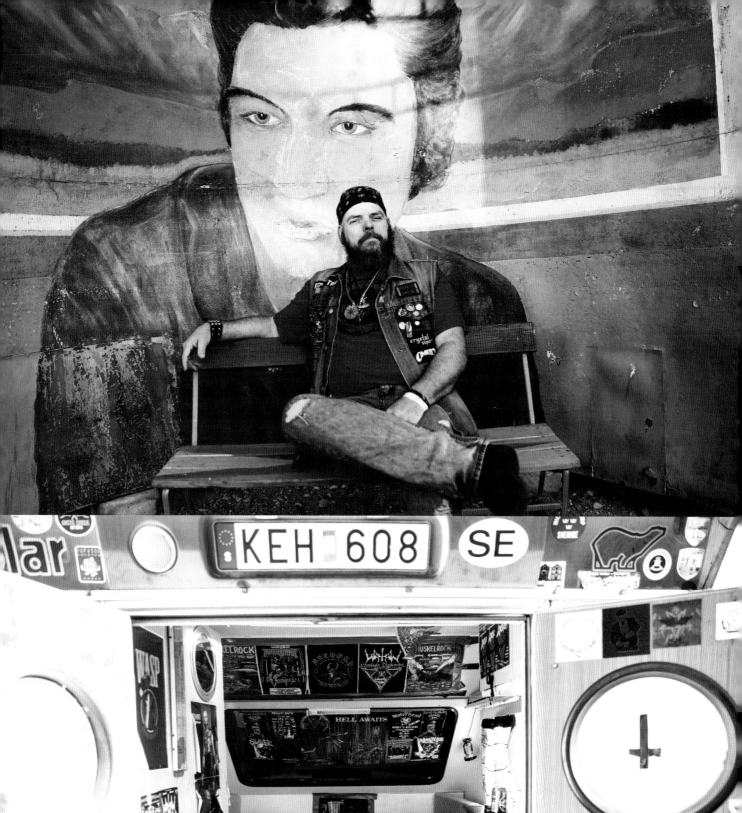
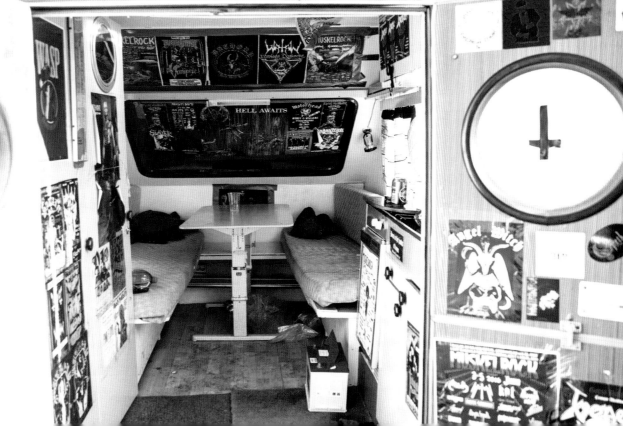

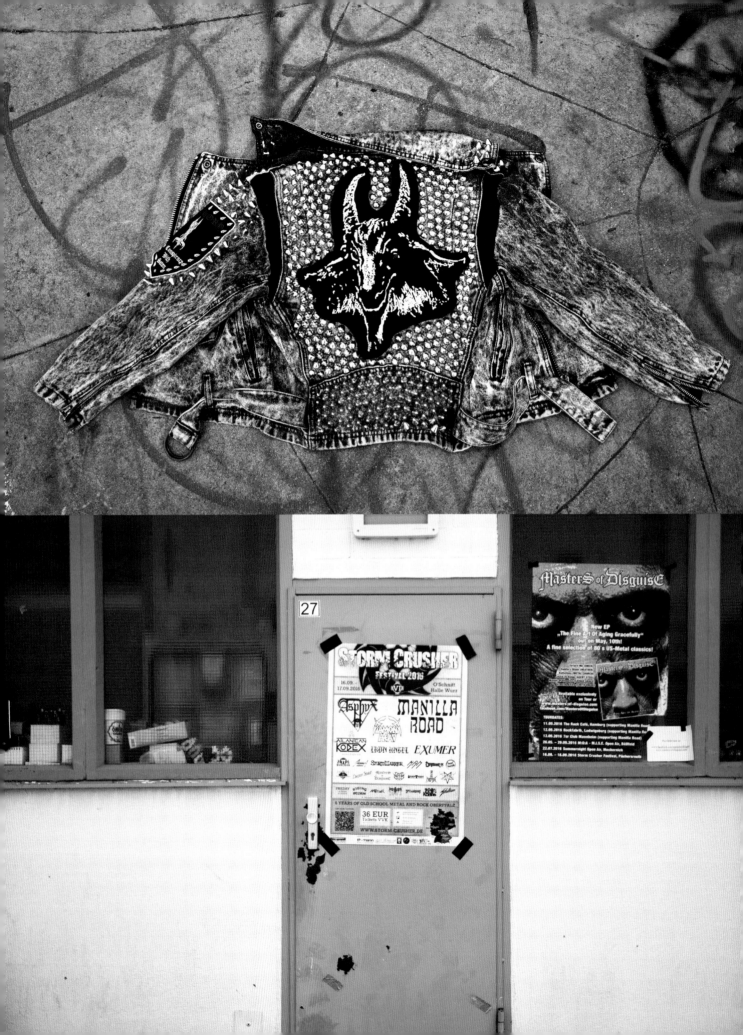

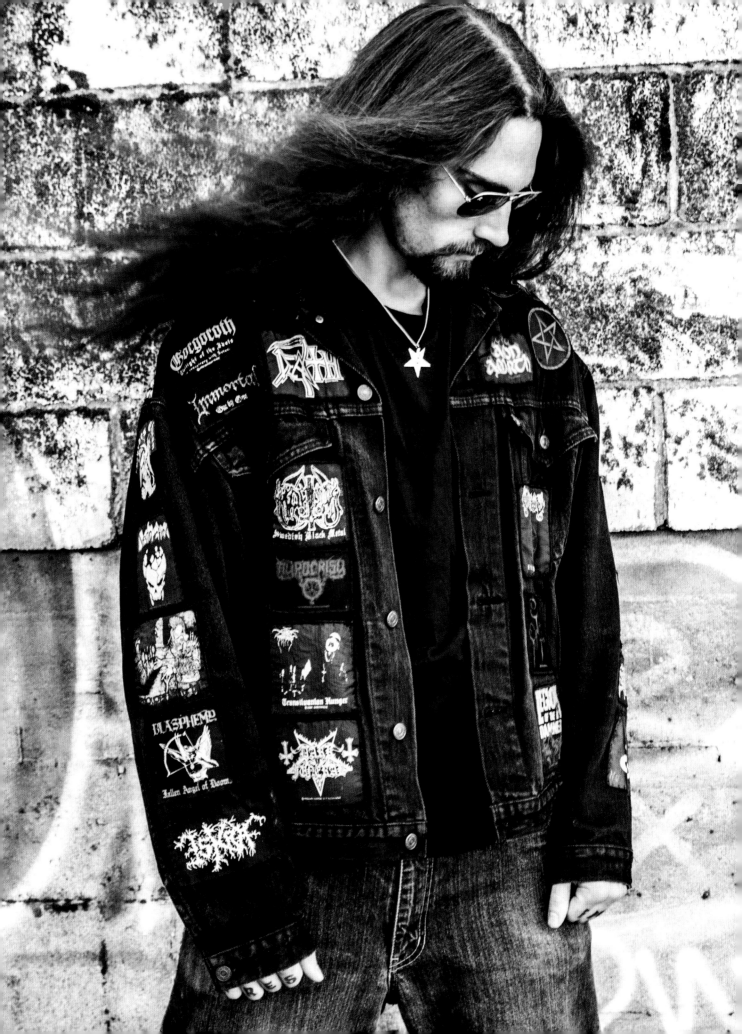

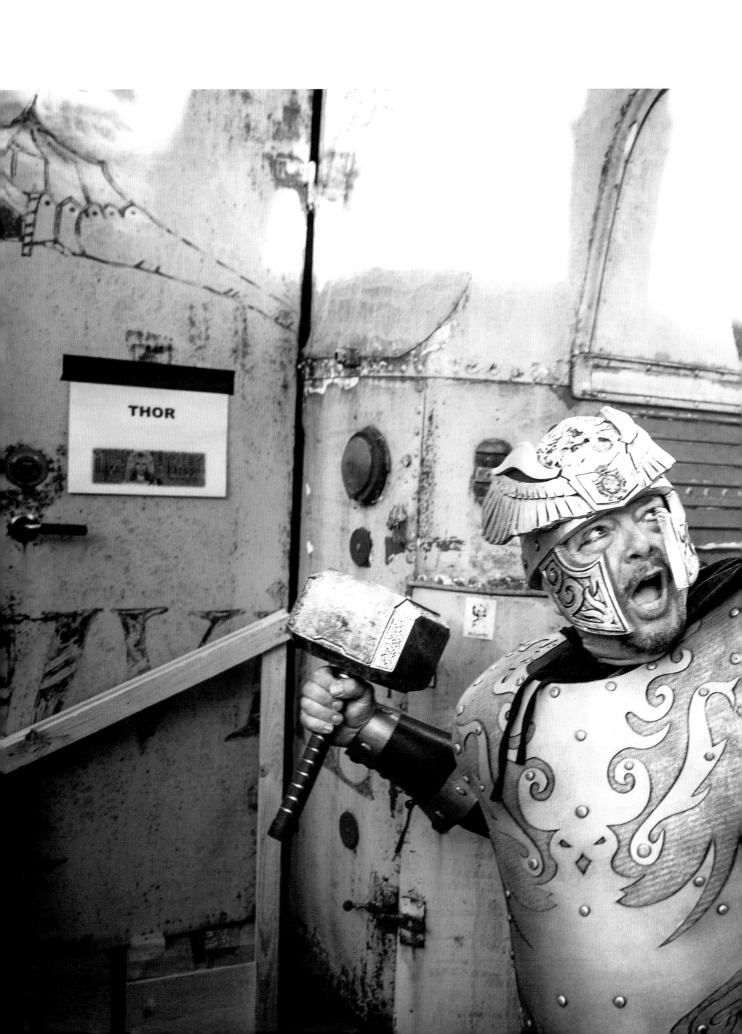

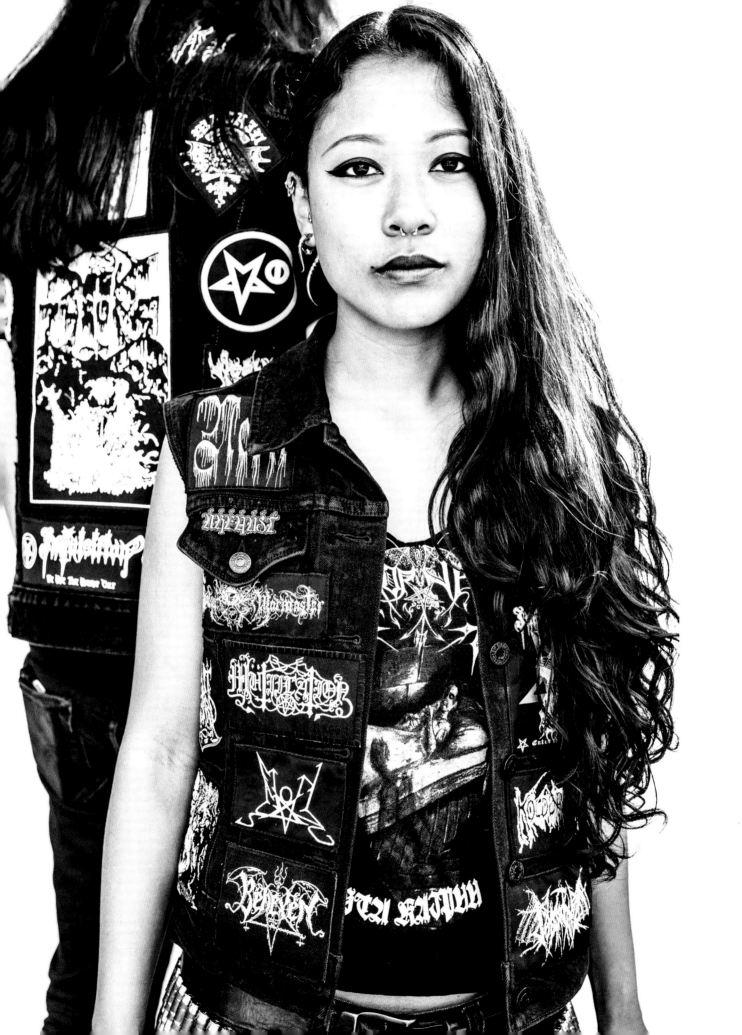

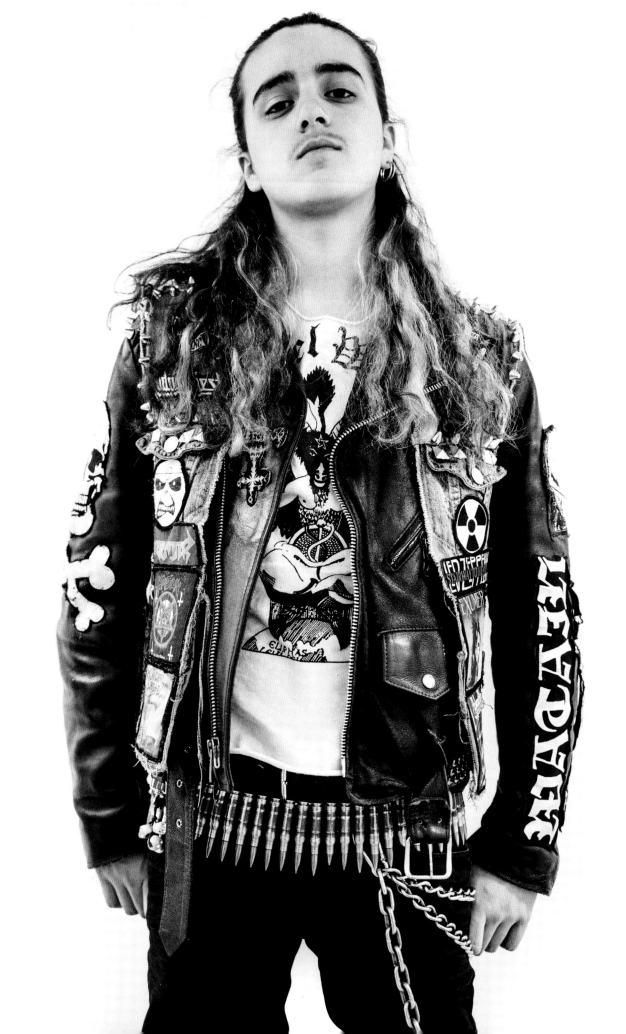

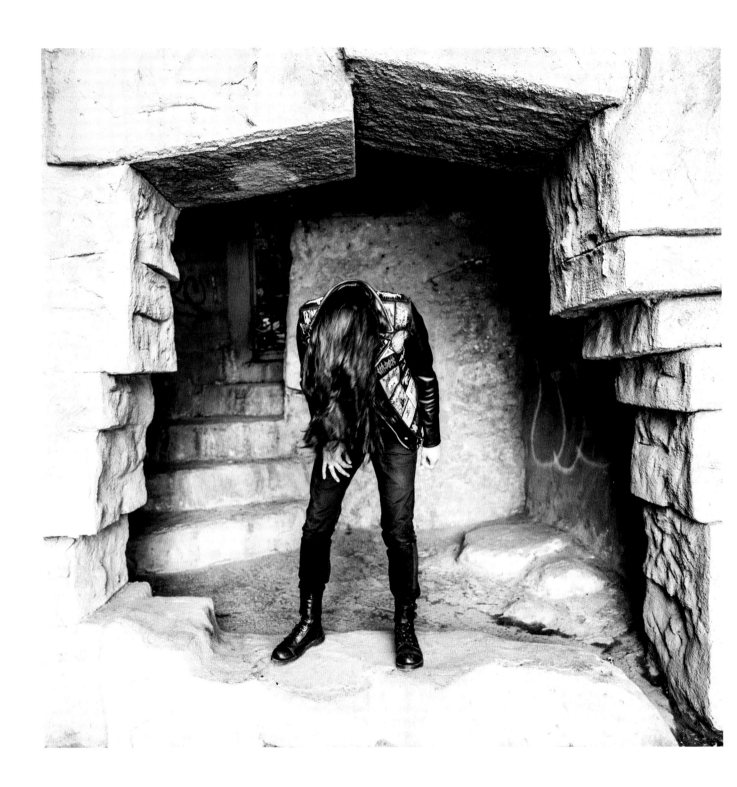

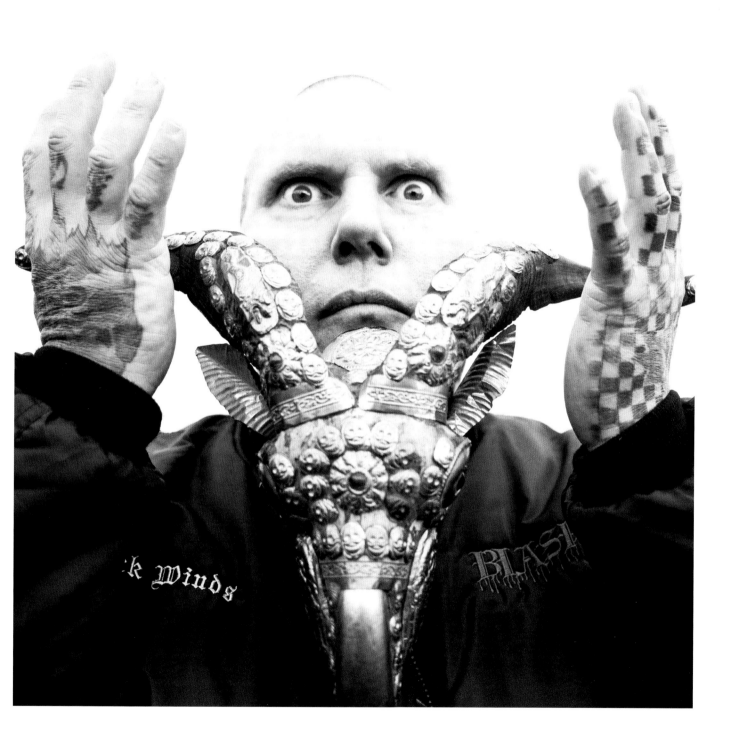

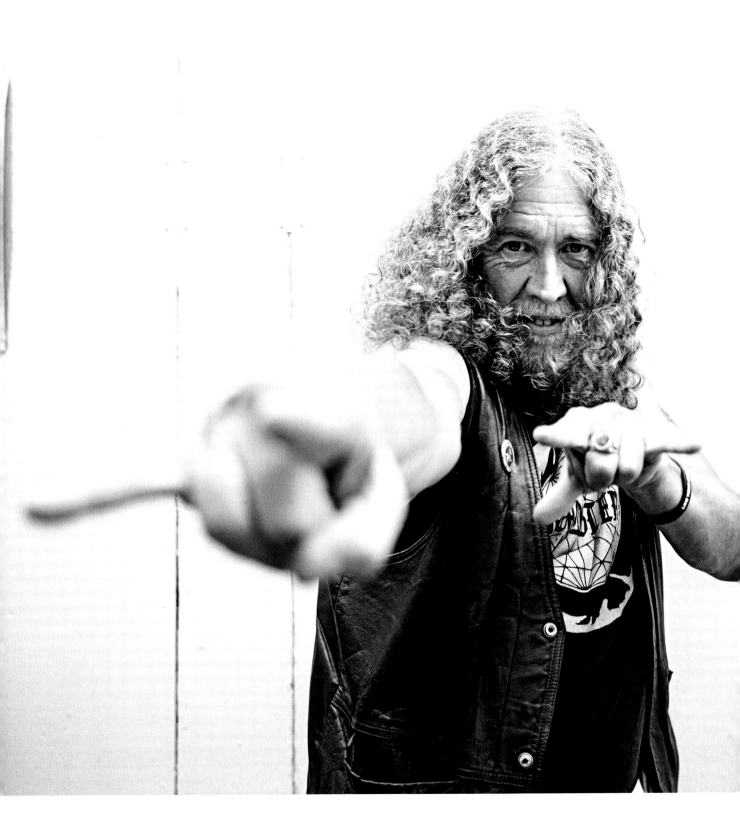

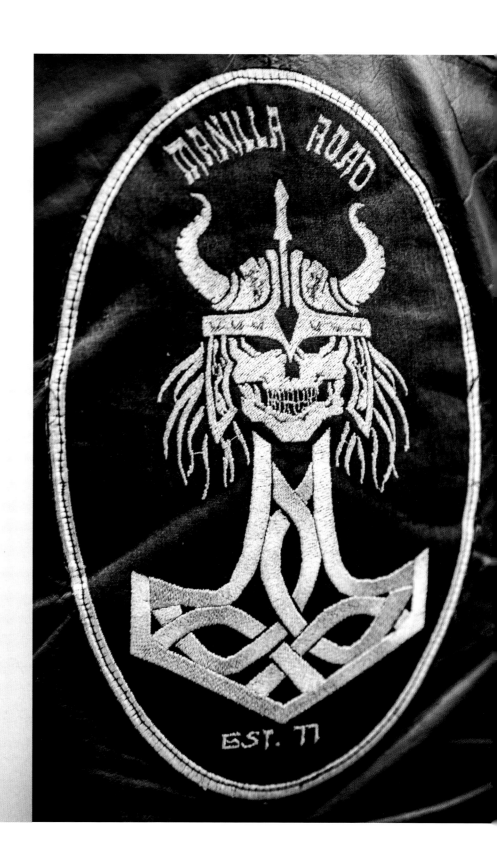

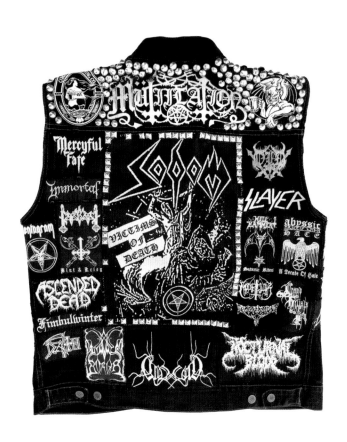

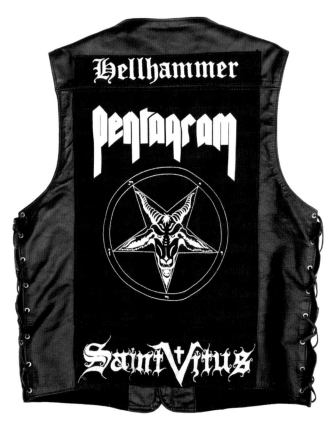

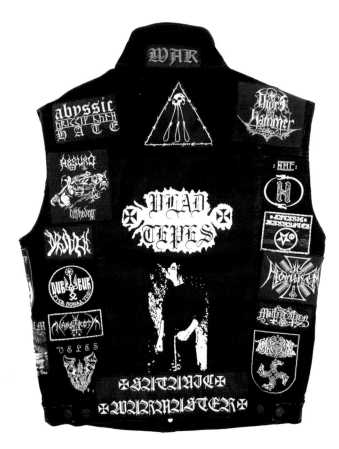

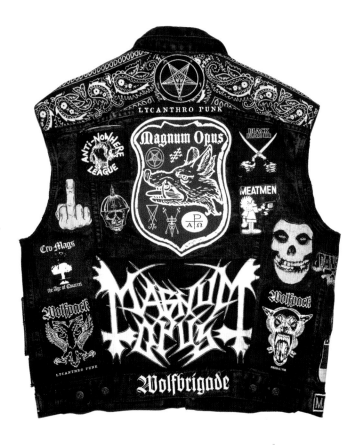

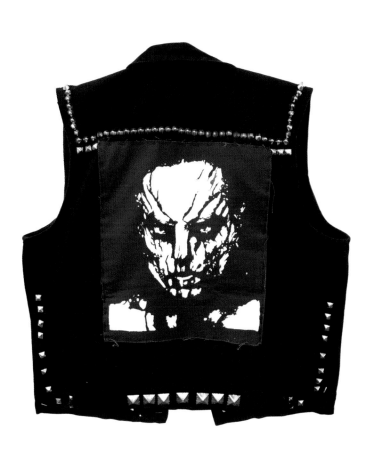

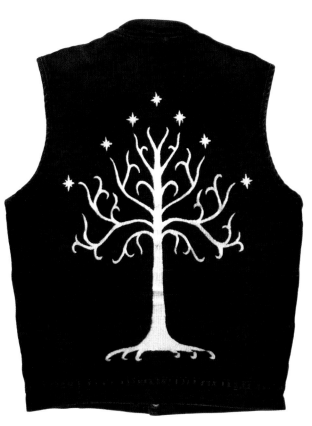

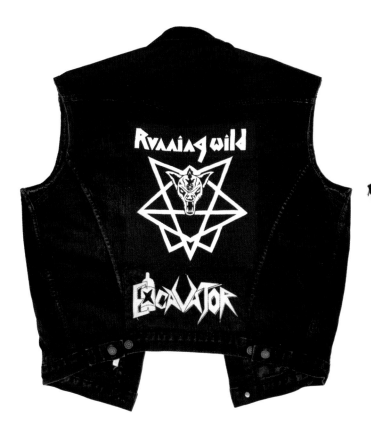

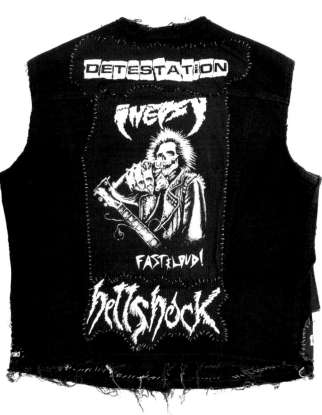

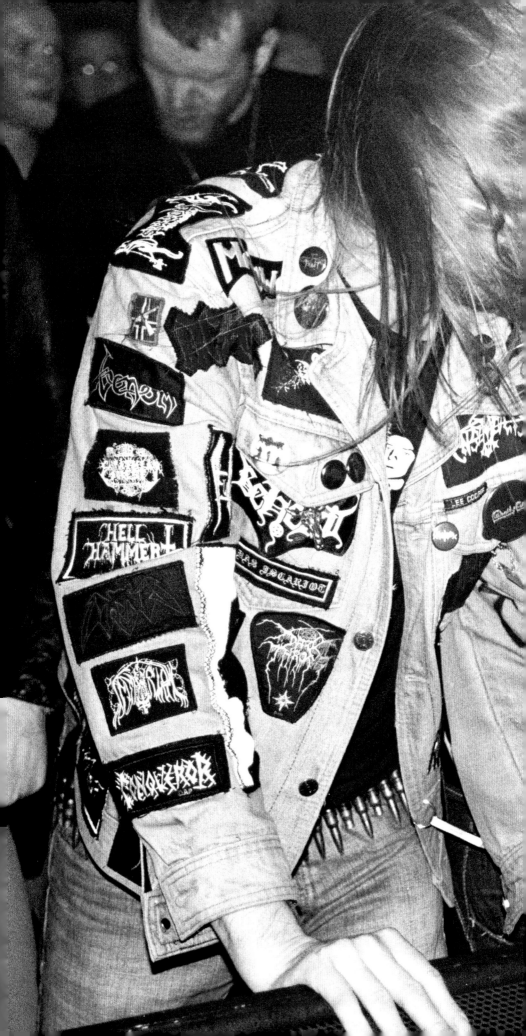

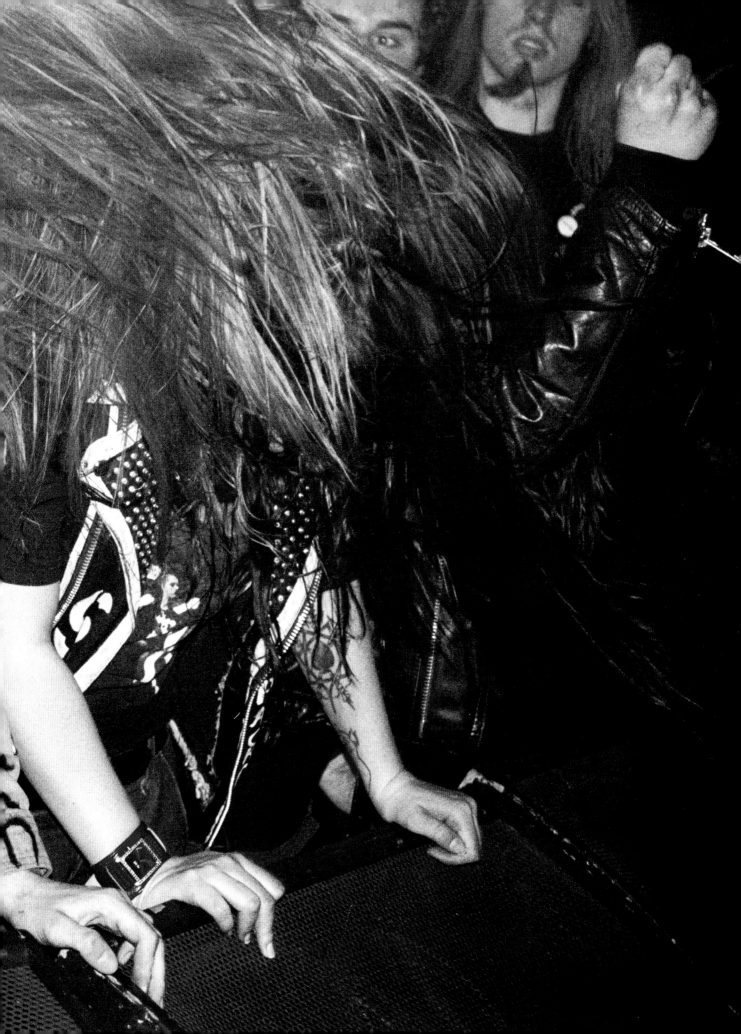

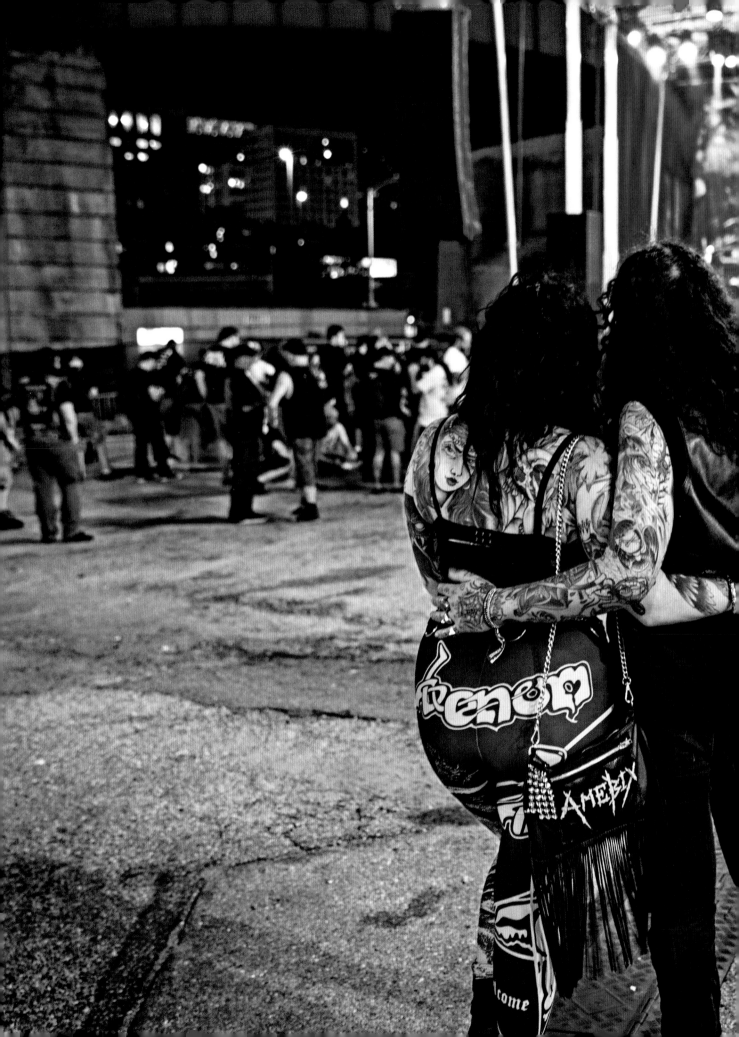

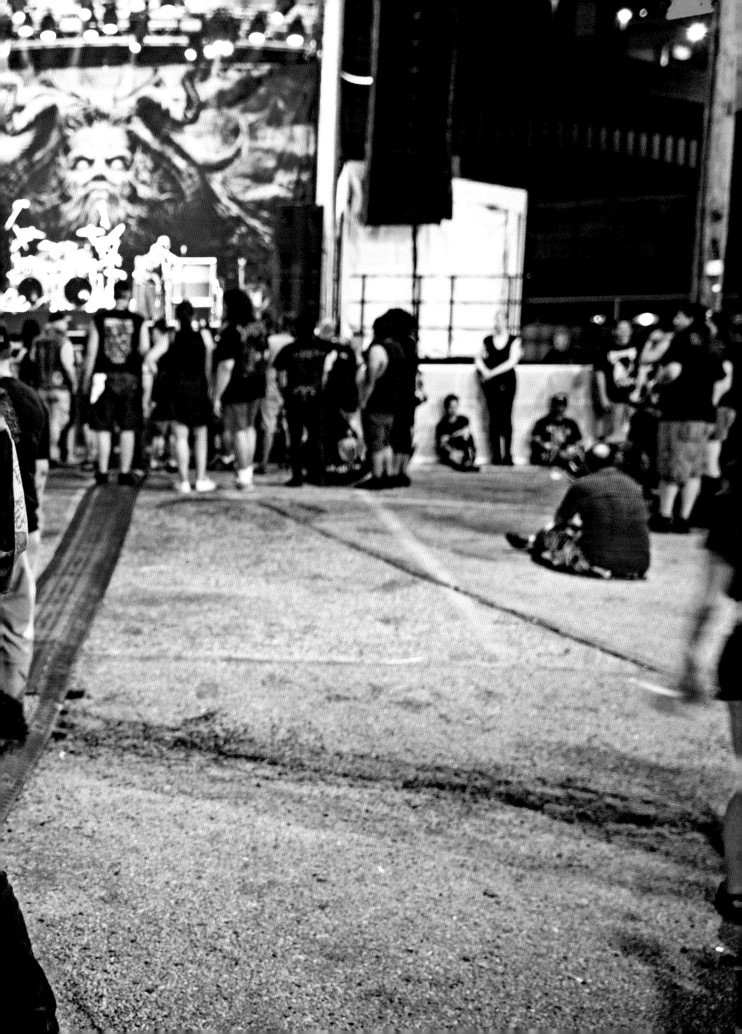

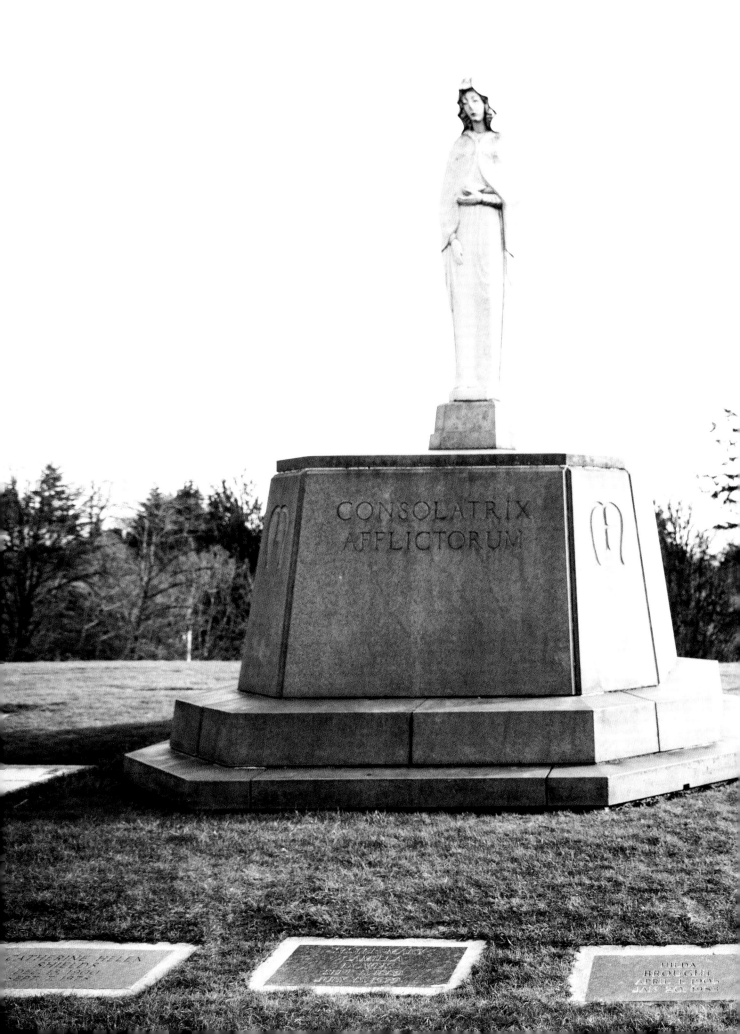

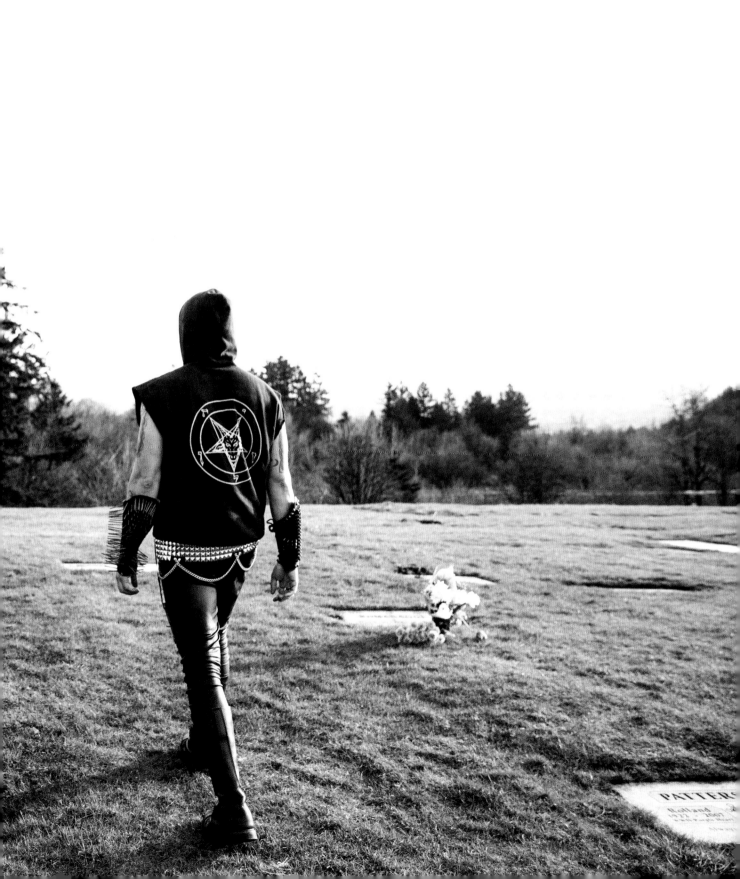

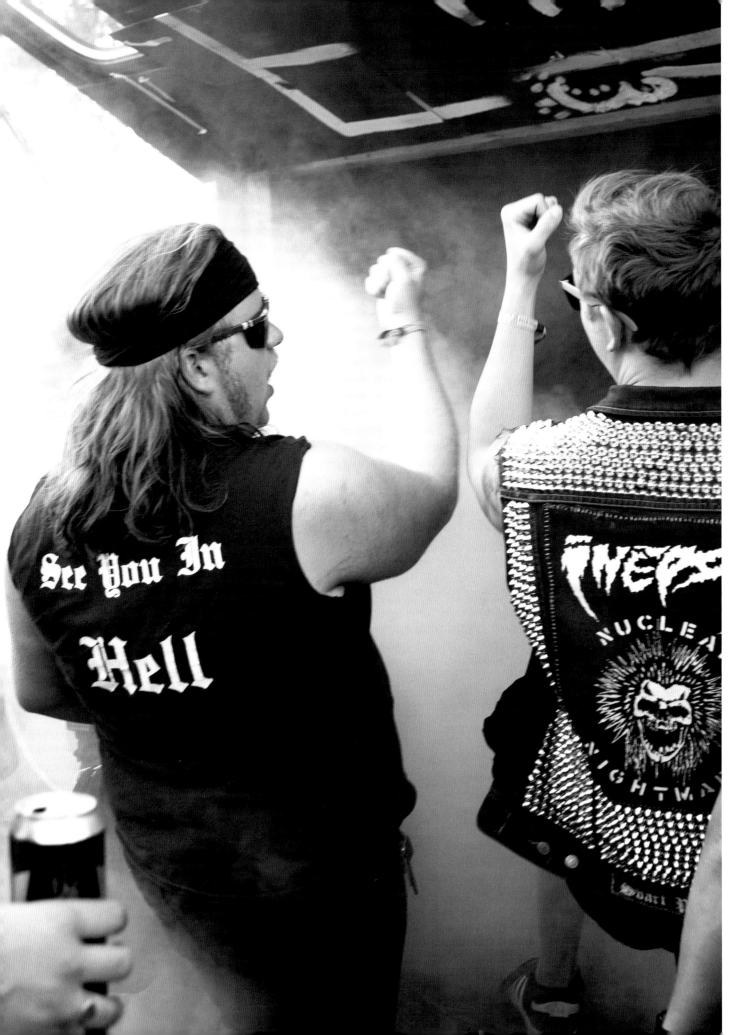

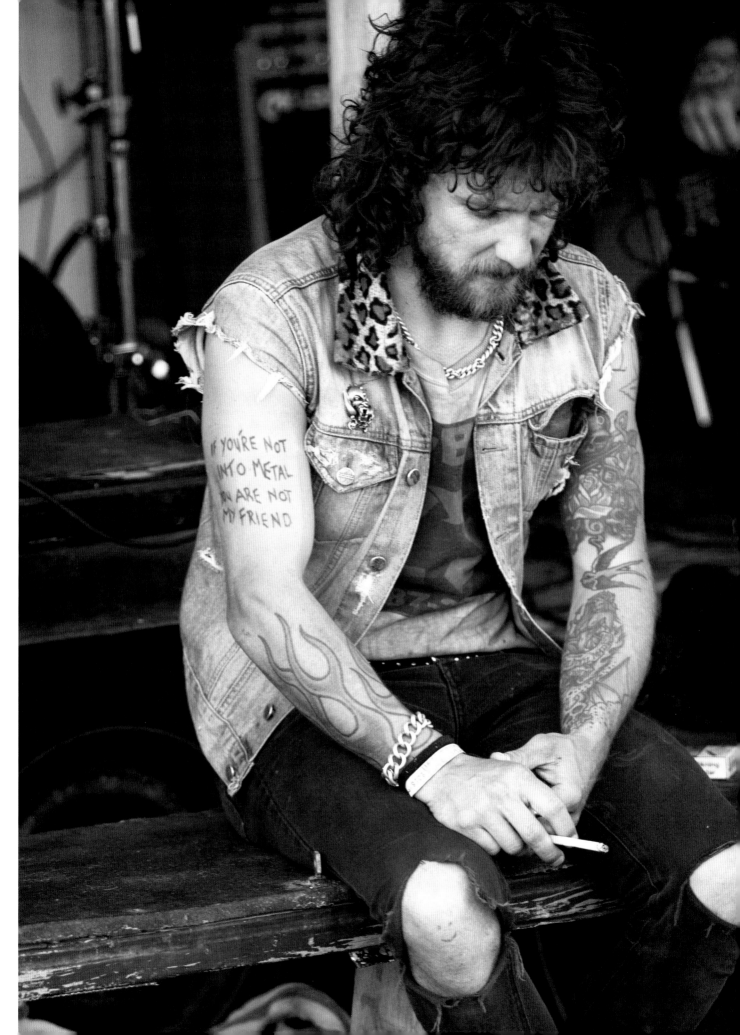

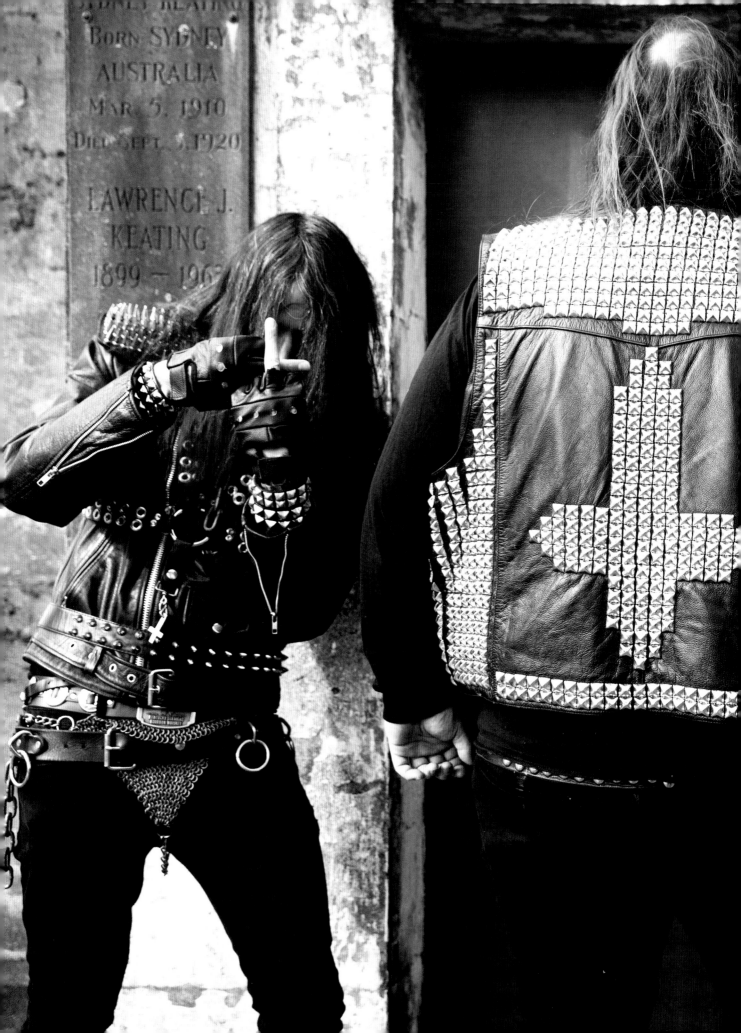

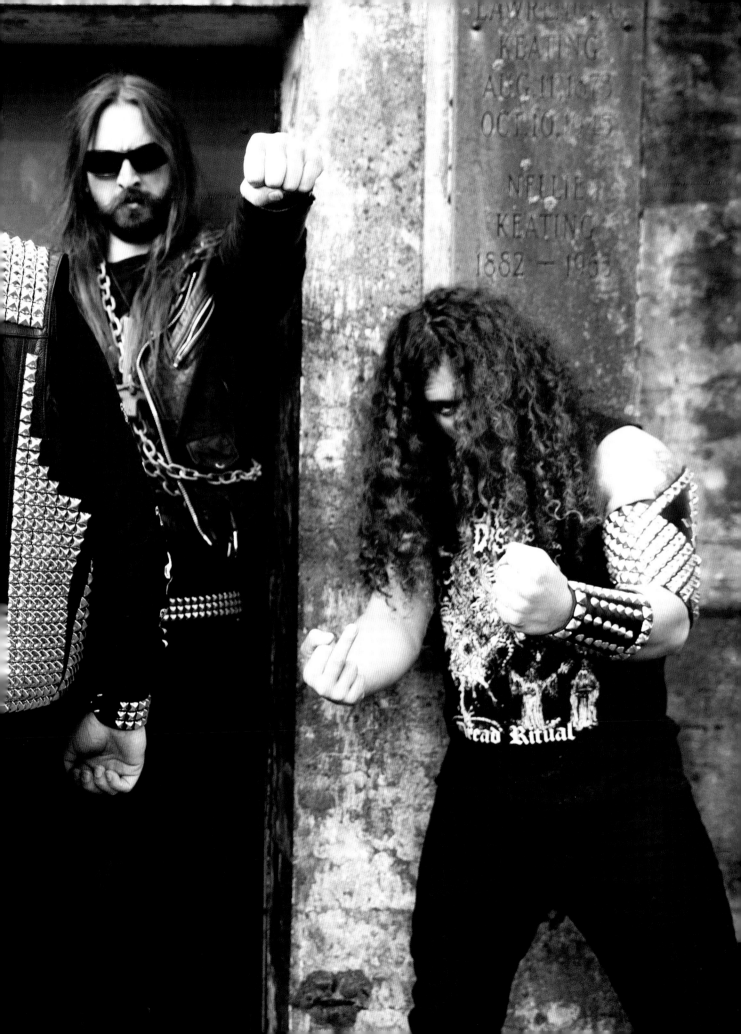

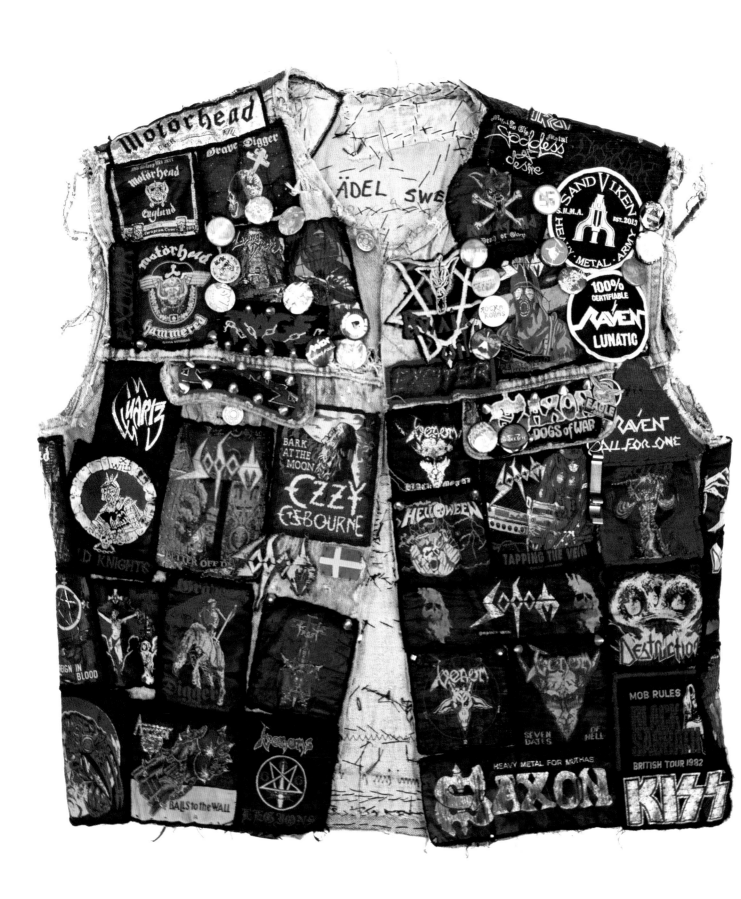

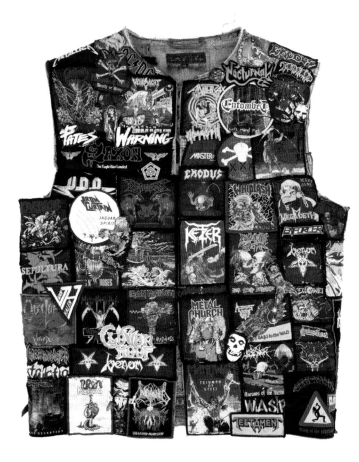

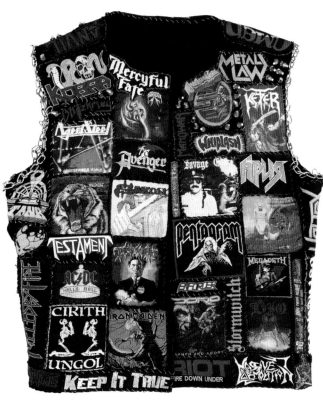

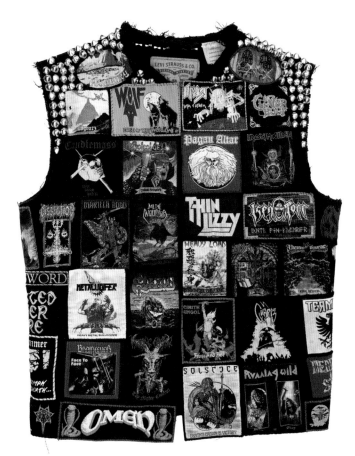

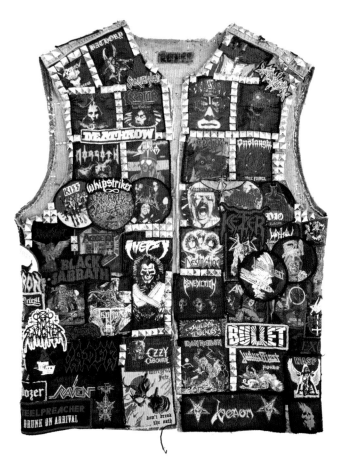

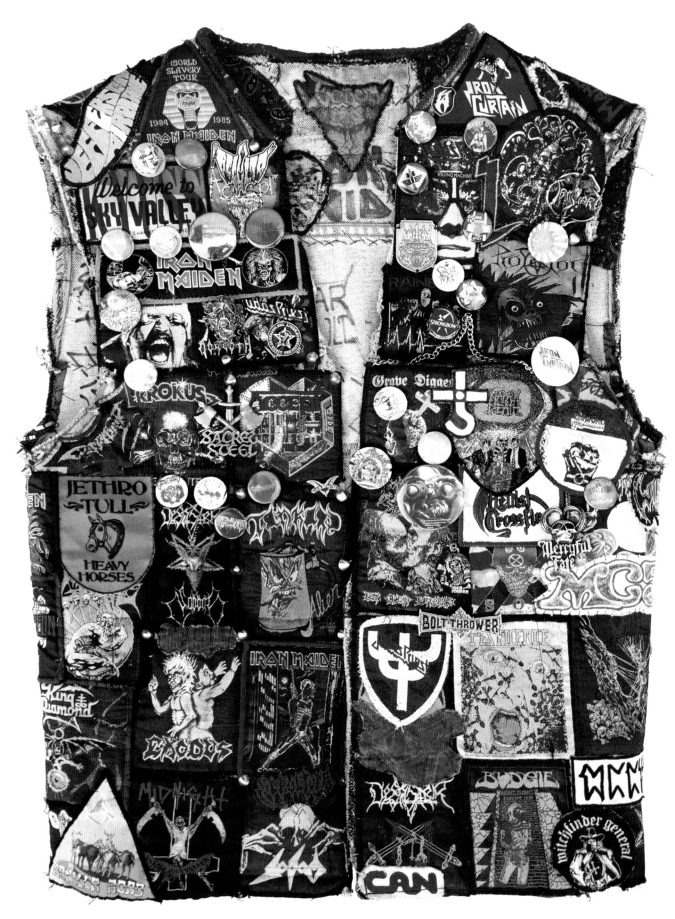

222

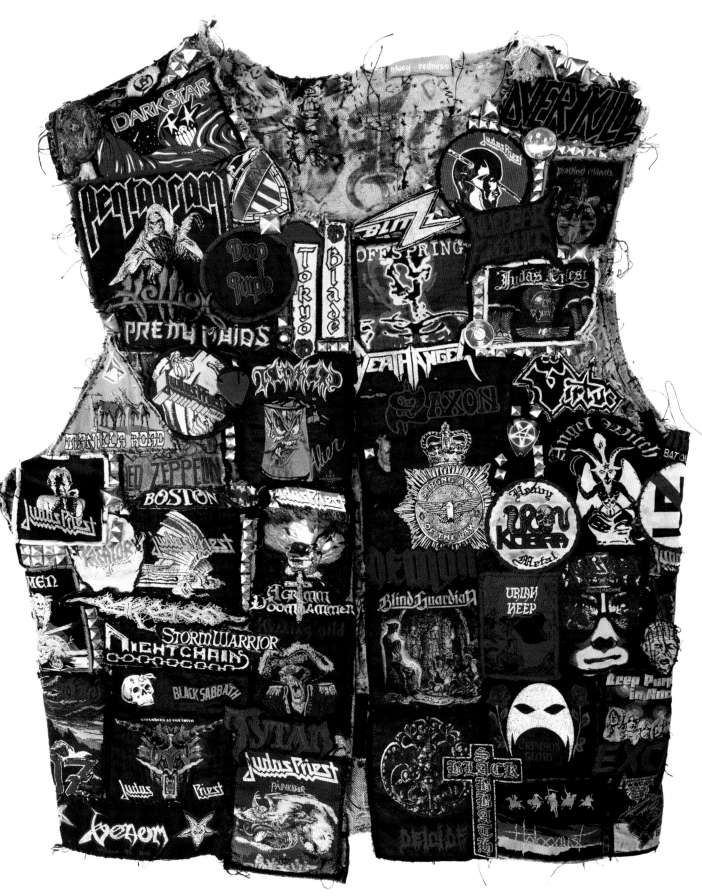

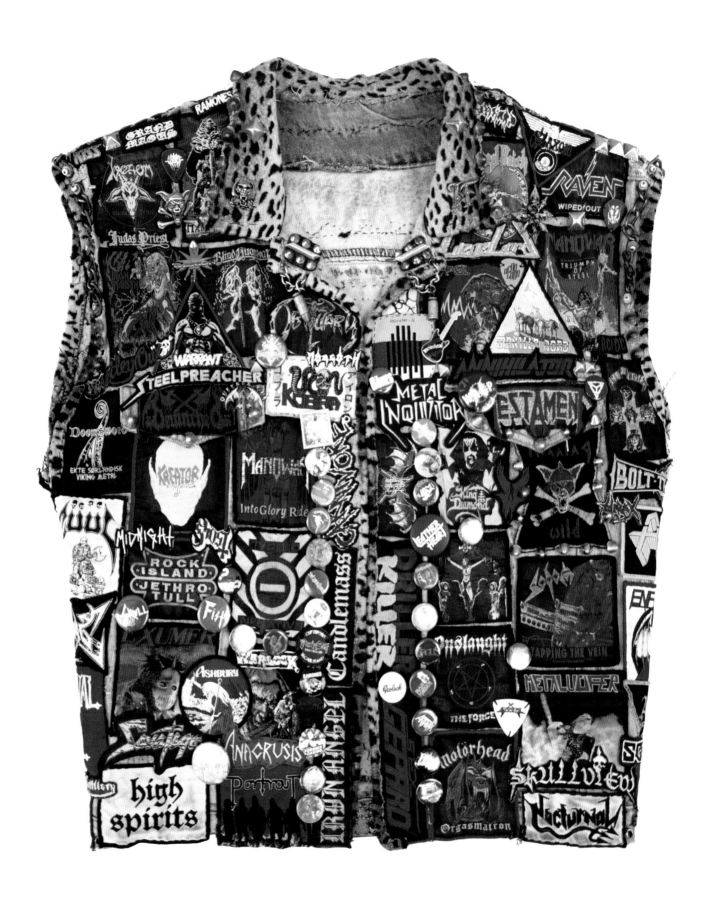

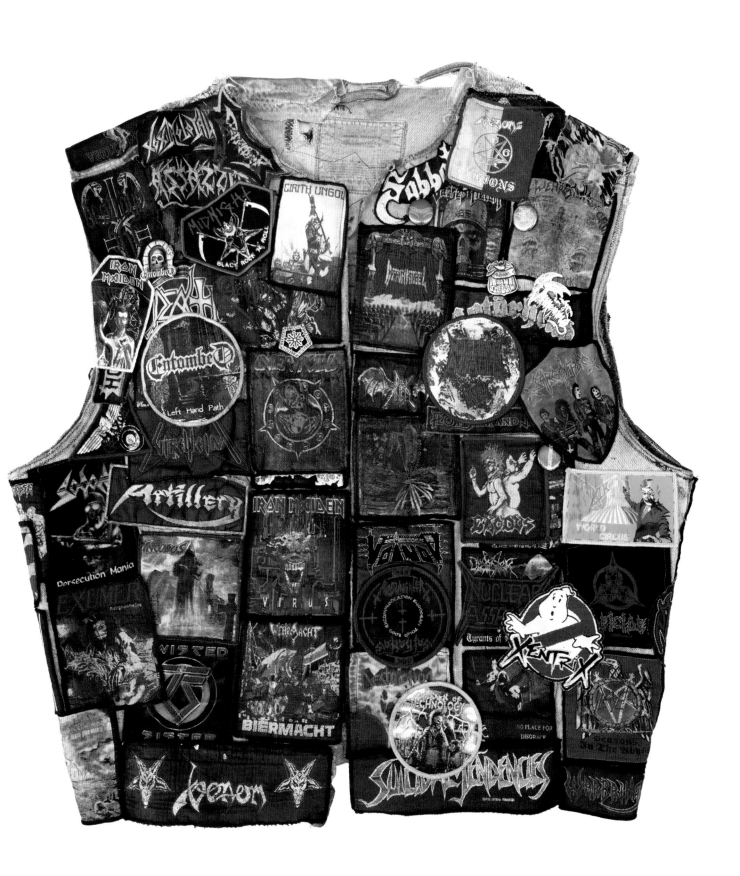

225

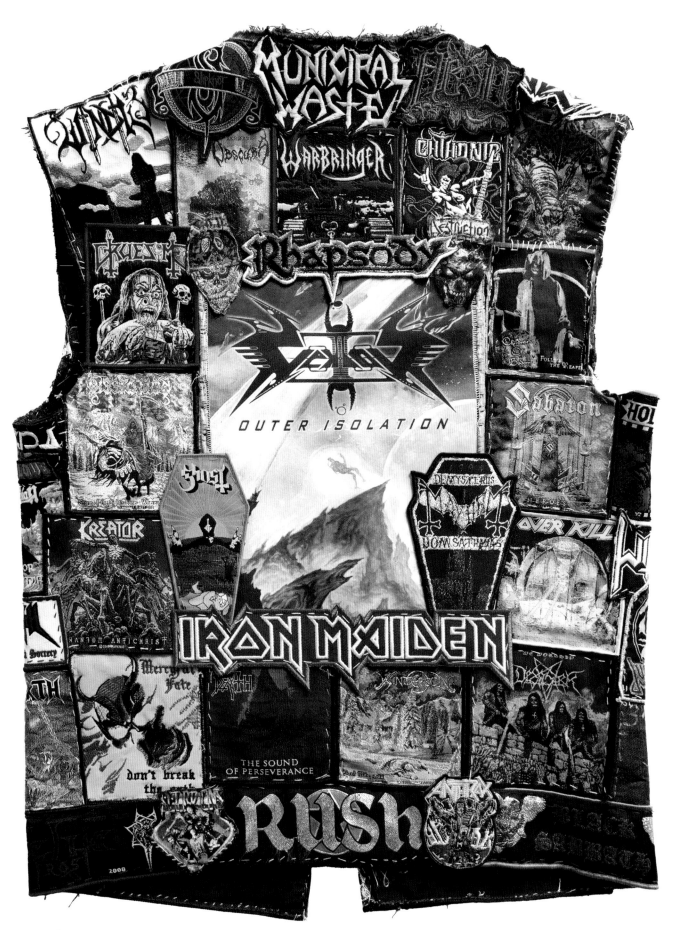

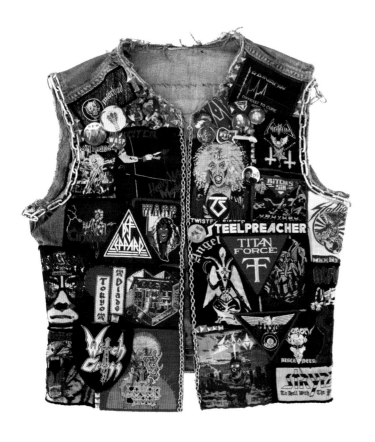
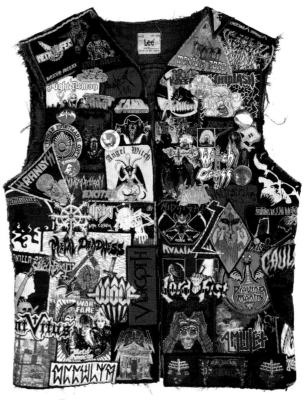
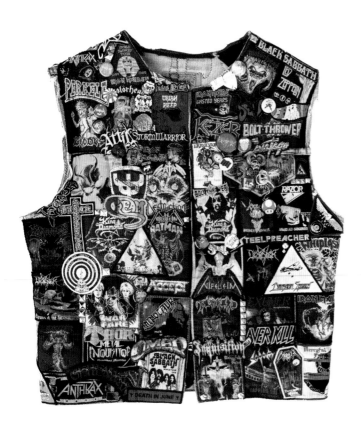
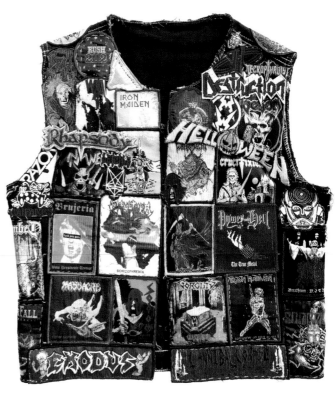

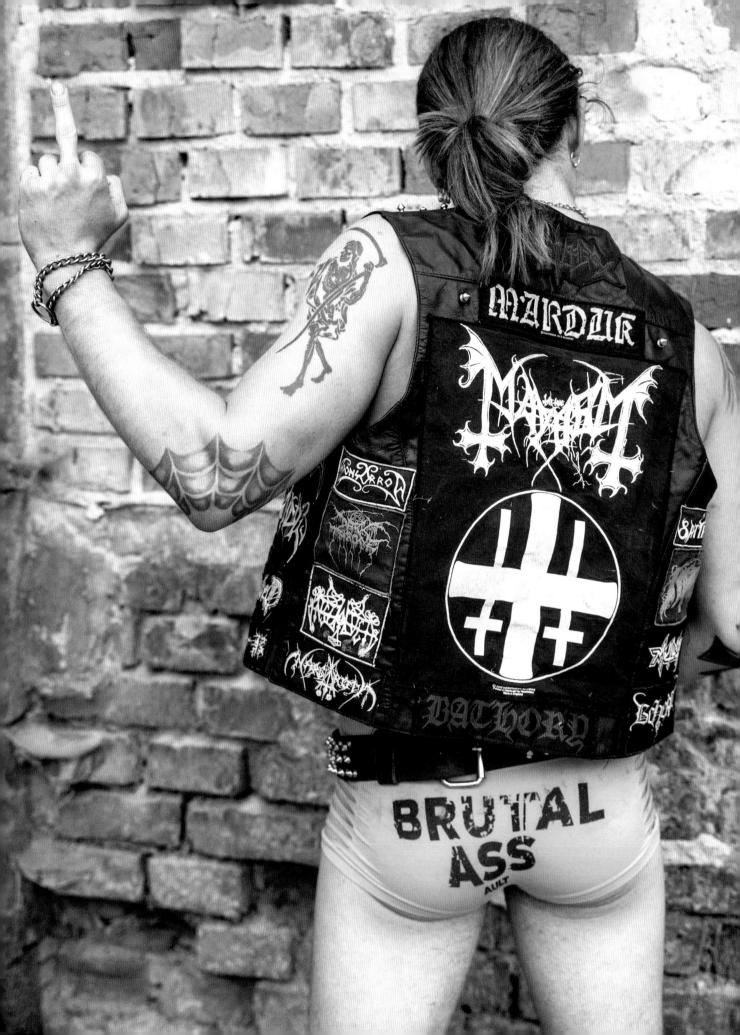

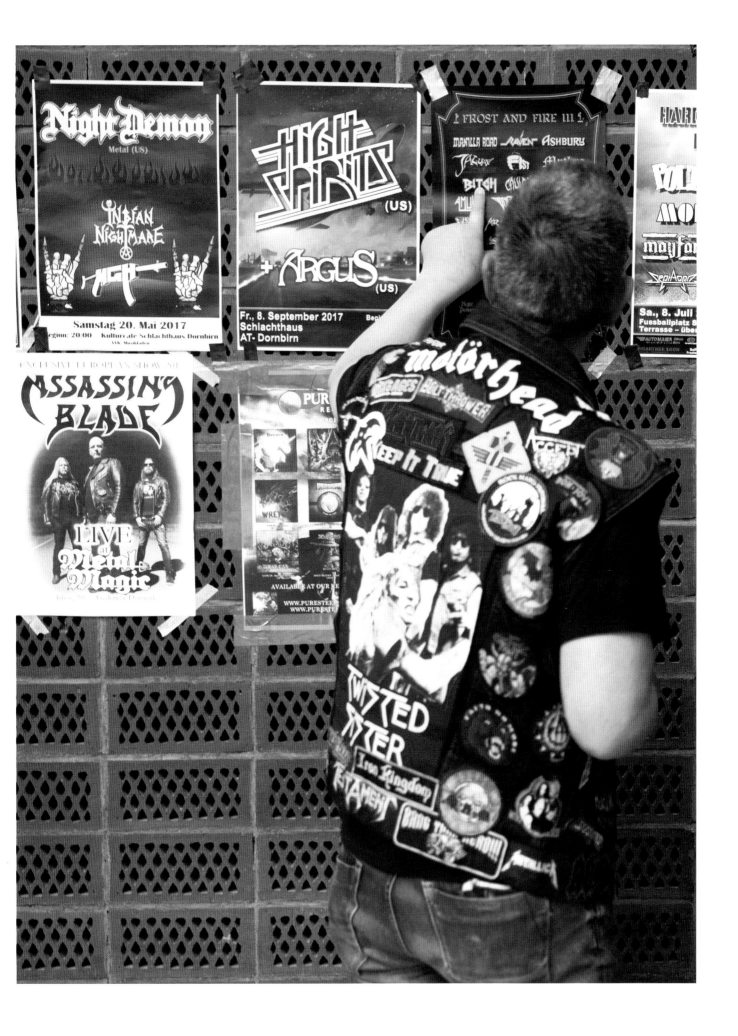

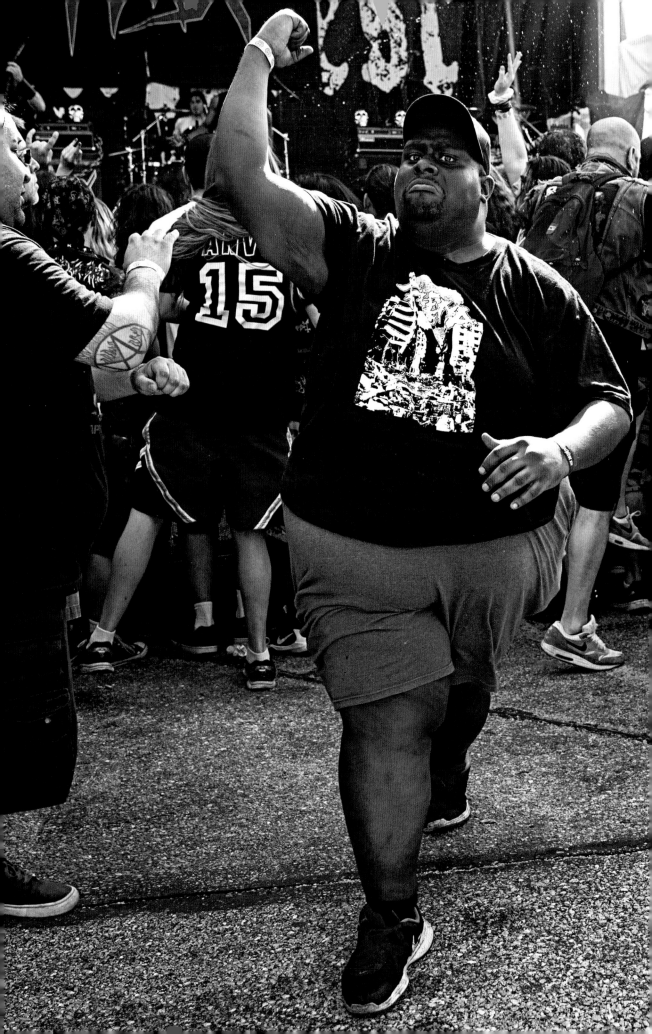

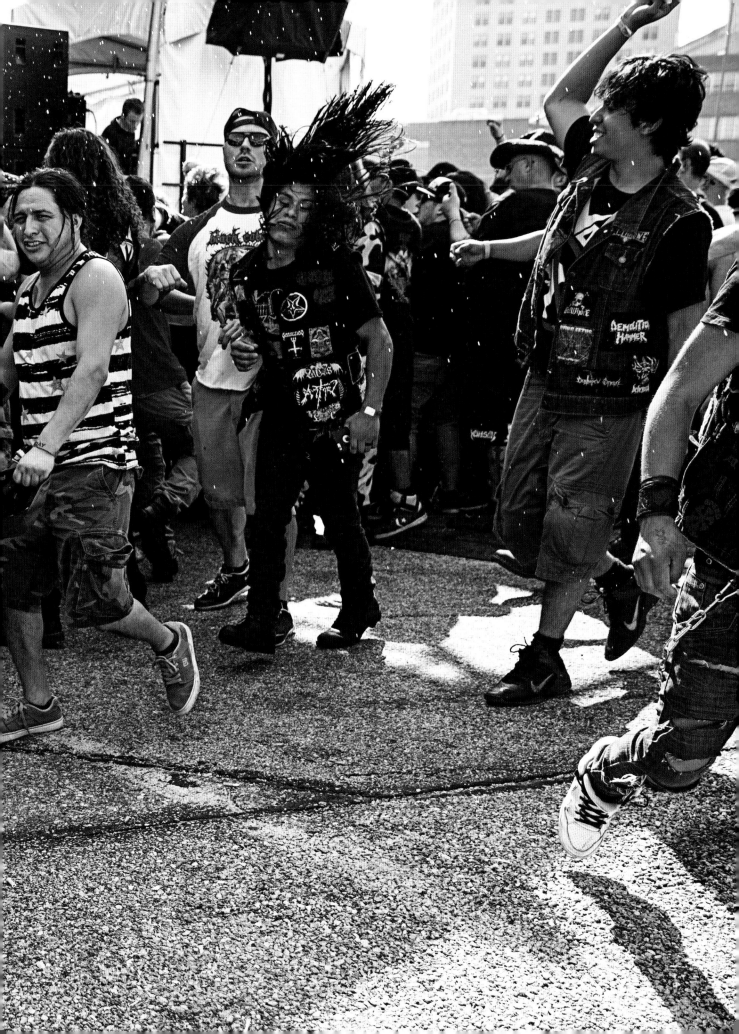

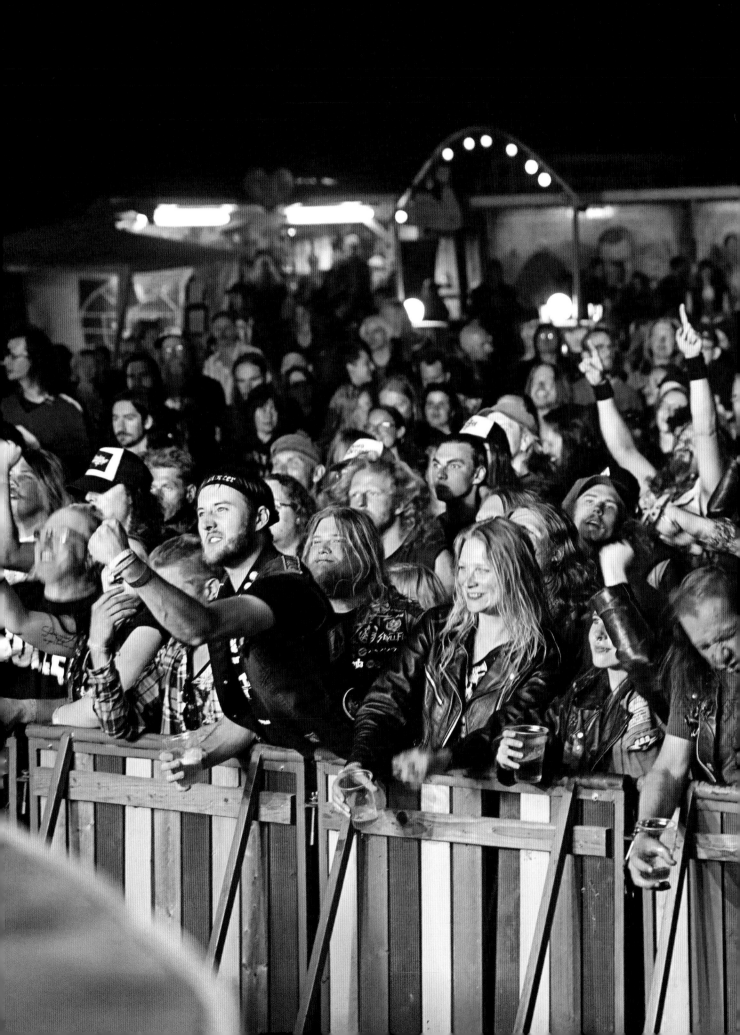

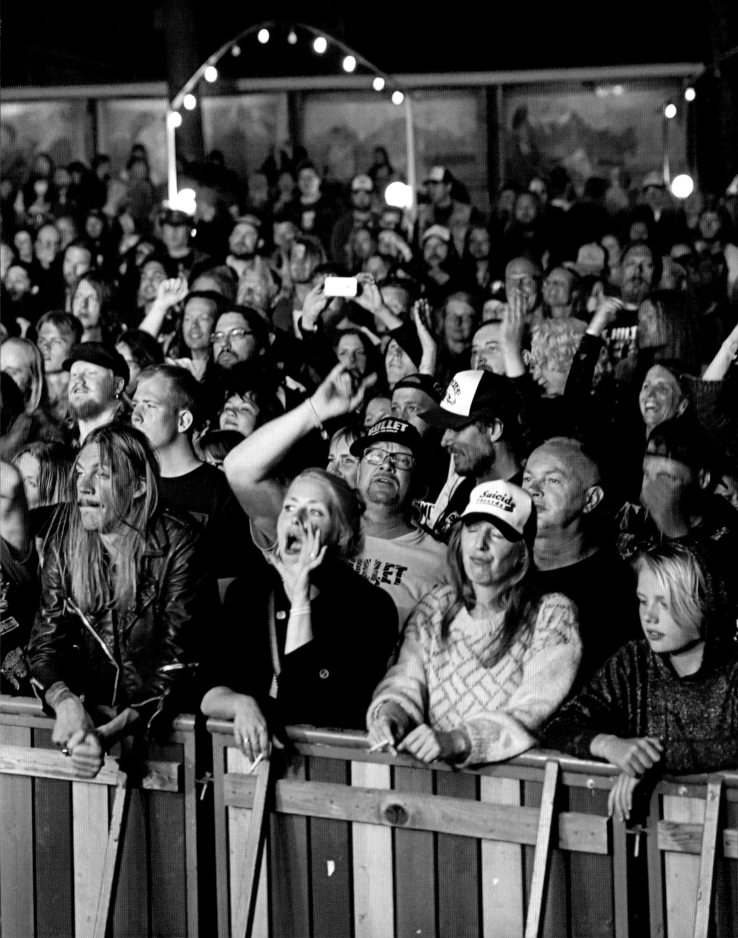

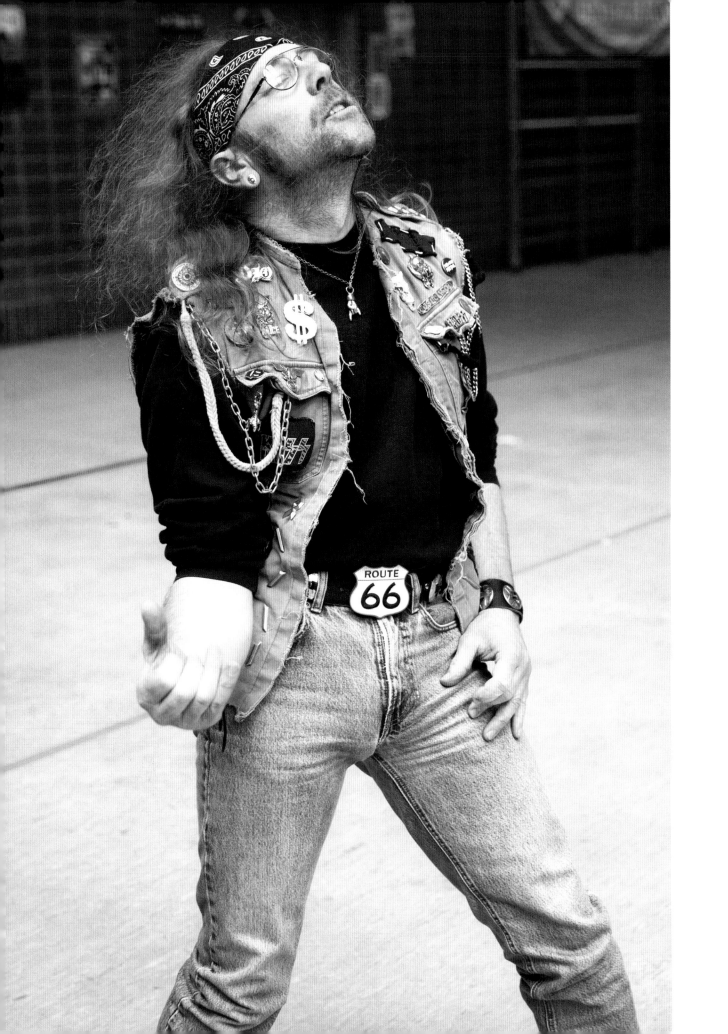

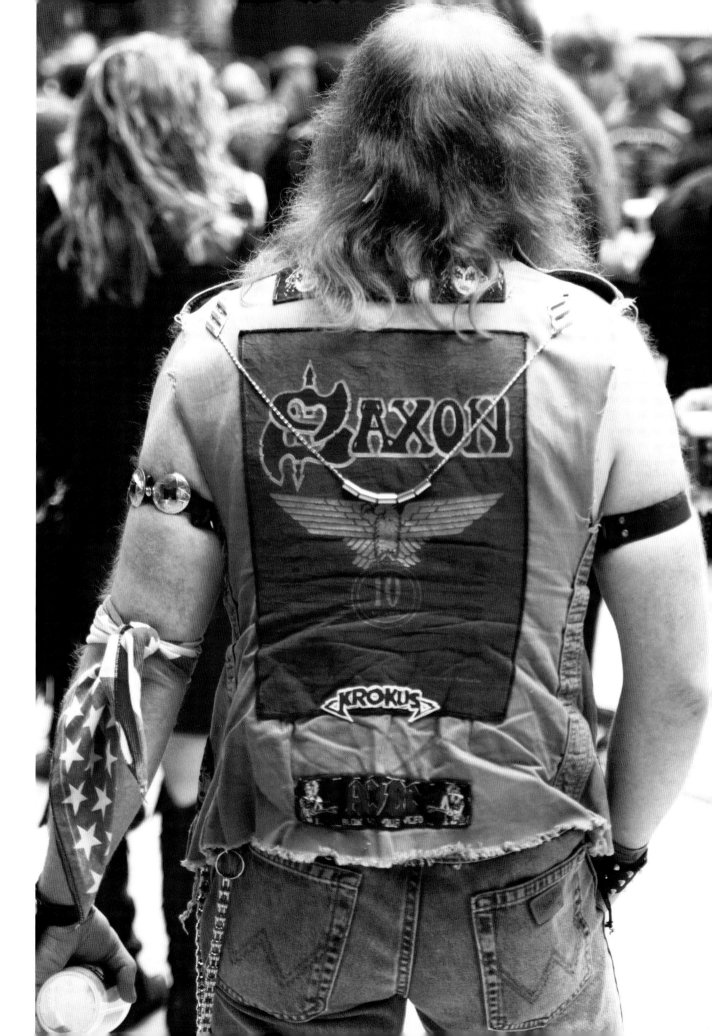

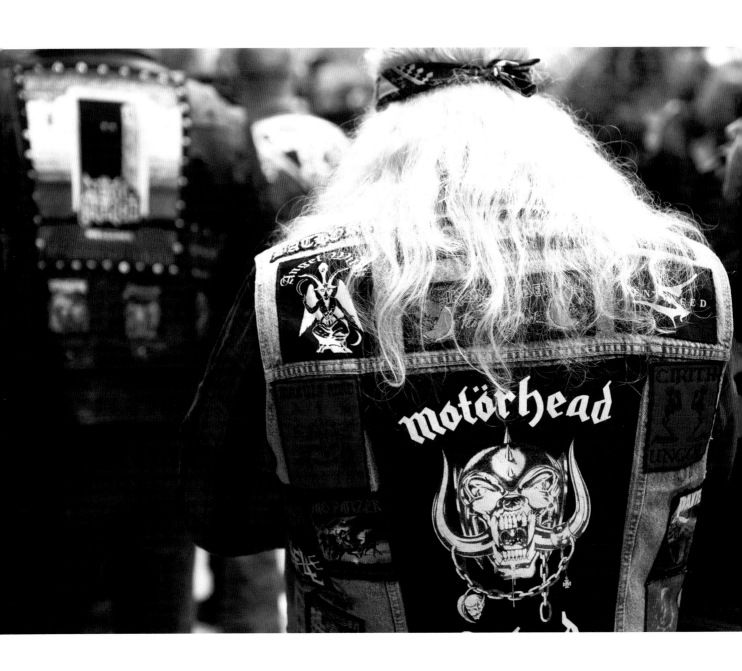

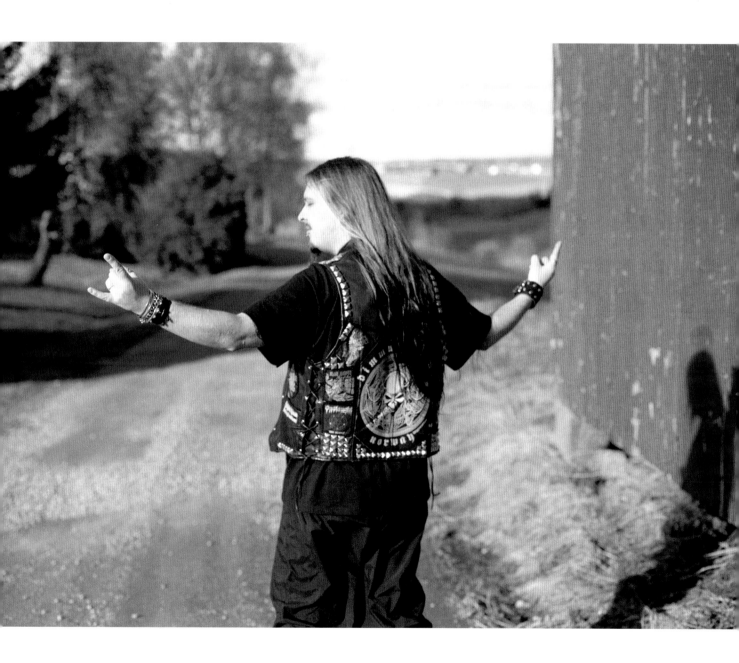

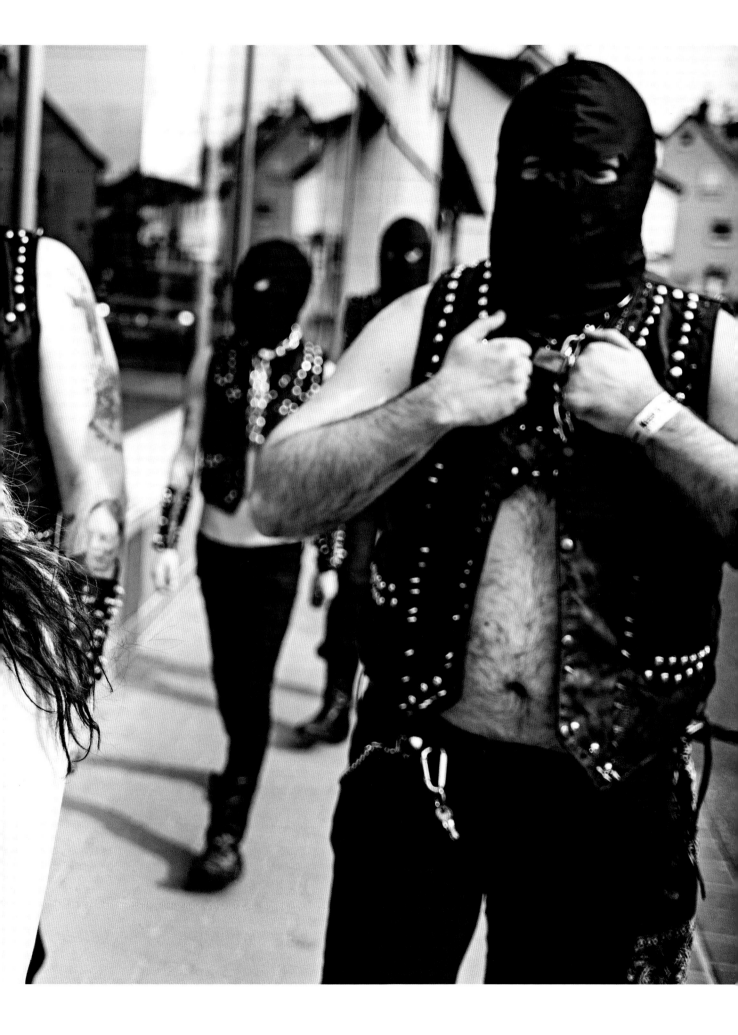

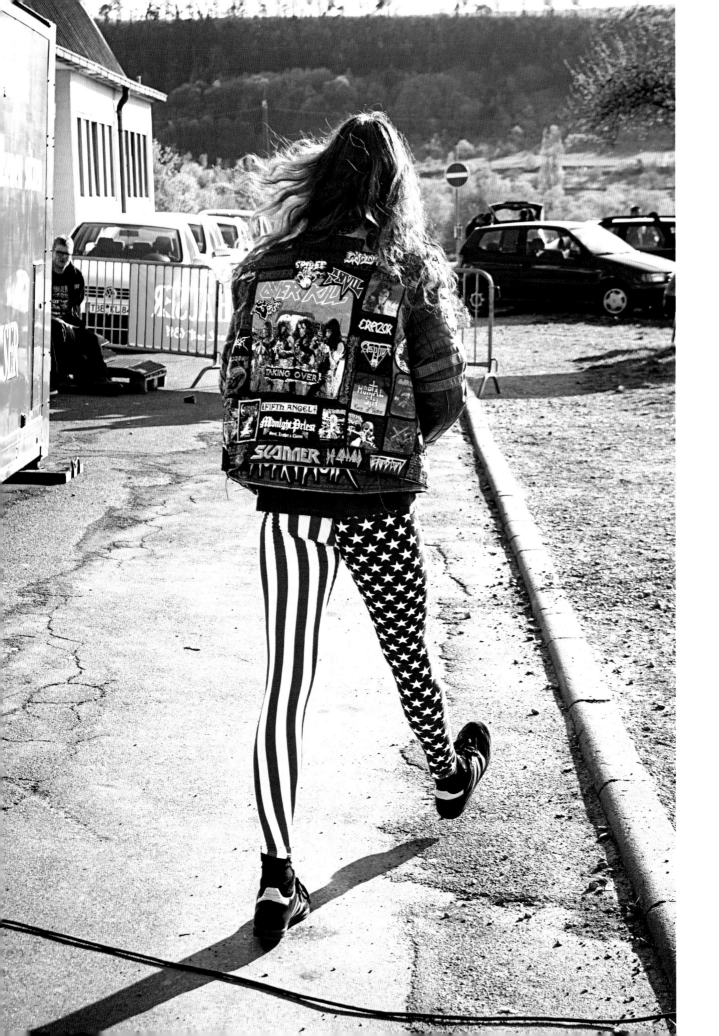

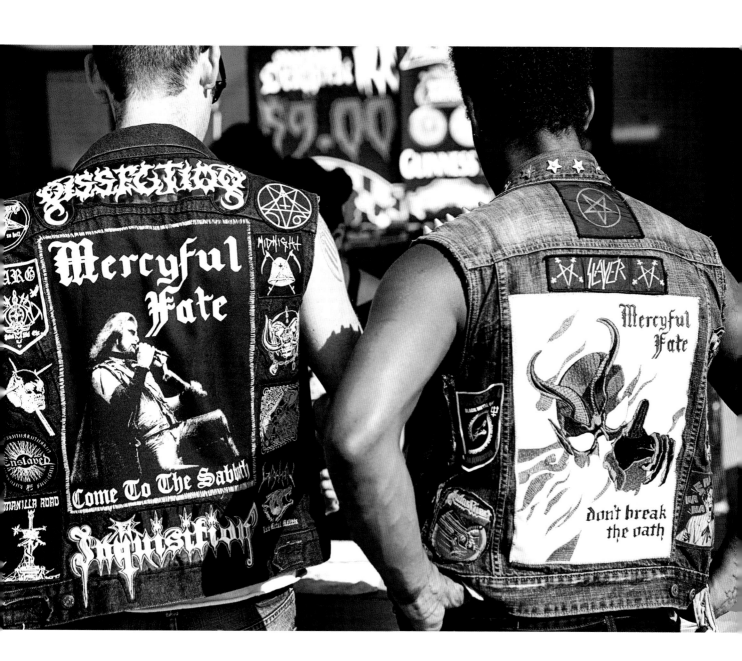

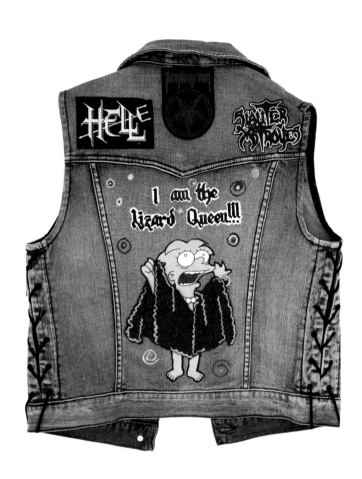

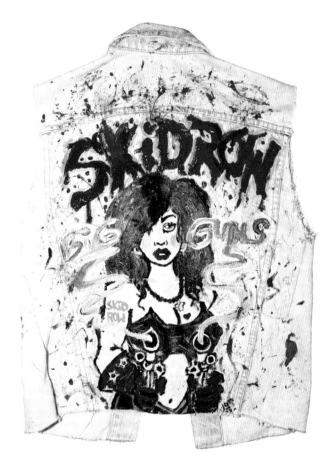

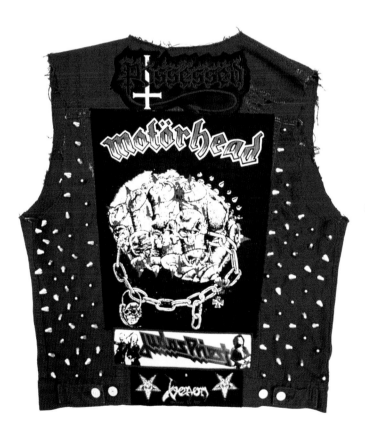

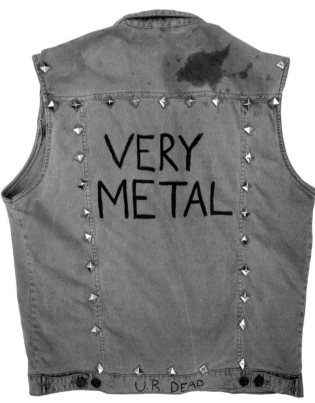

242

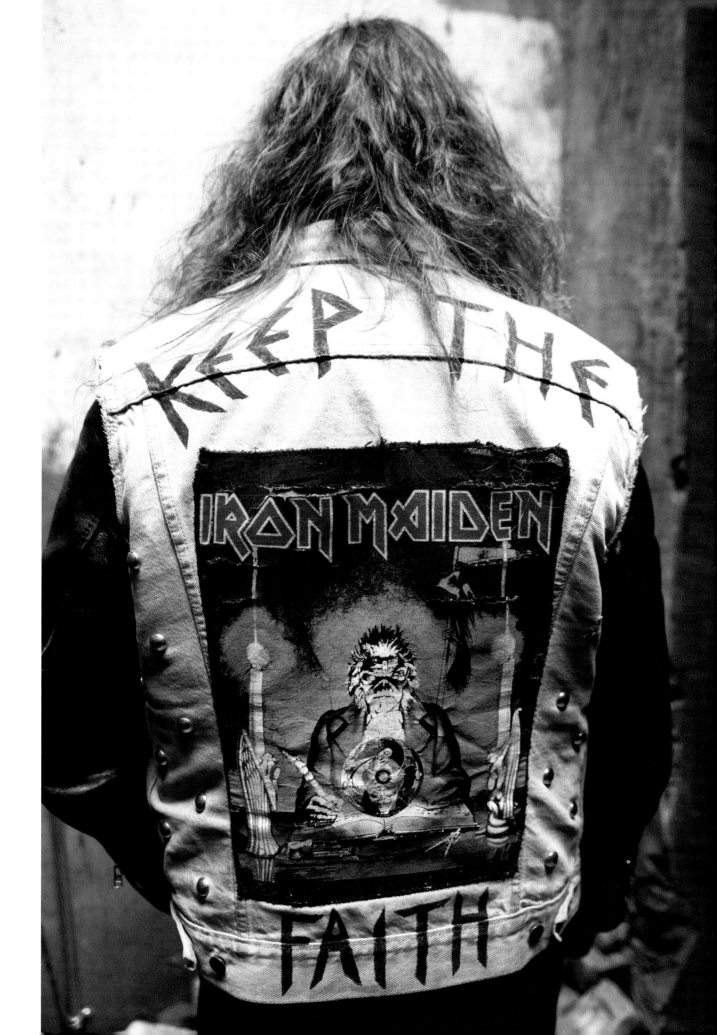

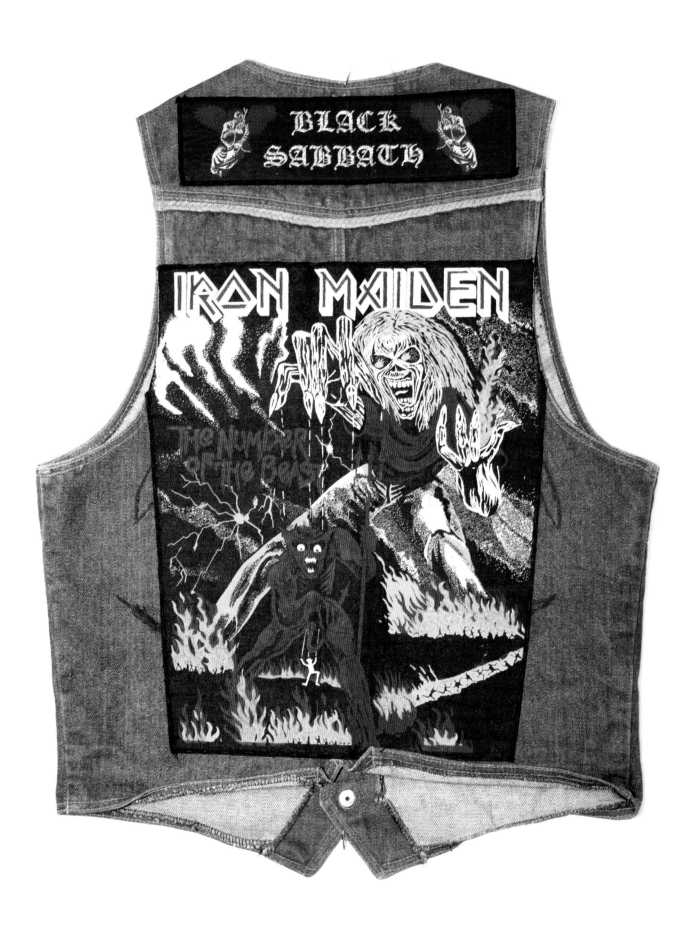

244

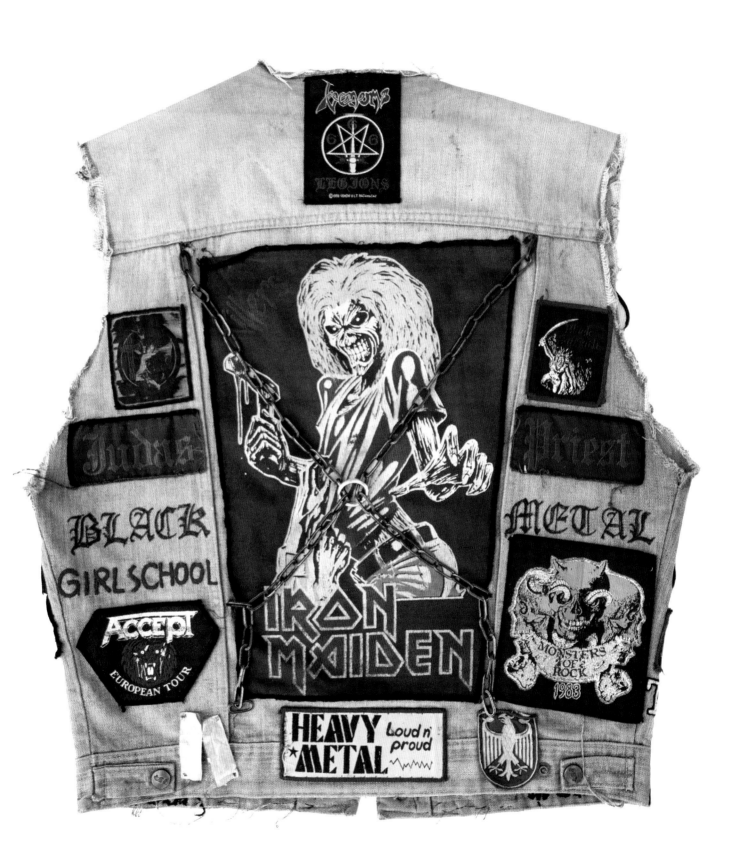

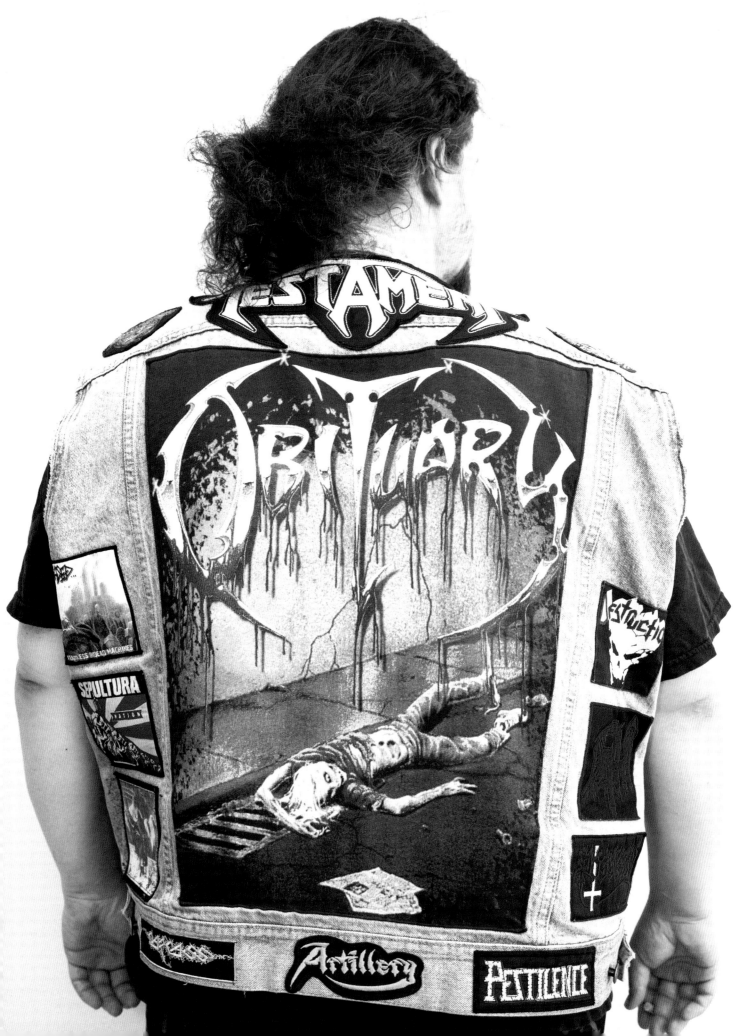

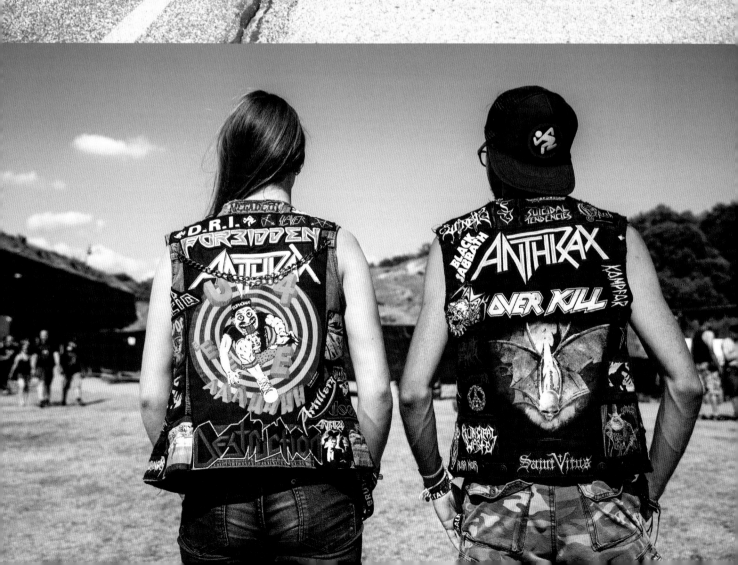

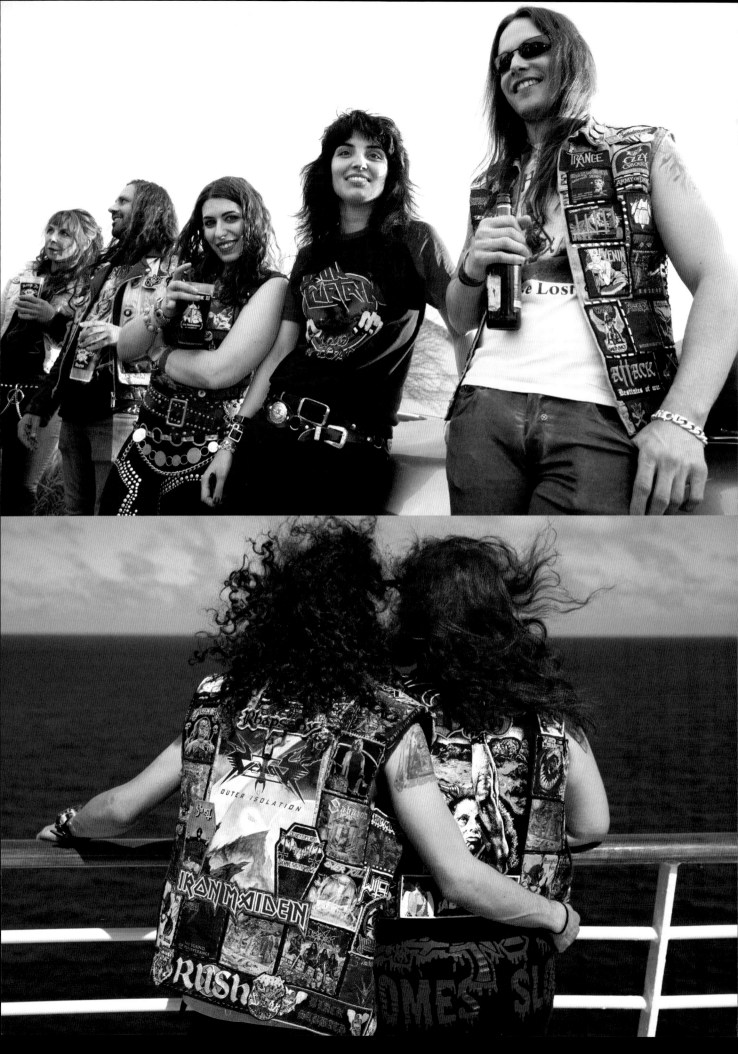

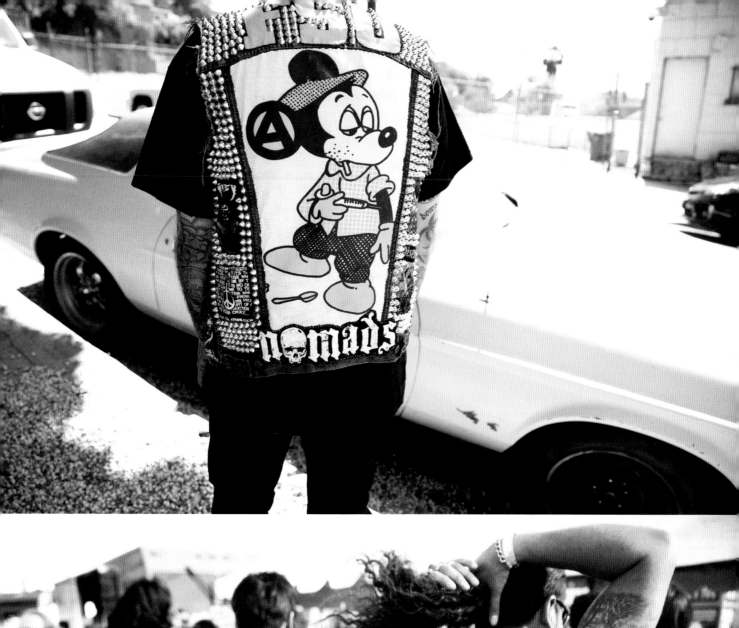
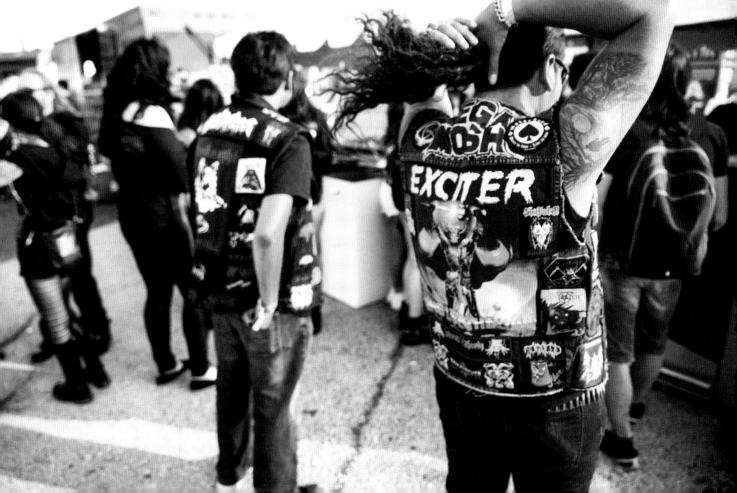

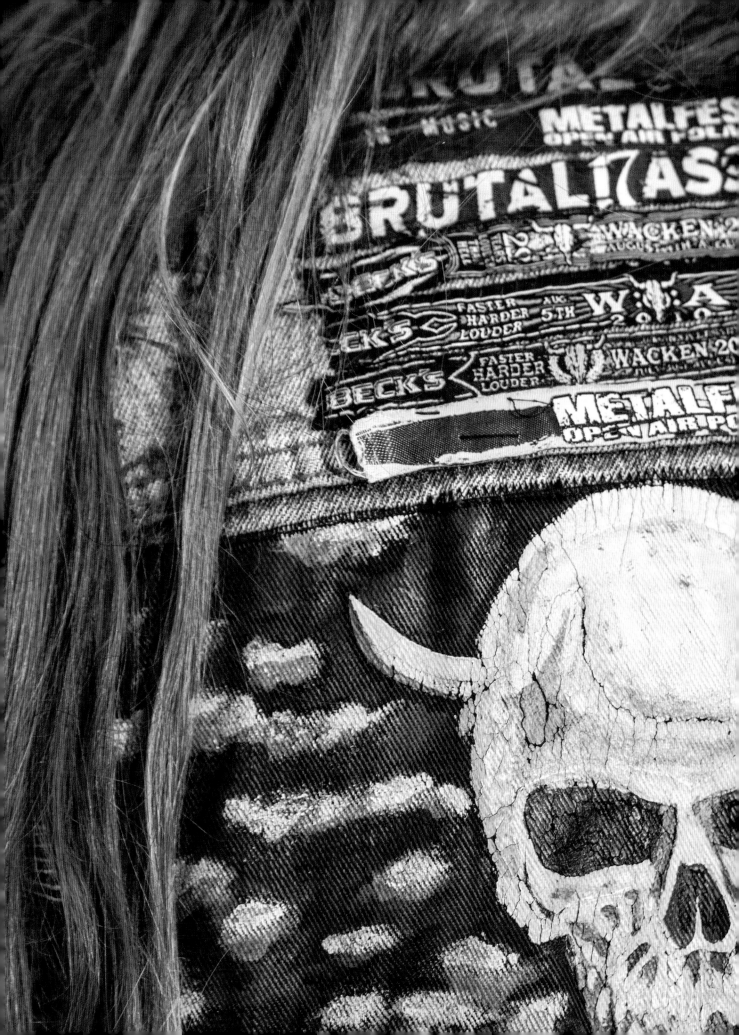

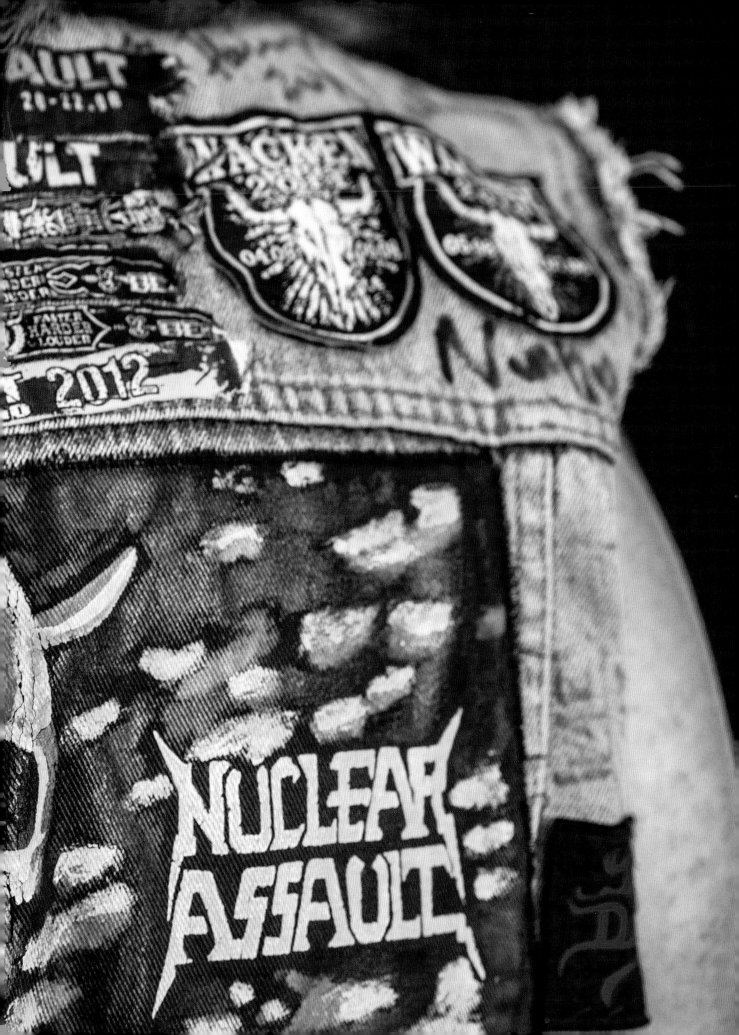

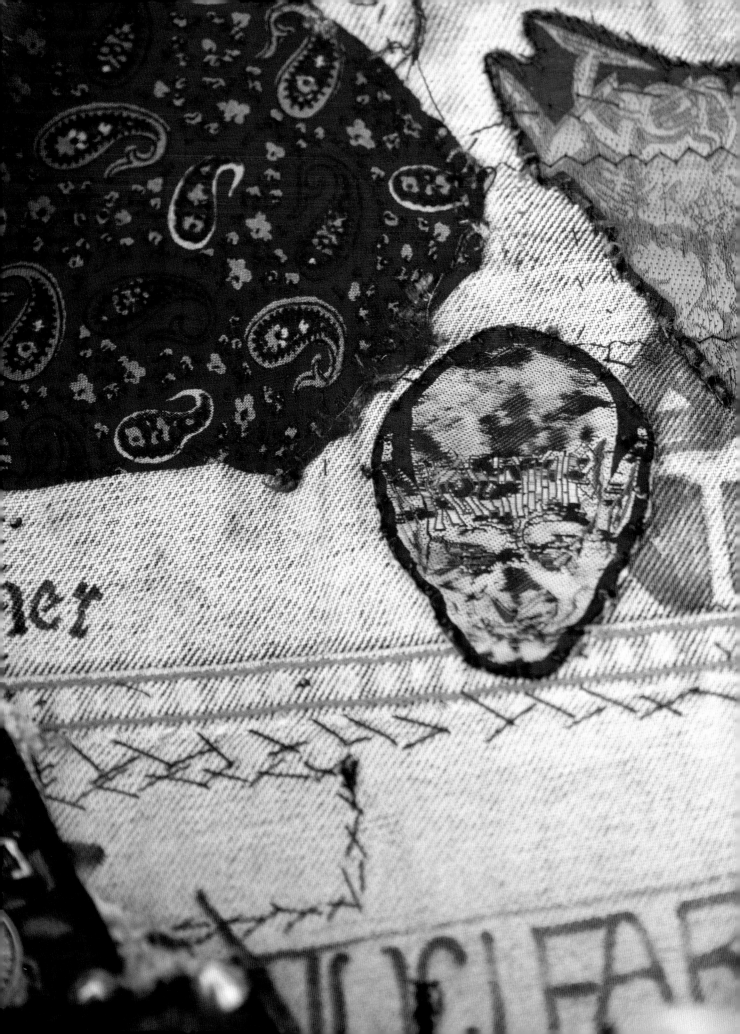

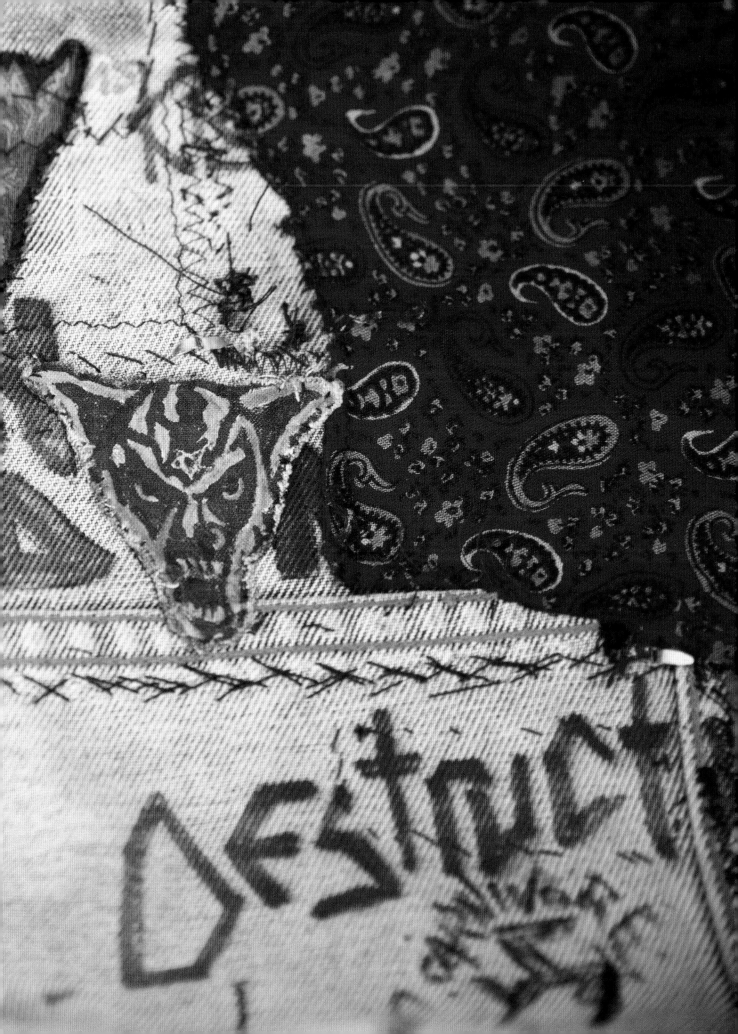

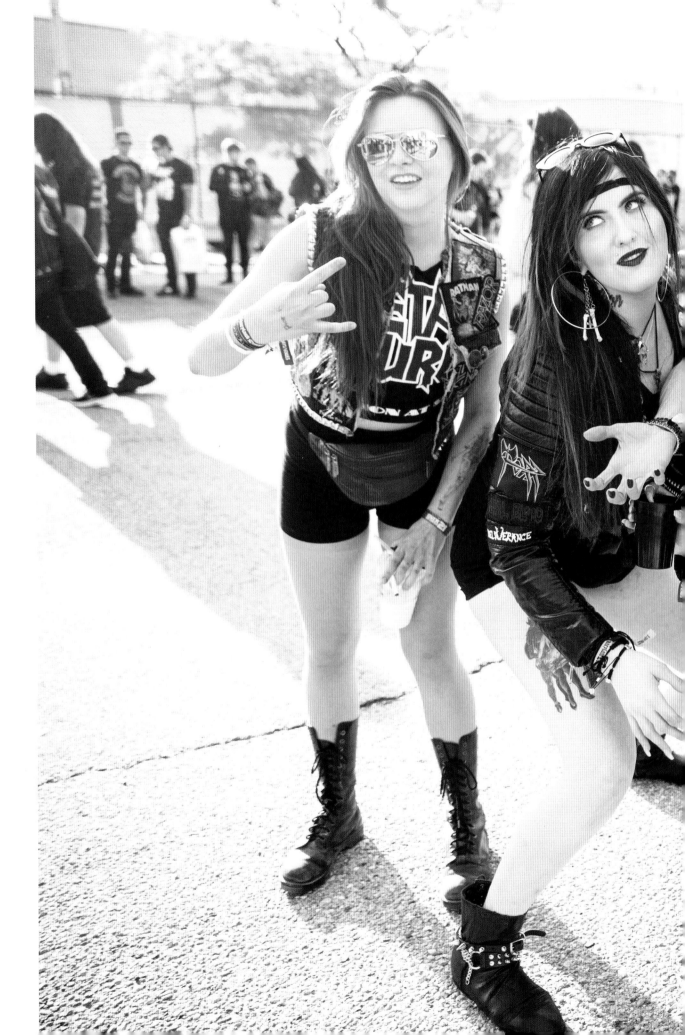

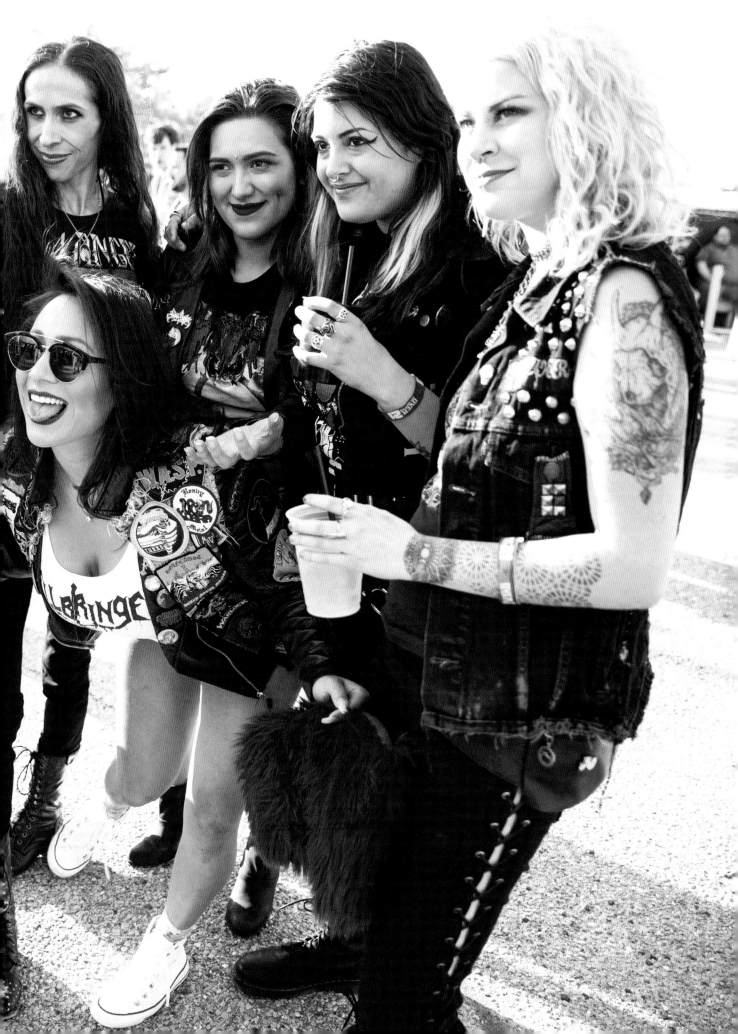

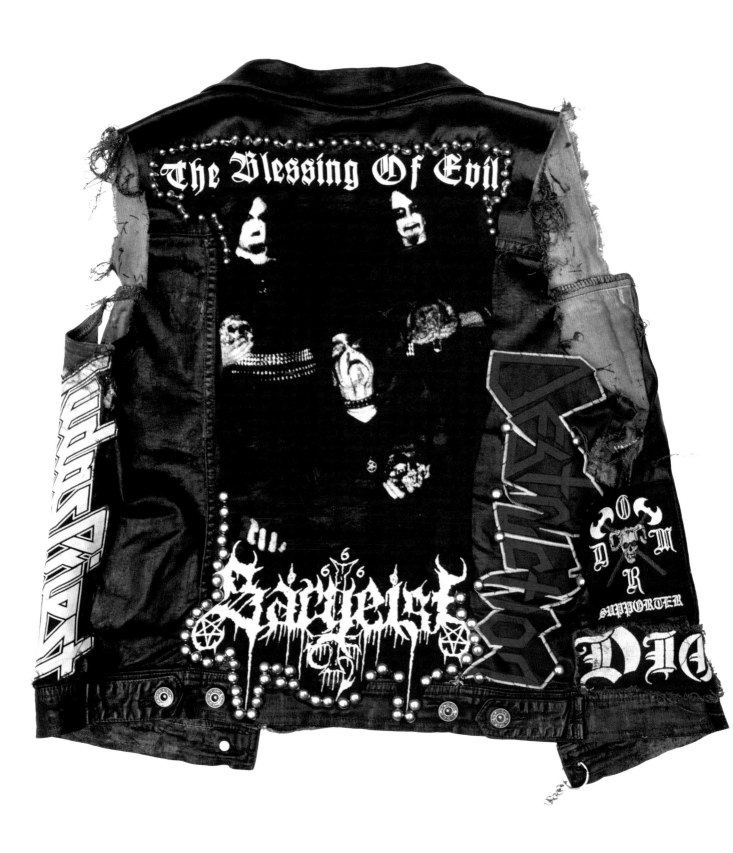

256

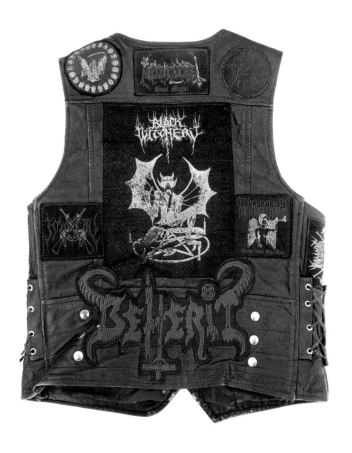

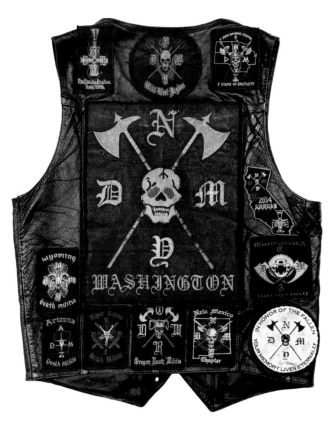

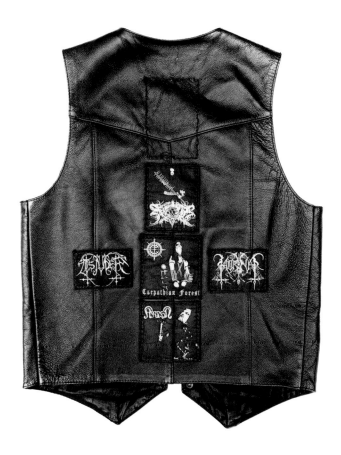

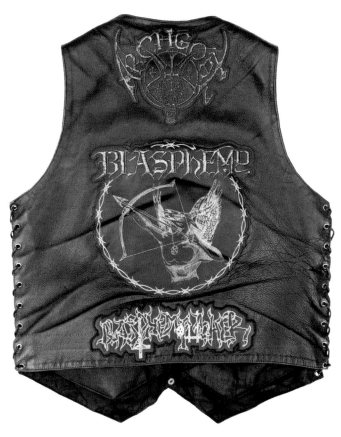

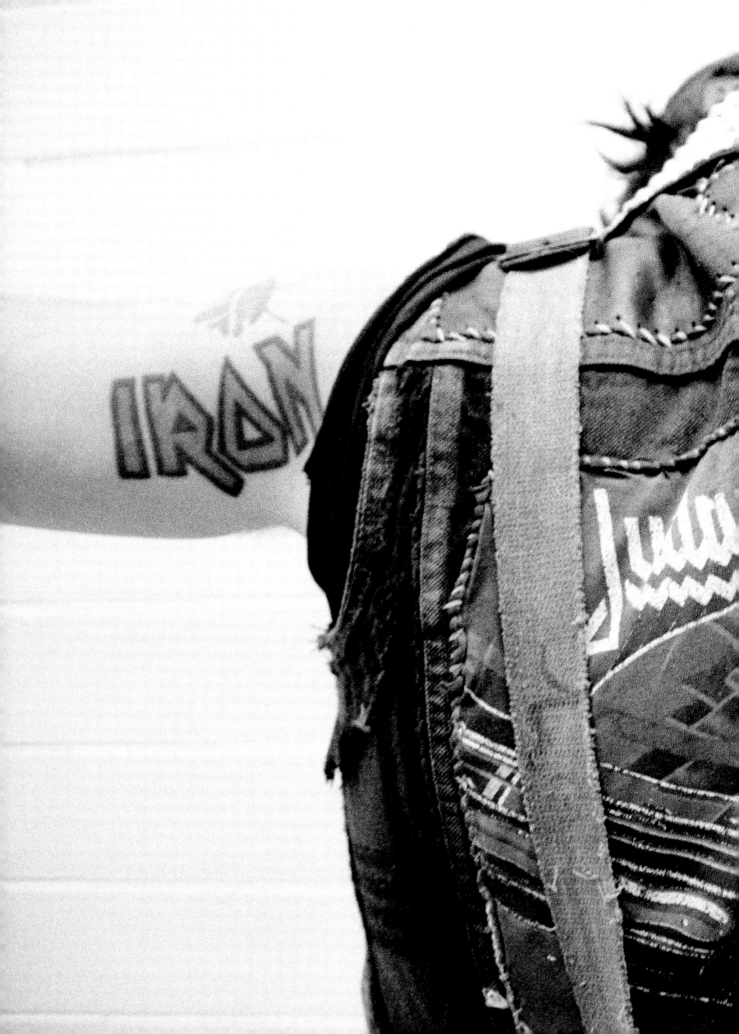

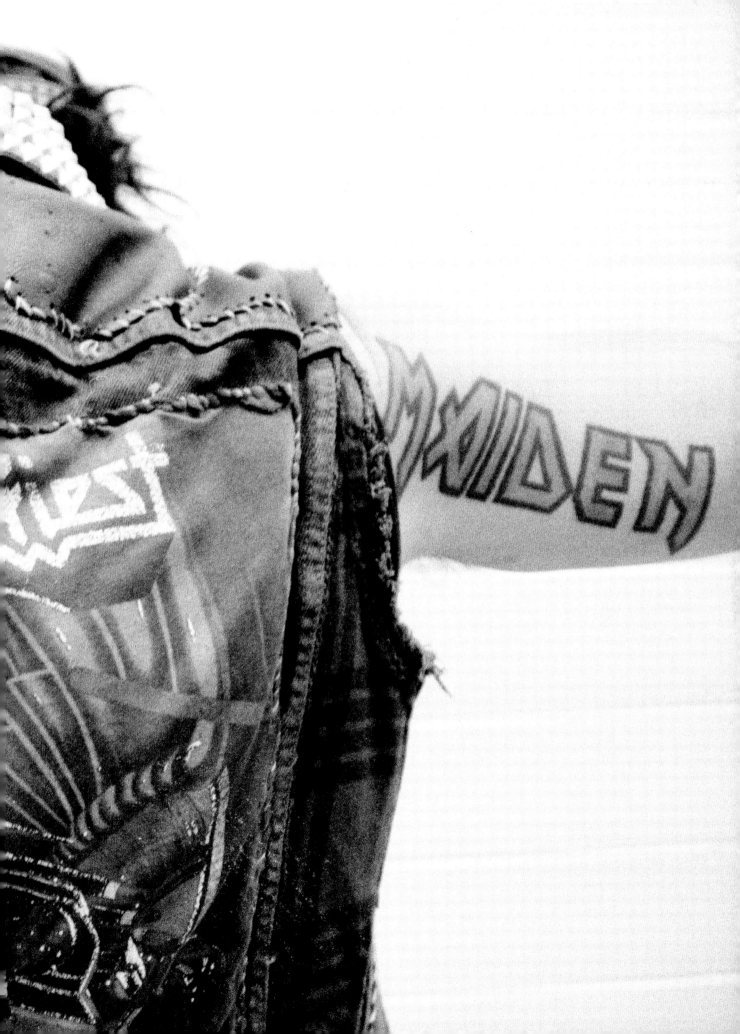

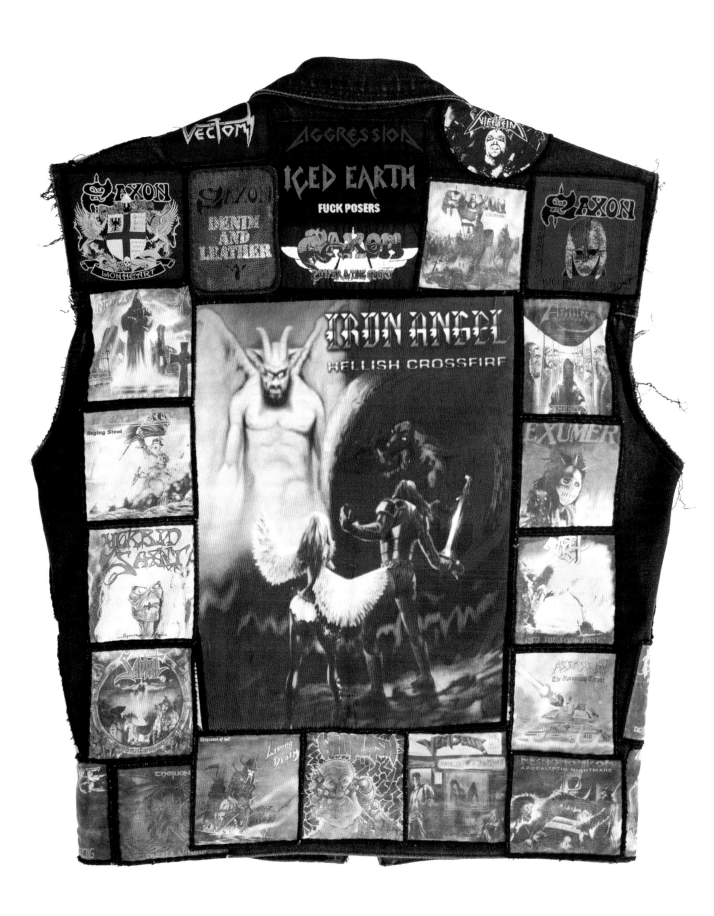

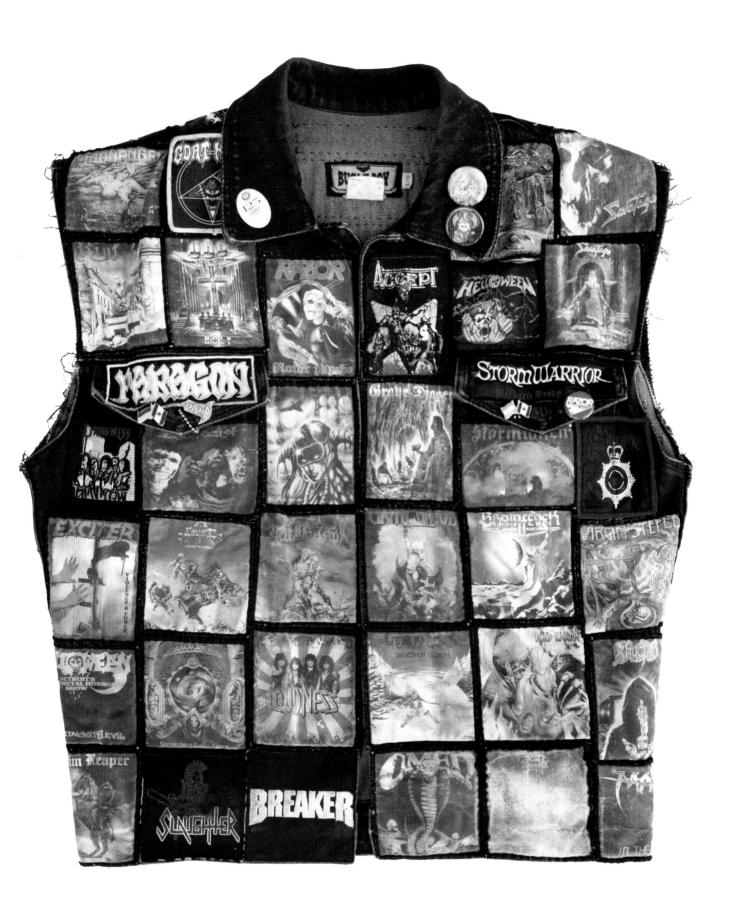

261

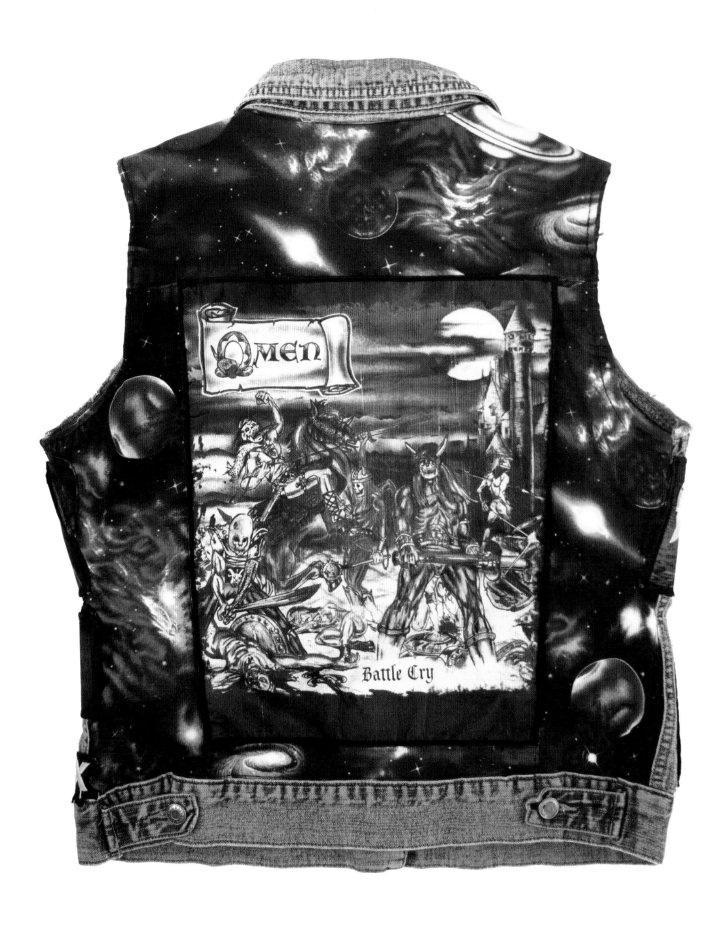

262

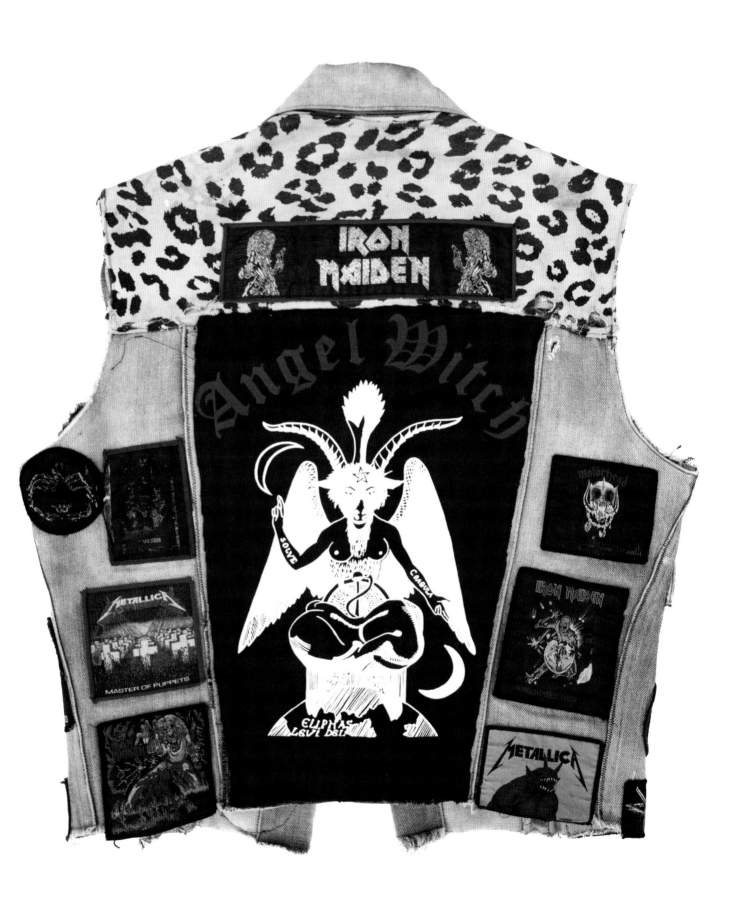

263

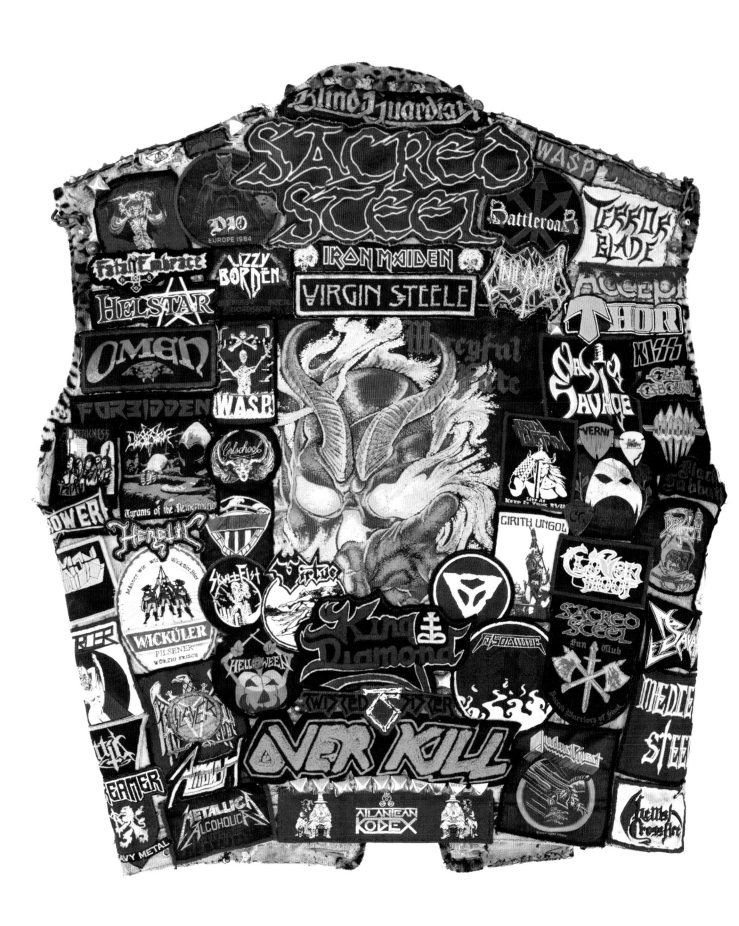

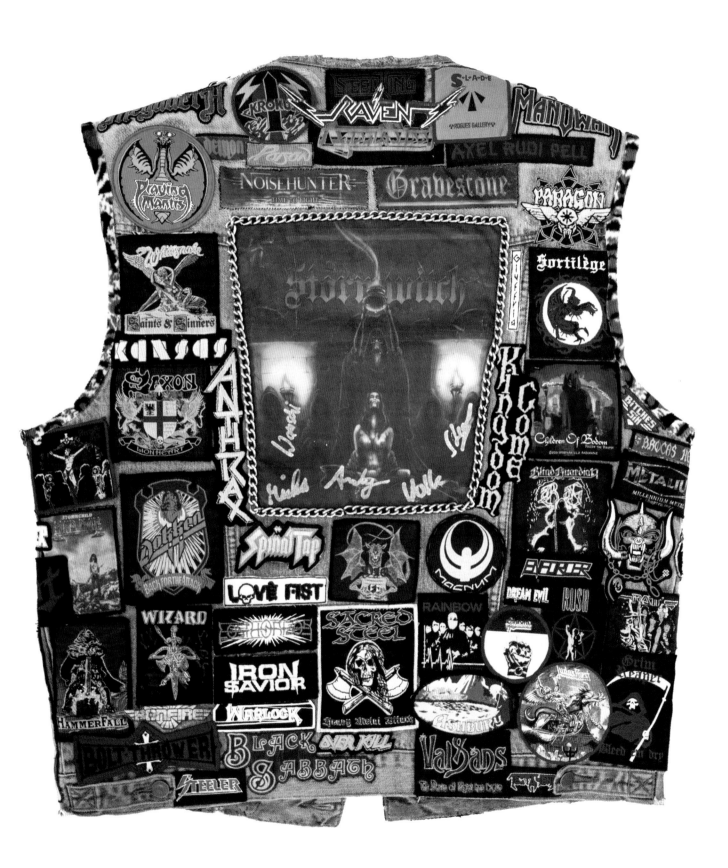

265

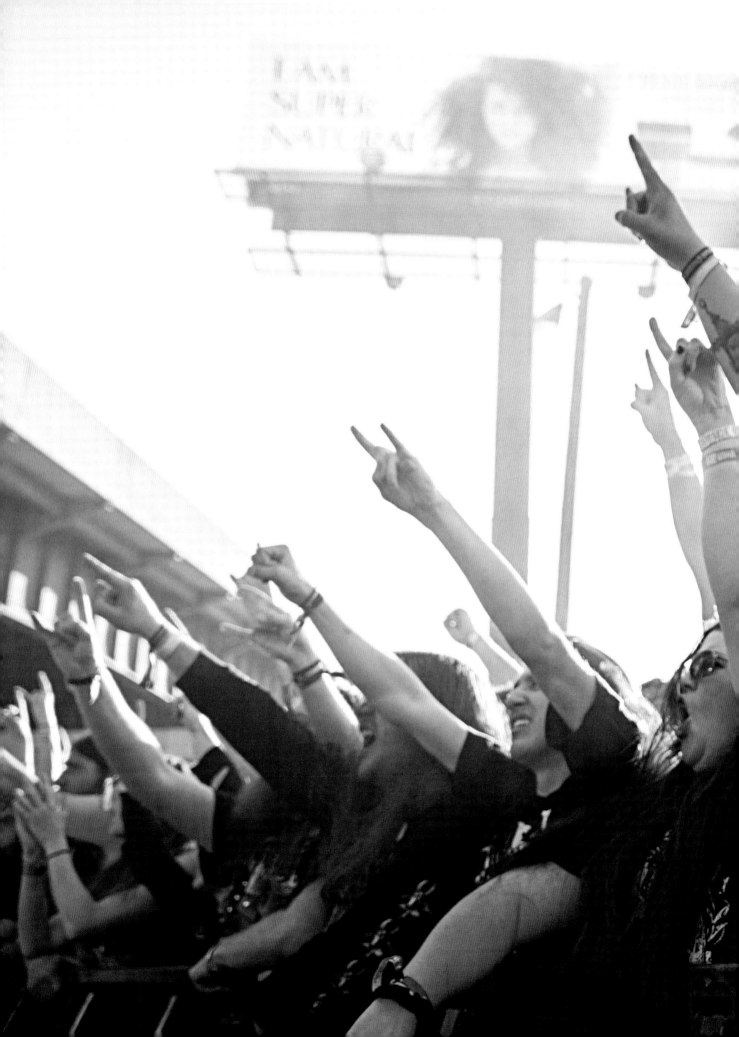

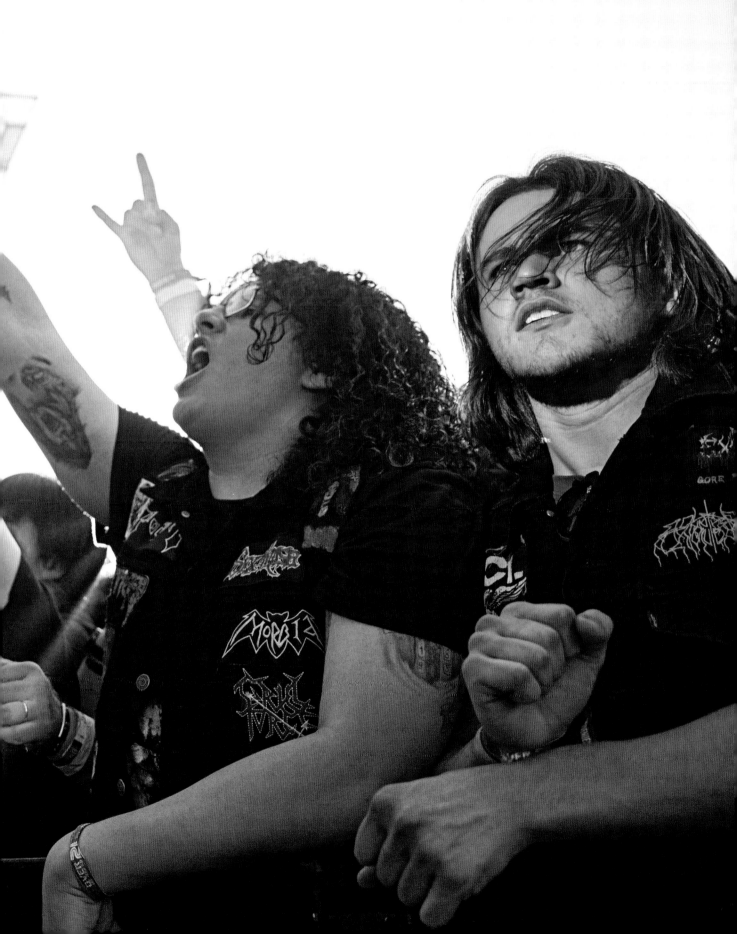

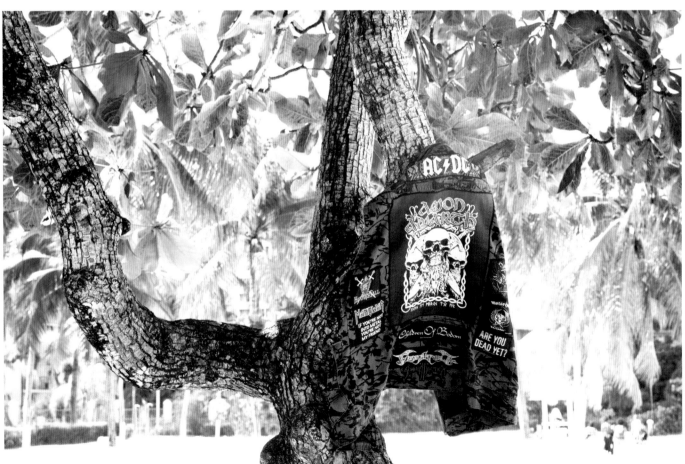

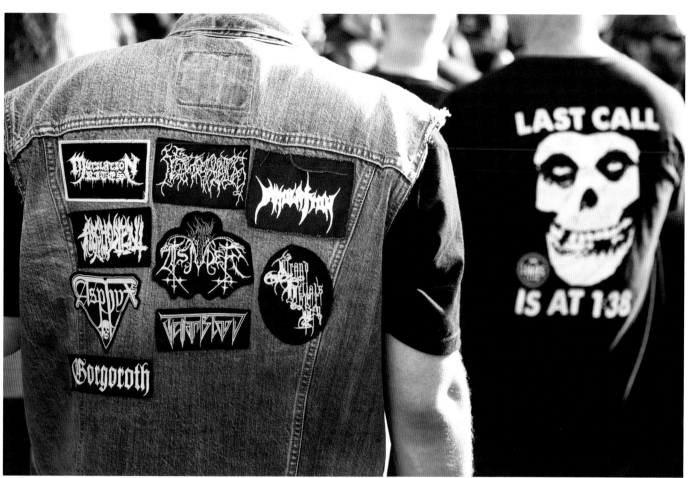

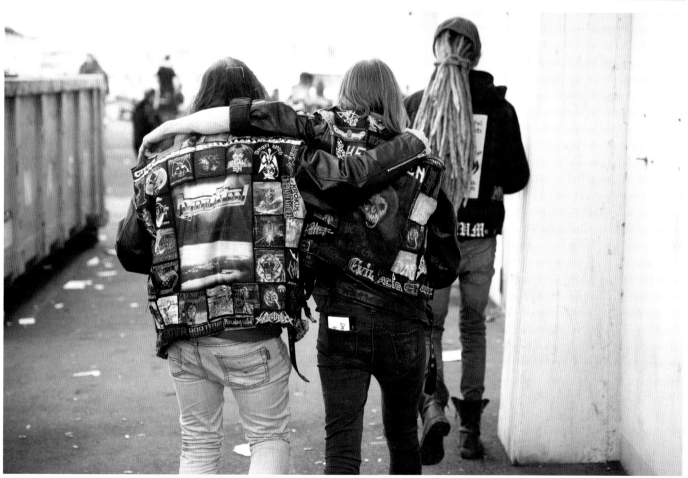

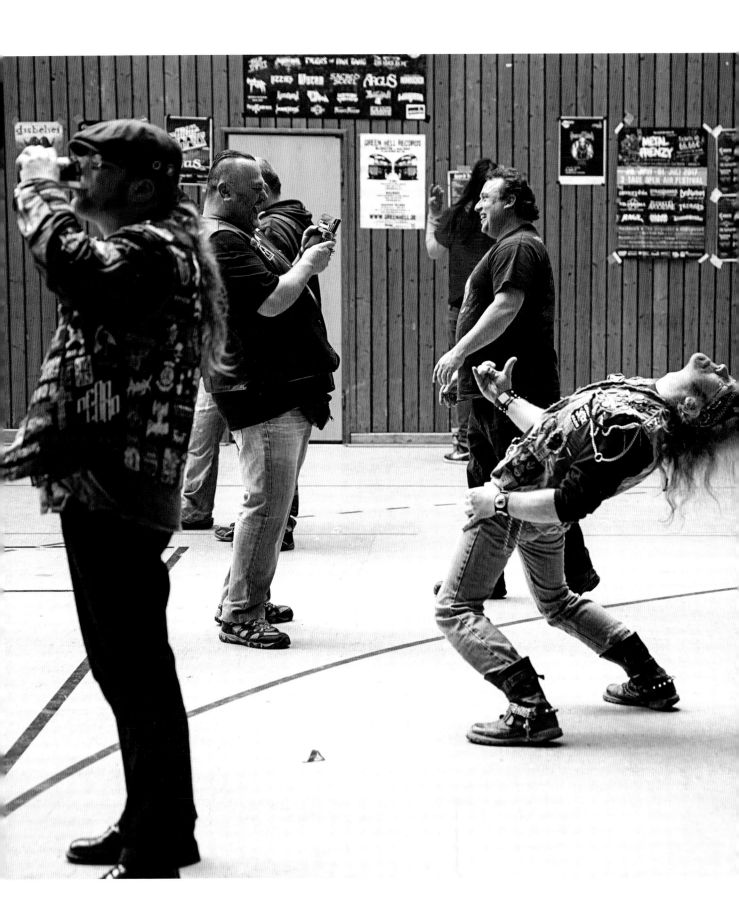

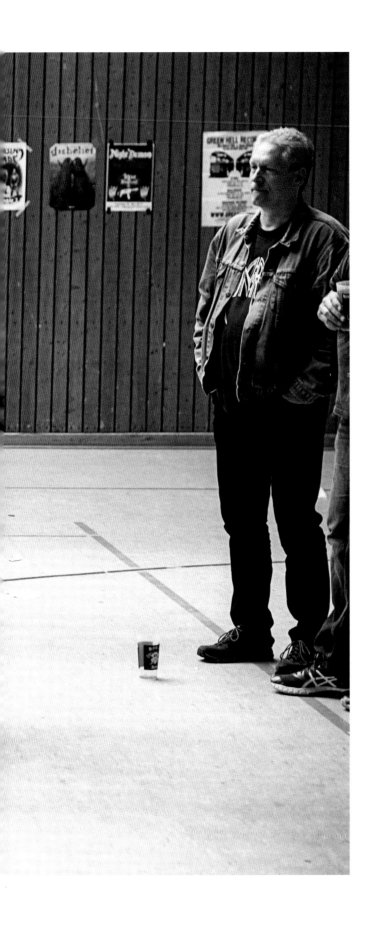

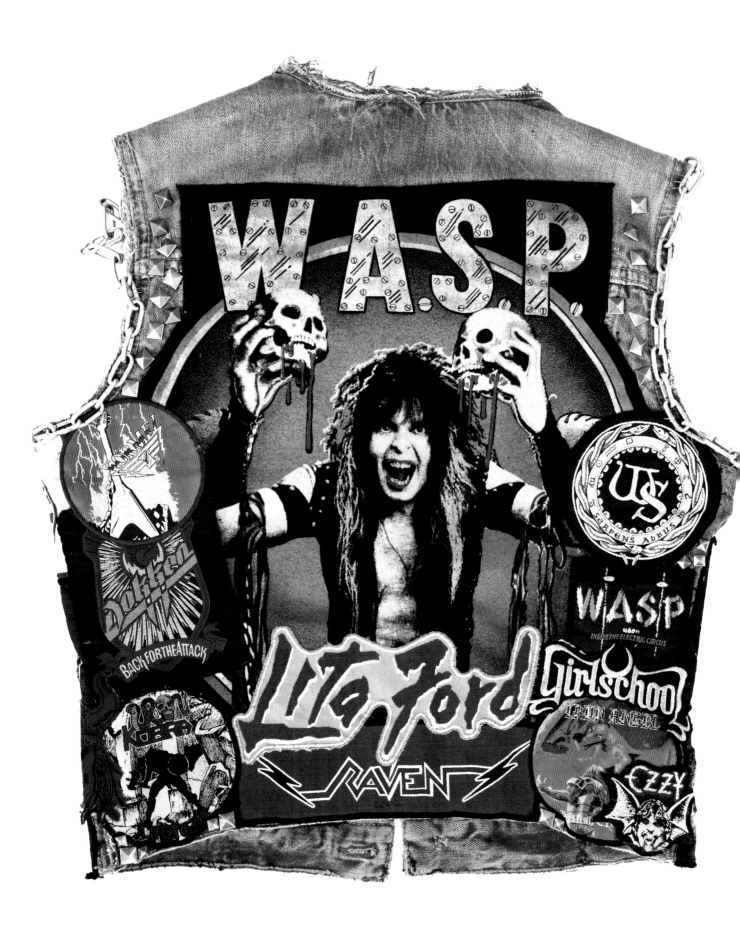

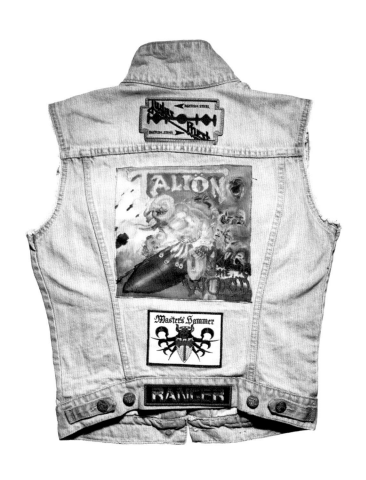

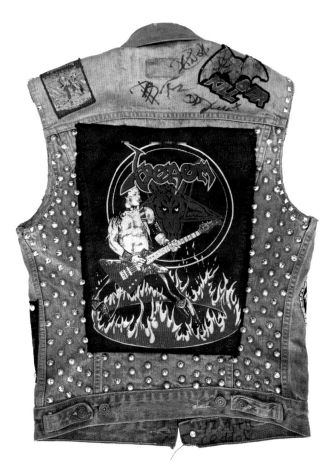

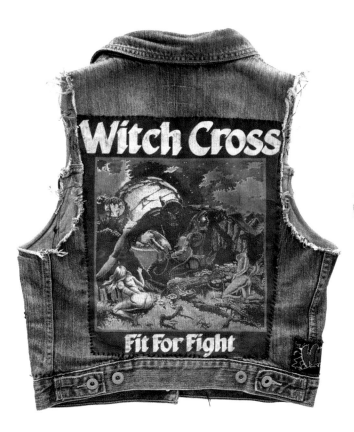

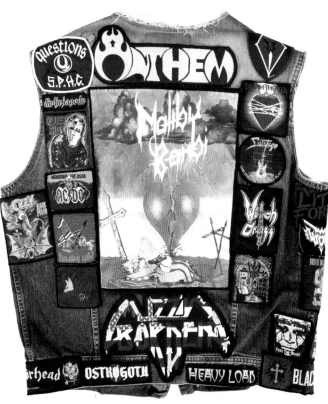

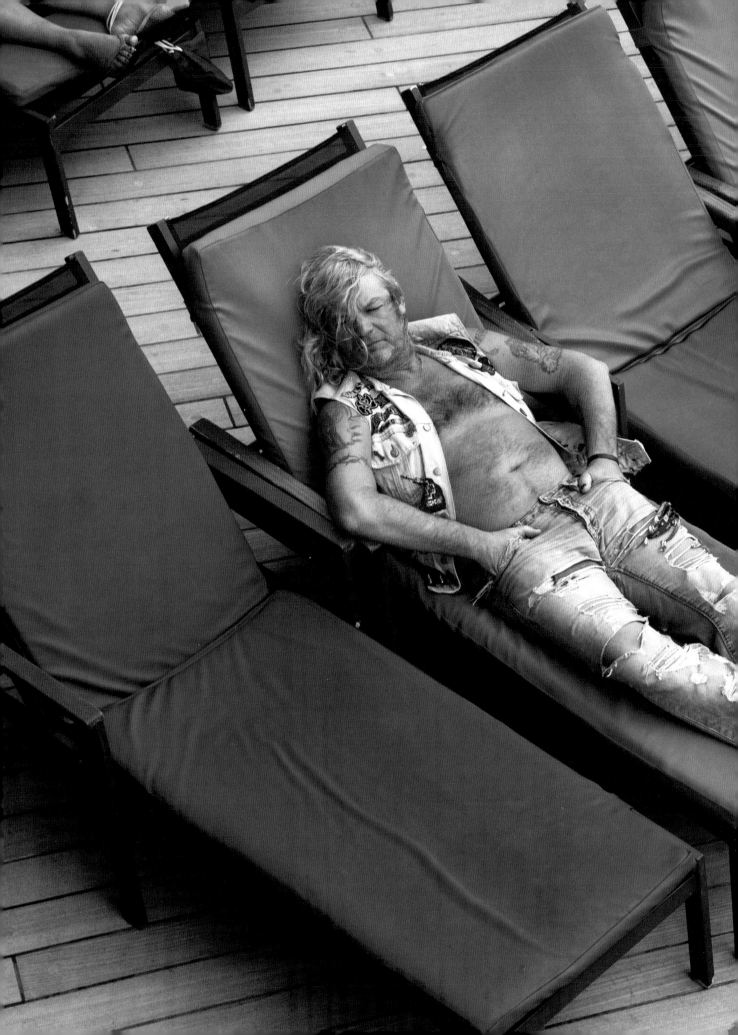

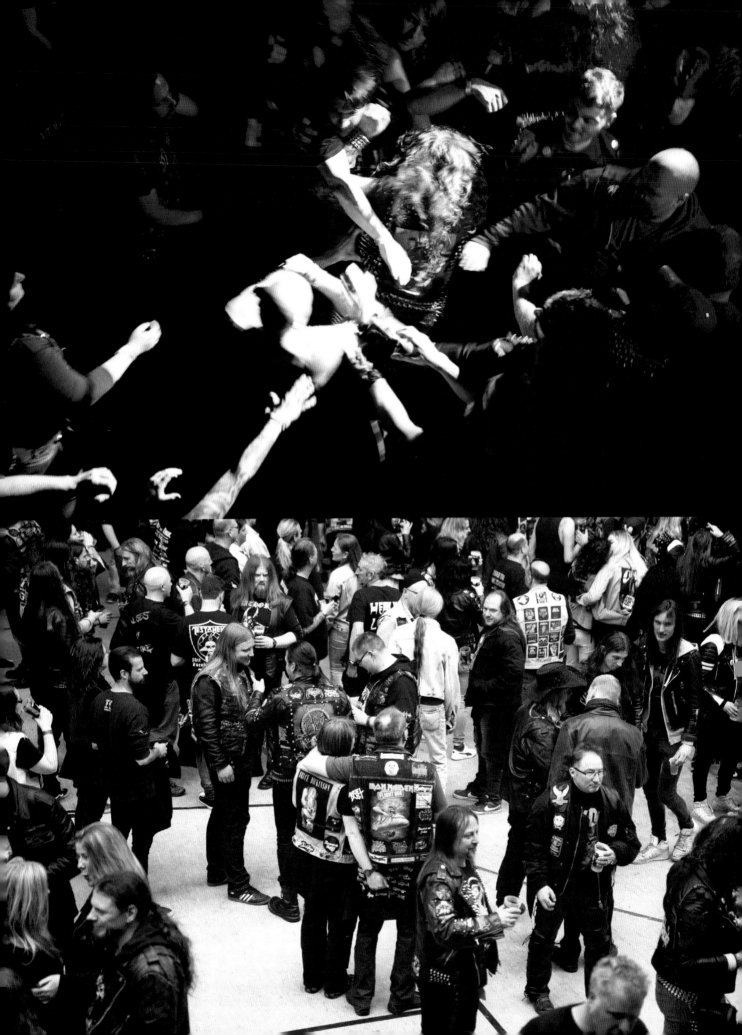

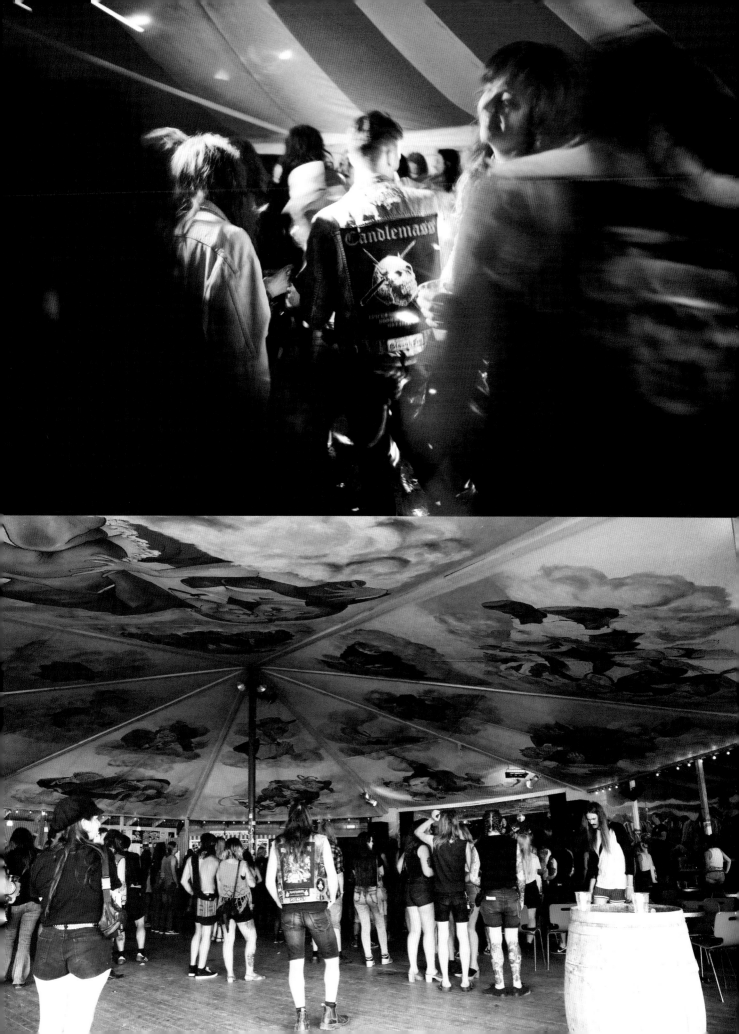

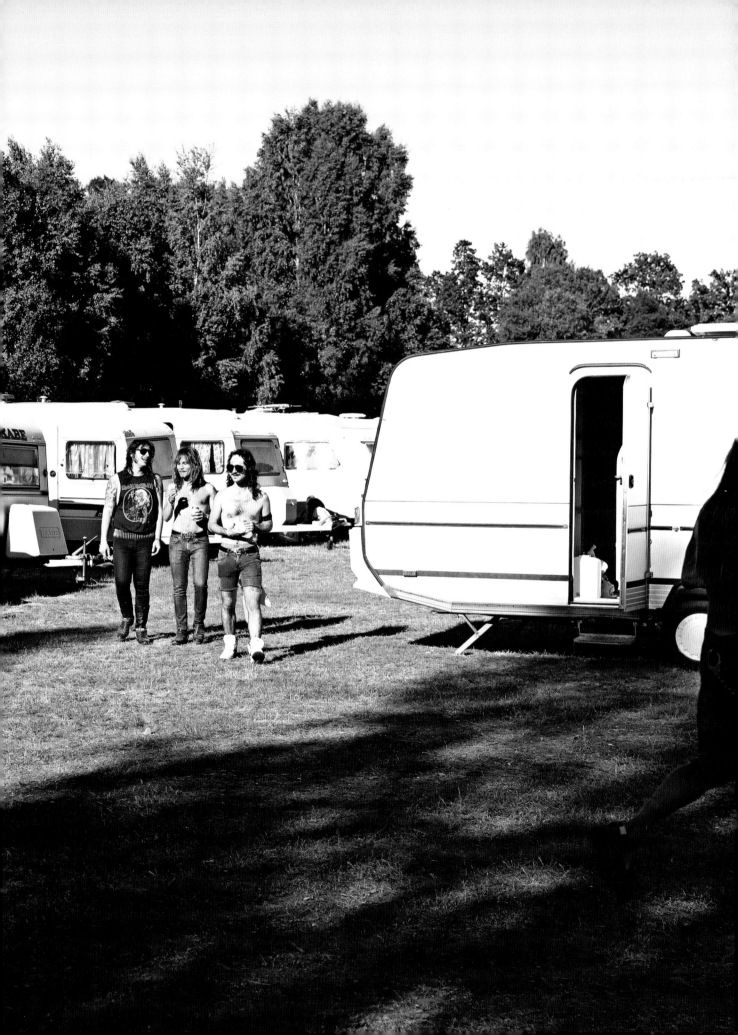

INDEX

Endpapers (front): Andre McFife, Köln, Germany (vest detail)

Title Page: Fenriz of Darkthrone, Bergen, Norway, 2006

4/5: Keep it True, Germany, 2016

6/7: Fans during Exciter performance,
 Maryland Death Fest, 2016

8: Patrick, Germany
9: Saint Titus, Germany

10: Jörk David, Köln, Germany
11: Jörk David, Köln, Germany

12/13: Keep it True, Germany, 2016

14/15: Fans watching Omen, Keep it True, Germany, 2017

16: Keep it True, Germany, 2017
17: Keep it True, Germany, 2017

18: Hugo, Madrid, Spain

20: Martin Hammerheart, Canada

22: Stefan, Austria
23: Valentin Raymond, France

24/25: Members of Armory, Alvesta, Sweden

26: Oscar of Helvetets Port, Sweden, 2018
27: Fan from Singapore watching Rock Goddess performance,
 Keep it True, Germany, 2016

28: Mark Schwartz, Seattle, Washington
29: Mark Schwartz, Seattle, Washington

30: Mirko Scarpa, Oslo, Norway
31: Matthias Weber, Switzerland

32/33: Muskelrock, Sweden, 2018

34/35: Latvian Metal Brothers, Brutal Assault Festival,
 Czech Republic, 2015

36: Jake Rogers of Visigoth, Salt Lake City, Utah
37: Jake Rogers of Visigoth, Salt Lake City, Utah

38: Unknown, San Diego Swap Meet, 2015
39: Hector, Born For Burning. Los Angeles, California

40/41: Muskelrock, Sweden, 2018

42/43: Fans watching Oliver/Dawson Saxon, Muskelrock,
 Sweden, 2018

44: Thomas Mandilas, Buffalo, New York
45: Thomas, Hamburg, Germany

46/47: Keep it True crowd, Germany, 2016

48: Mats Vogt with members of Armory, Sweden, 2018
49: Deathhammer, Kolbotn, Norway, 2017

50: Muskelrock, Sweden, 2018
51: Keep it True, Germany, 2017

52: Jake James, Florida
53: Rian James, Florida

54/55: Sadistic Intent, Los Angeles, California

56: High on Fire patch
57: Brutal Assault Festival, Czech Republic, 2015

58/59 Andre McFife (vest detail), Köln, Germany

60: Andre McFife, Köln, Germany
61: Andre McFife, Köln, Germany

62: Ian "Izzy" Dylan Alkire, 2016 (1991 – 2019)
 Sherlock, dog vest by Pethaus, 2016
63: Maryland Death fest during Hail of Bullets
 performance, 2016

64/65: During Medieval Steel performance, Keep it True,
 Germany, 2017

66: Gerd, Germany
67: Martin Baumann, Germany
 Ronniem Germany
 Gerd, Germany
 Brandon Brown of Savage Master, Harrodsburg, KY

68: Mats Vogt, Muskelrock, Sweden, 2018
69: Josh, Los Angeles, California, 2015

70: Jörk David, Köln, Germany
71: Stepo, Germany
 Felix, Germany
 Jörk David, Köln, Germany
 Daniel, Sweden

72: Adriana, Los Angeles, California
 Reiner, Dortmund, Germany
 Magnus, Sweden
 Unknown, California
73: Eric Roy, New York, New York

74: Andy Kassel, Germany
75: Unknown, California
 S. Schmal, Germany
 Kyle Legnon, Seattle, Washington
 Ieltxu, Bilbao, Spain

76/77: Chris Osterman of Iron Kingdom, Vancouver, British Columbia, 2016

78: Keep it True, Germany, 2016
79: Muskelrock couple, Sweden, 2018

80: Chris Rojas, Los Angeles, California
 Katon W. De Pena of Hirax
 William Murphy, Maryland
 Alysa, Wisconsin
81: Hansi Hilmer, Boise, Idaho

82/83: Hanna Hutzelmeier, Schwalbach, Germany

84: Saint Titus, Germany
85: Michael, Bavaria, Germany
 Dirk, Hamburg, Germany
 Maximillian Kreter, Gelsenkirchen, Germany
 Uwe Seger, Germany

86/87: Manilla Road, Muskelrock, Sweden, 2018

88: Muskelrock stage, Sweden, 2018
 Bullet Tour Bus, Muskelrock, Sweden, 2018
89: Fans watching Cirith Ungol, Muskelrock, Sweden, 2018
 Fans watching Night Demon, Keep it True, Germany, 2017

90: Stefan Hüskens of Metalucifer & Asphyx
 Dee Snider vest by Tore Bratseth of Old Funeral & Bombers
91: Dito, Italy
 Katon W. De Pena of Hirax

92: Keep it True, Germany, 2016
93: Keep it True, Germany, 2017

94: Jesse Elliot, Portland, Oregon
 Andreas Bosshard, Switzerland
 Fenriz of Darkthrone, Kolbotn, Norway
 Franzos of Stormhunter, Germany
95: Christian Wachter, Germany
 Don of the Dead of Nunslaughter
 Hanna Hutzelmeier, Schwalbach, Germany
 Dirk Volkmer, Hamburg, Germany

96/97: Keep it True, Germany, 2017

98/99: Tschak Tyrolean from Austria

100: Jake Rogers of Visigoth signing a vest for a fan, Keep it True, Germany, 2017
101: Lunchtime, Keep it True, Germany, 2017

102/103: Keep it True, Germany, 2017

104: Jon Medina, Painted by Justine Gonzalez
 Alex Miletich, Painted by Justine Gonzalez
 Ray from Cemetery Lust, Painted by Justine Gonzalez
 Martin Bemsel, Innsbruck, Austria
105: Bergelmir Crowley, Lauda-Konigshofen, Germany

106/107: Jake and Rian watching Exciter, Maryland Death Fest, 2016

108: Brutal Assault toilet, Czech Republic, 2015
109: Brian Crabaugh, Portland, Oregon

110: Aris Hunter Wales of Bewitcher, Portland, Oregon
111: Fenriz of Darkthrone, Bergen, Norway, 2006

112: Maryland Death Fest, 2016
113: Keep it True, Germany, 2016

114/115: Julia von Krusenstjerna & Sven Nilsson of Mystik, Musklerock, Sweden, 2018

116/117: Eduardo from Colombia, Maryland Death Fest, 2015

118: Dirk Volkmer, Hamburg, Germany
119: Andi Overkiller, Germany

120: Simon Bitterlich, Germany

121: Cory Knochenmus
 Marco, Germany
 Joel Grind of Toxic Holocaust, Portland, Oregon
 Unknown, Copenhell, Denmark

122/123: Couple, Keep it True, Germany, 2017

124: Keep it True, Germany, 2017
125: Keep it True, Germany, 2017

126/127: Keep it True, Germany, 2016

128/129: Maryland Death Fest, 2016

130/131: Keep it True, Germany, 2016

132: Nico Sauer, Germany
133: Cet, Germany

134: Mario Diaz, San Jose, California
 Henning, Germany
 Dave Duss, Switzerland
 Thomas Mandilas, Buffalo, New York
135: Thomas Brock, Germany

136/137: Muskelrock crowd during Zone Zero, Sweden, 2018

138: Peter Beste, Oregon
139: Peter Beste, Oregon

140: Nico Sauer, Germany
141: Stepo, Germany
 Andi Overkiller, Germany
 Iced Raid, Germany
 Thomas Brock, Germany

142: Bergelmir Crowley, Germany
143: Bergelmir Crowley, Germany

144: Paul Ehrenhardt of Stallion, Germany
145: Meshack, Portland, Oregon

146: Eric, Austria
 Tom, Germany
 Jaime Alberto, Monterrey, Mexico
 Alex Panz, Germany
147: Mart, Netherlands
 Marco Piña, Mexico City, Mexico
 Quinto, Italy
 Adem Akoz, Austria

148/149: 70,000 Tons of Metal cruise, 2016

150: Kim Galdamez, Los Angeles, California
151: Kim Galdamez, Los Angeles, California

152: Keep it True, Germany, 2016
153: Keep it True, Germany, 2017

154/155: Kim Galdamez, Los Angeles, California

156: Tim, Switzerland
157: Phil, Germany

158: Thomas Mandilas, Slayer vest (front)
159: Thomas Mandilas, Sodom vest (front)

160: Sven, Germany
 Jason Conde-Houston of Skelator, Seattle, Washington
 Jake Rogers of Visigoth, Salt Lake City, Utah
 Arne, Germany
161: Paul Berumen, Los Angeles, California
 Nacho, Madrid, Spain
 Popel Astra, Hamburg, Germany
 Martin Schulze, Essen, Germany

162/163: Maryland Death Fest couple, 2016

164: Maryland Death Fest, 2016
165: Bruce, Austria
 Adrian Parsons, Saskatoon, Saskatchewan, Canada
 Rotting Bitch, New Jersey
 Andross Drake of Panzergod/Peste Umbrarum

166/167: Nergal of Behemoth, Live in Eugene, Oregon, 2017

168: Rian James, Florida
 Thomas Mandilas
 Kim Galdamez
 Michelle
169: Josh, Los Angeles, California

170/171: Crowd during Hirax performance,
 Maryland Death Fest, 2016

172: Jef Whitehead of Leviathan with his daughter Grail,
 Portland, Oregon, 2016
173: Visigoth & Sherlock, Portland, Oregon, 2016

174: Javier Arias Garrosa, Madrid, Spain
175: Hansi Hilmer, Boise, Idaho
 Javier Arias Garrosa, Madrid, Spain
 Rachael McDonell, Atlanta, Georgia
 Javier Arias Garrosa, Madrid, Spain

176: Unknown, Germany
 Ronya Reinprecht, Innsbruck, Austria
 Yazan Chilch, Germany
 Kim Galdamez, Los Angeles, California
177: Keep it True, Germany, 2016

178: Meschack, Portland, Oregon
179: Tobias Gregor, Germany
 Iced Raid, Germany
 Diane Maya, Los Angeles, California
 Toni Moreno, Spain

180/181: Lauda-Konigshofen, Germany, 2016

182/183: Fans watching Soulfly on 70,000 Tons of Metal cruise, 2015

184/185: Abbath driving in Western Norway, 2007

186: Joop, Netherlands
 Thomas Mandilas, Buffalo, New York
 Thomas Mandilas, Buffalo, New York
 Alberto de larra Carrión, Spain
187: Thomas Mandilas, Buffalo, New York

188/189: Hector, Erick, Kim, Josh, Los Angeles, California, 2015

190/191: Bob of Hellhunter, San Francisco, California, 2015

192: Keep it True, Germany, 2017
193: Vest Detail, Keep it True, Germany, 2016
 Vest Detail, Keep it True, Germany, 2016
 Vest Detail, Amy Lee Carlson of Substratum, 2016,
 Keep it True, Germany, 2016

194/195: Members of Armory, Alvesta, Sweden, 2018

196: Ray of Cemetery Lust, Portland, Oregon
197: Bryan Patrick of Manilla Road, Sweden, 2018
 Camper Interior, Muskelrock, Sweden, 2018

198: Kim Galdamez, Los Angeles, California
 Keep it True exterior, Germany, 2016
199: Luke of Firecult, Vancouver, BC, 2016

200/201: Jon Mikl Thor, Muskelrock, Sweden, 2018

202: Phoebe Kuwahara and R.J. Larimore, Los Angeles,
 California, 2015
203: Jeff Monge of Nite Rite, New York, New York, 2015

204: R.J. Larimore, Los Angeles, California, 2015
205: Black Winds of Blasphemy, Vancouver, British Columbia,
 Canada, 2016

206: Mark "The Shark" Shelton of Manilla Road, 2015
 (1957 – 2018)
207: Mark Shelton's back patch

208: Jose Cristo Hernandez, San Diego, Calfornia
 Unknown, Los Angeles, California
 Tommy McDermott, California
 Phil Kyle, Pleurtuit, France
209: Raquel, California
 Robbie Houston of Skelator
 Unknown, Vancouver, British Columbia, Canada
 Robert, New York, New York

210/211: Audience at Old gig, Elm Street Pub, Oslo, Norway, 2002

212/213: Couple waiting for Testament concert,
 Maryland Death Fest, 2016

214/215: Ritual Butcherer of Archgoat, 2016

216: E. Hilterz audience, Muskelrock, Sweden, 2018
217: Björn of E. Hilterz, Muskelrock, Sweden, 2018

218/219: Cemetery Lust, Portland, Oregon, 2017

220: Daniel, Sweden
221: Manuel Weh, Germany
 Denis, Germany
 Jake Rogers of Visigoth, Salt Lake City, Utah
 Reiner, Dortmund, Germany

222: Felix, Germany
223: Thomas, Hamburg, Germany

224: Ralf, Germany
225: Patrick, Germany

226: Robert Jauregui, Los Angeles, California
227: Janin Klug, Germany
 Toni Moreno, Spain
 Hanna Hutzelmeier, Schwalbach, Germany
 Diane Maya, Los Angeles, California

228: Brutal Assault Festival, Czech Republic, 2015
229: Keep it True, Germany, 2017

230/231: Crowd during Hirax performance,
 Maryland Death Fest, 2016

232/233: Crowd during Bullet performance,
 Muskelrock, Sweden, 2018

234: Keep it True, Germany, 2017
235: Keep it True, Germany, 2016

236: Keep it True, Germany, 2017
237: Silenoz of Dimmu Borgir, Nannestad, Norway, 2003

238/239: Savage Master, Lauda-Konigshofen, Germany, 2017

240: Keep it True, Germany, 2017
241: Maryland Death Fest, 2016

242: Tina, Los Angeles, California
 Kim Galdamez, Los Angeles, California
 Eric Roy, New York, New York
 Unknown, Copenhell. Denmark
243: Chris Osterman of Iron Kingdom, Vancouver,
 British Columbia, Canada, 2015

244: Courtesy of UCLA collection
245: F.T. Wuppertal, Germany

246: Passenger on 70,000 Tons of Metal cruise
247: South American fans, Maryland Death Fest, 2015
 Brutal Assault Festival, Czech Republic, 2015

248: Spanish Crew at Keep it True, Germany, 2017
 Couple on 70,000 Tons of Metal cruise, 2017
249: Mike, Los Angeles, California, 2015
 Maryland Death Fest crowd, 2015

250/251: Brutal Assault, Czech Republic, 2015 (vest detail)

252/253: Felix, Germany (vest detail)

254/255: Ladies of Maryland Death Fest, 2015

256: Unknown, Portland Oregon
257: Bestial Saviour, Vancouver, British Columbia, Canada
 Gary Weber, Portland Oregon
 Jeremy Lucht, Portland, Oregon
 Bestial Saviour, Vancouver, British Columbia, Canada

258/259: Fan, Milwaukee Metal Fest, 2001

260: Clayton, Canada
261: Clayton, Canada

262: Madi Smith, Salt Lake City, Utah
263: Eddie, Netherlands

264: Ralf, Germany
265: Bernhard, Austria

266/267: Audience during Triptykon performance,
 Maryland Death Fest, 2015

268: Caravan, Muskelrock, Sweden, 2018
 Ocho Rios, Jamaica
269: Maryland Death Fest crowd, 2016
 Keep it True, Germany, 2017

270/271: Solitary rocker, Keep it True, Germany, 2017

272: Janin Klug, Germany
273: Jonas Bye of Flight, Painted by Helle Stenkløv
 Alex, Germany
 Rian James, Florida
 Andreas, Germany

274/275: 70000 Tons of Metal Cruise, 2015

276: Fistfight during Cirith Ungol performance, Defenders
 of the Old festival, Brooklyn, New York, 2017
 Keep it True, Germany, 2017
277: Party in the Tent, Muskelrock, Sweden, 2018
 Tyrolen, Muskelrock, Sweden, 2018

278/279: Campers, Muskelrock, Sweden, 2018

285: William Beste, 2017

Endpapers (back): Andre McFife, Köln, Germany (vest detail)

Thank you: Keep it True, Frost & Fire, Muskelrock, Maryland Death
Fest, Brutal Assault, 70000 Tons of Metal, Blekkmetal, Camilla Beste,
Christopher Rosales, Johan Kugelberg, Sacred Bones, Jon Mikl
Thor, Biff Byford, Dan Capp, Tuck Pendelton, Thurston Moore, David S.
Blanco, Martine Petra Hoel, Nico Poalillo, Pet Haus, Drowned in
Black, T-Shirt Slayer, and everyone around the world who helped me
with this project!

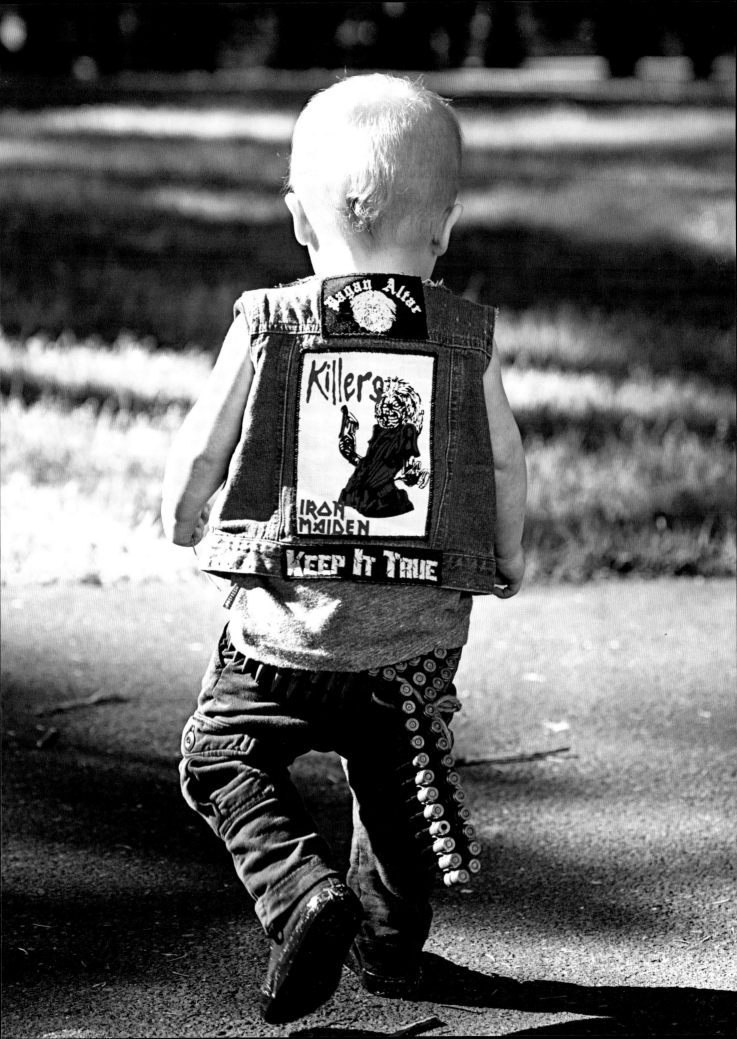

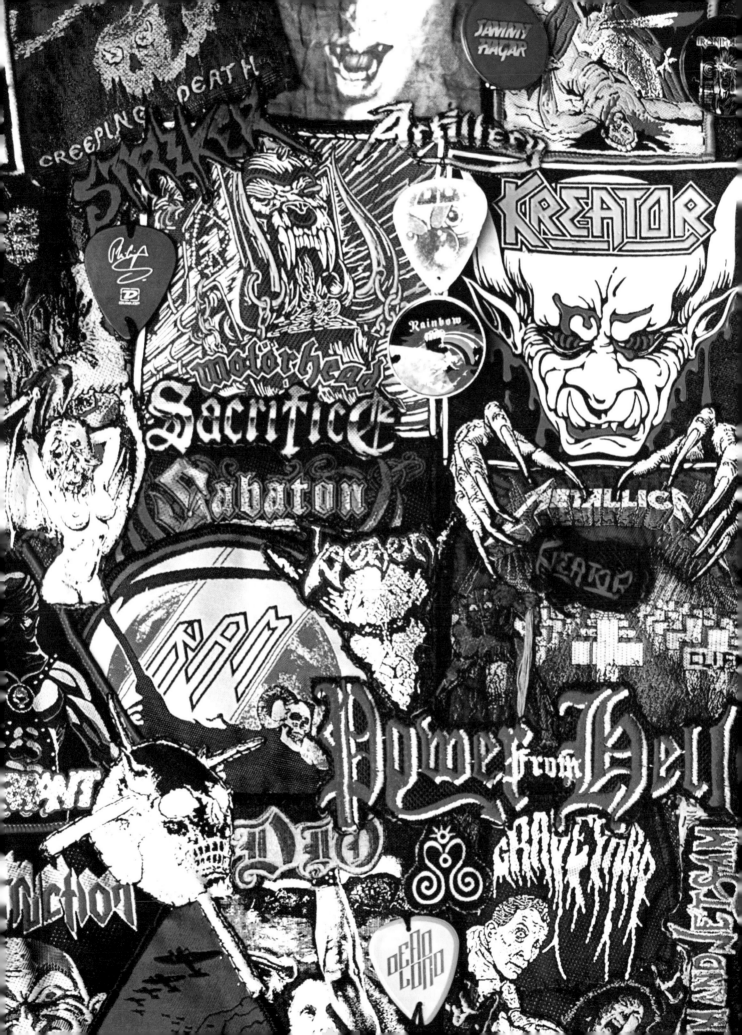